# MARIMEKKO

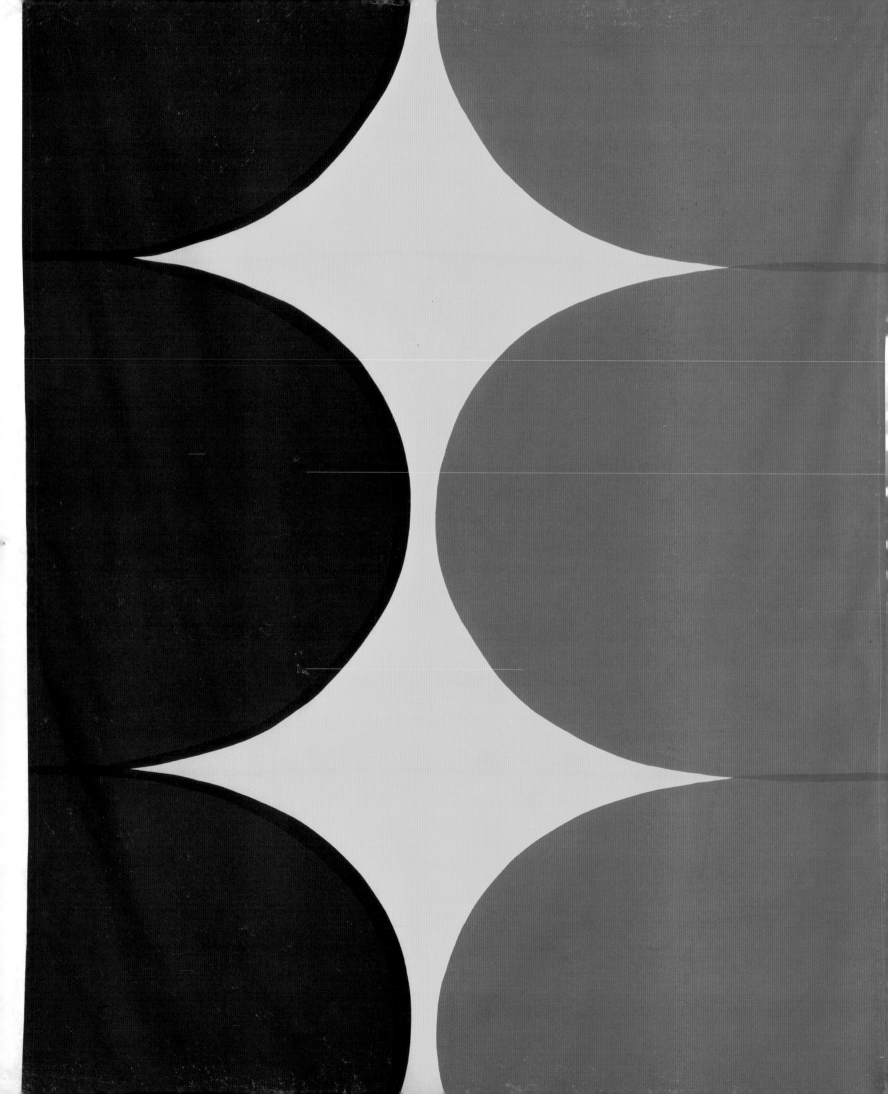

# MARIMEKKO

## FABRICS FASHION ARCHITECTURE

Marianne Aav, *Editor*

Published for The Bard Graduate Center for Studies
in the Decorative Arts, Design, and Culture, New York,
and the Design Museum, Finland, by Yale University Press,
New Haven and London

This catalogue is published in conjunction with the exhibition *Marimekko: Fabrics, Fashion, Architecture* held at The Bard Graduate Center for Studies in the Decorative Arts, Design, and Culture from November 21, 2003, through February 15, 2004.

Exhibition curator: *Marianne Aav*
Project coordinators at the Design Museum, Finland: *Eeva Viljanen* and *Maria Härkäpää*
Project coordinators at the Bard Graduate Center: *Ronald T. Labaco* and *Olga Valle Tetkowski*
Catalogue production: *Sally Salvesen*, London
Copyeditor: *Martina D'Alton*
Finnish-language translators: *David McDuff* and *John Arnold*

Director of Exhibitions and Executive Editor, Exhibition Catalogues: *Nina Stritzler-Levine*

Catalogue and jacket design:
*Minna Luoma*, Candy Graphics

Printed in Italy.

10 9 8 7 6 5 4 3 2

Library of Congress Cataloging-in-Publication Data
Marimekko / edited by Marianne Aav.
    p. cm.
Includes bibliographical references and index.
  ISBN 0-300-10183-X (cl. : alk. paper)
  1. Textile design—Finland—History—20th century.
  2. Costume design—Finland—History—20th century.
  3. Marimekko Oy—History. I. Aav, Marianne. II. Bard Graduate Center of Studies in the Decorative Arts, Design, and Culture. III. Title.
  TS1475.M37 2003
  338.7'67702'094897—dc22                    2003017532

Front cover: Maija Isola. *Unikko* pattern, 1964 (Checklist no. 63). • Annika Rimala. *Linjaviitta* dress, 1967; *Galleria* pattern by Vuokko Nurmesniemi, 1954 (Checklist no. 78). • Aarno Ruusuvuori. Design for the Marikylä experimental house known as the Marihouse, Bökars, Porvoo, ca. 1963. Pen and ink. Museum of Finnish Architecture, Helsinki.
Back cover: Maija Isola. *Nooa* pattern, 1961. • Liisa Suvanto. *Koppelo* dress; *Tiet* pattern, 1974 (Checklist no. 108).
Frontispiece: Maija Isola. *Istuva härkä* pattern, 1966 (Checklist no. 71).
Opposite contents page: Vuokko Nurmesniemi. Raincoat and umbrella; *Aaltopituus* pattern, 1958.

*Marimekko: Fabrics, Fashion, Architecture* has been made possible with the generous support of the Marimekko Corporation. Additional support has been provided by The Coby Foundation, Ltd.; the Ministry for Foreign Affairs of Finland; Crate and Barrel; and Finlandia Foundation National.

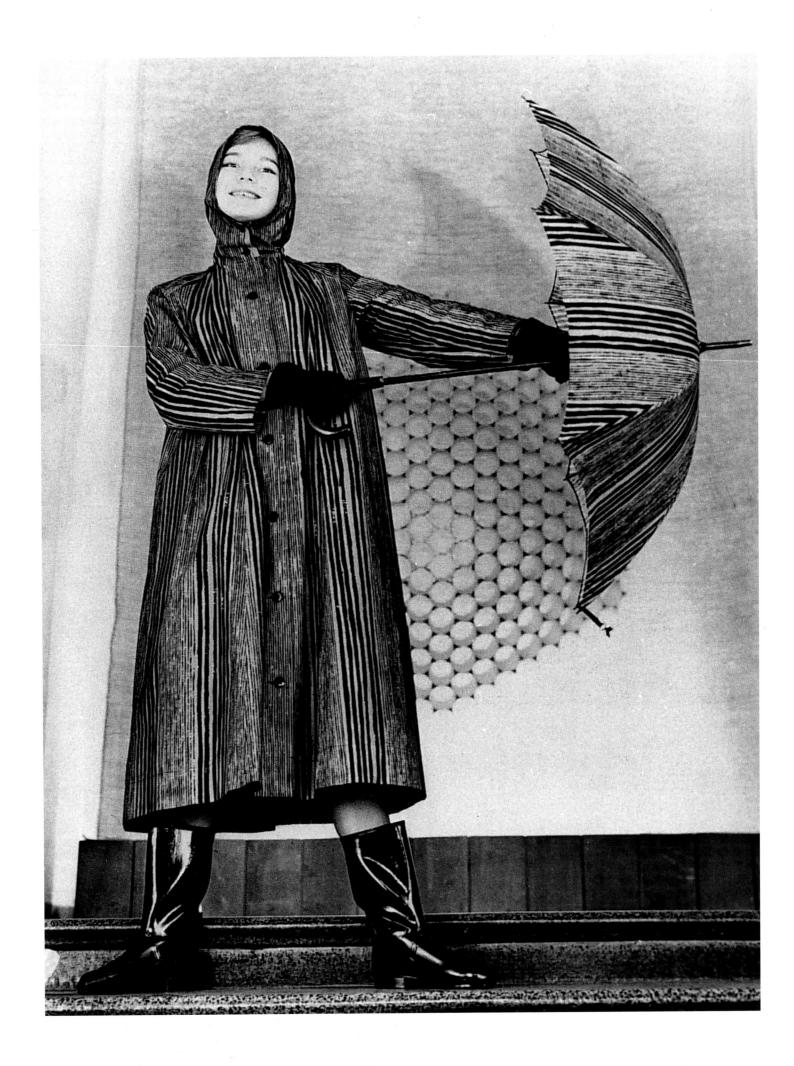

# Contents

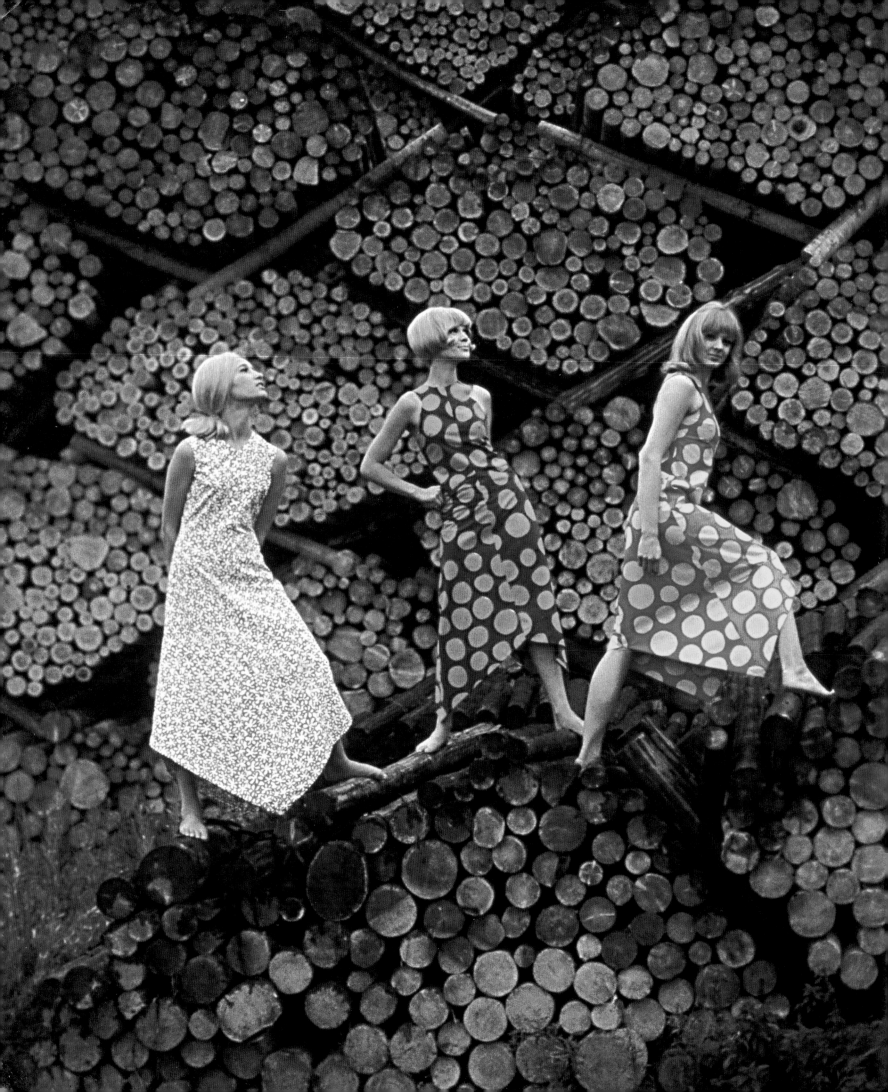

# Foreword

It is a source of great pride to include *Marimekko: Fabrics, Fashion, Architecture* in what is now the Bard Graduate Center's decade-long contribution to exhibition practice and catalogue production in the decorative arts, design, and culture. I hope that both scholars and the general public will benefit from and enjoy this exhibition and the illuminating publication that accompanies it. They will undoubtedly inspire further study.

Many people assume that they know the nature of the phenomenon called Marimekko; it is, however, an area of considerable ongoing scholarly inquiry. In the early years of the twenty-first century it has become common in the English-speaking world to associate Finland primarily with recent achievements in technology, despite the nation's rich design heritage. Finnish technology engenders many of the features that have been so admired in Finnish architecture and design, namely outstanding quality, refined materials and production methods, aesthetic sophistication, and attention to basic human needs. Nokia, for example, has attracted international attention not only as a catalyst for the proliferation of cell phones, but also as a design innovator with an outstanding corporate mentality. To better understand how it is that Finnish companies came to excel in international corporate culture, we need only look at the history of Marimekko, a company that exists outside the realm of technology. Despite its reputation in the decorative arts and design, however, Marimekko has never been the focus of a major publication outside Finland until now.

One does not have to search far to discover why Marimekko has endured for more than fifty years in the fiercely competitive world of fashion and lifestyle accessories. The reasons lie in the firm's visionary leadership and its distinct corporate philosophy based on individual creativity and the connection between design and everyday life. Marimekko also adheres to corporate values that are approaching extinction in the English-speaking world and are rare internationally in a climate that now appears to foster profit gains rather than design integrity and innovation. How many companies today would take the financial risks necessary to support the extensive roster of company designers employed at Marimekko? Although a percentage of its product line must of necessity be manufactured outside Finland, Marimekko continues to maintain seemingly anachronistic production methods at home (in an iconic factory building in Helsinki) in order to guarantee quality and encourage innovation. Few companies would do the same.

Many readers will associate Marimekko with the late 1950s and 1960s and the colorful, at times audacious, fabrics of Maija Isola and the fashion designs of Vuokko Nurmesniemi and Annika

◄ A Marimekko photo shoot for *Life* magazine, 1965. Courtesy of Tony Vaccaro/*Life*.

Rimala. Their contributions to design came to symbolize social and fashion revolution. In fact, today Marimekko continues to thrive by embracing its past while keeping a sharp eye on the future. This combination has made Marimekko an international exemplar of excellence in the decorative arts and design of the twenty-first century.

*Marimekko: Fabrics, Fashion, Architecture* is the result of a remarkable collaboration. Marianne Aav, director of the Design Museum, Finland, has been an outstanding partner in the realization of this project. I greatly appreciate her fine effort as curator of the exhibition and editor of the catalogue. Kirsti Paakkanen, president and CEO of Marimekko, has been an invaluable supporter of this project since its inception. We have all learned from her leadership qualities and have been inspired by her passion for Marimekko. Other individuals at Marimekko in Helsinki have given their time and provided important information including Helinä Uotila, Marja Korkeela, Riika Finni, and Samu Koski.

We have been fortunate to receive the generous financial assistance necessary to realize a project of this scope. I am grateful to the benefactors: Marimekko Oyj; The Coby Foundation, Ltd.; the Ministry of Foreign Affairs of Finland; Crate and Barrel; and Finlandia Foundation National. I appreciate the assistance of Jukka Leino, Consul General of Finland in New York. Ilkka Kalliomaa, cultural attaché at the Consulate of Finland in New York, has given his time to this project from the onset and shared his experience and knowledge of Marimekko.

The exhibition is composed primarily of loans from the Design Museum, Finland, and has been enriched by additional key loans from Susan Ward, Marja Suna, Marimekko Oyj, and the Museum of Finnish Architecture. I would also like to thank Timo Keinänen of the Museum of Finnish Architecture and the Finlandia University / Susan Peterson Collection in Hancock, Michigan, for their assistance with loans.

At the Design Museum, Finland, Eeva Viljanen and Maria Härkäpää were of great help on many aspects of the exhibition and the catalogue. Harri Kivilinna assisted on research and preparation of the objects for exhibition, and Riikka Jäväjä offered her great skill as a conservator to the preparation of the fabrics and clothing.

The realization of this catalogue is due largely to the contributions of an outstanding group of scholars, to teamwork, and to the generous sharing of ideas and research among individuals in Finland, England, and the United States. I would like to thank the authors — Marianne Aav, Antti Ainamo, Riitta Anttikoski, Hedvig Hedqvist, Lesley Jackson, Riitta Nikula, and Rebecka Tarschys — for their insights into the history of Marimekko. Minna Luoma has designed a magnificent catalogue that brilliantly captures the bold vision of Marimekko.

In addition she willingly took on tasks outside her domain, serving as picture editor and even as spiritual leader of the catalogue production. Rauno Träskelin produced the magnificent photography of the Marimekko Collection at the Design Museum, Finland, and other photographs for the catalogue in Finland. He also provided advice and assistance concerning the period illustrations. Additional photography was provided by Sheldan C. Collins. Linda Baron, Michael Stier, and Sonni Strenke helped to secure photographic rights and track down period photographs. The challenging task of translating the Finnish-language manuscripts was ably accomplished by David McDuff. John Arnold translated the catalogue section and Ms. Aav's introduction. Martina D'Alton has been a superb copyeditor. At Yale University Press, London, Sally Salvesen's skill as an editor and knowledge of catalogue production are visible throughout this publication. She is a cherished colleague. I am also grateful to John Nicoll for his guidance and direction.

Many individuals in Finland offered assistance, provided essential information and recollections about Marimekko. I would like to thank Ritva Falla, Fujiwo Ishimoto, Kristina Isola, Mysi Lahtinen, Vuokko Nurmesniemi, Ristomatti Ratia, Annika and Ilkka Rimala, Marja Suna and Petra Suvanto for their efforts on behalf of this project.

In the United States many colleagues willingly responded to research questions and provided photographs for the catalogue. In this regard I would like to thank Hamish Bowles, Elizabeth Broman, Crystal Cooper, Lynn Felsher, Mary Barelli Gallagher, Allan Goodrich, Gregory Herringshaw, Jack Lenor Larsen, Matilda McQuaid, Dante Ruzinok, Jane McC. Thompson, Tony Vaccaro, and Jim Wagner.

The exhibition department of the Bard Graduate Center, under the directorship of Nina Stritzler-Levine, has helped shape the content of the exhibition and the catalogue. The experience and knowledge of the department staff have been of great benefit to this project. Ronald T. Labaco has shared his knowledge of and passion for twentieth-century design, in addition to facilitating loans, relentlessly searching for answers to research questions, and providing extensive administrative support. In addition he helped structure the exhibition interpretation, particularly the brochure. Olga Valle Tetkowski has assisted with various administrative needs. Han Vu applied his knowledge of technology to many tasks, including the use of digital technology to produce the brochure.

The exhibition department staff has also been fortunate to have the assistance of a remarkable group of students: Yasmin Elshafei, Freyja Hartzell, and Charlotte Nicklas. Ms. Nicklas, Sarah Fogel, and Linda Stubbs brought their outstanding registrarial

skills to this project. The preparation and installation of an exhibition of this kind requires specific skills associated with the care and handling of textiles and fashion. Cathy Maguire has been a great asset in this regard. My thanks to Susan Loftin for the wonderful design of the installation. She has received the support of Ian Sullivan and the Bard Graduate Center installation crew. Jennie McCahey and Cindy Kang offered their assistance with the interpretation of the exhibition and with the essential needs of the exhibition gallery.

Tim Mulligan directed the press campaign with the assistance of David Tucker. The fundraising effort for this project was conducted by Susan Wall working with Tara D'Andrea, Maria Ermides Stegner, and Brian Keliher. Lorraine Bacalles provided assistance related to financial matters. Bonnie Poon and the staff of the public programs department have initiated a lively selection of public programs in conjunction with the exhibition. Jennie McCahey coordinated the gallery tour program with ingenuity and professionalism. I would also like to thank Sandra Fell for assisting with numerous administrative tasks in the director's office.

John Donovan and the staff of the Bard Graduate Center facilities and security department, including Orlando Diaz, Claudette Livingstone, Terence Lyons, Greg Negron, Jose Olivera, and Chandler

Small attended to many important tasks associated with the daily maintenance of the gallery.

Finally I would like to express my general appreciation once again to the staff of the Bard Graduate Center for their professionalism and their many contributions, which have helped to establish the Bard Graduate Center as one of the world's premier institutions devoted to the study of the decorative arts, design, and culture.

Susan Weber Soros
*Director, The Bard Graduate Center*

▶ Liisa Suvanto. *Kikapuu* dress in *Ruuturaita* pattern, 1974 (Checklist no. 104).

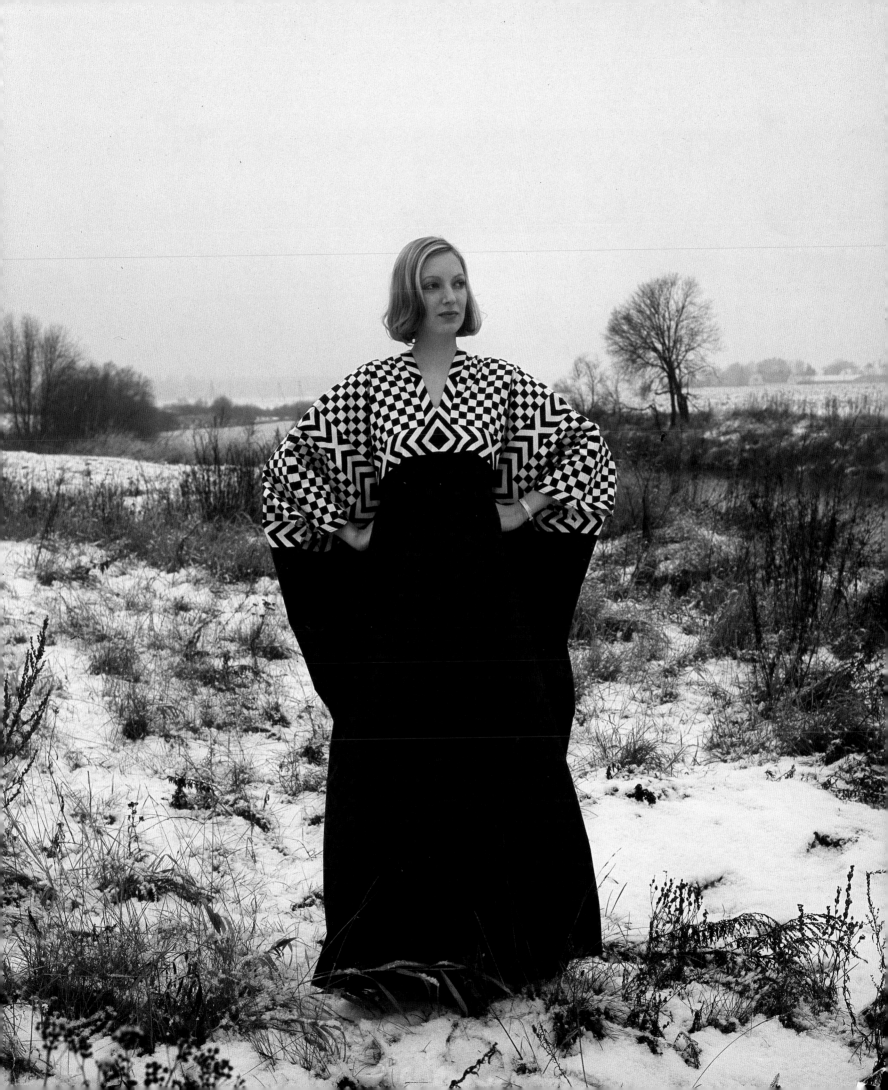

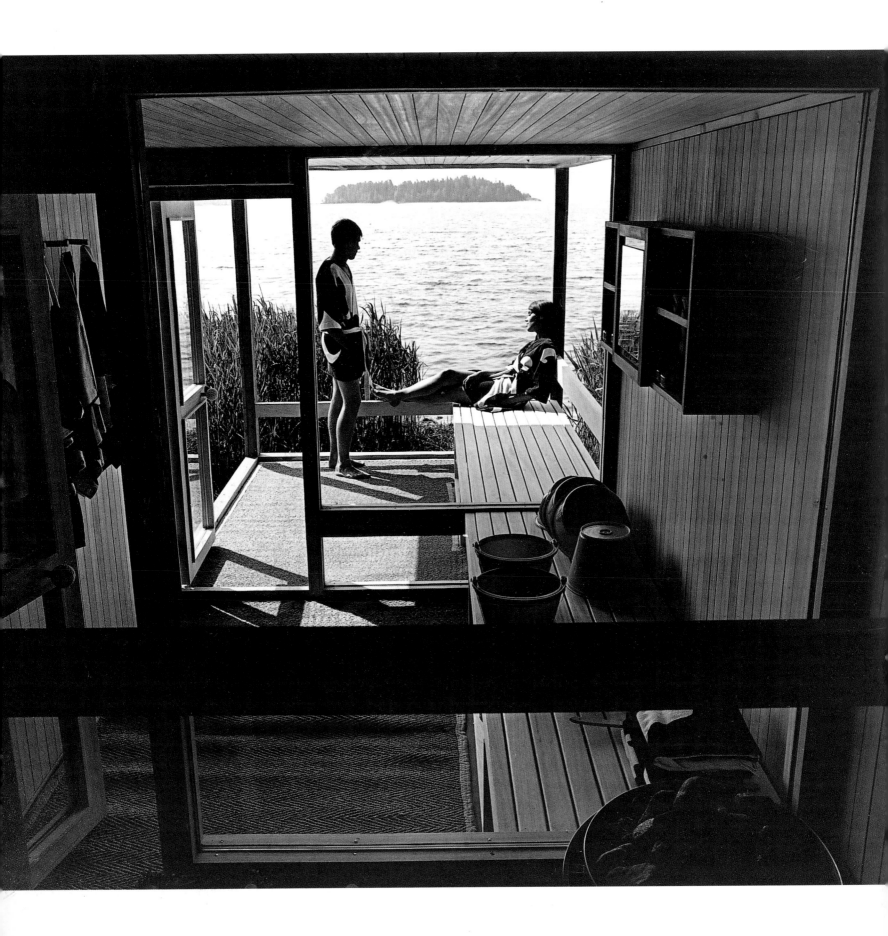

# Introduction

The Bard Graduate Center and the Design Museum, Finland, first worked together in 1998, on the exhibition *Modern Finnish Design: Utopian Ideals and Everyday Realities, 1930–1997*. As the name suggests, the exhibition analyzed the development of Finnish design from the post–World War I period to the end of the twentieth century. The present exhibition also focuses on Finnish design from this period. *Marimekko: Fabrics, Fashion, Architecture* is a penetrating analysis of one of the most fascinating and internationally renowned phenomena of Finnish design. The idea of producing an exhibition and associated book about Marimekko came into being in 2001, when the company celebrated its fiftieth anniversary and simultaneously enjoyed its greatest financial success to date. With its eventful, often tumultuous history, Marimekko had established its position as a global company.

With Alvar Aalto as leading light, Finnish architecture and design played a brilliant part in the modernist movement of the 1930s. This moment was curtailed by the outbreak of World War II, after which a new, young generation entered the arena of Finnish industrial arts, seizing the challenges of the postwar period with imagination and originality. These newcomers kept a close eye on the latest trends of the time and worked together with industry to create an aesthetically and functionally pleasing environment in line with the demands of the day. Marimekko played an important part in forging a new society in Finland and developing new aesthetics for both fashion and interior design. The fruits of the fertile collaboration between Finnish industry and design, including Marimekko, first took the international stage at the Milan Triennials of the 1950s.

In many respects Marimekko is a unique company by any standard. Its story reflects Finnish society and the progress achieved by Finland's industry in the second half of the twentieth century, but its boldness and originality were also in many ways ahead of its time, leading the way for other entrepreneurs. Marimekko's business concept is tinged by the ideology of modernism. Its theoretical foundation is profoundly visionary. It has also, since its inception, been a company whose ideological and aesthetic choices have been in the hands of women. Company president Armi Ratia's courage was crucial in recruiting promising young designers and fostering an atmosphere that allowed creativity to flourish. Collaboration between Ratia and the open-minded designers at Marimekko enabled the company's operations to expand from printed fabrics to the broader concept of designs for a new lifestyle. The idea of the *Mari* person came into being. In tangible terms, designing expanded from fabrics and garments to embrace a series of products as well as the built environment. The linkage of the

◄ Aarno Ruusuvuori. Marisauna, Karhusaari, Espoo, 1966.

Marimekko aesthetic to architecture was multi-dimensional from the start. Marimekko's stripped-down printed patterns appealed to architects and won them over. In addition, the loose, body-concealing, straight lines of Marimekko garments had points of contact with the all-protecting function of architecture.

The Marimekko aesthetic is all-embracing and total; this, of course, has never meant conformity. Marimekko is full of complementary opposites: national and international, tradition and modernity, closeness to nature and urbanism. The company's line has also been open to international influences. The Japanese aesthetic, in its affinity to nature and its understated lines, has always been close to Finnish ideals. Since the late 1960s, it has been a prominent part of the Marimekko aesthetic.

The objects in *Marimekko: Fabrics, Fashion, Architecture* are primarily from the Marimekko Collection in the Design Museum, Finland. Marimekko donated this collection to the museum at the time of its thirty-fifth anniversary exhibition in 1986. In all it comprises some 2,500 items of clothing and fabric as well as an extensive archive of models, pictures, and documents. The exhibition and associated publication are the most comprehensive portrayal of Marimekko's history, exploring the Marimekko phenomenon from many different angles. Design historian Lesley Jackson examines Marimekko's once revolutionary printed patterns in an international context, while architectural historian Riitta Nikula analyzes the architectonic expressions of the Marimekko aesthetic. Riitta Anttikoski views Marimekko fashion through the different approaches used by designers. Journalists Rebecka Tarschys and Hedvig Hedqvist, who have been writing about Marimekko since its early years, focus on the international dimensions of Marimekko, while economist Antti Ainamo considers the fundamentals of Marimekko's commercial success and the correlation of that success to design throughout the company's history.

On behalf of the Design Museum, Finland, I would like to express my warmest thanks to Susan Soros, director of the Bard Graduate Center, for presenting me with the splendid opportunity to make one of the best-loved sectors of Finnish design known to the American public. I would also like to thank Nina Stritzler-Levine, the director of exhibitions at the Bard Graduate Center, for her dedicated efforts toward making the Marimekko exhibition and book a reality. Many individuals at the Design Museum, the Bard Graduate Center, and Yale University Press have provided invaluable help in bringing this project to fruition and I am grateful to them all. It has been my great privilege to be part of this extraordinary project.

Marianne Aav
*Director, Design Museum, Finland*

## Editor's note

Translated literally, Marimekko means "Mary-dress," but it has other connotations as well. *Mekko* is an old Finnish word meaning "little girl's dress," which suited the fresh, new look of Marimekko in 1951, while at the same time connecting to Finnish tradition. There is further resonance in the name: "Mari" is an anagram for "Armi," thus linking the company closely to its charismatic founder, Armi Ratia. The depth of association of the company name extends to the names chosen for the fabric patterns and fashions. While many are straightforward, others defy translation. Some may have been chosen for their phonetic qualities or are deliberate misspellings that will be understood only by Finns as either humorous or old-fashioned. Others are in dialect or are old adages that may be unfamiliar today even to Finns. These will still have a phonetic impact or emotional content for most Finns, but probably not for others. In any event we have included translations in the text and checklist wherever possible, but not in the captions. Another complication, albeit a minor one, is that Marimekko designers, most of whom were women, changed their names when they married or remarried. For the reader's convenience we have used one name throughout, as, for example, in the case of Annika Rimala, who was also well known as "Annika Piha" and worked under "Annika Reunanen" as well. And over the course of a long history, many institutions and corporations have also changed their names, often more than once. Again, for the reader's convenience, we have tried to be consistent in using a single designation despite such changes. For example, we have chosen to use "Institute of Industrial Arts" (Taideteollinen Oppilaitos) throughout, although this school has had several names and is today the "University of Art and Design." There is one exception: in the texts that follow, the Design Museum, Finland, is variously called Designmuseo and The Finnish Museum of Art and Design, Helsinki. Most of the exhibition objects are illustrated in chapter 7. The archival photographs, unless otherwise noted, are from the Marimekko archive in the Design Museum, Finland. While many of the actual photographers are known, it is not always possible to match them with their work. The essay illustrations do not always have figure reference numbers in the text.

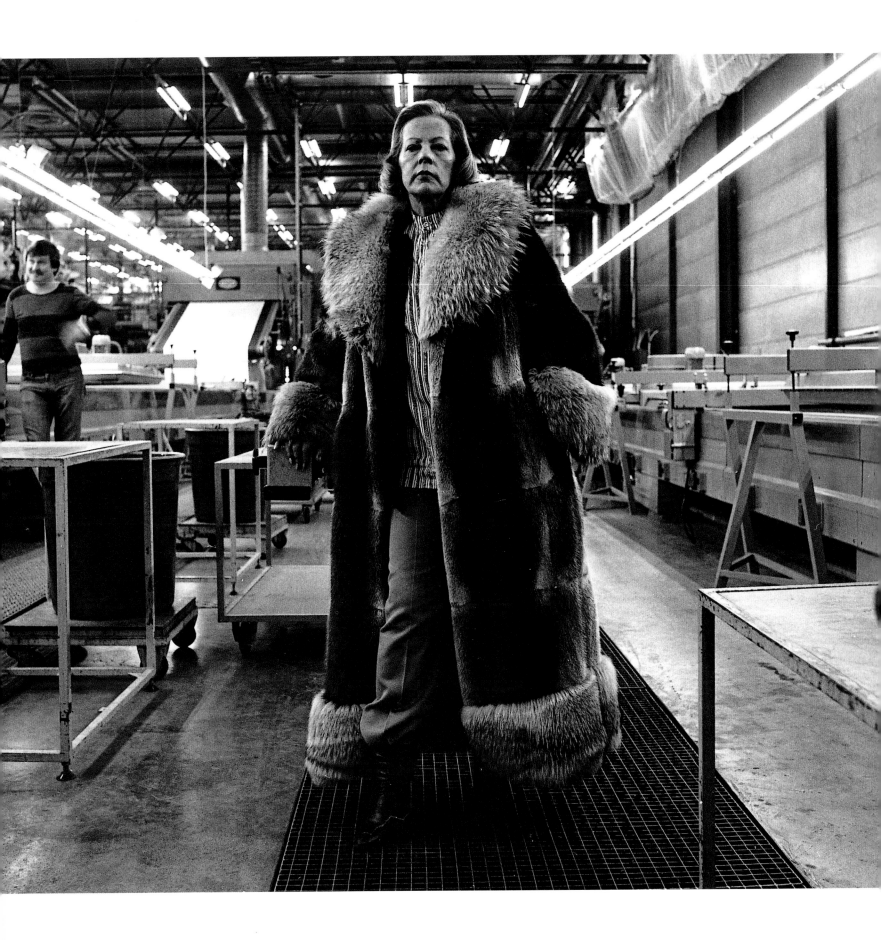

# 1. Armi Ratia and the Duality of a Design Enterprise

Marianne Aav

·

The first public presentation of Marimekko's fashion and textiles took place in 1951 in the wake of the first great triumph of Finnish design in the post–World War II era. The Ninth Milan Triennial, held in 1951, marked Finland's international breakthrough in the sphere of industrial art. Designed by Tapio Wirkkala, Finland's award-winning installation featured an array of remarkable textiles, ceramics, and glass — art objects representing a collaboration between artists and industry. Not since the 1930s had Finnish design met with such success in an international arena, and with the burgeoning of a media culture in the early 1950s, Finland's triumphs could be fully exploited. The designers' achievements were widely discussed in the Finnish press, and the designers themselves returned from Milan to a hero's welcome comparable to that accorded Olympic medallists. A star cult of Finnish designers was emerging. International recognition also encouraged industry to invest further in design, to establish permanent relations with artists, and to offer them almost a free hand in realizing their artistic ambitions.

◄ Fig. 1–1. Armi Ratia in the Marimekko factory at Herttoniemi, mid-1970s.

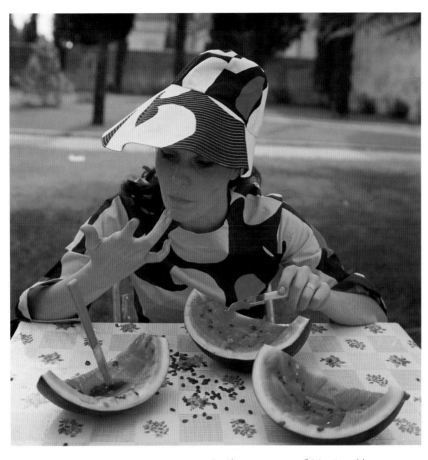

Fig. 1–2. Annika
Rimala. Hat and
dress; *Jokeri*
pattern, 1967.

toward the future of our industrial art, namely a firm that represents a new way of thinking in the textile and clothing sector — Marimekko."[1]

Marimekko's history can be characterized as a continuous struggle to balance design and fashion. As every account of the beginnings of Marimekko explains, the newly founded textile firm recognized the production of clothes as necessary to making itself known to the buying public. At the same time it was the revolutionary printed fabrics (fig. 1–3) that made the greatest impact in professional design circles.

This essay examines Marimekko within the context of its era and of mid-twentieth-century design, in Finland in particular. Integral to the success of the company was its founder, Armi Ratia, whose business philosophy and marketing strategies played key roles in launching Marimekko worldwide. While her husband, Viljo Ratia, undoubtedly played an important role as head of the firm's financial affairs, his story is largely outside the scope of this essay.

In many respects the success of Marimekko was linked to this milieu — it was in the right place, at the right time — but how Marimekko grew from this beginning and these elements is another story. The company developed (indeed, had to develop) in its own way. This is explained partly by the dualism that exists between design and fashion and partly by the personality and background of Marimekko's founder Armi Ratia (fig. 1–1). Design historian Erik Kruskopf wrote in 1989: "Clothes are among the textile products that can only loosely be considered a form of industrial art. This may be because of their definition as fashion and consumer goods; they fulfill their task at any given time, but are thereafter either worn out or become distinctly out-of-date.... But during the golden age of Finnish design in the 1950s and 60s a phenomenon appeared that is unquestionably one of the milestones pointing

## An authentically Finnish brand

Today (2003), the Marimekko trademark is familiar to every Finn and is recognized as a symbol of Finnishness throughout the world. It is considered as Finnish as rye bread or the sauna, like it or not. But Marimekko's importance has not always been undisputed. In 1964 the Eastern Finnish newspaper *Karjala* (Karelia) labeled Armi Ratia, who was Karelian-born, a "Karelian Cosmopolitan" and wrote: "The attitude to Marimekko clothes is seldom indifferent, they are either liked or loathed. People sometimes come into the Marimekko shops and spit with disgust. Or someone telephones obsessively because Marimekko hats are spoiling the look of the Helsinki streets! [Fig. 1–2.] The person whose taste is

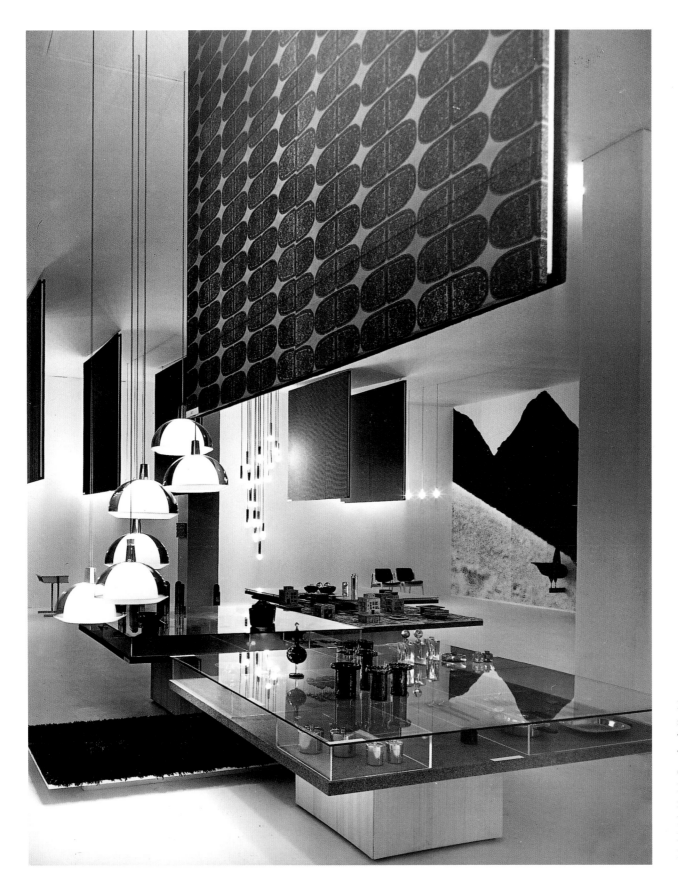

Fig. 1–3. Finnish section at the Milan Triennial, 1960. The pattern is *Tantsu* designed by Maija Isola, 1960. Finnish Society of Craft and Design Collection, Design Museum, Finland.

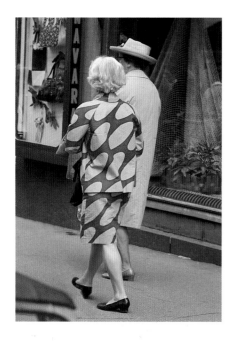 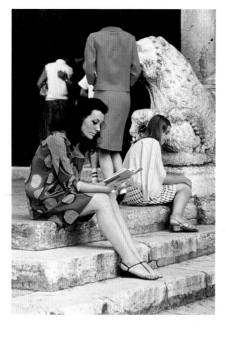 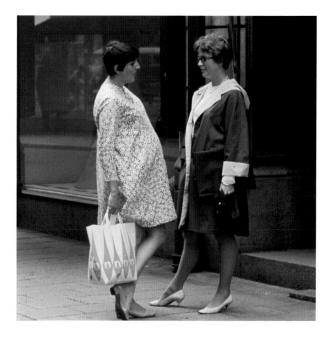

conventional, i.e. 'good', as they say, is often of the opinion that one can't dress in clothes like that, but butter has melted many times before, too ."[2]

Since Marimekko's inception, the company has provoked similar responses: on one hand, it has strong roots in Finnish tradition, an image it has always consciously tried to reinforce, while on the other hand, it has been distant from the conventional Finn, its products not always meeting with unreserved admiration. Yet the *Karjala* writer's prophecy came true: the butter melted. In fact, by the early 1990s, when Marimekko was threatened with bankruptcy, Kirsti Paakkanen, who purchased and rescued the company, was revered as the savior of a national treasure.[3] This status, this final "melting of the butter," was nurtured in part through a skillful and focused marketing campaign, or, as Armi Ratia preferred to put it: "Propagation is very important."[4]

Marimekko is full of contrasts, not just those between tradition and innovation. These pairings are in fact similar to those used by architect Juhani Pallasmaa to describe the multifaceted personality

of Tapio Wirkkala: In addition to traditionalism and innovation, there were: proximity to nature — urbanism; unique art — mass production; artistic — functional; everyday — festive; organic — geometric; rational — romantic; homeyness — exoticism, strangeness; ergonomics — pure form; asceticism — richness of form; Finnishness — internationalism (figs. 1–5 to 1–7). According to Pallasmaa, "it is these contradictory elements that give Wirkkala's objects their richness of association and timelessness."[5] When Marimekko is examined through the lens of Armi Ratia's directorship, the same pairs of opposites can be seen. We can also ask whether it is possible to recognize these pairings in Finnish design in general, or in fact whether they are the legitimate tensions associated with all good design. As Alvar Aalto wrote, "In every [design] instance there must be a simultaneous resolution of opposites."[6] In the case of both Marimekko and Tapio Wirkkala were these contrasts purely inborn or were they deliberately sought and reinforced, both from within and from without, either consciously or unconsciously?

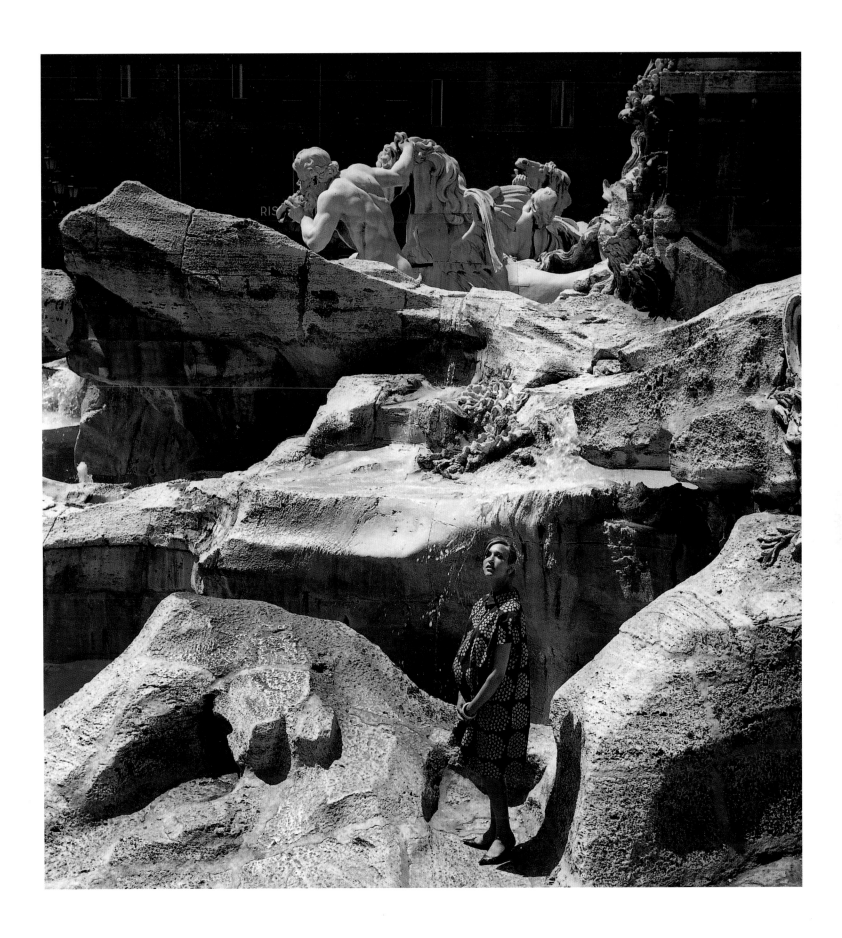

Fig. 1–6. Summer
bedroom in a Finnish
cottage, with Maija
Isola's *Silkkikuikka*
pattern textiles, 1961.

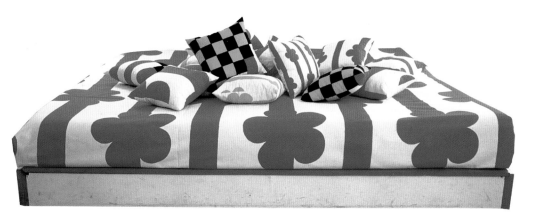

Fig. 1–7. Anneli
Qveflander. *Menuetti*
pattern, 1968.

These questions provide a key to understanding the phenomenon of Armi Ratia and Marimekko.

Marimekko came into being at a time that was characterized by tensions in Finnish design caused by international events, by World War II and its aftermath. The war and the resultant shortages of material goods created a yearning for beauty. On the one hand designs with romantic themes became popular, while on the other there was increased incentive to seek out new choices of design and materials. In 1945, in the twelfth yearbook issued by Suomen koristetaitelijain liitto, Ornamo (Finnish Association of Decorative Artists, Ornamo) the interior designer Ilmari Tapiovaara wrote about the opportunity inherent in such difficult times: "… scarcity is discovering its own style, it will apparently be the most important element in our industrial art for the next few years, a stylistic factor created by necessity." He also admired the elegant economy of Japanese art. "Poverty understood like this would be spiritual and aesthetic wealth, but it demands more from our artists as experts than the excesses of prosperity. The creative spirit should be more experimental, more inquisitive and have the explorer's mind."[7] Tapiovaara applied his design philosophy to his own furniture production in a beautifully pared-down way.

In many ways Marimekko, in the area of textile and clothing design, fulfilled Ilmari Tapiovaara's prophecy that scarcity would become a victory: in inventive hands the use of inexpensive cotton sheeting became an unparalleled success. Even mistakes in silk-screen printing originally carried out with somewhat primitive means became successful when it was realized that they could be turned into a trademark that guaranteed quality.

## Armi Ratia's student years

In the postwar era, the minimalist aesthetic in Finnish design was complemented by a strong cultural desire for innovation and artistic productivity. Additional impetus came with the international success of Finnish design through which there was an increased sense of national identity, often concentrated in individual personalities, such as Armi Ratia or Tapio Wirkkala. In 1964 in an article about successful businesswomen, one Finnish journalist wrote: "Armi Ratia ought really to be taken around the world to all the mass meetings, fairs, circuses and amusement parks. Put her on show and say: 'Look closely, this woman believes in herself, dares to be herself and dares to think in her own personal way!' — Armi Ratia is a phenomenon. And also a promulgator, Marimekko's lay preacher."[8]

This phenomenon was quite different from the textile art student, then Armi Airaksinen, who began her studies at the Taideteollisuuskeskuskoulu (Institute of Industrial Arts) in Helsinki in 1932. This was the first time she had left her native Karelia, the eastern region of Finland, which was quite different from the rest of the country. Its tradition, language, and even cuisine possessed a distinctive blend of Eastern cultural influences. The people of the region can be characterized as open and friendly, with a tradition of living in farmhouses, in extended family groups. Hospitality and feasting were a natural part of the social pattern.

Armi Ratia had been born in northern Karelia, in the village of Pälkjärvi, where her father ran a general store. She had three brothers, all of whom were killed fighting the Russians during the war. She had been educated in the regional capital, Viipuri, where she first encountered a sophisticated international cultural milieu among the Russian, French, and German minorities. Some time before

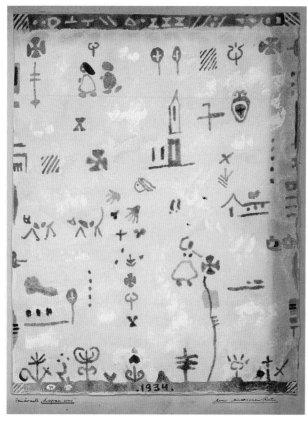

Fig. 1–8. Armi Airaksinen-Ratia. *Lapsen uni* (child's dream), drawing for a tapestry, 1934. Friends of Finnish Handicraft Collection, Design Museum, Finland.

1932, she met Viljo Ratia, another Karelian, through a mutual friend. When he left to study at the Finnish Military Academy in Helsinki, Armi chose to follow him, distancing herself from her family. At the Institute of Industrial Arts, classmate Birger Kaipiainen, a ceramist, remembered Armi as a shy girl who hardly ever said a word.[9] Years later, Eva Taimi, another near-contemporary and herself a textile artist, recalled Armi Ratia somewhat differently, as an unusually creative student, "who was able to design five competition entries while the rest of us could only manage to make one," (fig. 1–8).[10]

Whether Armi Airaksinen-Ratia was really a shy girl whose creative energy flowered when it was channeled correctly and in the right cultural climate, or whether the "shyness" of her student years stemmed from insecurities is not known. By 1954, as Marimekko's figurehead, she had lost that "shyness" and was described by an American editor as "one of the most fascinating rapid fire talkers I have met lately."[11]

As a public figure Ratia may have been in a class of her own, but the confidence she had was shared by many Finnish designers and artists of her generation. One reason for this was their training. Those whose careers began to flourish in the late 1940s had undergone the same training and virtually all of them had been influenced by Arttu Brummer, a teacher who fought ardently for the advancement of industrial art and himself a designer mainly of furniture and glassware. As a furniture designer Brummer took part in many of the major public projects of the period. He designed a number of interiors for the Parliament House (1930), including the Cabinet Office, and supplied furnishings for the entrance hall and committee rooms of Helsinki University (1937, 1949), working in the conservative tradition of Finnish classicism in contrast to Aalto. As a glassware designer, however, especially in the soft forms of his blown bubble-glass objects of the 1930s, Brummer approached the formal language of French progressive glass work of the period as typified by Maurice Marinot. Perhaps more important than Brummer's own production were his contributions as a promoter of industrial art. He was an outspoken public advocate of the connection between art and craft, and as a teacher he succeeded in infusing his students with enormous self-confidence. He also urged his best students to collaborate with industry. In fact he was partly responsible for Maija Isola beginning an association with Marimekko, one that was to last nearly forty years.

Almost without exception, the designers who studied at the Institute of Industrial Arts from 1930 to 1950 identify their most unforgettable memories

as the occasions when Brummer criticized their work, occasions that not only aroused fear, but also were inspirational. Marimekko designer Vuokko Nurmesniemi, for example, remembered Brummer mercilessly comparing the students' work to a kind of Finnish peasant sauce made with pork fat, calling it "imitative," but she nevertheless found him an incomparable mentor who inspired her throughout her career to "invent and experiment independently."[12] At Marimekko, the designers of the 1950s, such as Nurmesniemi, who participated in the earliest days of the company, had all experienced Brummer's enthusiastic approach to design. Brummer's own image of an ideal artist was a kind of universal virtuoso, a "Renaissance genius," whose creativity transcended the art/industry dichotomy. He cited as an example Finnish artist Akseli Gallen-Kallela,[13] who was both a painter and a distinguished textile artist. Gallen-Kallela's *Liekki* (Flame) *ryijy* rug, designed at the turn of the twentieth century, has acquired the status of a national icon.

Finnish textile art has for the most part been dominated by women. Only occasionally have male artists and architects been interested in textile design, most notably in the late nineteenth and early twentieth centuries, when modern interiors inspired by the notion of a *Gesamtkunstwerk* and by the English Arts and Crafts movement frequently included artist- or architect-designed textiles. These were temporary excursions into textile design, however, lacking any long-term commitment to this field of design. The general lack of recognition given textile design has been well documented by textile artists, who traded their dreams of an artist's career for the more practical reality of textile studies, often because of family pressure.[14] The weaving skills taught in the Institute of Industrial Arts were considered a suitable option for artistically inclined young women; after all, weaving related to the traditional domestic skills of housewives, which, it was presumed, they would one day need.

The regular teaching of textile art at the Institute of Industrial Arts began in the 1920s.[15] Courses were offered in weaving technique and pattern drawing. At first the programs primarily served the needs of the Suomen Käsityön Ystävät (Friends of Finnish Handicraft), an association founded to foster the handcraft tradition, and the teaching was directed by the association's weavers. This continued until 1928, when Hulda Potila, a third-year student, took charge of teaching, a role she filled until 1963.[16] During her tenure, mastery of techniques remained the primary focus, with an awareness of the structuralist weaving aesthetic developed by the German Bauhaus, which was known in Finland. At first, fabric printing was not part of the textile design curriculum, but there was a course in printmaking offered to painters of interior decoration (muralists, stencilers, and so on) and textile students could also take a class in linoleum block printing taught by Hannes Malisto, teacher of graphic design until 1950.[17] Malisto was succeeded by Kaj Franck, Leena Kotilainen, Maija Isola, Timo Sarpaneva, and Leena Nummi. The range of the class broadened during the tenure of Kirsti Rantanen in the 1960s and 70s. This was partly because Marimekko's success in the field of printed fabric production made new demands on the school's program, prompting greater concentration on the teaching of pattern making for commercial production and introducing experiments in silk screening in collaboration with industry.[18]

Armi Ratia had not originally intended to become a textile artist. As the daughter of a teacher, she planned to become an art teacher. When she

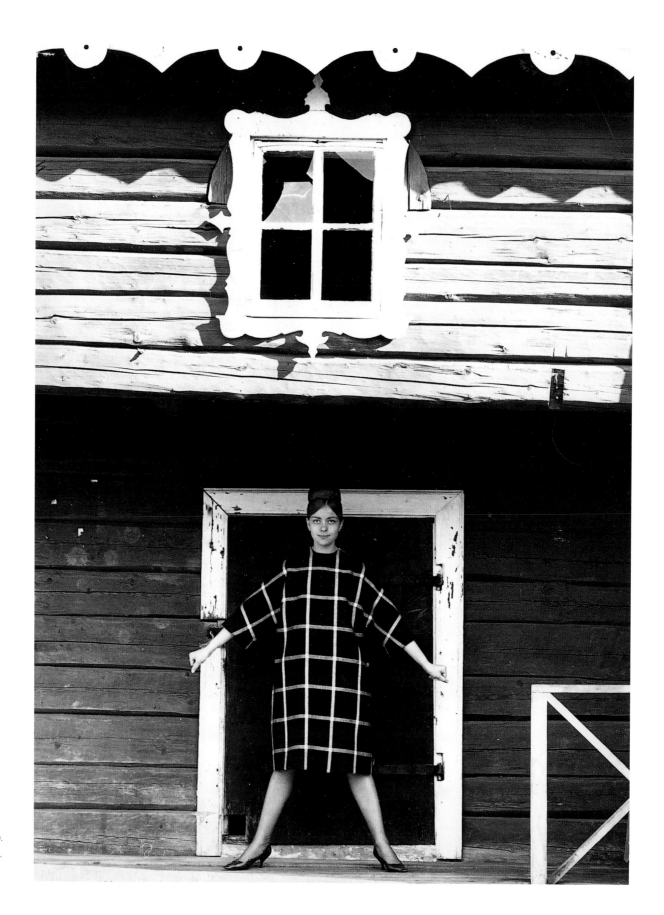

Fig. 1–9. Liisa Suvanto.
*Korpikyliä* dress, 1964.
Handwoven wool.

was not accepted into the training of her choice, however, she was drawn to the field of textile art.[19] Whether Marimekko would have existed had things not gone this way can never be known. Nonetheless, it is reasonable to suppose that in the 1950s Armi Ratia would probably not have blazed her way to the top in any field of industrial design other than textile art. Of the people who came to symbolize Finnish design in the postwar period, three names, all male, stand out: Tapio Wirkkala, Timo Sarpaneva, and Kaj Franck. Finnish industrial art of the 1950s was dominated by men, and partly for this reason it took a long time for Marimekko, a firm created and run by a woman, to be recognized as a part of the grand narrative of Finnish design.

## Armi Ratia's early career

In 1935 Armi graduated from the institute, and in the spring of that year she married Viljo Ratia. She returned to Karelia while Viljo was away serving in the army. In Viipuri, the cultural center of the region, long before Marimekko's founding, she established her own weaving workshop, eventually employing six weavers to manufacture furnishing fabrics, rugs, and wall-hangings. As a practitioner in a most traditional field of art handcraft, Ratia was also in contact with its leading institutions during this phase of her career. By examining aspects of the history of these institutions, we may also understand the socio-cultural and philosophical underpinnings of Marimekko.

In the 1870s, following the example of Swedish craftspeople, a polemic ensued in Finland about enhancing the quality of handmade goods by engaging the services of professional designers.[20] An increased supply of imported goods and the influence of international design had caused Finnish vernacular and craft traditions to begin

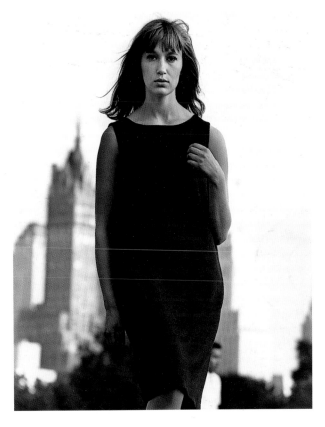

Fig. 1–10. Liisa Suvanto. *Tervapöpö* dress, 1964. Handwoven wool. Courtesy of Tony Vaccaro.

to lose their national character. Concern about the disappearance of the authentic and distinctive Finnish tradition initiated a movement for the preservation of indigenous craft. This led to the establishment of the Friends of Finnish Handicraft in 1879. The association was strengthened by having as its founder Fanny Churberg, who had begun as a painter and was one of the country's artistic elite.[21]

From the association's early days its members participated in exhibitions of decorative art, both in Finland and abroad. The country's foremost visual artists and architects were encouraged to continue the tradition of contributing to the working of the association, among other things designing *ryijy* rugs and tapestries.[22] The Friends of Finnish Handicraft soon became the principal supplier of textiles commissioned for ecclesiastical and public interiors. Thus the production of textiles that were not only

founded their own weaving workshops or companies, such as Taideteollisuus Oy – Konstindustri Ab founded in 1917 by Ingegerd Eklund, Lina Palmgren, and Maria Schwartzberg, three former members of the Friends. Many textile artists also began to work independently in the 1920s. Greta Skogster, for example, had her own weaving workshop and was the artistic director of the Helsinki firm Kotiahkeruus Oy. In another example, textile artist Margareta Ahlstedt founded her "decorative art workshop" in 1924.[23] In addition to working on public commissions, independent weaving workshops also focused on textiles for domestic interior design, a field that was becoming increasingly important. It was as part of this tradition that Armi Ratia started her workshop in 1935.[24]

Between 1920 and 1940 the possibilities for trained textile designers were very limited. One of the few avenues whereby textile artists could find exposure — and possibly employment — was through the competitions organized by the Friends of Finnish Handicraft as part of its mission. These competitions always attracted a great deal of attention and many participants, no matter what the specialized area of decorative art.[25] Similar competitions were held at the Institute of Industrial Arts. Brummer favored competitions as an adjunct to teaching composition, and the textile competitions included entries for cushions, cosies for teapots or coffee pots, *ryijy* rugs, and carpets.[26] Armi Ratia enjoyed considerable success in many of these competitions. The fifteen sketches for *ryijy* rugs, tablecloths, and cushions by Ratia (now in the Designmuseo's collection) serve as examples of the era.[27] They include stylized flower patterns and abstract compositions conceived in the spirit of cubism (fig. 1–11).

of artistic quality, but also technically innovative, had long been in the hands of one organization, and, through it, handcraft-based production. Armi Ratia's innovation was to adopt that handcraft tradition and apply it to the textile industry.

In the nineteenth century, those who designed textile patterns for the Friends of Finnish Handicraft were usually not the same individuals — weavers — who actually made the textiles. The association obtained new patterns either by commissioning them directly from artists or through the competitions sponsored by the Friends. After about 1910, the field of Finnish textile design gradually began to change, and increasingly the pattern designers for the Friends were textile artists who were also skilled at technical realization. In addition, around this time other organizations were formed to rival the Friends of Finnish Handicraft. Textile artists

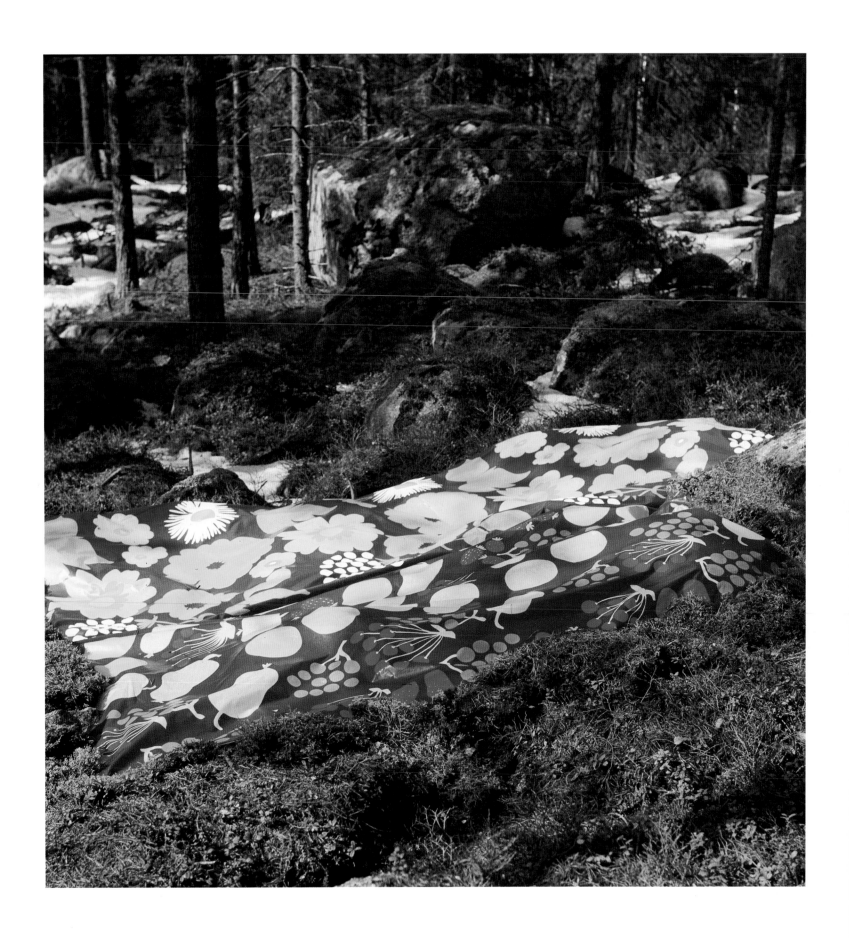

Fig. 1–13. Maija Isola.
*Poloneesi* pattern, 1963.
Oilcloth tablecloth.
From an unidentified
magazine clipping.

## Pioneers of Finnish printed fabric design

With the Russian invasion of her beloved Karelia in 1939, Ratia was forced to close her weaving workshop in Viipuri.[28] This was the first of two invasions of Karelia by the Russians during the war. More than 400,000 native Karelians were expelled from the ceded territory and moved west to other parts of Finland, bringing with them their strong local traditions, made more acute by the pain of absence — a sentiment that Armi never failed to exploit in her promotional images of feasts and parties, guests enjoying the countryside, and the omnipresent samovar (fig. 1–13).

Resettled in Helsinki, Armi spent seven years working as a copy writer at the Erva-Latvala advertising agency in Helsinki. Her next professional involvement with textile art took place after the war, in a new kind of world and from a different starting point. In 1949 she wrote an article for *Kaunis Koti* (Beautiful home), in which she identified the *ryijy* rug as an essential part of the Finnish tradition and predicted it would soon enjoy "a renaissance, though in a slightly modified form."[29] Her prediction proved to be correct, and in Finnish textile art of the 1950s pictorial, colored *ryijy* rugs ranked with Marimekko as emblems of the era.[30] Ratia herself, however, became interested in fabric printing as a modern alternative to weaving techniques. Eva Taimi, who worked at the Helsingin Taidevärjäämö (Helsinki Art Dyeworks) from 1937 to 1947, recalled Ratia as a frequent visitor to the factory during those years.[31] When Viljo Ratia acquired Printex, an oilcloth printing works, in 1949 he asked her to create new patterns for his business, and she recognized the possibility of starting her own printed fabric operation, leading to the establishment of Marimekko in 1951.[32]

Although Finland has a rich textile tradition and although individual fabric printers are named in civic records of Finnish town craftsmen in the eighteenth century, the Finnish textile manufacturers long depended on foreign imports for supplies of printed fabrics. This began to change in the mid-nineteenth century when, in 1861, the industrial manufacture of printed fabrics began after the Forssa cotton factory in southern Finland acquired a hand-driven fabric-printing machine. The following year it acquired a roller-printing machine, purchasing pre-engraved rollers from Germany, a practice it continued to follow until about 1926.[33] From an aesthetic point of view, Finnish printed fabric production was rather conventional and continued to be so in many factories long after World War II. In the early twentieth century, imported printed fabrics included stylized floral prints designed by the renowned British artist of the Arts and Crafts movement, C. F. A. Voysey. These were sold in Finland by the prestigious Iris shop, which had been founded in Helsinki in 1897 by Count Louis Sparre and can be considered the principal marketing retail outlet for English designers.[34] The firm was the sole Finnish agent for Liberty and Co., London, until representation was transferred to the architect Gustaf Strengell. Screen printing in general, and Liberty's fabrics in particular, were known in artistic circles and supplied to elite clients, but they were not widely used in Finland.

As in other parts of Europe, the most interesting artistic development in the production of printed fabrics in Finland occurred primarily in firms that employed silk-screen-printing techniques. Compared to roller printing, silk-screen printing offered opportunities for new and noticeably broader interpretations of representational and abstract patterns. Enthusiasm for making liberal use of

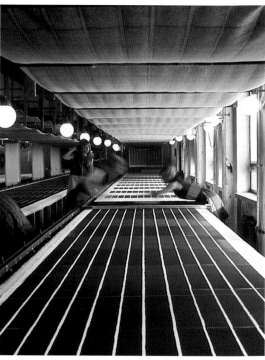

▸ Fig. 1–14. Katsuji Wakisaka. *Orret* pattern, 1977. From *Einfach — Marimekko* (Simply — Marimekko), pamphlet, *md* (möbel + dekoration), January 1978, photo by Fritz Dressler.

▸▸ Fig. 1–15. Armi Ratia. *Tiiliskivi* pattern, 1952. Photographed on the printing table in the Marimekko factory at Vanha Talvitie 3, 1950s. Courtesy of Tony Vaccaro/*Life*.

roller printers for artistic creativity had been curbed by the high cost of the engraved rollers, which meant that the selection of patterns tended to be cautious, with an eye to possible financial loss.[35] For both financial and technical reasons, therefore, it was natural that printed fabrics exploring new aesthetics were produced in small, primarily handcraft-oriented firms, such as the Helsingin Taidevärjäämö. This was the first fabric-printing works in Finland to experiment with the screen-printing method. One of its founder-owners, Uuno Sinervä, had studied the technique in Berlin during the 1930s.[36]

When Eva Taimi graduated from the Institute of Industrial Arts in 1937, she viewed the design of printed fabrics as an unrealistic career choice and, like many of her fellow students, planned to estab-lish her own weaving workshop. Yet the same year, when Helsingin Taidevärjäämö hired her, she became the first artist in Finland to work for the fabric printing industry.[37] A year later the Yhdistyneet

Villatehtaat Oy (United Wool Factories) hired Taimi's classmate, Kaj Franck, as a printed fabric designer.[38]

In the factory setting a designer's freedom was initially a very marginal concept. Taimi's interview gives the impression that the factory designer of the period was not viewed as an innovator, but rather as someone who adapted foreign patterns to the factory's production. Such designers were further limited by the shortage of materials caused by the war: even dyes had to be used with economy. Taimi was only gradually able to freely design her own patterns, consisting mainly of various floral motifs and figurative pictorial themes. The Helsin-gin Taidevärjäämö's production consisted of multi-colored prints realized with different techniques. In addition to designing for fabric yardage, Eva Taimi was also expected to design printed patterns for such other items as flags and lampshades. Al-though she had taken the printmaking course at the Institute of Industrial Arts, she only became acquainted with the silk-screening technique at

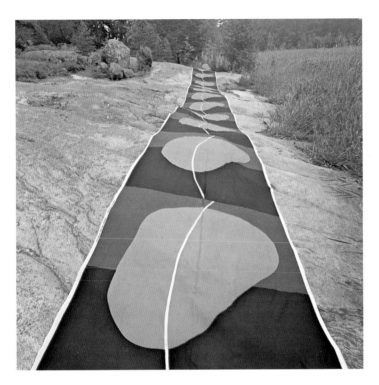
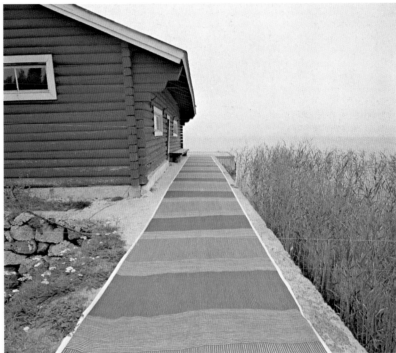

the Helsingin Taidevärjäämö. The factory also used a stencil technique that was closer to the linoleum-block printing of Taimi's student days.[39]

Among the customers of the Helsingin Taidevär-jäämö were several important interior design firms, such as Artek, Kotiahkeruus, Stockmann, and TeMa.[40] Artek, founded in 1935 to market the furniture of Alvar Aalto, embraced printed fabrics as part of its modernist program at a very early stage. Floral motifs and figurative printed fabrics were designed for Artek in the 1940s by Kaj Franck, Rut Bryk, and Rauha Aarnio.[41] Artek also imported French printed fabrics to Finland, namely the floral fabrics of Paule Marrot, which Artek had begun selling in the late 1930s for interiors. They became widely known after they were used in the Villa Mairea, designed by Alvar Aalto in 1938–39. Their influence seems evident: it is likely that Marrot's patterns were a direct source for those commissioned from Finnish artists in the early 1940s.

Printed fabrics continued to be sold and promot-ed by Artek. The Helsingin Taidevärjäämö printed

*Siena* fabric (1952), by Elissa Aalto, Alvar Aalto's second wife, as well as her influential and successful "H55," which she designed for the NK (Nordiska Kompaniet) department store in Stockholm, both of which are still offered today.[42] Both of these fabrics were small-patterned monochrome prints, unlike most of the patterns that Marimekko would develop. Artek also organized major exhibitions of modern art and design, notably for the promotion of French textiles. In 1950, for example, it arranged an exhibi-tion of Paule Marrot's work, and in 1958, the Artek store in Helsinki presented the work of Sweden's famed printed-fabric designer, Astrid Sampe.[43] Despite the importance of these developments in Finland and despite notable influences from abroad, the textile patterns that Marimekko devel-oped were distinctive, unlike others. Perhaps only the "machine-painted" *Ambiente* series, designed with a new printing method by Timo Sarpaneva for Finlayson Forssa / Tampella in the 1960s, could be considered comparable.

▾ Fig. 1–16. Pentti Rinta. *Kivi näkee unta* pattern, 1977. From *Einfach — Marimekko* (Simply — Marimekko), pamphlet, *md* (möbel + dekoration), January 1978, photo by Fritz Dressler.

▴ Fig. 1–17. Katsuji Wakisaka. *Ukset* pattern, 1977. From *Einfach — Marimekko* (Simply — Marimekko), pamphlet, *md* (möbel + dekoration), January 1978, photo by Fritz Dressler.

Fig. 1–18. Armi Ratia at Bökars, 1960s.

## Armi Ratia: A Finnish woman corporate executive

From its inception, Marimekko was a unique industrial enterprise in Finland: its director and part owner was a designer who had been trained in industrial art, and a woman at that. In 1972, when Marimekko was awarded the Finnish State Enterprise Award, much was made of the fact that this was the first time a firm with a woman director had won.[44] One way or another, gender was part of almost everything written about Marimekko and Armi Ratia. And the articles were legion, for every design journalist, every magazine and newspaper wanted to interview the successful woman director. Ratia, who well understood the value of publicity, gave such interviews readily and did not seem to mind the often facile way she and Marimekko were portrayed in the press. In the 1950s, for example, an American magazine described Ratia as "an attractive blonde" and quoted her as saying: "Marimekko really started as a joke three years ago.... We made some of our fabrics up into fashions which we designed ourselves and had a fashion show, just for fun."[45] Yet while some magazines focused on gender, Ratia undeniably succeeded in attaining the respect of the predominantly male business establishment in the 1960s.[46]

Perhaps a more important difference between Marimekko and other successful companies in the field of industrial art was that Marimekko was privately owned and received no support from large concerns, as did the Arabia porcelain factory and Iittala glassworks, for example. The absence of such backing and its attendant security was compensated for by their clear vision of purpose, which continued to be refined over the years. Armi and Viljo Ratia had founded a small workshop, whose success might perhaps seem surprising, but whose organization remained essentially the same: the principal power remained firmly in Armi Ratia's own hands, a point delicately underlined in the name of the firm in which one letter from her first name was transposed to form *Mari*. By being such an independent entity, Ratia could pursue her own line, from design to manufacturing to sales. In order to develop her own look, Ratia planned to found "a satellite, a kind of flying board of directors on which an architectonic view, marketing policy expertise, advertising and teaching techniques are represented."[47] This board was never established, but Marimekko designers were sent out to teach retail dealers how to sell Marimekko products.[48]

The firm's independence and the character traits of its director were also accompanied by a tendency to take risks that was unusual compared to other firms. The enormous postwar demand for consumer goods and the worldwide success of Finnish design inspired other firms to invest in collaboration with designers. In a 1949 issue of

*Arkkitehti*, Eva Taimi, who had moved from the Helsingin Taidevärjäämö to Vaasan Puuvilla (Vaasa Cotton), praised her new employer for the independence she enjoyed as a designer, and she also encouraged other manufacturers and designers to collaborate.[49] Her enthusiasm was tempered with time, however, and in a 1990 interview she commented revealingly and somewhat bitterly on Marimekko's success: "Well, the secret of Marimekko's success was that people did what they wanted there. In the large factory [Vaasa] I couldn't implement my ideas freely in the same way. I too had ideas that would have been easy to implement, but there was no one at the factory who understood them."[50]

From its early years Marimekko used two kinds of working methods in its association with artists. It had full-time designers on the staff and also bought patterns from freelance artists. The most long-lasting and fruitful of these freelance associations was with Maija Isola. It began with the purchase of patterns from a competition organized by Brummer, and continued until the artist's death in 2001. Each year Marimekko bought exclusive rights to printed fabric patterns from Isola, who worked from her own studio.[51] In addition to textile design, Isola was a painter and thus her work represented the dialogue between the art of the era and industrial design. In the collaboration between Isola and Marimekko and the shaping of the company's pattern collections, Armi Ratia and her design director Hilkka Rahikainen played predominant roles, selecting patterns for production from the large range in Isola's studio.[52]

Vuokko Nurmesniemi, who began her working career in 1953, was Marimekko's first full-time staff artist. In addition to designing patterns, she participated in planning shop interiors, in presenting Marimekko designs in shows, in public relations,

and in international sales. Both Nurmesniemi and her successor, Annika Rimala, have stressed, however, that they had complete freedom in their work.[53] A certain informality, which was considered a resource, occasionally resulted in failed design experiments — in fabrics that were unsuitable for normal retail sale and wound up in the annual "friendship sales."[54]

Marimekko's operation has always had a hint of bohemianism, which was sometimes revealed in the serious financial risks the company took.[55] Seemingly irrational business decisions have often been explained as having been caused by the managing director's impulsive nature, which certainly did play a part. On the other hand, the bohemian image associated with Ratia's artistic orientation and the firm's intellectual clientele emphasized the perception of Marimekko being guided by ethical values. Armi Ratia liked to project an unsophisticated image of herself, describing herself, for example, as "the worst-dressed woman in Helsinki."[56] Yet this was far from accurate — she very carefully observed the new movements in international haute couture and was an international

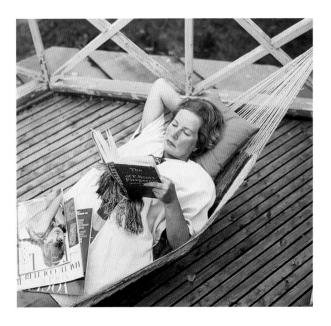

Fig. 1–19. Armi Ratia at Bökars, 1960s.

trendsetter. Even so, she tried to dissociate herself from the image of an international couturier. Her stance reflected a basic conflict within the company between fashion and design. While it was forced to conform to the demands of the fashion industry for new patterns each year, its mission was to create timeless, "classic" designs. In Ratia's words, whether true or not, "there are no annual growth rings at Marimekko."[57]

Marimekko's mission statement contains a reference to archetypal characters created by Aleksis Kivi, a nineteenth-century writer who is considered Finland's national author. This marriage of past and present was the basis on which Marimekko's business ideology and marketing strategy was built. Ultimately, it encompassed the idea of selling a lifestyle and constructing a complete environment.[58]

In her relation to the home, Armi Ratia confessed that she was heir to ideas that had originated in the early twentieth century, when the "home," as conceived in different parts of the world, was emerging as a focal point for design. In the Nordic countries at that time, the notion of the home's importance to human well-being was most actively propagated by the Swedish author Ellen Key, whose ideas were brought to Finland by, among others, Edward Elenius in his book *Kodin sisustaminen* (The furnishing of the home, 1910). During the 1920s it was believed that Finland, a nation torn apart by a civil war, could be reconstructed around the concept and design of the home. Arttu Brummer, the influential and multi-talented teacher of industrial design and a vigorous champion of handcraft, based his own design philosophy on ideas that had crystallized in the decorative arts of Sweden. The comfortable home environment as a beautiful object was seen to

form the nucleus of a successful and happy society. Gregor Paulsson's concept of *vackrare vardagsvara* (more beautiful things for everyday life), which had already been associated with the demands of mass production, jibed with Brummer's philosophy. His ideal was the "cosy" English home with its hearth and simple objects.[59]

In the 1930s "more beautiful things for everyday life" was embodied in the work of the Artek designers, including Marita Lybeck, Rauha Aarnio, Maija Heikinheimo, and Aino Aalto. In the late 1940s, in the aftermath of World War II, home design in Finland took on new importance, especially in the face of such enormous postwar projects as the resettlement of 400,000 Karelians who had been forced to leave their homes. Paulsson's ideas resurfaced in 1947, in the *"Kauneutta arkeen"* (Beautiful everyday) exhibition presented by the interior designer Maija Heikinheimo. In the early 1960s when another particularly large wave of migration took place, this time from the countryside to the cities, Marimekko was able to play a part in satisfying its needs. Armi Ratia also saw the future as a great challenge: "Housing and furniture will become more important than clothing, imagine how many people will move from mud huts to houses. What they will need is service and guidance, not design."[60]

But Armi Ratia did not want to be tied down to a single idea. Her great dream of the 1960s — the design and development of Marikylä, a new village of prefabricated modern homes, a kind of utopia — coexisted with the reality of the manor house of Bökars, which served as an official residence and radiated rural romanticism, a place for entertaining guests and for family vacations. Ratia was fond of presenting both of these environments to the press. At Bökars she maintained a

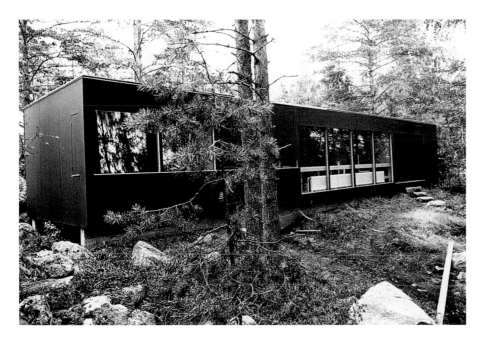

◄ Fig. 1–20. Aarno Ruusuvuori. The Mari-kylä experimental house known as the Marihouse, Bökars, 1966.

▼ Fig. 1–21. The Bökars manor house, 1960s. Courtesy of Tony Vaccaro.

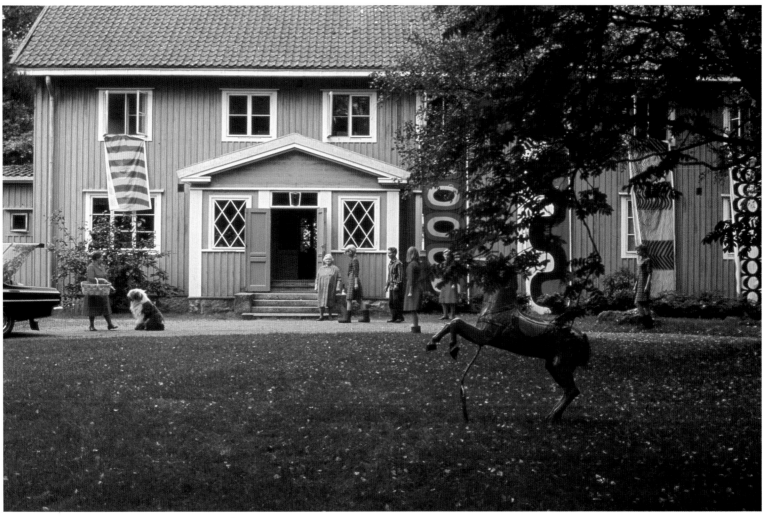

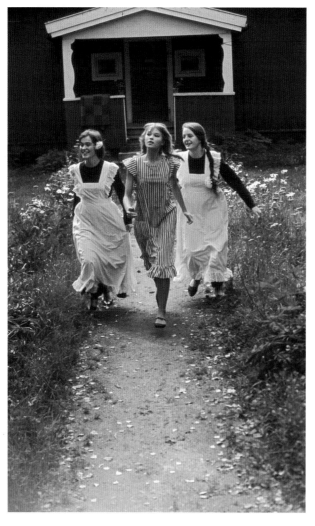

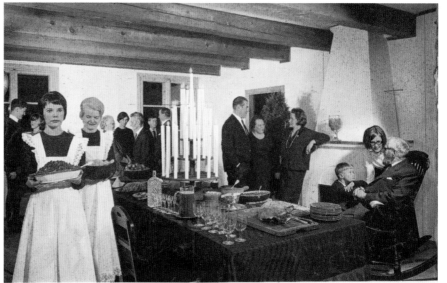

◀ Fig. 1–22. Vuokko Nurmesniemi. Apron, 1960s; *Piccolo* pattern, 1953. Courtesy of Tony Vaccaro/*Life*.

▼ Fig. 1–23. Carl Larsson. Family Christmas in Sundborn, Sweden, 1903. Watercolor. From *Hopeapeili* (December 1964): 2–3.

▼▼ Fig. 1–25. Christmas with Ratia family: groups, from right: Viljo Ratia's father Anton with two grandchildren, Eriika Ratia, and Jukka Ratia; Armi Ratia, Kerttu Mänty-kivi (housekeeper), and Viljo Ratia; at the window, Viljo's brother Urpo Ratia with his wife and children, partially obscured by two servants. From *Hopeapeili* (December 1964): 4–5.

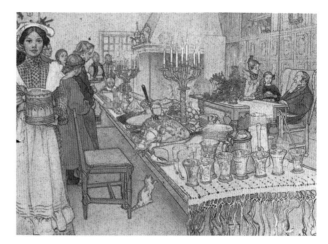

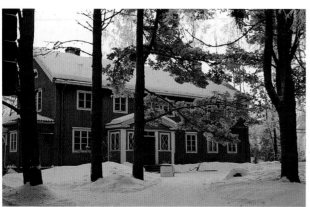

▲ Fig. 1–24. The Bökars manor house in winter, 1960s.

JOULUTUNNELMAA ARMI JA V. RATIAN PERHEPIIRISSÄ MEIDÄN AIKANAMME

KUVA: JUSSI POHJAKALLIO

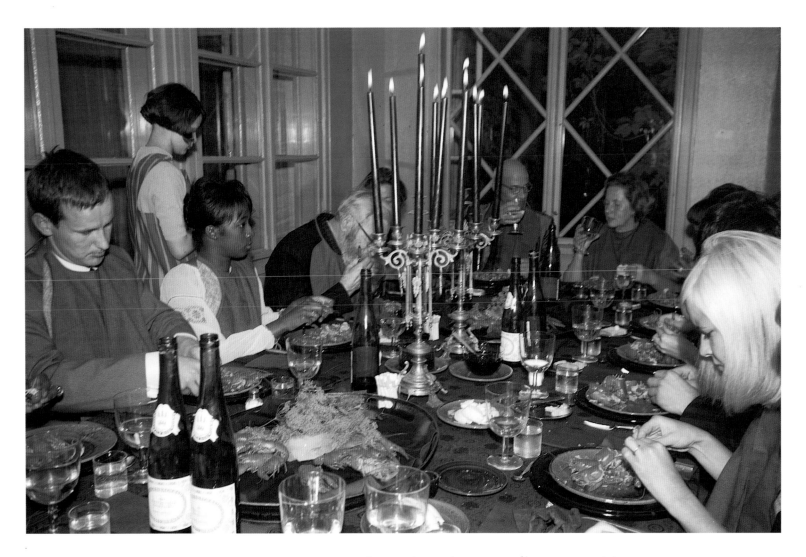

hospitable court, with chandeliers, a samovar, earthenware pots, and lace-covered beds. The journal *Hopeapeili* compared this ideal with the kind of world portrayed in paintings by the Swedish artist Carl Larsson (figs. 1–23, 1–25).[61]

The same contrast between modern and traditional, Finnish and international, was notable throughout Marimekko production. The fabric patterns, which were inspired by modern art, were combined with humble everyday cotton and simple lines. Even the exotic-sounding Finnish name "Marimekko" had a homespun explanation. The Marimekko clothes were photographed both in the midst of Finnish nature or rural buildings and in modern urban environments or at exhibitions of modern art. Armi Ratia herself seemed to personify the view presented by Edgar J. Kaufmann Jr., the director of the Department of Industrial Design at the Museum of Modern Art, New York, when he wrote in 1949: "The Finns must be tired of hearing foreigners assess their art as a special thing, the art of the north, of forests, of the people of mysterious language, etc. A very brief visit to Finland convinced me that the Finns themselves are a people of strong character and characteristics; different and vital. Their arts and crafts have a style and quality that places them in the midst of Western culture today."[62]

Fig. 1–26. Crayfish party at Bökars, 1960s. Armi Ratia sits at the head of the table.

1 Erik Kruskopf, *Suomen taideteollisuus: Suomalaisen muotoilun vaiheita* (Finnish industrial art: phases of Finnish design) (Porvoo: WSOY, 1989): 228.

2 "Karjalainen kosmopoliitti" (A Karelian cosmopolitan), signed "S.T.," *Karjala* (9 January 1964).

3 Tommy Tabermann and Tuija Wuori-Tabermann, *Spirit and Life* (Porvoo: Marimekko and WS Bookwell Oy, 2001): 22. The authors state that the ordinary man-in-the-street considered Paakkanen to be a good "old gal" and thought that "Marimekko's terrific."

4 Riitta Lindegren, "Marimekon maallikko-saarnaaja" (Marimekko's lay preacher), *Anna* 28 (1964): 18.

5 Juhani Pallasmaa, "The World of Tapio Wirkkala," in Marianne Aav, ed., *Tapio Wirkkala: Eye, Hand and Thought* (Porvoo: Museum of Art and Design and WSOY, 2000): 12.

6 Ibid.

7 Ilmari Tapiovaara, "Hyötytaide ja teollisuus" (Utility art and industry), *Ornamo* 12 (1945): 14–15.

8 Lindegren, "Marimekon maallikko-saarnaaja" (1964): 18.

9 Tuula Saarikoski, *Armi Ratia: Legenda jo eläessään* (Armi Ratia: a legend in her lifetime) (Porvoo: WSOY, 1977): 21.

10 Eva Taimi, interviewed by Eeva Viljanen, Desigmuseo, 14 May 1990, copy in the museum archive. Hereafter cited as Taimi interview, 14 May 1990.

11 Marilyn Hoffman, "Finnish Fashions Borrow Décor Gaiety: Husband — Wife Team Adapt Textiles to Clothes," *The Christian Science Monitor* (1 November 1954).

12 Vuokko Nurmesniemi, interviewed by the author, 3 April 2003.

13 Arttu Brummer, "Mieskohtainen kiitos edesmenneelle mestarille" (Personal thanks to a deceased master), *Domus* 2 (1931).

14 See, e.g., Marjo Wiberg, *The Textile Designer and the Art of Design: On the Formation of a Profession in Finland* (Helsinki: University of Art and Design, 1996).

15 *Taideteollisuuskeskuskoulun vuosikertomus* (Institute of Industrial Arts, annual report), 1924–25 (Helsinki: Suomen taideteollisuusyhdistys, 1925): 6. Before the 1920s, weaving was taught at the Hämeenlinnan Työkoulu (Hämeenlinna Craft School) founded by Fredrika Wetterhoff in 1885.

16 Marianne Aav, "Kansallinen tehtävä" (The national task), in *Ateneum Maskerad: Taideteollisuuden muotoja ja murroksia — Taideteollinen korkeakoulu 130 vuotta* (Ateneum Masquerade: Forms and crises in industrial art — 130th anniversary of the University of Art and Design), ed. Yrjö Sotamaa and Pia Strandman (Helsinki: Taideteollinen korkeakoulu, 1999): 117.

17 Taimi interview, 14 May 1990.

18 Päikki Priha, "Suunnittelijasta käsityö-läiseksi" (On the designer as craftsman), in *Ateneum Maskerad* (1999): 216. By the early 1960s Marimekko had become such an important player in the field that it influenced the academy curriculum, and it eventually gave rise in the mid-1970s to the start of several of Finland's small private print workshops, such as Puolukka and Pohjan Akka.

19 Taimi interview, 14 May 1990.

20 Carl Gustav Estlander, professor of aesthetics at Helsinki University, campaigned for the promotion of industrial art. As a result of the debate, the Veistokoulu (School of Art and Crafts, now University of Art and Design) was established in 1871, and to support its activities, a collection of designs was begun two years later. This collection formed the basis of the present-day Finnish Design Museum. In 1875 the Finnish Society for Crafts and Design was founded to maintain the school and the museum.

21 Fanny Churberg's impressionist landscapes met with some criticism, and, disappointed with this reaction, the artist gave up painting and concentrated on the promotion of Finnish handcraft.

22 Artists who made designs for the Friends of Finnish Handicraft included Akseli Gallen-Kallela, whose *ryijy* rugs and tapestries formed a central part of the display in the Finnish Pavilion at the Paris Exposition Universelle, 1900. Other architects and artists who designed for the Friends of Finnish Handicraft were Eliel Saarinen, Jarl Eklund, Väinö Blomstedt, Gabriel Engberg, Louis Sparre, Helene Schjerfbeck, and Armas Lindgren.

23 Ebba Brännback, *Margareta Ahlstedt-Willandt: Tekstiilitaiteilija — Textilkonst-när, 1888–1967* (Margareta Ahlstedt-Willandt: textile artist, 1888–1967), exh. cat. 24 (Helsinki: Taideteollisuus-museo, 1988): 3.

24 Saarikoski, *Armi Ratia* (1977): 21.

25 Rut Bryk, interviewed by Harri Kalha, Designmuseo, 22 November 1989, copy in the museum archive.

26 Taimi interview, 14 May 1990.

27 The design collections of the Friends of Finnish Handicraft are now in Designmuseo.

28 Artist information file, Designmuseo.

29 Armi Ratia, "Mihin ryijy joutui?" (Where did the *ryijy* rug go?), *Kaunis Koti* 4 (1949).

30 Famous innovators in the design of *ryijy* rugs were Eva Brummer (b. 1901) and Uhra Simberg-Ehrström (1914–79).

31 Taimi interview, 14 May 1990.

32 After his discharge from full-time army service in the early 1940s, Major Viljo Ratia experimented with poultry farming, after which he bought a bankrupt oilcloth factory. Around the same time Armi Ratia was planning to leave the Erva-Latvala advertising agency. *Karjala* reported that she was starting a rag-rug weaving workshop. "Karjalainen kosmo-poliitti" (9 January 1964).

33 Marianne Aav, "Printed Fabrics from Finland," in *Design Textile Scandinave, 1950 / 1980*, exh. cat. (Paris: Musée de l'Impression sur étoffes de Mulhouse, 1986): 23–25.

34 Marja Supinen, *AB. Iris: Suuri yritys* (AB. Iris: a large enterprise) (Helsinki: Kustannusosakeyhtiö Taide, 1993): 46–47. The Iris factory operated in Porvoo, a small southern Finnish town, from 1897

to 1902. It was founded by Louis Sparre, a Swedish count and painter. The factory made furniture designed by Sparre, as well as ceramics by the Anglo-Belgian ceramist A. W. Finch. In addition, the Iris store imported and sold Liberty fabrics, beginning in 1898.

35 Taimi interview, 14 May 1990.

36 Ibid.

37 Ibid.

38 Liisa Räsänen, "My ideal is social," in *Kaj Franck: Theme and variations*, publication 6 (Lahti: Heinola Town Museum Publications, 1997): 21.

39 Taimi interview, 14 May 1990.

40 Ibid.

41 Ibid.; see also Pekka Suhonen, "Artek 50 years — A short history," in *Artek*, exh. cat. no. 15. (Helsinki: Museum of Art and Design, 1985): 15.

42 Helena Woirhaye, *Maire Gullichsen, taiteen juoksutyttö* (Maire Gullichsen, messenger of art) (Helsinki: Museum of Art and Design, 2002): 166. In 1947 Gullichsen published a polemical article in *Taide* (no. 5–6) in defense of the concept of "more beautiful things for everyday life". In the 1950s in Björneborgs Tidning 9.9.1955 she continued to debate Ahlström's acquisition of the famous textile-printing company Porin Puuvilla Oy. As an example of good work in the design of textile patterns she cited Swedish textile designer Astrid Sampe and her experimental work for the NK department store.

43 Ilona Anhava, "List of the exhibitions by Artek ," in *Artek* (1985): 52–53. In 1958 Artek held an exhibition of French printed fabrics, which showed work by Paule Marrot, Suzanne Fontan, and Pierre Frey.

44 "Yrittäjäpalkinto ensi kerran naiselle" (Enterprise Award goes to woman for first time), *Kymen Keskilaakso* 25 (1972).

45 Hoffman, "Finnish Fashions" (1 November 1954).

46 See, e.g., the long interview with Ratia: "Niin, haluan perustaa sateliitin, eräänlaisen lentävän johtoryhmän" (Yes, I want to found a satellite, a kind of flying board of directors), *Liikemaailma* 7 (1964).

47 "Niin, haluan perustaa sateliitin"(1964).

48 Annika Rimala, interviewed by the author, 2 April 2003.

49 Aulis Blomstedt, "Taiteilijoittemme lausuntoja sarjatuotannosta" (Statements by our artists about mass production), *Arkkitehti* 1–2 (1949). Vaasan Puuvilla was located about 280 miles (450 km) northwest of Helsinki.

50 Taimi interview, 14 May 1990.

51 Sisko Nieminen, "Maija Isola — Ajaton surrealisti" (Maija Isola — A timeless surrealist), in *Maija Isola: Maalauksia vuosilta 1955–1988* (Maija Isola: paintings from the years 1955–1988), publication no. 4 (Hämeenlinna: Hämeenlinna Art Museum Publications, 1992).

52 Rimala interview, 2 April 2003.

53 Nurmesniemi interview, 4 March 2003; Rimala interview, 2 April 2003.

54 Rimala interview, 2 April 2003.

55 Ibid.

56 Juha Tanttu, "Marimekon Vanha Äiti on kuollut" (Marimekko's old mother has died), *Helsingin Sanomat* (4 October 1979).

57 Ibid.

58 The "Finnish — international" contrast was reflected in the firm's photography. This became evident, for example, in the 1960s when Risto Lounela took a series of photographs in which he used wild nature as a backdrop for clothes designed by Liisa Suvanto, while clothes designed by Annika Rimala were often photographed in modern urban environments.

59 For Arttu Brummer's concept of the home, see Marianne Aav, "Unelma kauneudesta" (A dream of beauty), in *Arttu Brummer: Taideteollisuuden tulisielu* (Arttu Brummer: a trailblazer of industrial art), ed. Marianne Aav (Helsinki: VAPK-kustannus, 1991): 81–87.

60 Tanttu, "Marimekon Vanha Äiti" (4 October 1979).

61 "Joulutunnelmaa Carl Larssonin perhepiirissä 60 vuotta sitten — Joulutunnelmaa Armi ja V. Ratian perhepiirissä meidän aikanamme" (The Christmas mood in Carl Larsson's family circle 60 years ago — The Christmas mood in Armi and V. Ratia's family circle in our own time), signed "L.I.," *Hopeapeili* (December 1964).

62 Edgar J. Kaufmann Jr., "Letter for Art and Industry of Finland," *Ornamo* (1949): 17.

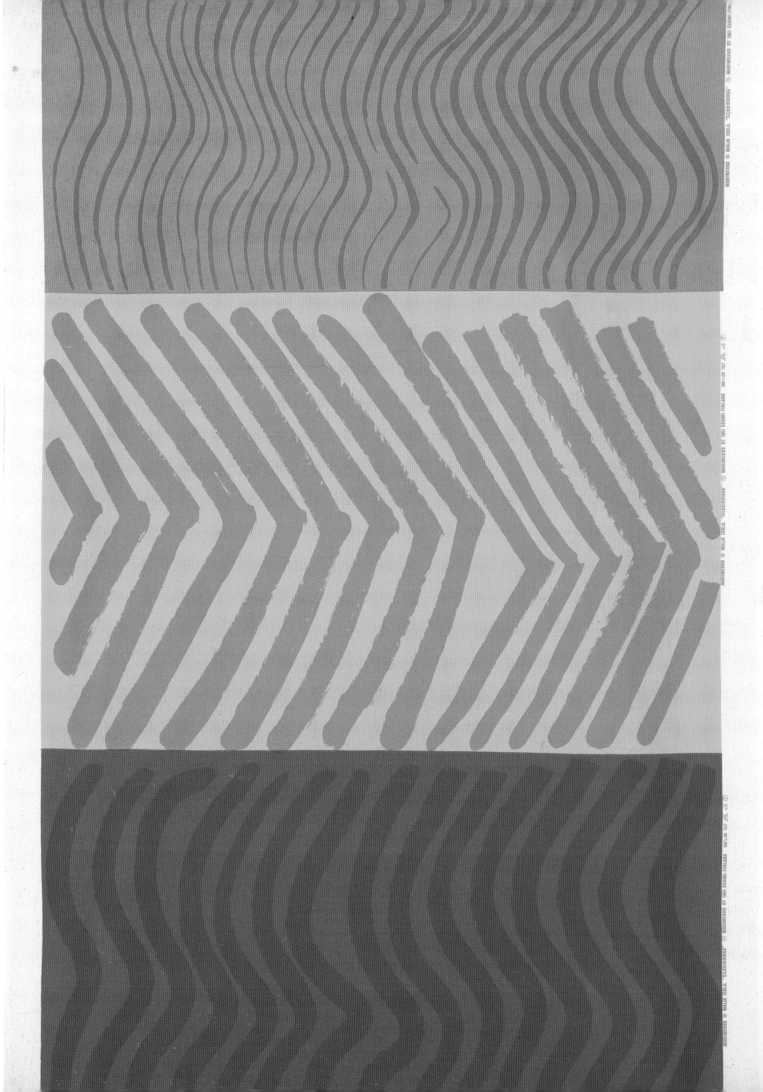

# 2. Textile Patterns in an International Context: Precursors, Contemporaries, and Successors
Lesley Jackson

The key to Marimekko's unique character lies in the enduring freshness and originality of its printed textile patterns, which have defined and underpinned the company's core identity for almost fifty years.[1] To date, most scholars have treated Marimekko in isolation as a uniquely Finnish phenomenon, unrelated to earlier or later developments in pattern design in other parts of Scandinavia or further afield. This essay seeks to place the company's patterns within a broader international framework, examining their evolution within the wider context of the development in twentieth-century European and American printed textiles.

## Marimekko's Precursors

It could be argued that the positive creative attitude to textile pattern demonstrated by Marimekko has its roots in the work of William Morris, who revitalized printed textiles in Britain during the late nineteenth century. However, by the start of the twentieth century the focus of the pattern-making world had shifted to Austria, and in stylistic terms Marimekko's earliest identifiable precursor is the Wiener Werkstätte, a hothouse of radical pattern design. I would argue that at both firms pattern was treated as a core activity, and there was substantial cross-fertilization between fashion and furnishing patterns, with similar or identical designs being adopted for garments, accessories and interiors.[2]

◄ Fig. 2–1. Maija Isola. *Silkkikuikka* pattern, 1961.

Drawing freely on the talents of specialist and nonspecialist designers (a daring strategy also used by Armi Ratia at Marimekko), the Wiener Werkstätte produced extensive collections of block-printed fashion and furnishing textiles during the 1910s and 1920s in an amazingly diverse range of experimental idioms (figs. 2–4, 2–5). However, while avant-garde abstraction was clearly important to both companies, it was by no means the only front on which experimentation took place. Diversity was the key to perennial freshness, and it was by encouraging creative individualism that a distinctive company identity emerged.

The Austrian architect Josef Frank contributed a number of textile patterns to the Wiener Werkstätte. He later established a company called Haus & Garten in Vienna in 1925, specializing in block-printed linen furnishing fabrics with dynamic floral patterns.[3] After emigrating to Sweden in 1933, he embarked on a fruitful collaboration with Svenskt Tenn. The vivid colors and robust compositions of Frank's patterns stimulated a new school of printed textile design in Sweden, which in turn had delayed impact in Finland after the war. Although Marimekko's designers broke away from Frank's reliance on representational motifs and developed different approaches to marketing and corporate philosophy, their approach to pattern was similarly dynamic in rhythmic terms and equally intense in its approach to color. By disseminating the vibrant, high-voltage Viennese style in Scandinavia, therefore, Frank brought the possibility of Marimekko one step closer.

Pattern design also flourished in France during the 1910s and 1920s, where bold use of eclectic textiles and wallpapers formed a key element in the repertoire of many leading *artistes-décorateurs*. Inspired by the example of the Wiener Werkstätte, the couturier Paul Poiret established the Atelier Martine in 1911 to create patterns for printed textiles and wallpapers.[4] For Poiret, freshness and spontaneity were the crucial qualities of pattern, so rather than employing trained professionals to produce slick designs, he nurtured the talents of untutored teenage girls. Their naive drawings of flowers and vegetation were converted into energetic patterns with a raw, primitive edge. Poiret's dual interest in fashion and furnishings and his instinctive appreciation of the liberating effects of pattern can both later be seen in Marimekko, as can the childlike simplicity nurtured at the Atelier Martine, with its emphasis on communication through strong color and expressive forms.

Poiret was also instrumental in encouraging the artist Raoul Dufy to design printed textiles, recognizing the potential of his wood engravings.[5] After initially collaborating with Poiret in 1911, Dufy teamed up the following year with the Lyon textile manufacturer Bianchini-Férier, for whom he subsequently created more than two thousand dress and furnishing patterns (fig. 2–2). The crisp tonal contrasts and cursive lines of Dufy's graphic style adapted well to block-printed textiles. Also influential in France during the mid-1920s was another artist, Sonia Delaunay, who designed a series of printed silk dress fabrics with abstract geometric patterns. Actively fostering cross-fertilization between art and design, Delaunay's patterns are closely related to her "color rhythm" paintings (fig. 2–3). She referred to her textiles as "*tissus simultanés,*" believing that "the cut of a dress is to be conceived at the same time as its decoration."[6] Her commitment to abstraction, and her radical ideas about the integration of pattern and dress, presaged the innovations at Marimekko thirty years later.

Until the 1920s most printed textiles of artistic distinction were produced by hand-block-printing,

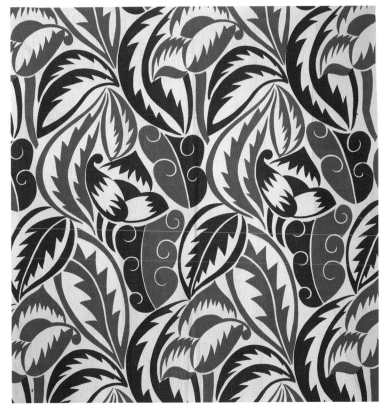

▶ Fig. 2–2. Raoul Dufy. *Grand Feuillages* pattern for Bianchini-Férier, ca. 1920. Trustees of the Victoria and Albert Museum, London, Misc. 2:30-1934.

▶▶ 2–3. Sonia Delaunay. Sketch for a fabric pattern, 1920s. From Sonia Delaunay, *Tapis et tissus*, L'art international d'aujourd'hui, vol. 15 (Paris: Charles Moreau, 1929): plate. 13.

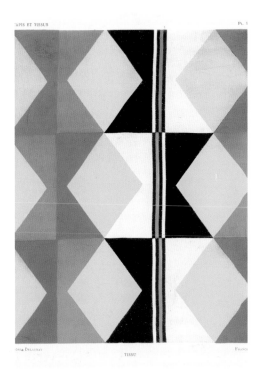

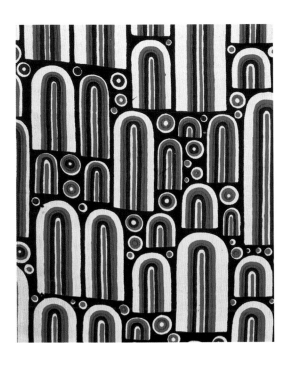

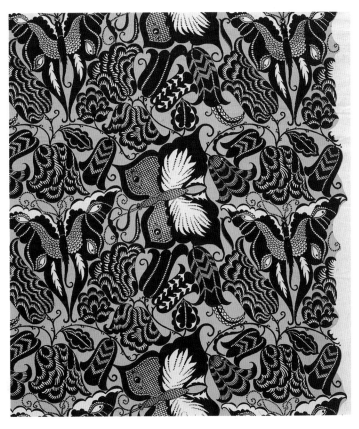

◀◀ 2–4. Carl Otto Czeschka. *Wasserorgel* pattern for the Wiener Werkstätte, 1910–12. MAK, Vienna, Austria.

◀ 2–5. Dagobert Peche. *Schwalbenschwanz* pattern for the Wiener Werkstätte, ca. 1913. MAK Vienna, Austria, T11146.

while lower-cost fabrics for the mass market were generally roller-printed by machine. During the 1930s, however, block-printing was gradually superseded by screen-printing, which offered greater opportunities for creative license. Silk screens were easier and cheaper to produce than carved wooden blocks, and the printing process itself was more straightforward, making the method particularly attractive to small-scale producers with limited capital and little previous experience. In artistic terms screen-printing also had many practical advantages, allowing much greater flexibility in the handling of color, scale, and textural effects.[7] All these factors are pertinent to Marimekko. In fact, without screen-printing, it is unlikely that Marimekko would have come into being at all.

The first steps toward the widespread international adoption of screen-printing took place in Britain during the early 1930s. Several new artist-led firms were founded, including Edinburgh Weavers and Allan Walton Textiles. They took full advantage of the new process. In addition, a number of established firms such as Old Bleach Linen Company, Donald Brothers, and Warner & Son began to experiment with screen-printing during the 1930s, adopting it for their more progressive lines. This, combined with the growing number of freelance textile designers working in Britain, as well as the increasing involvement of artists, resulted in a golden era of printed textile design.[8] Stylized patterns of birds, flowers, and leaves were the British forte, depicted in mellow colors in a relaxed modern style. The most prominent designer of the period was American-born Marion Dorn, who worked with several leading British firms. Dorn was the first designer to respond in a mature way to the liberating potential of screen-printing, which proved an ideal medium for her fluid, layered, organic designs.[9]

Swedish textiles were also invigorated by the introduction of screen-printing during the 1930s. First to adopt the technique was Elsa Gullberg AB and Ljungbergs Textiltryck.[10] Following the lead of Josef Frank, Elsa Gullberg designed patterns featuring native wildflowers. Ljungbergs printed fabrics for both Svenskt Tenn and Nordiska Kompaniet (NK), a major Stockholm department store, which established a forward-looking in-house textile studio known as NK Textilkammare in 1937 headed by the designer Astrid Sampe. Gocken Jobs and the exiled Danish architect Arne Jacobsen both designed lyrical florals for NK during the war. Afterward Stig Lindberg's lively collection of playful, figurative and organic patterns for NK set an upbeat tone for the early postwar period.[11]

Astrid Sampe's own designs reached full maturity during the 1950s.[12] Responding to trends in contemporary architecture, she developed a series of masterly, controlled, geometric patterns. She also commissioned designs from architects, notably Sven Markelius, who created a series of quasi-mathematical patterns, including *Pythagoras* (1952) and *Set Square* (1954). Sampe's other passion was for contemporary art, which she promoted through NK's Signed Textiles collection (1954), featuring patterns by artists and graphic designers. This tactic of forging links with practitioners from outside the textile sphere formed part of a concerted policy aimed at broadening the vocabulary of printed textiles.

NK clearly had a decisive influence on Marimekko during its formative years, providing the initial model and ongoing inspiration for Armi Ratia's artistic experiments during the 1950s. The NK designer whose work had the most direct influence at Marimekko was Finnish-born Viola Gråsten. She was employed as an in-house designer at NK

during the late 1940s and early 1950s, where she also designed *ryijy* rugs. Her free-spirited approach to textile design was captured in irregular, fluid, abstract patterns, such as *Oomph* (1952; fig. 2–6) and *Revy* (1954).[13] Fearless use of strong color was another distinctive feature of her work, particularly the juxtaposition of tones of similar intensity. When Vuokko Nurmesniemi joined Marimekko in 1953, it was to Gråsten's work that Armi Ratia directed her for inspiration,[14] and one design by Gråsten herself is documented in the Marimekko archives (fig. 2–9).[15] Maija Isola was also an admirer of Gråsten's work, and the latter's influence can be detected in various aspects of Isola's early designs.

By the 1930s Finland's textile industry had become quite significant in scale. Woven textiles accounted for the bulk of production, but roller-printed textiles were also manufactured. At this date, however, aesthetic awareness within the industry was limited, printed textile design being largely the province of draftsmen and engineers. "None of the mills has an artist for designing patterns," complained the journal *Nuori Voima* (young power) in 1945; "Textile manufacturers purchase so-called scrap patterns from abroad, after these have toured the whole of Europe. The poorest of them ultimately find their way to Finland."[16] This deficiency was compounded by the fact that the Institute of Industrial Arts (Taideteollinen Oppilaitos) in Helsinki concentrated on training textile artists rather than textile designers. According to Marjo Wiberg in her study of the Finnish textile design profession, "design educators and other design world authorities had suspicious or even hostile attitudes toward industry, and the training of textile artists focused on artistic expression and hand-weaving."[17] *Ryijy* rugs and weaving continued to form the core syllabus at the institute for many years.

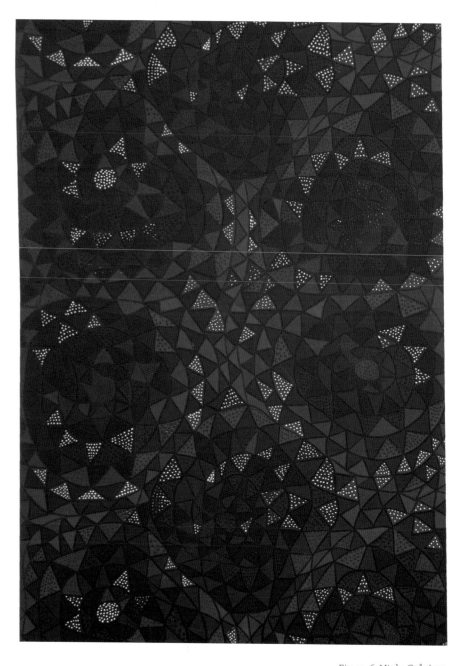

Fig. 2–6. Viola Gråsten. *Oomph* pattern for the Nordiska Kompaniet, Stockholm, 1952. Röhsska Museet, Gothenburg, Sweden.

As in Sweden, the introduction of screen-printing stimulated a more positive attitude toward the design of printed textiles. The first company in Finland to embrace the technique was Helsingin Taidevärjäämö (Helsinki Art Dyeworks), a workshop established by Roine Ryynänen and the husband-and-wife team, Uuno and Sirkka Sinervä, in 1926.[18] Initially their fabrics were block-printed, but screen-printing was introduced from Germany during the early 1930s. In 1937 Helsingin Taidevärjäämö appointed their first professional designer, Eva Taimi, who had trained at the Institute of Industrial Arts. Taimi's early designs have the same refreshing simplicity and lack of pretension as the work of Elsa Gullberg in Sweden.[19] Stylized floral patterns were her hallmark at this date, often printed in three or four colors on white or unbleached cloth, as in *Eeva* (1940) and *Lördag* (Saturday, 1942). Both these patterns, and others featuring primitive figurative motifs, had a strong folk art quality. *Kanapiika* (henhouse maid, 1940), showing a girl feeding chickens, and *Lapinraita* (Lapp stripe, 1944), a banded pattern depicting Laplanders and reindeer, were typical of this genre. Another designer who supplied patterns to Helsingin Taidevärjäämö during the war was Kaj Franck, better known for his work in ceramics and glass. Created between 1944 and 1945, his designs included naturalistic plant patterns and whimsical figurative designs.[20]

As well as producing their own patterns, Helsingin Taidevärjäämö designed and printed textiles on behalf of other companies, including the Helsinki department store Stockmann and the interior design firm Artek. Eva Taimi's contributions to Artek included a colorful wildflower-sprig design called *Niittykukkia* (meadow flowers, 1943; fig. 2–7), and a more restrained small-scale star-and-dot pattern called *Aino* (1947). Before the war Artek's printed

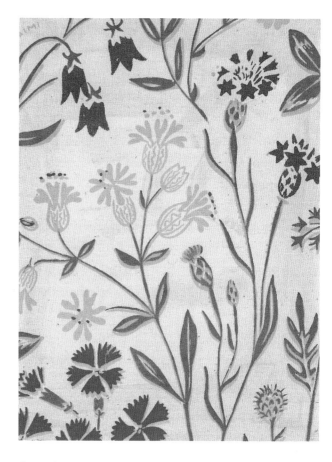

► Fig. 2–7. Eva Taimi. *Niittykukkia* pattern for Artek, 1943.

furnishing fabrics also included stylized florals by Aino Aalto, cloud designs by Marita Lybeck, and amoeboid patterns by Kaj Franck.[21] During the 1950s there was a noticeable shift in style, and Artek's subsequent designs took the form of recessive, geometric, monochrome abstracts by Alvar Aalto and his second wife, Elissa Aalto. The cool, clinical precision of Artek's postwar style contrasted markedly with the more relaxed, vibrant, hand-drawn aesthetic developed by Marimekko.

Eva Taimi's style also underwent a distinct change from 1947 onward, after she moved to a larger commercial company, Vaasan Puuvilla (Vaasa Cotton). Not only did her drawing style become much freer, as reflected in flower and leaf patterns such as *Flora* (1947) and *Varjot* (shadows, 1949), but she also began to experiment with a new vocabulary of abstract motifs, first seen in designs such as

*Seiga* and *Virta* (stream, both 1950). Over the next few years her patterns became increasingly uninhibited, both in color and composition, as reflected in the doodlelike *Sahara* (1951; fig. 2–8), the scribbly *Oikku* (whim, 1952), and the spiraling *Kisa* (game, 1953). During the mid-1950s her style closely paralleled that of Maija Isola and Vuokko Nurmesniemi at Marimekko. Taimi's irregular, abstract grid pattern, *Lassila-Tikanoja* (1955), could easily be mistaken for a Marimekko design. As a precursor of Marimekko, Eva Taimi clearly set the pace, but once Marimekko was established, its adventurous approach to pattern seems to have spurred Taimi on.

Ultimately, however, the design climate at Vaasan Puuvilla proved much less conducive to innovation than that at Marimekko. When Taimi took up her post she had been full of optimism. In 1949 she was quoted as saying: "I have had only positive experiences of my work as an artist in an industrial establishment. I have been able to design independently and according to my own wishes, the only restrictions being certain technical problems and the range of available dyes."[22] Gradually, however, the situation at the factory began to deteriorate, with increasing interference in design matters at management level and in 1957 Taimi decided to leave. By this date Marimekko was in the ascendant, and Taimi's pioneering achievements were soon eclipsed.[23]

## Marimekko

The arrival of Printex / Marimekko in 1949 irrevocably altered the landscape of Finnish printed textiles. By the end of the 1960s Marimekko had revolutionized the medium on an international level. Ironically, what was once perceived as a weakness — Finland's cultural remoteness and isolation — now became its strength. Being so far removed

from mainstream currents in fashion and furnishings appears to have made Marimekko's designers more self-reliant and much less vulnerable to external influences. Finland's position on the border between Eastern and Western Europe, with strong cultural ties in both directions, also gave a distinctive twist to Marimekko's creative expression. As the writer Anna-Liisa Ahmavaara noted in 1970 in her contemporary survey, *Finnish Textiles*, "Many people have pointed to that boundless longing for beauty that the war and the years following it produced, and to the fruitful process brought about by Finland's geographical position: the ingredients being western rationalism on the one hand and the freshness and carefree spirit of the east on the other."[24]

The driving force behind Marimekko was Armi Ratia. Her decision to promote abstract patterns for both furnishings and fashion, at a time when the

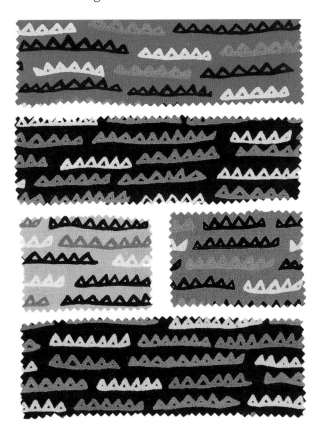

Fig. 2–8. Eva Taimi. Swatches of *Sahara* pattern for Vaasan Puuvilla, 1951.

rest of the textile industry in Finland was still committed to florals, was characteristically daring and perverse.[25] This shift toward abstraction not only reflected trends in modern architecture and contemporary art, but also coincided with the emergence of a more progressive aesthetic in Finnish *ryijy* rugs. Indeed the correspondences between the early printed textiles of Marimekko and the new school of contemporary *ryijy* rugs by designers such as Eva Brummer, Uhra Simberg-Ehrström, and Kirsti Ilvessalo, suggest a degree of cross-fertilization between the two. Expressive abstract patterns, either in stark black and white or saturated with strong color, formed the basis of both media, with mechanical precision avoided in favor of the subtle blurring of colors and lines. In addition, the new emphasis on large-scale abstract patterns as a decorative statement within the domestic interior provides another common thread linking the two.[26]

Armi Ratia herself designed some early patterns for Marimekko, including two minimalist, monochrome geometrics called *Faruk* and *Tiiliskivi* (brick, both 1952). Ratia had originally trained as a textile

artist at the Institute of Industrial Arts during the 1930s, and subsequently practiced as a designer of *ryijy* rugs.[27] Among her fellow students was Eva Taimi, and Ratia later became a regular visitor at Helsingin Taidevärjäämö, which triggered her interest in screen-printed textiles.[28] However, it was as an art director and public relations expert, rather than as a designer, that Ratia really came into her own. Following the lead of Astrid Sampe at NK, she commissioned patterns from various artists and designers around 1950, including Björn Landström, Elis Muona, Per-Olof Nyström, Eeva-Inkeri Tilhe, and Viola Gråsten (fig. 2–9).[29] What proved to be the making of Marimekko, however, was Ratia's foresight in recognizing the potential of two untried young designers, fresh out of college — Maija Isola, who joined Printex in 1949, and Vuokko Nurmesniemi, who designed for both Printex and Marimekko from 1953 to 1960. "Armi Ratia challenged people and gave them possibilities," observed Maija's daughter Kristina Isola. "Because Ratia liked Maija Isola's designs and believed in them, she took care that they were sold."[30]

## Maija Isola

Maija Isola came to Armi Ratia's attention after winning a competition for printed fabrics at the Institute of Industrial Arts in Helsinki, where she studied from 1946 to 1949.[31] She had been encouraged to pursue textiles by the institute's art director, Arttu Brummer (a family friend), although even at this early date her primary interest was art. Isola began designing furnishing fabrics for Printex in 1949 and continued until her retirement in 1987. Working mainly from her own studio, she created 533 designs for Marimekko over the course of her thirty-eight-year career. From 1961 onward, following a disagreement with Armi Ratia, she chose to

Fig. 2–9. Viola Gråsten. Fabric pattern for Marimekko, 1950s.

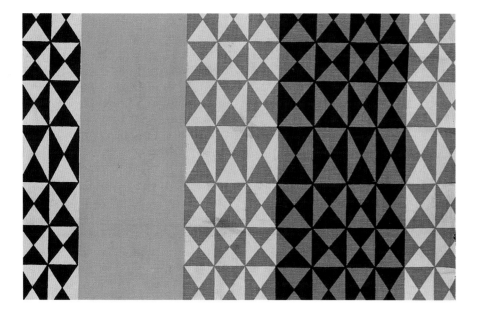

work independently, selling designs to Marimekko on a freelance basis. Even though Isola always preferred to work at a distance from the factory, she remained extremely loyal to the company, and throughout her career Marimekko remained her principal client.[32] Isola's relationship with Armi Ratia was sometimes stormy, but the desire to surprise Ratia and to win her approval remained a primary motivating factor over the years. Ratia, in turn, placed enormous faith in Isola. Marimekko's identity was (and to certain extent still is) intimately allied with her work.

For Isola, design was an activity to be enjoyed, and the intensity of her enthusiasm is clearly reflected in her work. Passionate about art, she began painting during the early 1950s, and she regarded herself as an artist rather than a designer.[33] Painting acted as a release for her creativity, and she wanted her patterns to carry the same resonance as her paintings. During her youth she greatly admired Matisse, Picasso, and Chagall, whose fluid brushstrokes were echoed in her early designs. Later she developed a taste for American abstract art, and during the 1960s the purity and boldness of dramatic large-scale canvases by Mark Rothko, Morris Louis, Barnett Newman, Ellsworth Kelly, and Frank Stella, for example, clearly influenced her adventurous approach to composition and scale.[34] However, Isola had no inclination to copy other artists. Her mission in life was to find her own creative voice. Solitary and fiercely independent-minded, Isola valued personal freedom above all else. These character traits not only determined the way she lived her life, but also shaped her approach to design. Isola found foreign travel extremely stimulating, for example, and she regularly spent periods abroad.[35] The breadth of her interests and her receptiveness to external

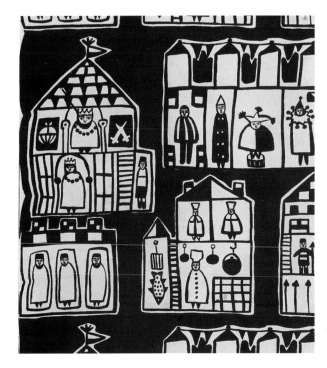

Fig. 2–10. Maija Isola. *Kuningas* pattern, 1952.

stimuli influenced the ambitious, imaginative agenda she pursued in her designs.

Three distinct, but contrasting, impulses are evident in Isola's earliest textile designs. One was her enthusiasm for drawing, reflected in two energetic, linear patterns depicting vases and lamps, *Amfora* (1949) and *Pienet lamput* (small lamps, 1950), loosely inspired by Matisse. These designs were drawn using Alphacolour, a new type of chalky crayon that came on the market after the war and produced exceptionally strong graphic effects. Isola's nascent interest in abstraction also surfaced at an early stage. Geometric compositions, such as the diamond-patterned *Harlekiini* (harlequin, 1949) and the bold, graphic *Viuhka* (fan, 1954), typified her early experimental abstract designs. It was not until the 1960s, however, that Isola would really find her own voice in this idiom with her large-scale, fluid, organic designs.

Another dimension to Isola's early output was established by her exuberant nursery patterns, typified by *Norsu* (elephant, 1952), featuring lions

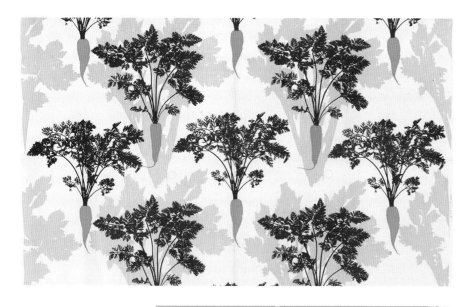

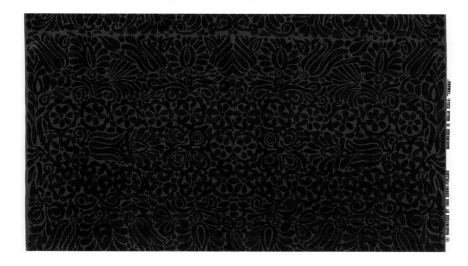

▲ Fig. 2–11. Maija Isola. *Ryytimaa* pattern, 1957.

▶ Fig. 2–12. Maija Isola. *Kivet* pattern, 1956. (Checklist no. 12).

▼ Fig. 2–13. Maija Isola. *Tamara* pattern, 1960. (Checklist no. 37).

and elephants in striped circus tents. Often depicted in the style of children's drawings, these patterns were created for her young daughter Kristina. Isola herself grew up on a farm near Riihimäki, an area of Finland to which she remained greatly attached, and where she returned to live in later years. In *Musta lammas* (black sheep, 1950) she depicted a child's view of life in the countryside, with animals in the fields and stick figures engaged in rural pursuits. As a child she and her two sisters made paper dolls and told stories about these characters and their adventures. Another pattern that drew on her childhood memories was *Kuningas* (king, 1952; fig. 2–10), depicting dollhouses crammed with a medley of characters, such as cooks, court jesters, and kings.[36]

In 1957 Maija Isola embarked on a groundbreaking series of designs that ultimately totaled twenty-four. Now known as the *Luonto* (nature) series, they depicted life-size naturalistic images of plants in silhouette.[37] These patterns were created using actual plant specimens, an idea prompted by a school project of her daughter's, which involved collecting and pressing plants. Rather than being drawn or painted, the patterns were created using a photographic process, which involved exposing the plant itself directly onto a screen. The silhouette was then printed onto paper, and this image was used to produce the final printing screen (or screens).[38] Later, after Marimekko acquired an enlarging machine, Isola created several nature patterns in which the specimens were significantly scaled up, as in the daisy pattern *Auringonkukka* (sunflower, 1959).

The plants featured in the *Luonto* series ranged from ferns and twigs to leaf sprays and clumps of grass. Isola favored plants with intricate, feathery, lacy, or spindly outlines, as these were more arrest-

ing in silhouette. Some patterns were created using dried plants, such as *Humiseva* (murmuring, 1957), *Putkinotko* (dell of wild chervil, 1958), and *Mänty* (pine, 1959). These designs featured two sets of overlapping motifs in different shades of the same color. Another group of designs was created using fresh plants. Printed in monochrome, these patterns were more repetitive in their compositions, with isolated motifs arranged in rows. Designs of this second type included *Havanna* (1958), *Saunakukka* (chamomile, 1957) and *Tuulenpesä* (witches' broom, 1959). A leafy pattern called *Ruusupuu* (rose tree, 1957) was unusual because pink rose motifs were added to the basic black silhouette.[39] Another memorable variant was *Ryytimaa* (herb garden, 1957; fig. 2–11), which featured large fawn-colored silhouettes of celery, overlaid with carrots, printed in orange with dark green feathery tops.

Maija Isola's ability to operate concurrently on two different levels — at both a micro and a macro scale — is one of the most striking features of her approach to pattern design. The *Luonto* series, with its quasi-scientific approach to design and its minute, photographic attention to detail, illustrates her attraction to micro-patterns. At the other end of the spectrum were macropatterns such as *Kivet* (stones, 1956; fig. 2–12), in which images were abstracted, simplified, and dramatically enlarged. Whereas this pattern presaged the bold, large-scale, macrodesigns of the Jonah and Architect groups, the *Luonto* series paved the way for further exploration of micropatterns in the Ornament and Baroque series.

The designs later grouped together as the *Ornamentti* (ornament) series marked a significant departure for Maija Isola, opening up an exciting new decorative vocabulary and a fresh approach to color and composition. Launched in 1959, they were prompted by Isola's enthusiastic response to some books on Slovakian folk art illustrating a variety of traditional textiles such as embroidery and lace. By extracting elements from these textiles and reconstituting them in a different context, Isola developed a radical new genre of ornamental abstract designs. The first step was to redraw selected motifs to make them sharper and more graphic. Drawing by eye, rather than copying mechanically, was a crucial element in this process. The stencillike, filigree patterns were then photographically enlarged, thereby magnifying any irregularities in the drawings. The final patterns were created by rearranging these "sampled" Slovakian motifs, then overlaying them with colored stripes.

At the time these designs were being developed, the Finnish government was actively pursuing a policy of closer relations with the Soviet Union. A program of cultural exchange stimulated considerable interest in Slavic culture within Finland. So-called friendship parties were organized for visiting Russian artists, and traditional Russian music became popular. It was against this background that Maija Isola's interest in Slovakian folk art developed. The unashamed richness of the *Ornamentti* series, however, was also a reaction against the exaggerated purity and restraint of early postwar Scandinavian modern design. Isola realized that consumers were ready to accept something richer and more overtly decorative. The Ornament designs challenged the prevailing aesthetic, and the overwhelmingly positive reaction with which they were greeted, both by the press and by the public, confirmed that her instincts were correct. Isola herself was so excited by the initial breakthrough in 1959 that the following year she created a second collection with new designs.

Most of the patterns in the first collection were structured in horizontal or vertical bands, as in *Käspaikka* (Karelian hand towel) and *Patrunessa* (both 1959). However, the scale and density of the motifs varied quite considerably, as did the choice of colors. In the second collection Isola increased the tempo, partly by introducing more vigorous, larger scale patterns, such as *Tamara* (fig. 2–13) and *Ataman* (both 1960), partly through the increased dynamism of the patterns themselves, as in *Tulipunainen* (flame red, 1960), with its radiating, spiraling and zigzagging elements. Brighter colors were also adopted, and at times the colorways seemed to be almost provocatively raw and strident, as in a version of *Sarafan* (1960), printed in pink, red, yellow, and green. Some of these later patterns featured egg- or pocket-shaped elements, as in *Tantsu* (country dance) and *Satula* (saddle, both 1960), suggesting the vernacular folk art origins of the designs.

The *Barokki* (Baroque) series, launched in 1962, was a direct successor to the Ornament series, but instead of Slovakian folk art motifs, it was inspired by a variety of European historical woven textiles,

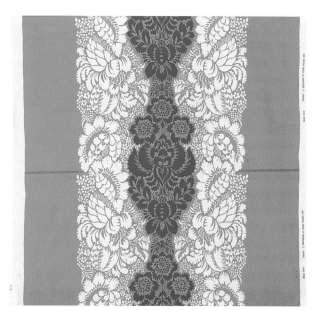

Fig. 2–14. Maija Isola. *Ananas* pattern, 1962.

loosely described as *Baroque*. Visually, the basic effects were similar to the *Ornamentti* series, with decorative silhouettes being superimposed against a colored ground. Many of the new patterns, however, were more sophisticated in their imagery and more formal in their compositions, such as *Fandango* (1962). Some were overtly grandiose, such as *Savoijin kaali* (savoy cabbage, 1962) composed of complex scrolling motifs in wide columns with classic Baroque mirror repeats. Others, such as *Reseda* and *Rosmariini* (rosemary, both 1962), were less ostentatious, featuring small-scale medallions and cartouches arranged in simple rows. In general, a more subtle and muted palette was adopted for the Baroque series, characterized by neutral or pastel tones. Sections of pattern were sometimes picked out in the negative (light on dark), while other parts remained in the positive (dark on light), as in *Ananas* (pineapple, 1962; fig. 2–14).

The intricate micropatterns of the *Ornamentti* and *Barokki* series were in stark contrast to the bold, painterly macropatterns of the *Joonas* (Jonah) series, dating from 1961. This group, consisting of eight designs, was created at a time when Isola was unable to work in her studio at home, so she went into the factory at night. Isola normally worked on the floor, as she disliked the physical constraints of sitting in a chair. On this occasion, however, she worked standing up, using a large thick brush to paint on long lengths of paper rolled out on the empty printing tables. Working to the accompaniment of music, she "danced with the brush,"[40] producing a series of dramatic, spontaneous, calligraphic, rhythmic paintings in black.

*Joonas* (1961; fig. 2–15), the title pattern from the series, is composed of large, loosely drawn circles with tentacle-like divisions. This design was inspired

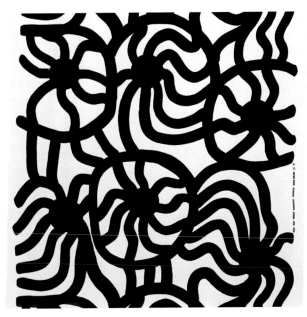

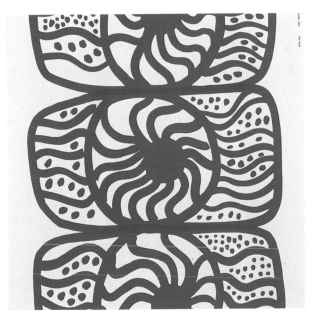

◄◄ Fig. 2–15. Maija Isola. *Joonas* pattern, 1961. (Checklist no. 42).

◄ Fig. 2–16. Maija Isola. *Nooa* pattern, 1961.

by an experience in the Mediterranean, when Isola was looking at the sea and saw the sun reflected on the surface of the lapping water.[41] The title also refers to the Old Testament character, Jonah, who was swallowed by a whale. Another closely related pattern featuring similar motifs, *Nooa* (Noah, 1961; fig. 2–16), also suggests Biblical allusions and has shared associations with water. Several patterns in the Jonah series were named after birds, although the patterns themselves were abstract, and the associations were lateral, rather than literal. In *Silkkikuikka* (great crested grebe, 1961; fig. 2–1) the giant undulating lines and chevrons may evoke water, plumage, or flight. All the designs in this series were strongly gestural. Chevrons crop up again in *Käki* (cuckoo, 1961) along with ladder and circle motifs, while *Kissapöllö* (cat owl, 1961) consists of a mass of circles, suggestive of eyes. Created in a brief intense flurry, the Jonah series marked a pivotal moment in Isola's oeuvre. The dramatically increased scale of the patterns and their loose uninhibited style revealed the designer's new confidence. These breakthroughs led directly to the so-called *Arkkitehti* series.

*Arkkitehti* (architect) series was a title adopted at the factory as a way of promoting Maija Isola's large-scale designs to architects and interior decorators. The title emphasizes the graphic impact of these designs and highlights their suitability for public spaces. Isola herself objected to the name *Arkkitehti* series, however, believing that the end use of a fabric cannot be predetermined by the designer. The title is also misleading in that it implies a degree of rationalism and calculation behind the series, whereas the patterns actually evolved much more spontaneously. Unlike her earlier designs, which were mainly created in groups, each pattern in the *Arkkitehti* series was conceived individually. Some designs were painted, while others were created using cut paper, a technique well suited to compositions featuring large expanses of flat color. Isola may have been influenced by the monumental cut and torn colored paper collages created by Matisse in his later years. By this date, however, she had also developed an interest in contemporary American abstract art, although no particular artist provides a precedent for these designs.

Evocative of the decade in which they were created — and heralding the later fashion for supergraphics — the patterns of the *Arkkitehti* series remain unsurpassed in their visual directness and potency. With these patterns Isola rose to a new level and found her purest voice. She was not alone in tackling large-scale abstract patterns during the 1960s, but what distinguishes her designs from those of her contemporaries is the radical simplicity of her vocabulary and the gigantic scale of individual motifs. Although the *Arkkitehti* series explored new and unfamiliar forms of abstraction and the designs themselves were gargantuan in scale, somehow they avoided becoming impersonal or alienating. Sophisticated though Isola's patterns appear, they are never slick or mechanical. There is something primitive about them that appeals on an elemental level. Armi Ratia was extremely enthusiastic about these powerful, maximized designs, which she felt embodied the essence of the Marimekko ethos.

While aiming for purity and clarity, Isola deliberately avoided clinical precision. Many of her patterns carefully preserve the expressive imperfections of the human hand, as in *Sulhasmies* (bridegroom, 1966), with its wavering, linear motifs, and *Tibet* (1968), a jerky, horizontal, banded design created using photography. Similar concerns also underlie Isola's famous large-scale, organic designs. Patterns such as *Lokki* (seagull, 1961; fig. 2–18) and *Seireeni* (siren, 1964) are all the more vigorous and arresting for the subtle irregularity of their outlines. Marimekko's continuing commitment to hand-screen-printing at a time when the rest of the textile industry was switching to mechanized production, was perhaps significant in this respect. The slight technical imperfections and idiosyncrasies inherent in the hand-screen-printing process complemented the emphatically handmade artistic qualities of Isola's designs.

Isola's skill in designing compositions as a never-ending fluid sequence was particularly remarkable, as in the dramatic snaking *Seireeni* and the bulbous ballooning *Kaivo* (well, 1964). This explains why these fabrics were so often photographed on the printing tables at the factory, because they were so compelling as long lengths, as in the case of *Gabriel* (1968), an oozing ribbon pattern resembling an oil slick. Although Isola designed a few geometric patterns during the 1960s, such as *Husaari* (hussar, 1966) and *Kroketti* (croquet, 1967), the majority of her designs were overtly organic and plastic, as in *Pergola* (1965) and *Kasbah* (1966). There is something intrinsically appealing about flowing, curvilinear shapes, but Isola's compositions, with their extravagantly sinuous, undulating, meandering, swelling, surging, and billowing forms, are particularly seductive. Water is the image that most readily comes to mind in attempting to evoke their fluidity — from the bobbing waves of *Taifuuni* (typhoon, 1968; fig. 2–19) to the seeping ebb and flow of *Kaksintaistelu* (duel, 1968; fig. 2–20).

Willful asymmetry was another daring feature of many of Isola's patterns, as in the lopsided feathered motifs of *Keisarinkruunu* (crown imperial, 1966) and the flowing tentacles of *Albatrossi* (albatross, 1967; fig. 2–17). A reflection of her independent, free-spirited approach to design, it signified the strength of her determination not to be bound by conventions. These designs, and others such as *Mustasukkainen* (jealous, 1967), with its giant, swirling blossom motifs, suggest possible cross-fertilization with the contemporary phenomenon of psychedelia. However, although Isola's designs hinted at elements of drug-induced

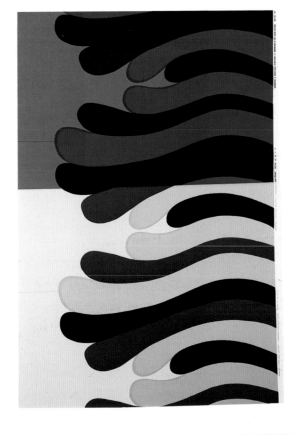

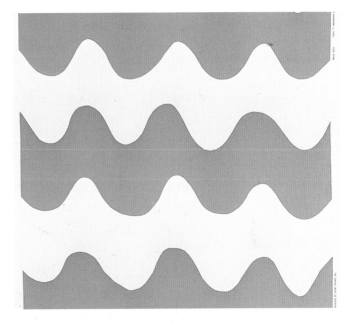

▸ Fig. 2–17. Maija Isola.
*Albatrossi* pattern, 1967.

▸▸ Fig. 2–18. Maija Isola.
*Lokki* pattern, 1961.
(Checklist no. 43).

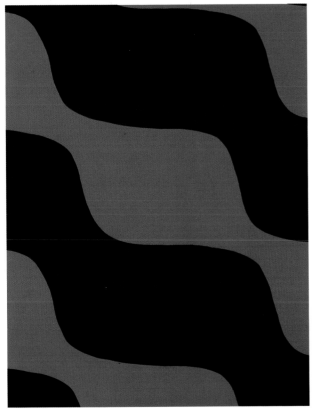

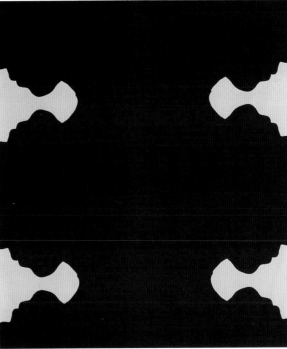

◂◂ Fig. 2–19. Maija Isola.
*Taifuuni* pattern, 1968.

◂ Fig. 2–20. Maija Isola.
*Kaksintaistelu* pattern,
1968.

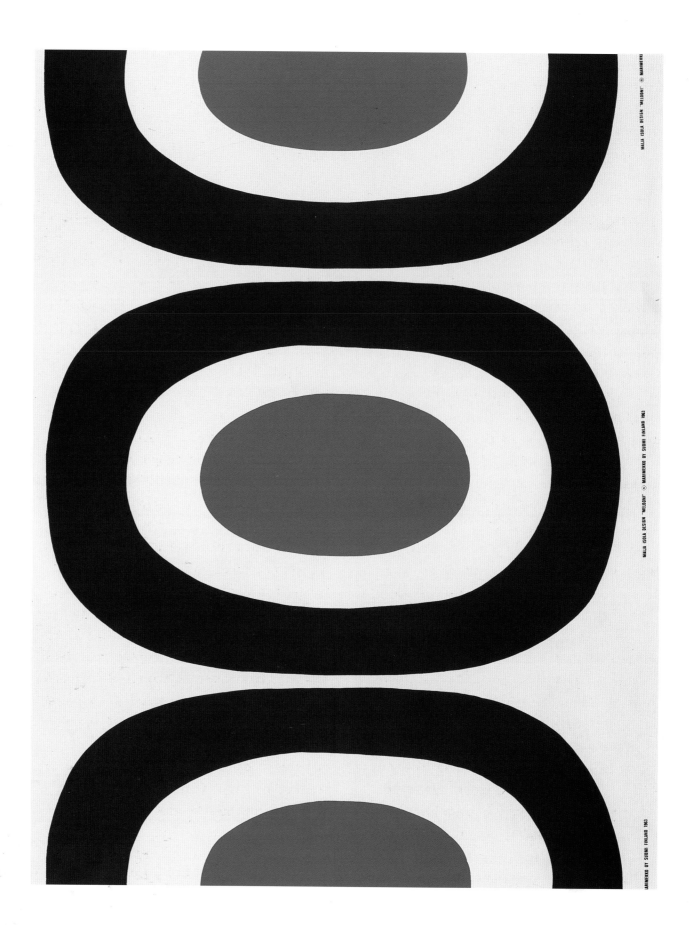

Fig. 2–21. Maija Isola.
*Melooni* pattern, 1963.

pattern meltdown, there was no looseness or arbitrariness about them. Maximized and minimalist in equal measure, her patterns were at once restrained and expressive, expansive yet condensed.

The evolution of *Melooni* (melon, 1963; fig. 2–21) throws light on Isola's method of abstracting motifs and reducing designs to their essence. *Melooni* was also produced in a more overtly representational variant, *Vesimelooni* (watermelon, 1963), depicting an actual watermelon. The abstract *Melooni* was created by stripping away overlaid details to create a pure abstract design of three concentric ovals. Thus, instead of fruit, *Melooni* evokes associations with contemporary abstract art, particularly Op Art and the target paintings of Jasper Johns. In the case of the iconic *Unikko* (poppy, 1964), although the pattern is representational, the exploded poppies are completely transfigured by their exaggerated flatness and extraordinary scale. In fact, the flowers are so enormous and imposing that the image becomes graphic rather than illustrative, operating like a giant billboard.

Maija Isola spoke of the need for designers to live in their own time or a little ahead of it.[42] *Unikko* neatly demonstrates this point, paralleling the Carnaby Street phenomenon in Swinging London, presaging the eruption of Flower Power and prompting parallels with Pop Art and the screen-prints of Andy Warhol. Similarly evocative of the artistic and social climate of the 1960s was a pattern created around the time of the Summer of Love called *Siamilaiset sydämet* (Siamese hearts, 1968), featuring huge multicolored hearts. When Kristina Isola was a student during the late 1960s, she and her mother often socialized. Fundamentally young at heart, Maija Isola enthusiastically followed young people's taste. With her love of travel and her passionate commitment to personal

freedom, she shared many of their concerns. Not surprisingly, popular culture occasionally had a discernible influence on the subject matter, style, and mood of her designs. Two of her patterns made specific allusions to songs by the Beatles and were drawn in the cartoon style associated with their animated feature film *Yellow Submarine*. Isola's *Lovelovelove* (1968), suggesting an aerial view of the countryside, alluded to the refrain in "All You Need Is Love" (1967). The "trippy" imagery and heightened coloring of the period are conspicuous in *Mansikkavuoret* (strawberry hills, 1969), which featured giant red strawberries floating in the sky — overt references to the Beatles' "Strawberry Fields" and "Lucy in the Sky with Diamonds" (both 1967).[43]

In 1969 Isola created a topical thematic collection called the *Avaruus* (space) series, inspired by the Apollo moon landing. Designs included *Meteori* (meteor, 1969), composed of alternating black dots and white circles, and *Raketti* (rocket, 1969), evoking the solar system through large multicolored disks. Two of the most imposing designs in this series, *Kiintotähti* (planet) and *Linnunrata* (milky-way, both 1969), were dominated by giant full-width circle motifs. One represented huge fiery suns, the other a galaxy of twinkling stars.[44] Circle motifs symbolizing the sun had preoccupied Isola since the Jonah series in 1961. They resurfaced again in patterns such as *Rammari* (gramophone, 1969), featuring huge red spheres against a yellow sky.

At the same time as Maija Isola was scaling new heights of maximization in the *Arkkitehti* series, she continued to pursue her interest in micropatterns. At intervals throughout the 1960s she created intricate patterns inspired by natural phenomena, often swarming with tiny markings

suggestive of microorganisms. An early example, *Tassu* (paw, 1959), featured footprints composed of clusters of tiny dots. In *Koralli* (coral, 1961; fig. 2–22), a black and white pattern of fine dotted spirals in pinwheel formations conjured up images of coral. *Levä* (seaweed, 1962) was printed in white on black with myriad tight-knit clusters of dots and rings. Although less-well-known than her large-scale designs, these patterns highlight the multidimensional nature of Isola's engagement with design, and the richness and complexity of her oeuvre.

As the fashion for maximization began to wane, Maija Isola created fewer large-scale organic designs, the daubed *Staccato* and *Traktori* (tractor, both 1973) being two of the last patterns in this genre. Mathematical precision became the keynote of her later abstracts, as in *Ruutuvaltti* (check trumps, 1971), with its checkerboard and chevron pattern. Isola's growing interest in flower painting triggered a wave of floral patterns during the 1970s. Patterns such as *Charles* (1973) and *Florestan* (1975), with their lively brushstrokes, singing colors, and explosive compositions, encapsulate the relaxed exuberance of her later designs.

Maija Isola's final works were created in partnership with Kristina Isola between 1979 and 1987.[45]

Fig. 2–22. Maija Isola. *Koralli* pattern, 1961.

This radical change in working practice inevitably altered the character of her later designs. While still at school, Kristina had begun to assist her mother in the early 1960s and continued intermittently over the ensuing years, learning through hands-on experience. Their method of collaboration involved each of them producing preliminary sketches on the same theme, then pooling their designs, deciding which ones to develop, and choosing colorways together. Crisp, flat, geometric abstracts and delicate, small-scale, stylized florals were the two main genres they explored. At the time of writing, Kristina Isola continues to design for Marimekko on a freelance basis. One of her responsibilities in recent years has been overseeing the reissues of Maija Isola's early designs, a task for which her early apprenticeship and personal insights make her ideally equipped to perform.

Maija Isola's long and intense relationship with Marimekko was unique in the history of textiles. Tireless in her commitment to innovation and originality, she repeatedly redefined and reinvigorated Marimekko's pattern collection, enriching it on every occasion. Experimenting on an amazing variety of fronts, she channeled her energies in an extremely positive and single-minded way, elevating textiles to the level of art through her inspired handling of color, pattern, and scale. Her patterns have an enduring magnetism that seems to get stronger over time.

## Vuokko Nurmesniemi

The other designer who shaped the character of Marimekko's patterns during the formative years was Vuokko Nurmesniemi, who worked for the company from 1953 to 1960.[46] In addition to designing a series of groundbreaking furnishing fabrics for Printex, she created numerous dress

fabrics and garments for Marimekko's fashion line, mainly from 1956 onward. Nurmesniemi's original training was in ceramics, but she developed a parallel interest in textiles while studying at the Institute of Industrial Arts in Helsinki during the early 1950s.[47] Ironically, though, it was probably her lack of professional training that made her such an innovative textile designer.

Nurmesniemi recalls that shortly after she began working for Marimekko, Armi Ratia showed her a printed fabric called *Oomph* (1952; fig 2–6) designed by Viola Gråsten for Nordiska Kompaniet. Ratia greatly admired Gråsten's work and suggested that Nurmesniemi create a pattern in response to it. However excited she may have been by the dynamism of *Oomph*, Nurmesniemi had no desire to copy it. In fact, it made her more determined than ever to develop an original style of her own.[48]

Nevertheless, her exposure to Gråsten's work at this decisive stage in her career was clearly significant, acting as a catalyst for her subsequent experiments at Marimekko.

Extreme graphic simplicity allied with daring use of color was the basic formula employed by Nurmesniemi in her furnishing fabric patterns. Focusing on color relationships and the rhythmic interplay of verticals and horizontals, she dramatically increased the scale of her designs, while condensing the pattern to a series of stripes and planes. Her first pattern, *Tiibet* (1953), was composed of two vertical colored bands intersected by horizontal stripes of unprinted cloth.[49] Although geometric abstraction was not new, hitherto it had been limited to patterns with small repeats. Large-scale furnishing prints with full-width patterns were a novelty at this date. In most countries it was

Fig. 2–23. Vuokko Nurmesniemi. *Indus* pattern, 1953.

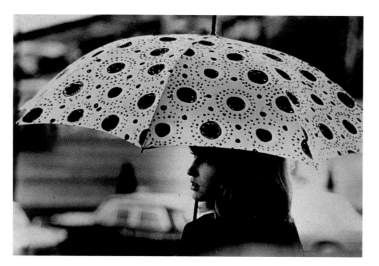

▸ Fig. 2–24. Umbrella; *Suolampi* pattern by Vuokko Nurmesniemi, 1959.

▸▸ Fig. 2–25. Vuokko Nurmesniemi. *Puoliyö* pattern, 1959.

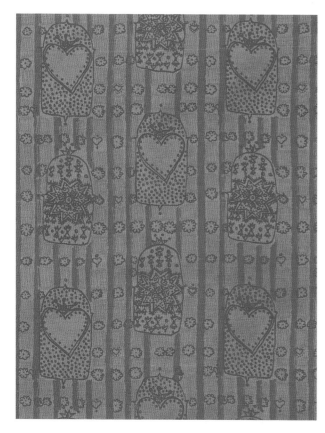

▴ Fig. 2–26. Vuokko Nurmesniemi. *Sydän kukka* pattern, 1959.

▸ Fig. 2–27. Vuokko Nurmesniemi. *Muksunhylly* pattern, 1959.

not until the 1960s that they gained widespread acceptance. The audacious maximization of Nurmesniemi's patterns made them strikingly ahead of their time.[50]

Another key feature of Nurmesniemi's furnishing fabrics, which became a hallmark of Marimekko, was the overlapping of adjacent colors to create a third intermediate shade. This simple but highly effective device, first seen in patterns such as *Indus* (fig. 2–23) and *Ram* (both 1953), exploited the fact that the dyes in hand-screen-printed fabrics move as they seep into the cloth. Whereas other textile companies went to great lengths to achieve precision and eliminate printing overlaps, Marimekko accentuated these natural "faults," exploiting them as a positive design feature. Eva Taimi's experiences at Vaasan Puuvilla were in stark contrast to those of Nurmesniemi at Marimekko: "Vaasan Puuvilla was so fastidious, the technical work was so precise that you couldn't miss by a millimeter. . . . Nothing was allowed to overlap. And therefore they just wouldn't understand anything that was freer, unforced or a bit diffuse. I wanted to design in a less restricted way, Marimekko went on to do that sort of thing."[51]

Rhythmic variety and color were crucial ingredients in bringing Nurmesniemi's designs to life, because the actual compositions were so understated. In *Rötti* (1954), for example, the pattern alternates between busy sections of narrow stripes and quieter sections of broader bands. Although limited to four basic colors, overlapping stripes multiply the number of colors, thereby intensifying its dynamic impact. An inspired colorist, Nurmesniemi worked instinctively rather than scientifically, choosing colors for their emotional appeal. Sizzling high-voltage colors were her specialty, although her palette varied from somber juxtapositions of dark colors, to piquant tonal contrasts, to intense clashing ensembles. Over the years her growing confidence in combining unlikely colors produced some startling effects, as in *Hennika* (1958), composed of three overlapping horizontal bands in pink, orange, and red. At this date the only other designer to compare with Nurmesniemi for sheer audacity and bravado in the use of color was Alexander Girard at Herman Miller in the United States.

Youthful exuberance was the keynote of Vuokko Nurmesniemi's dress fabric patterns, which embodied the bubbling enthusiasm of a young designer at the outset of her career. Because Nurmesniemi was in the enviable position of designing the clothes in which her patterns were incorporated, this gave added impetus to her activities in printed textile design. The garments she designed were loose and nonconstrictive, radically simple in their cut and construction. Printed fabrics were their defining feature, and the relaxed informality of Nurmesniemi's patterns perfectly complemented the casual style of dress.

Unlike Sonia Delaunay's textiles, which were conceived for specific garments, Nurmesniemi's patterns were designed to be as flexible as possible. In contrast to her furnishing fabrics, most of her dress patterns were compact and small scale, the one exception being *Galleria* (1954), a broad-striped pattern that paved the way for Annika Rimala's outsize dress prints of the 1960s. Although multifunctional and modest in size, her patterns were nonetheless full of character and far from recessive. Great reliance was placed on the appeal of the hand-drawn. Like Maija Isola, Nurmesniemi admired the spontaneity of children's drawings, a graphic style she explored in a furnishing fabric called *Muksunhylly* (kid's shelf, 1959; fig. 2–27),

depicting a red-cheeked girl. Similar qualities of naiveté and freshness characterized her abstract dress fabric designs.

Wobbly stripes, scribbly lines, and dots formed the basis of her deliberately primitive decorative vocabulary, and many patterns consisted of subtle variations on a theme. Stripes provided the richest seam of exploration, as in the two-tone stripes of *Piccolo* (1953) and *Pepe* (1955), the three-color ribbons of *Raituli* (stripy, 1959), and the fine lines of *Varvunraita* (twig stripe, 1959). Circles were another recurrent motif, with interpretations ranging from the irregular dots of *Pirput parput* (tiny trifles, 1958) to the concentric rings of *Valkea varsa* (white foal, 1959) and the tight-knit circles of *Kissanviikset* (cat's whisker, 1959). Checkerboard compositions were another favored device. In *Pohjanakka* (little old woman from the north, 1954), the pattern was composed of rectangles. In *Noppa* (dice, 1954; fig. 2–28) irregular squares were overprinted so that the colors overlapped.

Complementing this vocabulary of geometric forms, Nurmesniemi drew on a pool of more personal and whimsical motifs, including hearts, stars and flowers. Patterns of this kind, such as *Villikirsikka* (wild cherry, 1959) and *Sydän kukka* (heart flower, 1959; fig. 2–26), were more overtly feminine in character. Spidery, doodlelike motifs

formed the basis of many compositions, as in the intricate, wiry *Loru* (nonsense poem, 1959–60) and the lacy *Helmipitsi* (pearl lace, 1959). In *Ruukku* (pot, 1959) the pattern was printed in the negative, with skeletal white lines against a colored ground.

As in Nurmesniemi's furnishing fabrics, color played a central role in her fashion prints, and she excelled in concocting daring and imaginative color cocktails. Each pattern was produced in several colorways, the relationship between contrasting or complementary colors dramatically affecting the impact of the designs. Color was particularly vital in sketchy crayon patterns, such as *Hirventupa* (elk cabin, 1959), *Linjaarirattaat* (spring wagon, 1959) and *Suolampi* (bog pond, 1959; fig. 2–24), which were much looser and more textural in style. In designs where several motifs overlapped, such as *Puoliyö* (midnight, 1959; fig. 2–25), overprinting resulted in some extraordinary color hybrids.

Although Nurmesniemi's collaboration with Marimekko was relatively brief, her seven years at the company were highly productive. Having single-handedly formulated the unique Marimekko look in fashion, her influence lived on and flourished long after her departure in 1960.[52] When Annika Rimala took over the reins, she recalled that "Vuokko's trace was extremely strong."[53]

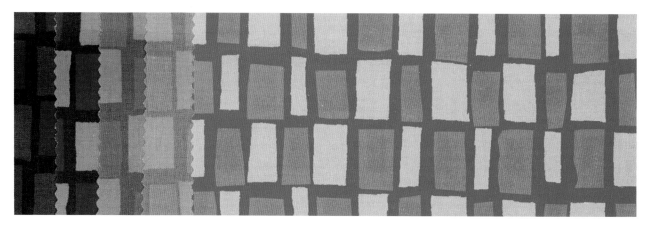

Fig. 2–28. Vuokko Nurmesniemi. *Noppa* pattern, 1954.

## Annika Rimala

Picking up seamlessly where Vuokko Nurmesniemi had left off, Annika Rimala[54] — Marimekko's fashion designer from 1959 to 1982 — continued to champion printed patterns. Rimala had originally trained as a graphic designer at the Institute of Industrial Arts in Helsinki, so it was no surprise that her patterns reflected a strong sense of graphic awareness. For her first fashion collection she drew on existing patterns by Nurmesniemi, as well as some newly commissioned designs by Oiva Toikka. Subsequently better known as a glass designer, Toikka contributed a number of small-scale doodlelike patterns very much in the Nurmesniemi style, such as *Hamppu* (hemp, 1961). Gradually, however, as Rimala began to design more fabrics, she was able to stamp her own mark on Marimekko's fashion line.

A punchy small-scale pattern called *Hilla* (cloudberry, 1961) was Rimala's first design. Other early contributions included *Samettiruusu* (velvet rose, 1963), depicting blurred rosettes, and *Puketti* (bouquet, 1964), featuring clusters of tiny flower heads. "In the beginning the fabrics and also the colors were 'small' and 'silent'," Rimala observed.[55] Later, however, as she grew in confidence, her patterns became more assertive. *Petrooli* (petroleum, 1963; fig. 2–29), a bold eye-catching pattern composed of concentric circles in bright colors, was among the first of these more provocative designs. *Tarha* (garden, 1963), with its loose, scrolling motifs and dotted background, also marked an increase in intensity and scale. Scribbly linear flower patterns and fishscale designs, such as *Kukka* (flower, 1965), *Pikkusuomu* (small scale, 1965), and *Iso suomu* (big scale, 1965), were developed as part of Rimala's increasingly dynamic repertoire.

During the mid-1960s, encouraged by Armi Ratia, who was keen to stimulate cross-fertilization from furnishings to fashion, Rimala created a memorable series of gigantic, free-flowing organic patterns, including *Iso laine* (big wave, 1965) and *Keidas* (oasis, 1967). Paralleling Maija Isola's *Arkkitehti* series, Rimala's exploded fashion prints had such huge repeats that only a small section of the pattern could be fitted onto a dress. The larger and more extravagant the print, the more forceful its impact in fashion terms. However, having pushed dress patterns literally as far as they could go during the mid-1960s, the only option afterward was to downsize and embrace uniformity. Rimala's solution was the *Tasaraita* (even stripe) collection of cotton jersey casualwear, launched in 1968. A runaway hit throughout the 1970s, *Tasaraita* replaced the flamboyant individualism of large-scale patterns with the high-voltage intensity of saturation stripes.

◄ Fig. 2–29. Annika Rimala. *Petrooli* pattern, 1963.

Fig. 2–30. Katsuji
Wakisaka. *Bo-Boo*
pattern, 1975.
(Checklist no. 112).

## Katsuji Wakisaka

Marimekko's furnishing fabrics also took on a new character during the 1970s following the recruitment of two Japanese designers, Katsuji Wakisaka and Fujiwo Ishimoto. Supplementing the work of Maija Isola, these "second-generation" Marimekko designers introduced new aesthetics, which developed and expanded the Marimekko style, while respecting the company's fundamental ethos.

Trained at Kyoto School of Art and Design, Katsuji Wakisaka worked for Marimekko from 1968 to 1976. He was only twenty-four when he came to Finland and presented his portfolio to Armi Ratia. From the outset, playfulness was the keynote of his approach to design, and the company benefited greatly from the freshness of his imagery and style. Co-opting the naive idiom of children's drawings, his first pattern, *Yume* (1969), featured primitive animals floating surreally like giant balloons in the sky.[56] The same combination of gaucheness and maximization underlies *Hana* (1969), depicting huge, gawky, black and white tulips. Even abstract geometric patterns were treated as a game, literally so in *Cross-Word Puzzle* (1972), an ingenious, fragmented, checkerboard design. The condensed, flattened style of cartoon graphics was one of Wakisaka's favorite idioms. Many of his designs resemble children's book illustrations, as in *Kalikka* (1975; fig. 2–32), with its streets of storybook houses, and *Bo-Boo* (1975; fig. 2–30), with its rows of brightly colored toy trucks and cars.

Deliberately blurring the line between the living room and the nursery, Wakisaka injected a spirit of fun into Marimekko's home furnishings. Exuberant pop patterns, such as *Sademetsä* (rainforest) and *Pähkinäpuu* (nut tree, both 1974), featuring oversized nuts and berries, acted as a cheerful antidote to the prevailing economic gloom of the worldwide

▲ Fig. 2–31. Katsuji Wakisaka. *Kiinan-ruusu* pattern, 1976.

◄ Fig. 2–32. Katsuji Wakisaka. *Kalikka* pattern, 1975.

recession in the mid-1970s. High-voltage coloring was another explosive device, brilliantly exploited in the ebullient *Karuselli* (carousel, 1973), with its giant painterly flowers, and the vibrant *Kesä* (summer, 1975), with its magnified spiky foliage. Larger-than-life motifs were also common, as in the exploded mauve roses of *Kiinanruusu* (rose of China, 1976; fig. 2–31), literally falling off the edge of the cloth. Wakisaka's impact at Marimekko, although short-lived, was intensely exhilarating. Just at the point when the company might have started flagging, he gave it a new lease of life.

## Fujiwo Ishimoto

Fujiwo Ishimoto was initially attracted to Marimekko by Maija Isola's *Arkkitehti* series. After studying design and graphics at the National University of Art in Tokyo, Ishimoto worked as a commercial artist for six years. On his arrival in Finland in 1970, there were no openings at Marimekko itself, but he was hired by Décembre Oy, a company run by Armi Ratia's son, Ristomatti Ratia. Four years later, in 1974, Ishimoto joined Marimekko and remains chief furnishing fabric designer at the time of writing.

Ishimoto's earliest patterns reflected his attempts to blend in with the prevailing Marimekko aesthetic, as in *Kuja* (lane, 1976), with its chirpy chickens and cartoon flowers.[57] Gradually, however, Ishimoto began to develop patterns that expressed his own character and culture, although his initial attempts to break the mold were rejected by the company because they "weren't Marimekko."[58] His breakthrough came with *Jama* and *Sumo* (both 1977), two bold, full-width, calligraphic designs. While upholding the Marimekko tradition of maximization, these simple, forceful, brushstroke patterns were distinctively Japanese.

► Fig. 2–33. Fujiwo Ishimoto. From top: *Mesi, Vihma, Riite, Rahka* patterns, part of the *Mättäillä* collection, 1979.

Fig. 2–34.
Fujiwo Ishimoto.
*Harha* pattern, 1982.

Another crucial turning point for Ishimoto was the *Mättäillä* (on the hummocks) collection of 1979, evoking the bogs, forests and wildflowers of rural Finland (fig. 2–33). Marking a new departure in terms of composition and scale, these patterns consisted of small hand-drawn textural dots, dashes, and sprigs. Drawing on his earlier experience of designing fabrics for kimonos, Ishimoto introduced the idea of collections based on contrast (a Japanese concept) rather than coordination (the standard European model).[59] Interestingly, some of Ishimoto's designs recall the spidery dress-fabric patterns of Vuokko Nurmesniemi from the 1950s, thus unconsciously following a Marimekko tradition. Produced as both positive and negative prints, the collection was groundbreaking in its choice of color and cloth. Some patterns were printed in indigo on unbleached cotton, recalling traditional Japanese stencil-dyed textiles.

Once the *Mättäillä* collection had proved to be commercially successful, Ishimoto was given more creative freedom at Marimekko. Richly prolific and inventive, he has produced a series of landmark thematic collections, as well as many remarkable individual designs. Webs and meshes were one of his early themes, explored in patterns such as *Katve* (shade, 1980), with its gossamer-like cocoons, and *Hohto* (shine, 1981), composed of fine crisscrossing threads. Harnessing a wide spectrum of drawing tools, Ishimoto has constantly varied the rhythms and textures of his designs. His extraordinary visual dexterity is reflected in patterns as diverse as the frenetic, scribbly *Harha* (illusion, 1982; fig. 2–34), the dancing, calligraphic *Oikkuja* (whims), and the slow, dragged brushstroke effects of *Raju* (fierce, all 1982).

For the large patchwork patterns of the *Maisema* (landscape, 1982) collection, Ishimoto used crayons to produce soft, multilayered, crosshatched effects.

The varied colorways of the *Maisema* collection were intended to evoke the changing colors of the Finnish landscape in different seasons. His next collection, *Iso karhu* (big bear, 1983), was prompted by a book celebrating the traditions of the Finno-Ugrian people. The rich colors he adopted in some patterns echoed the vibrancy of traditional Lapp costume. The ragged outlines of the patterns in this collection were loosely inspired by *ikats* (warp-dyed woven textiles). Some patterns were arranged as neat checkerboard designs, such as *Ostjakki* (Ostyak, 1983); others were melted and unstructured, such as *Karhusaari* (bear island).

The breakdown and disintegration of pattern has been a recurrent theme in Ishimoto's work over several decades. *Kenttä* (field, 1986), an early experiment in computer-generated pattern, featured pixelated figures in various stages of decomposition. The grainy images of the *Sinitaivas* (blue sky, 1986) collection, with their moody evocations of cloudy skies, capitalized on a new type of printing process permitting graduated shading and the subtle transition from one color to another. Unconventional printing methods were also used to create the unique, swirling, marbled patterns of the *Sydäntalvi* (midwinter, 1987) collection. These fabrics were printed using two screens of different sizes, so that the pattern constantly varied along the length of the cloth.

Three diverse patterns from 1989 demonstrate Ishimoto's fascination with different technical processes and graphic effects. In *Salava* (brittle willow) he used exploded half tone images of painted leaves; in *Lainehtiva* (waving) he exploited a giant black and white photograph of a field of wheat; while in *Kesanto* (fallow) he employed traditional watercolor to depict wildflowers. Tirelessly experimental, Ishimoto has cited Hiroshi

Awatsuji, another outstandingly talented and technically innovative Japanese printed-textile designer, as one of the artists he most admires.[60] Grateful for the unique opportunities he was given at Marimekko, Ishimoto credited the company's former art director, Hilkka Rahikainen (herself a designer for Marimekko during the 1960s), with helping him to focus his diffuse ideas. "Marimekko has helped me find a voice as a designer," he acknowledged. "I needed the framework of Marimekko to develop."[61]

## Marimekko's Contemporaries and Successors

The more successful Marimekko became during the 1960s, the greater its impact on other Finnish companies. "Printex printed cottons have had a number of successors," observed Anna-Liisa Ahmavaara in a survey of Finnish textiles in 1970.[62] Marimekko was clearly the inspiration behind Helenius Oy, a progressive printed-textile company established by Erkki Helenius in 1960. Toward the end of the decade Helenius adopted a graphic formula of large, flat, stylized patterns that drew overtly on Marimekko designs, as in Nana Suni's horizontal banded-ogee pattern *Kupoli* (cupola), which echoed the composition and scale of Maija Isola's wavy *Lokki*. Cross-fertilization was also evident in Anita Wangel's giant free-form pattern *Meritursas* (sea ogre), which recalled Annika Rimala's scrolling *Keidas*.[63]

An even more direct spin-off from Marimekko was Vuokko Oy, the fashion and furnishings company established by Vuokko Nurmesniemi in 1964. Although the designer set out to establish a different identity for her own company, inevitably there were some elements of similarity between the two firms. Full-width repeats had been one of the most innovative features of Nurmesniemi's furnishing

fabrics for Marimekko during the mid-1950s, although her early dress-fabric prints had been mostly small in scale. For her new dual-use fashion and furnishing fabrics Nurmesniemi applied this maximizing approach across the board. Her first pattern, *Pyörre* (whirl, 1964), featured a giant radiating whirlpool motif. Originally used as circular cushion covers in an exhibition installation at Jyväskylä, the fabric was subsequently employed to dramatic effect in a simple shift dress.[64]

Whereas overlapping colors had been a key element of Nurmesniemi's early designs for Marimekko, her later patterns were crisply printed in a single color on white cloth. Sometimes the same design was scaled up several times, the largest patterns being so large that they spilled off the edge of the cloth. The purity and austerity of her patterns were matched by the monumental simplicity of her garments. "I have tried to simplify my creations without forgetting the richness of life itself," she explained.[65]

By the end of the 1960s Nurmesniemi's decorative vocabulary had been refined to a series of pure geometric motifs, as in the broad stripes of *Poikkiraita* (cross stripe), the large squares of *Iso Neliö* (large square).[66] During the 1970s her patterns became even more minimal and understated, drawing her further away from the prevailing brightly colored, exuberant Marimekko style. By this date the wobbly lines of Nurmesniemi's early patterns for Marimekko had been succeeded by pure geometry and ruler precision. However, having pushed this aesthetic as far as it would go, Nurmesniemi began to explore new avenues during the early 1980s. In 1984 she designed a collection of nine patterns called *Kirjeitä Chopinille* (letters to Chopin), in which expressive calligraphic notations were used to evoke music, rhythm, and dance.[67] In

this series, Nurmesniemi harked back unconsciously to her earliest Marimekko designs. Although the scale of the patterns was different, their shared starting point — spontaneous notation — recalled familiar Marimekko terrain.

As well as acting as a catalyst for new companies, Marimekko also had a positive impact on design awareness in existing Finnish firms. Porin Puuvilla (Pori Cotton Mills, founded 1898), for example, benefited directly from the revolution in taste that Marimekko had triggered. Among the patterns created during the 1960s by their designer Raili Konttinen was the Op Art-inspired *Fabrina*, composed of small, medium, and large circles in clashing blue, turquoise, and orange.[68]

The 1960s was also an exciting period for Tampella (founded 1856), whose printed textiles took on an extremely progressive character at this date. Marimekko's influence could also be recognized here, nowhere more so than in Perttu Mentula's *Space 1* (fig. 2–35), a large-scale pattern composed of irregular undulating horizontal bands evoking a lunar landscape.[69] Tampella, however,

Fig. 2–35. Perttu Mentula. *Space 1* pattern, 1970s.

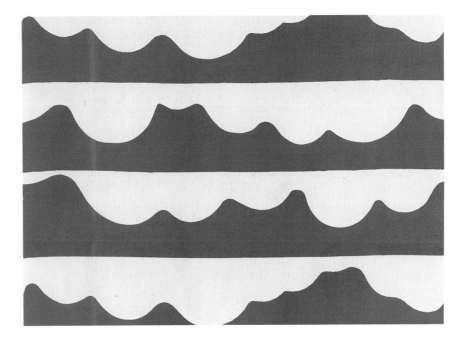

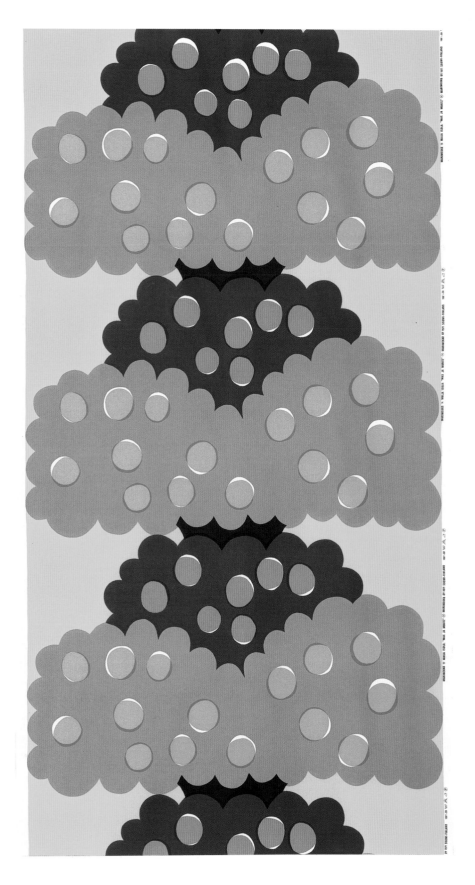

was by no means a satellite of Marimekko; it had its own distinctive identity. During the 1960s the company benefited greatly from the input of two highly original designers, Marjatta Metsovaara and Timo Sarpaneva.

Metsovaara was already well known by this date for the innovative, textured, woven textiles produced by her company, Metsovaara Oy, since 1954. An outstanding colorist, she had originally studied textiles with Maija Isola at the Institute of Industrial Arts, so the parallels between their careers are especially pertinent.[70] On the whole, however, Metsovaara's patterns were busier than Isola's, with a more eclectic range of imagery and a different palette. Rich, dense, stylized florals in intoxicating colors, such as the mosaiclike *Kukka* (flower, 1962), were one of her specialties.[71] This design evoked the paintings of Gustav Klimt, while another pattern, *Ruusu* (rose), infused the rose motifs of Charles Rennie Mackintosh with a psychedelic twist.[72] Where Metsovaara drew closest to Isola was in her simpler, flatter designs. *Suvi* (summer), a pop-inspired pattern of flowers and trees, shared the distinctive cartoon aesthetic of Isola's *Max ja Moritz* (1971; fig. 2–36).[73] But perhaps the most Marimekko-like of Metsovaara's patterns were two large-scale, organic designs featuring multicolored, wavy, horizontal stripes: *Laava*, evoking lava flow, and *Niili*, referring to the Nile River (fig. 2–37).[74]

Timo Sarpaneva, although best-known as a glass and ceramics designer, had been involved with textiles from the outset of his career. Between 1955 and 1965 Sarpaneva designed printed fabrics for PMK (Puuvillatehtaitten myyntikonttori, the Cotton Mills' Sales Office), a joint marketing organization servicing several Finnish textile firms. This was how he came to collaborate with Tampella, where his radical, painterly *Ambiente* collections

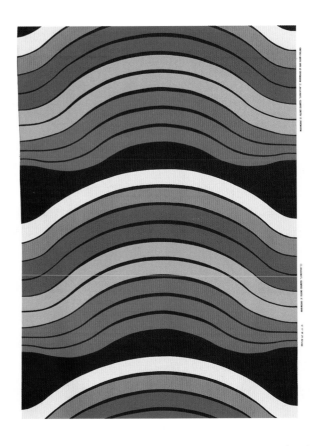

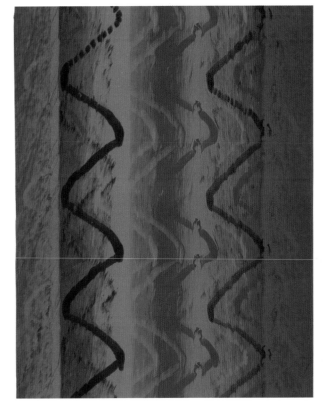

◄◄ Fig. 2–37.
Marjatta Metsovaara.
*Niili* pattern, 1960s.

◄ Fig. 2–38.
Timo Sarpaneva.
*Ambiente* patterns for
Finlayson, 1964–69.

were produced between 1964 and 1969.[75] Described by Sarpaneva as "industrial monotypes,"[76] the *Ambiente* range was machine-painted by robot automation using a modified form of rotary printing. Drawing on nearly two thousand settings, *Ambiente* fabrics were produced in innumerable color schemes, from intense crimson and turquoise, to subtle pea green, cream, and black. Some designs were left as blurred stripes, while others were merged and distorted to varying degrees. The most arresting patterns were those in which the dyes had been blown from side to side to create marbled, herringbone, and zigzag effects (fig. 2–38). In one variant, *Palmikko* (braid), the cloth was decorated along its length by a single, unbroken, irregular, snaking trail. Although this sinuous pattern loosely recalled Maija Isola's *Seireeni*, *Palmikko* was much freer. The flatness of Marimekko's patterns also contrasted markedly with the rich textures and

three-dimensional optical effects of the *Ambiente* range. Produced at several factories in Finland, as well as under license abroad, *Ambiente* scored a huge international success, further enhancing Finland's reputation for creativity in printed textiles.

Buoyed by success during the 1960s, Tampella remained at the forefront of innovations in Finnish printed textiles for the next two decades. Direct cross-fertilization between Tampella and Marimekko continued at intervals during the 1970s, partly through the agency of Maija Lavonen, a freelance textile artist who contributed patterns to both firms. Her *Harlekiini* pattern for Tampella bore striking similarities to a brightly colored patchwork design called *Piippu* (pipe, 1974) for Marimekko.[77]

Tampella's chief designer and artistic director from 1981 to 1985, Anneli Airikka-Lammi, like many of her contemporaries, had been strongly influenced by Maija Isola early in her career. This is evident in

◄◄ Fig. 2–36.
Maija Isola. *Max ja Moritz* pattern, 1971.

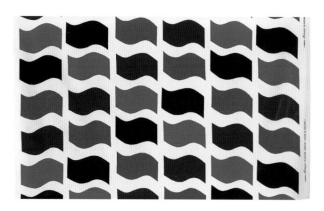

▶ Fig. 2–39.
Maija Lavonen.
*Melody* pattern, 1975.

▶▶ Fig. 2–40.
Jukka Vesterinen.
Fabric pattern for
Finlayson, 1970s.

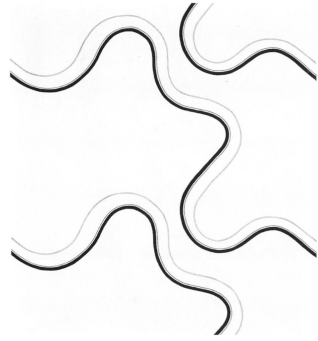

an overtly Marimekko-influenced pattern, *Napapiiri* (polar circle, 1972), produced by the Italian firm Socota.[78] Airikka-Lammi's subsequent designs for Tampella were colorful, vibrant, and positive, still celebrating the Marimekko legacy, but in a more indirect and generalized way.

Another company spurred on by Marimekko was Finlayson-Forssa (created through the merger of two previously independent companies in 1934), which tapped directly into the Marimekko aesthetic by commissioning a series of printed furnishing-fabric patterns from Annika Rimala during the late 1960s.[79] Maija Lavonen also created patterns for Finlayson, including *Melody* (1975; fig. 2–39), featuring wavy red and blue flag motifs, which had the same graphic clarity as the work of Maija Isola.[80] The large-scale organic patterns of the *Arkkitehti* series were also the underlying source of inspiration for an imposing full-width design by Jukka Vesterinen for Finlayson, featuring snaking lines meandering freely around the cloth (fig. 2–40).[81]

The continuing inventiveness of Marimekko clearly helped to sustain the creative momentum within the Finnish textile industry as a whole, at a time when other countries were becoming much more timid and conservative. As design historian Penny Sparke noted in 1982: "There is a feeling of confidence and vitality in the Finnish textile trade, backed up by growing export figures. It is an

inspiring phenomenon and one which should make other countries feel that furnishing fabrics need not be the dull or discreetly neutral backcloth to life that they so often are."[82] Whereas during the 1930s the Finns had lagged far behind other countries in the field of printed textile design, fifty years later they were leading the world, and Marimekko was the catalyst behind the revolution.

Although there was no true British counterpart to Marimekko, two companies, Ascher and Horrockses, made a name for themselves during the late 1940s through the originality of their dress fabric prints. Ascher (London) Ltd. was founded in 1942 by two Czech émigrés, Zika and Lida Ascher.[83] Lida Ascher's simple, scribbly patterns formed the company's basic repertoire during the early years, providing an interesting comparison to Vuokko Nurmesniemi's designs at Marimekko. By commissioning dress-fabric patterns and scarves from high-profile artists such as Henry Moore, Ascher played a key role during the early postwar period in drawing public attention to the aesthetic potential

of printed-textile design. Horrockses also greatly enlivened British fashion from 1946 onward with their stylish printed-cotton frocks.[84] As at Marimekko, eye-catching pattern was a crucial ingredient. Designs arranged in broad horizontal bands, often composed of energetic, wiry, linear motifs, were their specialty during the late 1940s, many created by Alastair Morton. During the 1950s Horrockses' chief designer was Pat Albeck, whose lively patterns gave a new twist to traditional florals.

In the field of furnishing fabrics, Marimekko's closest British counterpart was Heal Fabrics, founded as a subsidiary of the London department store, Heal & Son, in 1941.[85] Under the dynamic leadership of its managing director, Tom Worthington, Heal Fabrics developed a formidable reputation for innovation during the 1950s and 1960s. Unlike Marimekko, they acted as a converter rather than a manufacturer, buying in cloth and employing contract printers. Also, rather than using in-house designers, Heal's purchased patterns from an army of freelance designers, most of whom also designed concurrently for other firms.

The outstanding designer of the early postwar period was Lucienne Day, with whom Heal Fabrics enjoyed a long and productive relationship.[86] Day revolutionized the British market with *Calyx* (1951), a dynamic abstract organic pattern printed in contrasting acid and earthy tones, first shown at the Festival of Britain. Like Maija Isola, Day was consistently imaginative and inventive over several decades. During the early 1950s she was equally adept at creating lively abstracts such as *Ticker Tape* (1953), witty figurative patterns such as *Spectators* (1953), and spindly plant designs such as *Dandelion Clocks* (1953). Later patterns were bolder and more consciously architectural, again paralleling the evolution of Maija Isola. By the end of the 1950s,

patterns featuring skeletal leaves and feathery grasses had been replaced by silhouetted trees, as in *Sequoia* (1959). The following decade she developed a series of bold, large-scale, abstract geometric designs, including *Causeway* (1967) and *Sunrise* (1969).

During the 1960s Heal's collections were greatly enriched by the contributions of Barbara Brown, who explored a striking Op Art–inspired aesthetic (fig. 2–41). Like Maija Isola, Brown relished the opportunity of designing on a massive scale, which suited the architectural aspirations of the period. Aesthetically Heal's line was much broader than Marimekko's, but it shared the same commitment to breaking the mold.

Heal Fabrics's closest rival in artistic terms was Hull Traders, a small textile-printing firm established in 1957. Their high-principled art-led approach,

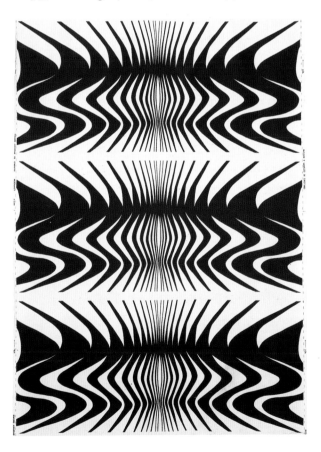

Fig. 2–41. Barbara Brown. *Expansion* pattern for Heal Fabrics, 1966. Trustees of the Victoria and Albert Museum, London, Circ. 269-1967.

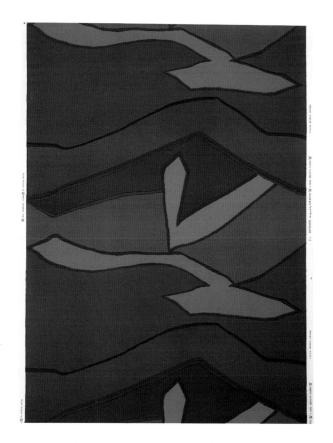

Fig. 2–42. Shirley Craven. *Division* pattern, 1964. Whitworth Art Gallery, University of Manchester, UK, 11293.

along with their commitment to hand-screen-printing, provide direct parallels with Marimekko. Hull's chief designer and art director was Shirley Craven. Like Maija Isola, Craven was strongly independent-minded and committed to developing textiles as a form of art (fig. 2–42). Craven had a free hand in choosing the rest of the company's range and adopted an extremely adventurous buying policy. "Textiles should be an artistic field, not just a commercial transaction," she believed, echoing the philosophy of Armi Ratia.[87] Fearless experimental abstraction was the norm at Hull Traders.

Whereas British manufacturers often engaged in a direct and overtly enthusiastic way with the latest artistic trends, the impact of contemporary art at Marimekko was more lateral and indirect. However, the key point about all these British firms was that, like Marimekko, they were actively design-led rather than market-led, initiators of change rather than followers of existing trends. By treating the consumer as intelligent and discriminating, willing to absorb radical new ideas, these flagship companies opened the mass market to progressive textiles and fashions, revitalizing the sector as a whole.

The hitherto conservative American textile industry was also electrified by a wave of enthusiasm for hand-screen-printing after the war. During the 1940s many enterprising small businesses were established, frequently run by artists, such as the sculptor Angelo Testa. Catering to the needs of modern architects, they often produced both textiles and wallpapers, as in the case of Ben Rose. Rose created numerous entertaining and inventive patterns during the 1950s and 1960s. *Groves* (1955), depicting silhouettes of leafless trees, was similar to Maija Isola's *Putkinotko* in the way it exploited screen-printing to create two-tone shadowlike effects. Three husband and wife duos were also among the most creative firms: Adler-Schnee (run by Ruth Adler Schnee and Edward Schnee), Elenhank (run by Hank Kluck and Eleanor Kluck) and Laverne Originals (run by Erwine Laverne and Estelle Laverne). Their high-spirited and stimulating patterns reflected the same kind of creative optimism as Marimekko's designs.[88]

Small though these companies were, they spearheaded a dramatic improvement in the quality of pattern design in the United States, actively fostering cross-fertilization between architecture, painting, sculpture, graphic design and printed textiles. Two progressive furniture companies, Knoll Associates and Herman Miller, who diversified into printed textiles in 1947 and 1952 respectively, also had a significant impact in raising aesthetic standards. Alexander Girard's patterns for Herman Miller, with their simple, flat, cutout shapes and rich, layered colors, provide

fascinating parallels with Marimekko (fig. 2–43).[89] Trained as an architect, Girard treated pattern as a form of graphic design, reducing his compositions to the purest and most basic elements. His most memorable patterns, *Rain* (1953) and *Feathers* (1957), consisted of a single repeated, overlapping motif printed in several translucent colors. Where the shapes intersected, the secondary and tertiary tones were comparable to the overlapping colors of Marimekko's classic stripes.

The designer Jack Lenor Larsen was a great admirer of both Alexander Girard and Marimekko. In 1953 he established his own company, initially producing woven textiles, with screen-printed fabrics added to the range from 1956. Larsen's early patterns, such as *Midsummer* (1956) and *Primavera* (1959), used color in a seductive and intoxicating way, sometimes printing on velvet to intensify the richness of the effects.[90] Later, the psychedelic patterns of Larsen's Butterfly collection (1967) echoed the uninhibited fluidity of Annika Rimala's scrolling dress patterns. Created as flexible upholstery for sculptural foam furniture, these stretch nylon fabrics fused pattern and furniture in the same way that Marimekko fused pattern and dress.

As Marimekko expanded internationally, Sweden became one of its most receptive markets. During the 1960s, under the direction of the designer Inez

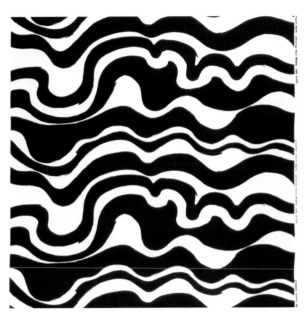

Fig. 2–44.
Sven Fristedt. *Stora Bält* pattern for Borås Wäfveri, 1970. Borås Textilmuseum, Sweden.

Svensson, Borås Wäfveri emerged as one of the most adventurous Swedish textile firms. A number of freelance designers were employed and even Maija Isola herself was a contributor on at least one occasion, a rare example of her designing for another firm.[91] In 1965 Sven Fristedt joined Borås Wäfveri, having previously worked for Katja of Sweden. In fashion terms Katja was the Swedish equivalent of Marimekko, and Fristedt had played a large part in establishing their image with his startlingly bold dress fabric patterns.[92] Fristedt's arrival at Borås prompted a wave of dynamic Op Art– and Pop Art–inspired patterns, starting with *Oppo* (1966). Maximization was rife at Borås Wäfveri during the 1970s, where Fristedt created a series of full-width, swirling abstract patterns. Some designs were in stark black and white, such as *Stora Bält* (1970; fig. 2–44), others were printed in ghostly white on white, such as *Frost* (1970).[93] It is hard to imagine such ambitious patterns being produced before the liberating impact of Maija Isola's *Arkkitehti* series.

After leaving Borås Wäfveri in 1969, Inez Svensson became one of the prime movers behind the Tiogruppen (also known as Ten Swedish Designers),

◄ Fig. 2–43.
Alexander Girard. *Ribbons* pattern for Herman Miller, 1957. Cooper-Hewitt National Design Museum, Smithsonian Institution, New York.

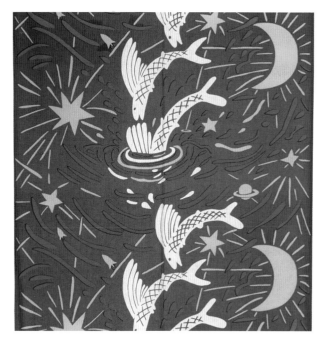

Fig. 2–45. Carl Johan de Geer. *Flygfiskar* pattern for Tiogruppen, 1974. Tiogruppen, Stockholm.

a group of designers from various backgrounds in textiles, fashion, and graphics, who established their own textile company in 1970. Passionate about pattern, but frustrated by the negative attitudes of manufacturers, the Tiogruppen set out to reinvigorate printed textiles through their bold, colorful, "neo-simple" designs. Employing Borås Wäfveri to print their fabrics, the group launched new collections approximately every two years, retaining full control over the production and marketing of their own designs.[94]

Although the Tiogruppen's patterns were smaller and more repetitive than those of Marimekko, graphically they were equally assertive. Color was used in a similarly direct and provocative way, as in *Flygfiskar* (flying fish; fig. 2–45) by Carl Johan De Geer from the Sea collection (1975), printed in a dazzling combination of bright red, yellow, and blue. Color provided the vital linking element between otherwise disparate patterns by different designers. In the Black/White collection (1977), for example, all the designs had either white or black backgrounds. Ingela Håkansson's *Sågblad* (saw blade, 1977) was

particularly striking, featuring red, yellow, blue, and green leaves floating against a black backdrop. While clearly an offspring of Marimekko, the Tiogruppen had a mind and agenda of its own.

Since the 1980s Swedish and Finnish textile companies have been exceptional in bucking the retrogressive trends that have prevailed in other countries. IKEA, for example, has consistently produced attractive modern printed textiles, often commissioned from leading Swedish designers, including members of the Tiogruppen. Meanwhile, at the upper end of the market, another enlightened Swedish firm, Kinnasand, has emerged over the last two decades as a champion of contemporary pattern design. The creative exchange that has taken place between Finland and Sweden over the last half century has clearly been of mutual benefit to both parties. Significantly, one of the latest designers to enter the Marimekko fold has been Swedish-born Anna Danielsson. Today Marimekko and Kinnasand stand head and shoulders above their competitors — not only in Scandinavia, but internationally — in their commitment to innovative forward-looking pattern design.

Marimekko's impact on contemporary design is now twofold. As well as continuing to push forward the creative boundaries by introducing exciting and innovative new patterns, the company has invigorated the market by reintroducing "vintage" designs from the 1950s to the 1980s by Maija Isola, Fujiwo Ishimoto, and Katsuji Wakisaka. Many of these patterns still look so enduringly fresh and modern that the younger generation of consumers are unaware that the designs are several decades old. As well as stimulating a new audience, these reissues serve as a timely reminder of Marimekko's pivotal position in the history of twentieth-century printed textiles as a whole.

Acknowledgements: I am grateful to the Embassy of Finland in London and the Designmuseo in Helsinki for jointly funding my research trip to Finland. Many thanks to Anna Maria-Liukko at the embassy and Marianne Aav at the museum for their help in arranging this. At Designmuseo I would also like to thank Ebba Brännback and Maria Härkä-pää for providing access to the textile collections in storage. Special thanks to Maria for all her subsequent help with my followup queries and research. I am extremely grateful to Kristina Isola, Vuokko Nurmesniemi, and Fujiwo Ishimoto for agreeing to be interviewed, and for their generosity in providing information and checking my text. — L.J.

1 The name *Marimekko* is used to encom-pass the activities of both the fashion company Marimekko, established in 1951, and its predecessor and parent company Printex, the textile-printing firm estab-lished in 1949. Until 1966 both names were used in parallel, but following the merger of the two companies that year, the name Printex was dropped in favor of Marimekko.

2 For a wide-ranging survey of twentieth-century printed textiles, see Lesley Jackson, *20th Century Pattern Design: Textile and Wallpaper Pioneers* (London: Mitchell Beazley; New York: Princeton Architectural Press, 2002). For the Wiener Werkstätte, see ibid., pp. 35–41; Angela Völker, *Textiles of the Wiener Werkstätte, 1910–1932* (London: Thames & Hudson, 1994). The creation of pattern for unified decorative schemes in architecture, interiors, design, and fashion was, how-ever, prevalent among architect-design-ers associated with the so-called Art Nouveau on the Continent and in Great Britain.

3 See Kristina Wängberg-Eriksson, *Josef Frank: Textile Designs* (Lund, Sweden: Bokförlaget Signum, 1999); Jackson, *Pattern Design* (2002): 40–42.

4 See Jacques Deslandres and Dorothée

Lalanne, *Poiret: Paul Poiret, 1879–1944* (London: Thames & Hudson, 1987); Jackson, *Pattern Design* (2002): 47–48.

5 See Bryan Robertson and Sarah Wilson, eds., *Raoul Dufy* (London: Hayward Gallery, 1983); Jackson, *Pattern Design* (2002): 48–49.

6 Quoted in Jacques Damase, *Sonia Delaunay: Fashion and Fabrics* (London: Thames & Hudson, 1991): 58; Jackson, *Pattern Design* (2002): 54–55.

7 Antony Hunt, *Textile Design* (London: Studio, 1937): 50.

8 See H. G. Hayes Marshall, *British Textile Designers Today* (Leigh-on-Sea, Brighton: Frank Lewis, 1939); Valerie Mendes, *British Textiles from 1900 to 1937* (London: V&A Publications, 1992); Jackson, *Pattern Design* (2002): 66–86.

9 See Christine Boydell, *The Architect of Floors: Modernism, Art and Marion Dorn Designs*, Schoeser, Coggleshall, Essex, 1996; Jackson, *Pattern Design* (2002): 66, 81, 84, 86–87.

10 See Inez Svensson, *Tryckta tyger från 30-tal till 80-tal*, (Stockholm: Liber Förlag, 1984); Jackson, *Pattern Design* (2002): 89–93.

11 See Helena Dahlbäck Lutteman, ed. *Stig Lindberg: Formgivare* (Stockholm: Nationalmuseum, 1982); Jackson, *Pattern Design* (2002): 90–91, 121–23.

12 See Helena Dahlbäck Lutteman, ed., *Astrid Sampe: Swedish Industrial Textiles* (Stockholm: Nationalmuseum, 1984); Jackson, *Pattern Design* (2002): 89–91, 121–24. Examples of Astrid Sampe's work and the designs she commissioned are held in the NK Archives, National-museum, Stockholm.

13 Jackson, *Pattern Design* (2002): 122–24.

14 Vuokko Nurmesniemi, conversation with the author, 17 September 2002.

15 Untitled and undated printed cotton in the collection of Designmuseo, acc. no. 6681. The abstract geometric pattern is composed of a grid of alternating black and white triangular hourglass motifs, overlaid with yellow and gray vertical bands.

16 Quoted in Marjo Wiberg, *The Textile Designer and the Art of Design: On the Formation of a Profession in Finland* (Helsinki: University of Art and Design, 1996): 93.

17 Ibid., p. 79.

18 Hannele Nyman, "Helsingin Taide-värjäämö," in Marianne Aav and Nina Stritzler-Levine, eds., *Finnish Modern Design* (New Haven and London: Yale University Press and Bard Graduate Center for Studies in the Decorative Arts, 1998): 386.

19 Designmuseo in Helsinki holds two pattern books containing samples of Eva Taimi's designs for Helsingin Taide-värjäämö (1937–47) and Vaasan Puuvilla (1947–57), as well as a collection of longer lengths of fabric. For an illustration of Eva Taimi's pattern *Kimppu* (1944), see Aav and Stritzler-Levine, eds., *Finnish Modern Design* (1998): 285, cat. 38.

20 Several examples of Kaj Franck's textiles are in Designmuseo. See also Sirpa Juuti, Kaisa Koivisto, and Tauno Tarna, eds., *Kaj Franck: teema ja muunnelmia* (Lahti: Lahden Tuotepaino Oy, 1997): 21–22; *Kaj Franck: Muotoilija, Formgivare, Designer* (Helsinki: Taideteollisuusmuseo / WSOY, 1993): 300; Wiberg, *Textile Designer* (1996): 90.

21 Pekka Suhonen, *Artek: Alku, tausta, kehitys* (Espoo: Artek, 1985): 78–79; Leena Svinhufvud, "Finnish Textiles en Route to Modernity" in Aav and Stritzler-Levine, eds., *Finnish Modern Design* (1998): 190; Wiberg, *Textile Designer* (1996): 75 and 90.

22 Aulis Blomstedt, "Artists speak about mass production," *Arkkitehti* (1949); quoted in Wiberg, *Textile Designer* (1996): 95.

23 Eva Taimi's earlier reputation is indicated by the fact that six of her fabrics for Vaasan Puuvilla were acquired by the Victoria & Albert Museum, London, in 1956 (Circ.72-1956 – Circ.77-1956).

24 Anna-Liisa Ahmavaara, *Finnish Textiles* (Helsinki: Otava, 1970): 1.

25 " 'Why floral?' she asked. 'Because every-body is printing florals,' I replied. 'And

because everyone is printing them, you must print something else. You have to be different'" (Viljo Ratia, "Early recollections," in Pekka Suhonen, ed., *Phenomenon Marimekko* [Helsinki: Marimekko Oy, 1986]: 23).

26 Significantly during this period many leading Finnish printed and woven textile designers, including Vuokko Nurmesniemi and Viola Gråsten, also designed *ryijy* rugs.

27 A collection of design drawings of *ryijy* rugs by Armi Ratia is held by Designmuseo.

28 Wiberg, *Textile Designer* (1996): 92. At one point Armi Ratia apparently suggested that she and Taimi set up their own company together, but this did not come to fruition.

29 Examples of fabrics by these designers are held in Designmuseo.

30 Kristina Isola, conversation with the author, 18 September 2002.

31 Much of the biographical information about Maija Isola in the following account, and the personal insights into her character, were provided by her daughter, Kristina Isola, in a conversation with the author 18 September 2002. She also supplied a biographical resumé of her mother, along with background details about the origins of individual patterns and groups of designs, for which I am most grateful. Most of the fabrics referred to in the text are in Designmuseo.

32 Isola only designed for a few other companies, among whom were the UK-based Danasco Fabrics and the Swedish firm, Borås Wäfveri. For an illustration of Isola's *Ripitys* pattern for Danasco (ca. 1961), see Ngozi Ikoku, ed., *Post-War British Textiles* (London: Francesca Galloway, 2002): 38, cat. 2.30. For an illustration of Isola's *Punkaharju* for Danasco, see *The Ambassador*, no. 4 (1961): 61.

33 Her first exhibition of paintings took place at the Taidehalli, Helsinki, in 1955. She exhibited her paintings regularly until the end of the 1970s, both in Helsinki and abroad. Many of her paintings are now in Hämeenlinna Art Museum.

34 Kristina Isola recalls that during the 1960s Maija Isola subscribed to an American magazine that featured this type of work, possibly *Art International.*

35 Maija Isola's first foreign trip was to Norway in 1949. After this she traveled abroad regularly until 1982, mainly to Europe, but also to North America, South America, and North Africa. During 1953–54 she spent a whole year in Spain. She was in Paris during the civil unrest in May 1968. From 1971 to 1974 she lived at Oran in Algeria, and in 1977 she spent three months at Boone, North Carolina.

36 A collection of dolls and dollhouses belonging to the Isola family is now in the museum at Riihimäki.

37 The descriptive categories used in this essay to identify the main themes in Isola's work are those recorded in a thesis on Maija Isola by Soile Sarvisto. The information in this thesis is significant because it was based on a series of personal interviews with the designer at the peak of her career (Soile Sarvisto, "Tekstiilitaiteilija Maija Isola: Printex-Marimekko Oy:n painetut kankaat 1949–1969," thesis, University of Helsinki, 1970).

38 This technique was developed by Arvo Nurmi, head of printing at Printex, with Isola herself being closely involved in making the screens; see Suhonen, *Phenomenon Marimekko* (1986): 118.

39 *Putkinotko* and *Ruusupuu* both utilized the same plant (*karhunputki*, or cow parsley). *Putkinotko* featured the dried flowerheads; *Ruusupuu* used the leafy stem.

40 This was how Maija Isola later described the experience to her daughter (Kristina Isola, conversation with the author, 18 September 2002).

41 It has been suggested that this pattern represents eyeballs, but Kristina Isola says this is incorrect (ibid.). The following information was supplied by Kristina Isola, and is based on her notes of a conversation with her mother.

42 Ibid.

43 This pattern followed a simpler design called *Mansikka* (1967), featuring smaller red strawberries against a plain yellow ground.

44 Illustrated in Ahmavaara, *Finnish Textiles* (1970): 46–47.

45 During this period Kristina Isola worked under the name Kristina Leppo, but she has since returned to Isola.

46 Vuokko Nurmesniemi's maiden name was Eskolin. When she first started working for Marimekko her patterns were initially produced under the name Vuokko Eskolin, and subsequently under the name Vuokko Eskolin-Nurmesniemi.

47 She completed her studies in 1952. The ceramics and fashion departments were located next to each other within the institute, thereby fostering links between the two.

48 Information supplied by Vuokko Nurmesniemi in a conversation with the author, 17 September 2002. This account is also supported by the biographical text in a publicity brochure, *Vuokko Nurmesniemi* (ca. 1995).

49 Examples of all the patterns by Vuokko Nurmesniemi discussed in this essay are held in Designmuseo.

50 Initially Arvo Nurmi, who was in charge of printing at Marimekko, thought it would be impossible to produce such large patterns with the limited equipment available at the factory. In order to print Nurmesniemi's designs, the steamer had to be modified to ensure that the large expanses of color were fastened evenly onto the cloth.

51 Quoted in Wiberg, *Textile Designer* (1996): 99.

52 Vuokko Nurmesniemi left Marimekko following a rift with Armi Ratia. She had become increasingly frustrated at not being given the credit she felt she deserved for creating the Marimekko look. In publicity, Nurmesniemi was rarely acknowledged as the designer of Marimekko's fashion line. Instead, Armi Ratia, as the public face of Marimekko, won most of the accolades.

53 Quoted in *Annika Rimala, 1960–2000: Väriä arkeen* (Helsinki: Taideteollisuus-museo, 2000): 18.

54 Annika Rimala's maiden name was Tegengren. She worked at Marimekko under three married names: Reunanen, Piha and Rimala.

55 Quoted in *Annika Rimala* (2000): 18. All the patterns by Rimala discussed in this section are illustrated therein.

56 Some of Katsuji Wakisaka's patterns are illustrated in Suhonen, ed., *Phenomenon Marimekko* (1986): 132–33. Others are held by Designmuseo.

57 Many of Fujiwo Ishimoto's patterns are illustrated in Carla Enbom, *Fujiwo Ishimoto: Matkalla — Resan — On The Road* (Helsinki: Marimekko Oy, 2001). Others are held by Designmuseo.

58 Fujiwo Ishimoto, conversation with the author, 16 September 2002.

59 Ibid.

60 Ibid.

61 Ibid.

62 Ahmavaara, *Finnish Textiles* (1970): 3.

63 Ibid., pp. 50–51.

64 Illustrated in Lesley Jackson, *Sixties: Decade of Design Revolution* (London: Phaidon, 1998): 173. The exhibition at Jyväskylä was designed by Vuokko's husband, Antti Nurmesniemi.

65 Quoted in Colin Naylor, ed., *Contemporary Designers* (Chicago and London: St James Press, 1990): 162.

66 Ahmavaara, *Finnish Textiles* (1970): 41–43.

67 Some of Nurmesniemi's designs are illustrated in a 16-page publicity pamphlet, *Vuokko Nurmesniemi* (1994), exhibition catalogue, publ. Ikaalisten taidekeskus. The Finnish Design Museum has a substantial collection of work by Vuokko Oy, including both fashion and furnishing fabrics.

68 Ahmavaara, *Finnish Textiles* (1970): 48. See also Aav and Stritzler-Levine, *Finnish Modern Design* (1998): 186 and 393.

69 Designmuseo, acc. no. 8688.

70 Kristina Isola recalled a degree of competitive rivalry between the two

(conversation with the author, 18 September 2002).

71 Designmuseo, acc. no. 8538.

72 Ibid., acc. no. 8536.

73 Ibid., acc. no. 8548.

74 Ibid., acc. no. 8526. Ahmavaara, *Finnish Textiles* (1970): 39.

75 Many examples from this range are in Designmuseo.

76 Quoted in Kaj Kalin, *Sarpaneva* (Helsinki: Otava, 1985).

77 Designmuseo, acc. nos. 12308 and 6961.

78 Victoria & Albert Museum, London, Circ.151-1974

79 Ahmavaara, *Finnish Textiles* (1970): 49.

80 Designmuseo, acc. no. 8568.

81 Ibid., acc. no. 6700.

82 Penny Sparke, "Bold strokes on a broad canvas," *Design* (June 1982): 32.

83 See Valerie Mendes and Frances Hinchcliffe, *Ascher: Fabric, Art, Fashion* (London: Victoria & Albert Museum, 1987); Jackson, *Pattern Design* (2002): 97–98.

84 See Christine Boydell, *Our Best Dresses: The Story of Horrockses Fashions Limited* exhib. leaflet (Preston: Harris Museum and Art Gallery, 2001).

85 See Susanna Goodden, *A History of Heal's* (London: Heal & Son, 1984); Jackson *Pattern Design* (2002): 98–100, 142–46, 181–83.

86 See Lesley Jackson, *Robin and Lucienne Day: Pioneers of Contemporary Design* (London: Mitchell Beazley, 2001), published in the United States as *Robin and Lucienne Day: Pioneers of Modern Design* (New York: Princeton Architectural Press, 2001).

87 "The Roots of Contemporary," *Ambassador* (January 1963): 61; Jackson, *Pattern Design* (2002): 104, 146–48.

88 See Christa C. Mayer Thurman, *Rooted in Chicago: Fifty Years of Textile Design Traditions*, Museum Studies, vol. 23, no.1 (Chicago: Art Institute of Chicago, 1997); Jackson, *Pattern Design* (2002): 109–14, 160.

89 See Leslie Piña, *Alexander Girard: Designs for Herman Miller* (Atglen, Penn.: Schiffer, 1998); Jackson, *Pattern Design* (2002): 114–15, 160–61.

90 See Jack Lenor Larsen, *Jack Lenor Larsen: 30 Years of Creative Textiles* (Paris: Musée des Arts Décoratifs, New York: Jack Lenor Larsen, 1981); Jackson, *Pattern Design* (2002): 161–63.

91 Jackson, *Pattern Design* (2002): 138–41. One of the patterns designed by Isola for Borås Wäfveri was *Oksa*. For an illustration of a sample of this design see *Design & Style Sale 1930–2000*, Boldon Auctions (UK) sale cat., 6 November 2002, lot 237; also accessible on the internet, www.boldonauctions.co.uk/Catalogues/AS1102/lot237.jpg.

92 Svensson, *Tryckta Tyger* (1984): 72–73. According to Kristina Isola, Maija Isola greatly admired the work of Katja of Sweden (conversation with the author, 18 September 2002).

93 Jackson, *Pattern Design* (2002): 170–72.

94 See Kerstin Wickman, *Ten Swedish Designs: Printed Patterns* (Stockholm: Raster Förlag, 2001); Jackson, *Pattern Design* (2002): 166–71, 195–96.

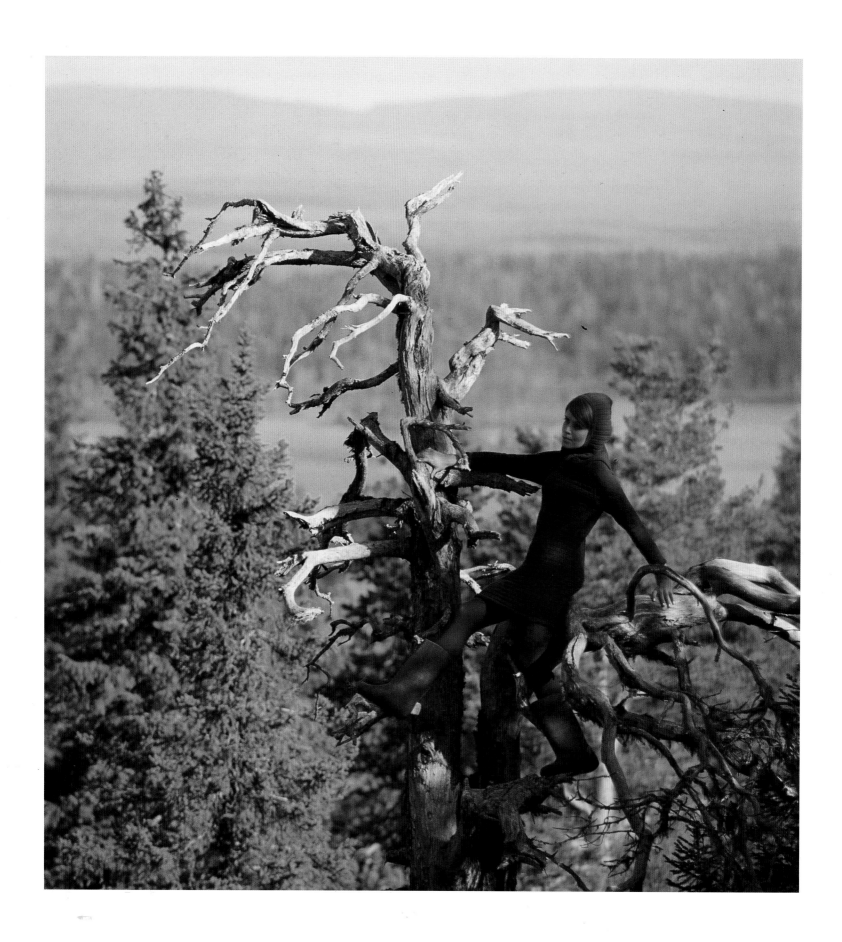

# 3. Fashion: Individuality and Industry

Riitta Anttikoski

The earliest success of Marimekko can be attributed to the company's distinctive fabric patterns introduced in the 1950s. When applied to fashion, the fabrics created a unique image that would eventually rival Parisian haute couture. The actual appeal of Marimekko fashion, however, had more significance than merely that of the designer label. Marimekko represented a new, individualized fashion culture and a lifestyle that captured the imagination of consumers around the world. The smock dress, for example, attracted intellectual women who believed that wearing a widely marketed uniform would increase rather than diminish their individuality. Although Marimekko is generally associated with women's fashion, men were also attracted to the informality of the clothing, particularly during the 1960s. The *Jokapoika* (everyboy, 1956) shirt was originally designed for men but became a unisex fashion, a symbol of the Marimekko lifestyle.

◄ Fig. 3–1. Liisa Suvanto. *Tarkiainen* dress, 1967. Knitted wool.

How was such an influential fashion house established in the Nordic world? The answer lies with Marimekko's first CEO, Armi Ratia, and her intuition that industry and the salon culture could unite to create a new concept of fashion. She surrounded herself with talented individuals from all walks of life who enabled her to realize her vision. In the fashion world alone, in many ways she was a pioneer, paving the way for such innovations as the women's pantsuit. Ratia's own preferred working clothes were trousers and the *Jokapoika* shirt.

Although Marimekko distanced itself from Paris fashions, it closely monitored the main trends in international fashion. Hemlines rose and fell — skirts were shortened into minis or lengthened to the floor — and new effects were created by combining two different-colored materials. Prints employed Op Art and Pop Art designs, and new spatial effects were created with woolen knitwear.

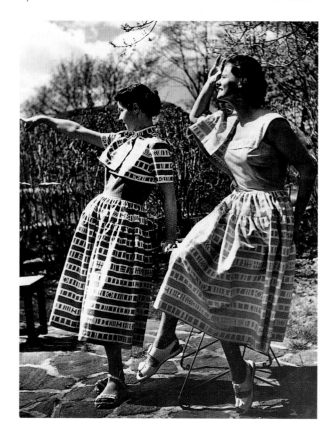

Fig. 3–2. Riitta Immonen. Dresses; *Tik-Tak* pattern by Eeva-Inkeri Tilhe, 1951. These designs were for the first Marimekko fashion show, held at the Kalastajatorppa restaurant, Helsinki.

Ratia took her designers to Paris fashion shows and was upset if she saw them yawning.[1] They were also instructed not to make direct copies of what they saw — everything was to be thoroughly transformed into Marimekko style.[2]

Marimekko's example inspired other manufacturers to try out their own new printed fabrics, a move supported by the cotton mills. Unlike Marimekko's designers, those employed by other manufacturers remained anonymous, working for the company and making specially commissioned garments for customers — as was the custom of the time.[3] Marimekko's success with international sales encouraged other Finnish clothing entrepreneurs to target the Western marketplace. Because clothing had been part of the bilateral trade agreement with the Soviet Union since the late 1950s, the Finnish clothing industry had been lulled into thinking in terms of long series and assured sales to Russia, with the result that efforts to appeal to the West had lagged behind.

Although Marimekko established its permanent position in the international world of fashion in the 1960s, its "fashion philosophy" evolved in the 1950s as a result of the fertile collaboration between Armi Ratia and Vuokko Nurmesniemi. In the early 1950s Finland had almost no fashion industry. Most retail clothing was made by tailors and seamstresses in small quantities.[4] Finland's first trained fashion designers were graduates of the dress design department at the Institute of Industrial Arts in the early 1950s. In the postwar period, however, existing clothing manufacturers were reluctant to employ them. Rationing of materials for the Finnish retail clothing trade ended in the late 1940s, but it took many years for manufacturers to produce anything other than coats and underwear.[5] The most talented designers worked in their own

studios and sold to small groups of elite clients.

Marimekko's fashion line started in the spring of 1951 as nothing more than a clever marketing idea for printed fabrics by Printex; it was a venture that Ratia herself described in 1954 "as a joke."[6] Riitta Immonen was brought in to design the outfits (fig. 3–2). Despite the material shortages and economic difficulties in Finland, Immonen had established herself as a prominent women's fashion designer and owned a salon in Helsinki. She had a loyal clientele, which, together with Ratia's vision and media contacts, ensured the success of their collaboration. Ratia and Immonen worked closely together. Ratia provided new patterns, Immonen focused on the cut of the clothes. The result was Marimekko. According to the Finnish trade registry, the new firm was devoted to the "manufacture of all kinds of costumes and accessories, including commissioned work, and the wholesale and retail sale of those materials, and their production and export."[7]

The first fashion show (fig. 3–3) was held at the Kalastajatorppa restaurant in Helsinki's Munkkiniemi district; it was the largest and most elegant since the war, with the best-known Finnish fashion models.[8] The collection consisted of twenty-four outfits with wide, feminine, calf-length skirts that were perfect for showing off the Printex fabrics, narrow shoulder lines, tight waists, and short jackets. The materials were cotton, cotton and rayon (cellulose-based synthetic fiber), and linen.[9] The designs were feminine, lively, and a perfect contrast to the austerity of the war years.[10] Following the practice of Christian Dior, creator of the New Look (1947), each design had a name, a company policy that continues today.[11] The printed program for the fashion show also credited the seven fabric designers and identified the runway models.

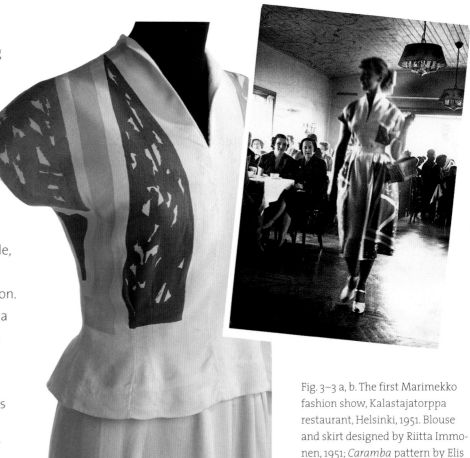

Fig. 3–3 a, b. The first Marimekko fashion show, Kalastajatorppa restaurant, Helsinki, 1951. Blouse and skirt designed by Riitta Immonen, 1951; *Caramba* pattern by Elis Muona, 1950. (Checklist no. 5).

The event was a great success with the press and public alike.[12] Critics announced that "a new name has joined the ranks of the Finnish fashion studios — the amusing-sounding Mari Mekko."[13] They praised the fabrics by Maija Isola and Elis Muona, and, unexpectedly, there were immediate inquiries about placing orders. The success was both pleasing and overwhelming, since no thought had been given to actual production. While Ratia was eager to please would-be clients, Immonen was unwilling to expand her studio to accommodate a larger production line, and she decided she was unsuited to serial production.[14] Determined not to lose potential clients, Ratia set up a workshop in her home. Although Marimekko was able to fill the initial orders,

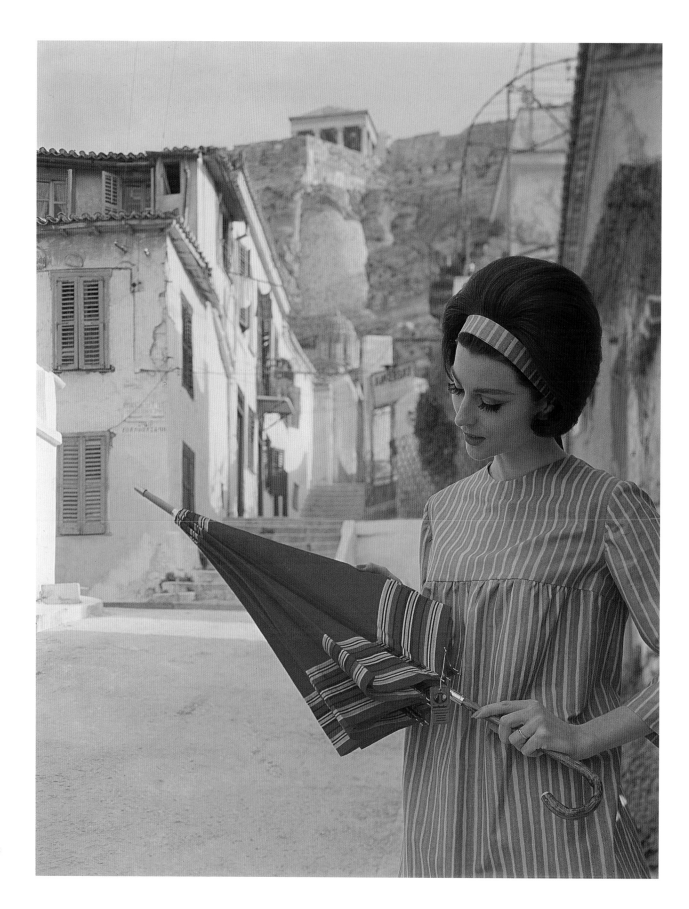

Fig. 3–4. Vuokko
Nurmesniemi. Dress;
*Piccolo* pattern, 1953.

the lack of an adequate facility impeded growth. A small number of custom dresses, a few artists' smocks, some pinafore skirts designed by Armi Ratia, and a line of gift accessories for the Finnish clientele kept the company solvent, at least temporarily. During the first half of the fifties Marimekko fashions were cut at the firm's own workshop in Helsinki, but sewn by seamstresses in their own homes.

In spite of the amateurish start and financial difficulties, from the beginning Ratia believed in Marimekko's future.[15] In 1951 she told Immonen that she intended to create a concept that would make every Finn want to own at least one Marimekko garment.[16] In 1953 Ratia hired Vuokko Eskolin-Nurmesniemi, a young designer who was to have considerable impact on the future of Marimekko. Nurmesniemi's husband, interior designer Antti Nurmesniemi, had worked on the interiors of the Palace Hotel (1951–53), in which Marimekko had an office. Vuokko Nurmesniemi's first Marimekko designs were for furnishing fabrics, but she soon became the firm's first full-time fashion designer — in fact she was one of the first full-time designers in the Finnish fashion industry as a whole. Nurmesniemi's first pattern was *Tiibet* (1953) which had large planes of flat color. The same year she designed *Piccolo*, a pattern of free pencil stripes (fig. 3–4), which was used a few years later for the *Jokapoika* shirt design (1956). This combination made *Piccolo* Nurmesniemi's best-known design for Marimekko. She had started her career by making her own clothes from the fabrics she designed, and with few exceptions she concentrated on fashion fabrics. Ratia, who was eager to expand Marimekko, saw potential in Nurmesniemi's fashion designs, and in the fall of 1955 Marimekko started producing them in the firm's dressmaking workshop at Tuntu-

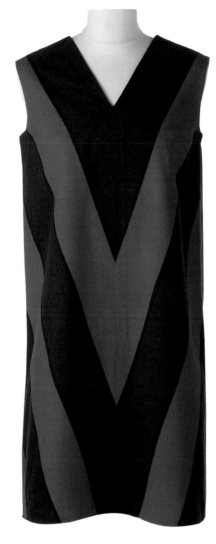

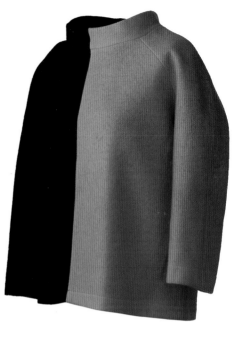

◄ Fig. 3–5. Vuokko Nurmesniemi. *Alkupaita* dress, 1955; *Galleria* pattern, 1954. (Checklist no. 11).

▲ Fig. 3–6. Vuokko Nurmesniemi. Blouse, 1956. Wool. (Checklist no. 13).

rikatu, Helsinki. In the spring of 1956 the first collection of dresses designed by Nurmesniemi was presented in a fashion show organized in Helsinki at the Palace restaurant.[17]

Nurmesniemi's dress designs continued the casual simple lines already associated with Marimekko (figs. 3–5, 3–6). In an interview in 1960 Nurmesniemi explained her approach.[18] She did not set out to create fashion, which she viewed as part of the design process. For Nurmesniemi the design of a garment went hand-in-hand with the pattern of the fabric, because the forms had to fit the cut of the garment. A strong pattern demanded

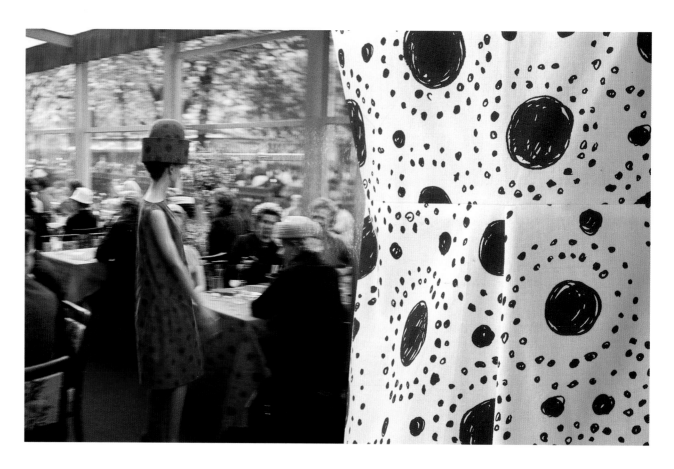

a simple garment. Nurmesniemi's mission was to produce practical fashion for everybody — particularly for home and summer use. Her dresses were not intended to emphasize the female form but to reveal the individuality of the wearer. The ideas expressed by Nurmesniemi obviously reflected Ratia's own design principles, based on combining simplicity with modernity. In 1954 Ratia expressed this in poetic terms: "Marimekko is the projection of the path of Männistön muorin Venla and Vuohenkalman Anna [Finnish archetypal figures] onto the highways, streets, homes and the whole environment of life in a changing world."[19]

A few years later, Armi Ratia expressed the same ideas in *American Fabrics* (1963): "I really don't sell clothes, I sell a way of living. They are designs, not fashions . . . . The cut is as simple as possible. My approach is something like the architect's. He makes

a house for people to live in. I make a dress for women to live in. . . . [Marimekko garments] are for the woman who wants to forget her dress. They are for such women as the many intellectuals we have in Finland . . . . I sell an idea rather than dresses. I sell a new woman. Only two to five out of a hundred in Finland may be called Marimekko women. The Marimekko woman is easily recognized. She may work in an office or at home, but her style in wearing dresses is to forget them."[20] Ratia recalled telling Marimekko's future fashion designers that the clothes "must not recall fancy dresses. Get rid of sweetness, instead create simplicity. Mari starts from a simple shirt and tar barrels. There is no understanding for tight waists, drapes, brocades, blue fox capes."[21]

Ratia's notion of the timelessness of Marimekko fashion also distinguished the designs from the

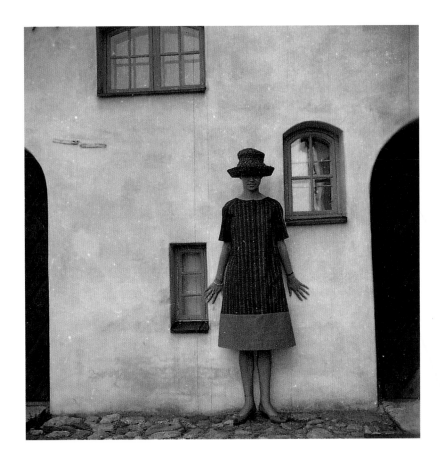

norm. This was achieved by means of both the choice of fabrics — mainly cotton and also wool — and the styles, which were simple and easy to wear. Marimekko's cotton dresses differed from the clothes offered by other manufacturers, who favored new materials, including artificial fibers such as nylon, polyester, and Dacron. After the heavy, easily creased, synthetic wool used during the war years, these materials with their easy-maintenance qualities attracted considerable attention. Floral-patterned and polka-dot nylon fabrics became increasingly popular for summer dresses and were widely used. Marimekko believed in cotton, even though it creased easily and was rather stiff, especially when hand-printed, compared to the artificial fibers. In an interview in 1964 Ratia said that she believed that Marimekko garments would live even in tomorrow's world,

where there would be no room for a "tight-waisted corset" style of fashion.[22]

From the start of her Marimekko career, Nurmesniemi broke with tradition by reusing her most successful and felicitous fashion designs in successive collections. In subsequent versions new work was signalled by new fabric patterns or fresh colorways. She developed restrained forms for her dresses and coat-dresses with narrow shoulder lines flaring toward the hem. They had as few seams as possible and a single dart, if any, creating a type of smock or long shirt. [Figs. 3–7, 3–8.]

Marimekko's fashion show in the spring of 1956 established Nurmesniemi's reputation as a fashion designer in Finland. A newspaper declared that her clothes were "in the same class as design," referring to industrial design objects.[23] The garments were as simple and timeless as possible: there

▸ Fig. 3–8. Vuokko Nurmesniemi. Dress; *Kuurupiilo* pattern, 1959. Courtesy of Vuokko Nurmesniemi.

▴ Fig. 3–9. Vuokko Nurmesniemi. *Lintu sininen* dress; *Suolampi* pattern, 1959. (Checklist no. 28).

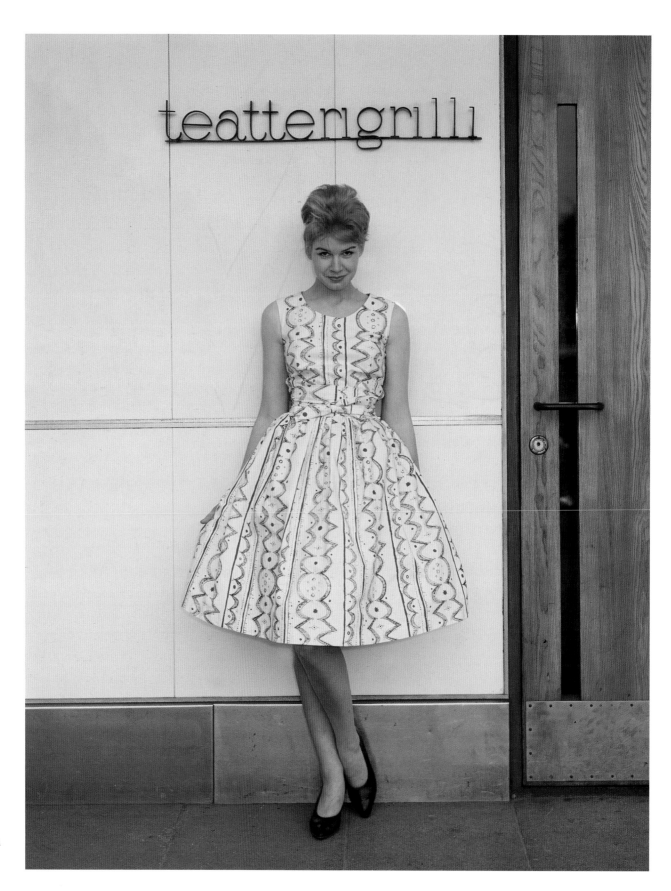

Fig. 3–10. Vuokko
Nurmesniemi. Dress in
*Prenikka* pattern, 1958.

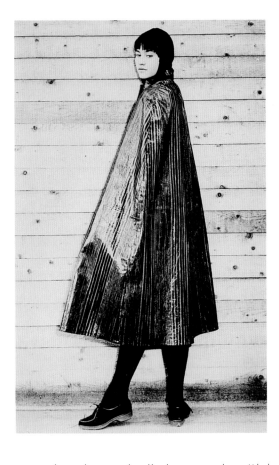

◄◄ Fig. 3–11. Vuokko Nurmesniemi. Raincoat in *Aaltopituus* pattern, 1958. Oiled cotton. Courtesy of Vuokko Nurmesniemi.

◄ Fig. 3–12. Vuokko Nurmesniemi. Girl's shirt and trousers, 1958; *Piccolo* pattern, 1953.

were sleeveless and collarless smocks with buttons; straight jackets and shorts; pirate or full-length trousers and wide shirts; and tight blouses. She used her own striped fabrics, which the critics described as "fireworks of colors."[24]

Nurmesniemi's Marimekko dresses represented a post–World War II fashion revolution — a liberation from girdles and the restricted fashions of the era.[25] Previous post-war garments had been mocked as colorless and clumsy, but Marimekko's wide dresses that covered the outlines of the body were praised as elegant and glowing with color. Some were reminiscent of little girls' dresses and were in fact also available in children's sizes. In her Empire-style dresses Nurmesniemi experimented with a short bodice, ending below the bust. She made concessions to the romantic in her "foundation dresses." They mimicked the forms of Asian temples and were

identified as the "pagoda line," with varying flounce widths.[26] The collars of the coats, outfits, and dresses were narrow or nonexistent. Nurmesniemi paid particular attention to the structure of the sleeve, which was usually narrow. Her adaptations of the kimono sleeve, in particular, were reminiscent of the close-fitting sleeves of the traditional baby's coat.[27]

From the early years Marimekko's fashion designers were also involved in the marketing and promotion of their designs. Nurmesniemi arranged photography sessions, organized fashion shows, designed newspaper advertisements and even wrote the texts for them. At the turn of the 1960s Annika Rimala inherited Nurmesniemi's position, but as a promoter of her own designs she took a more anonymous role.

Soon after the 1956 fashion show Marimekko began moving into international markets, but not

without difficulties. Timo Sarpaneva, one of Finland's leading designers of the postwar period and the secretary of the Finnish organizing committee of the Milan Triennial, invited Marimekko to present a fashion show at the opening of the 1957 Milan exhibition. Sarpaneva's invitation was an indication that fashion was beginning to be recognized as an industrial art.[28] At the last minute, however, the Marimekko fashion show was canceled, but Marimekko products were displayed in the windows of the Rinascente department store, which were then being managed by a young window dresser named Giorgio Armani (fig. 5–2).[29]

The next showings of Marimekko dresses outside Finland were in 1958 — at the Brussels World's Fair and the Galleri Artek in Stockholm. The collection was similar to previous ones. The Swedish press was especially impressed by the bright, strong colors of the fabrics used for dresses designed by Nurmesniemi. The most significant breakthrough on the export market came a year later, however, in the United States. In the summer of 1959 American architect Benjamin Thompson organized an exhibition of Finnish design to be shown in Cambridge, Massachusetts, at Design Research, the firm and shop he had founded. He had met Armi Ratia at the Brussels World's Fair and invited her to participate.

Fig. 3–13. Shoes; *Kuurupiilo* pattern by Vuokko Nurmesniemi, 1959. (Checklist no. 158).

She selected examples of the work of some two dozen Finnish designers, naturally including Marimekko dresses and fabrics, and Vuokko Nurmesniemi contributed to the installation design.[30] The fashion models chosen to wear Marimekko at the exhibition's fashion show were recruited from colleges in the Boston area, as a way of demonstrating that Marimekko's cottons were suitable for a Massachusetts winter and of connecting Marimekko with the intellectual climate of the city.[31] The trip was Nurmesniemi's international breakthrough as a fashion designer. The newspapers praised her designs, her skill, and especially the colors of her dresses.

The following year Jacqueline Kennedy, who was known for her haute couture style, bought eight Marimekko dresses designed by Nurmesniemi and was shown on the cover of *Sports Illustrated* in one of them.[32] She chose a selection of summer dresses — sleeveless short sundresses with flounces in the hem, and wide, collarless dresses with and without flounces at the hem (figs. 3–14, 3–15).[33]

Although Ratia encouraged designers to do independent work, she feared that too much publicity for an individual designer might cause the company to become too closely identified with one designer's personality, thus threatening her own views of Marimekko's development. In 1961 Vuokko Nurmesniemi left for a trip to India and never returned to Marimekko. Three years later, she founded her own company, simply named Vuokko. Ratia and Nurmesniemi had forged the foundation for Marimekko's fashion line, and Vuokko's personal style lived on for years in the exciting patterns and color combinations of her fabrics, and in the clothes that she designed. For Ratia the chief concern was to promote the concept of a Marimekko lifestyle and to strengthen Marimekko's brand recognition.

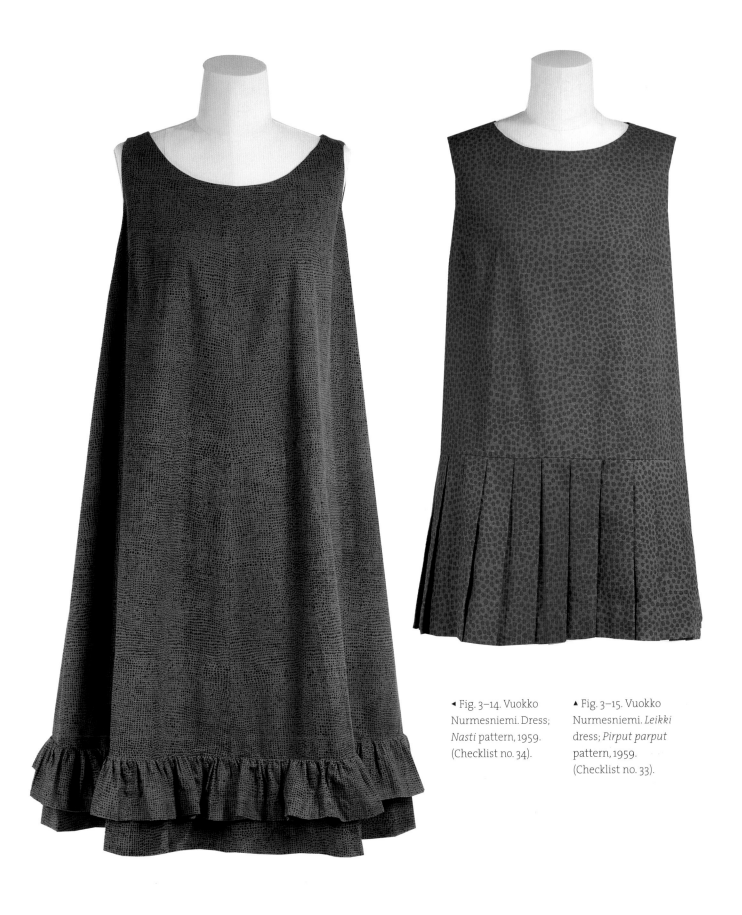

◄ Fig. 3–14. Vuokko
Nurmesniemi. Dress;
*Nasti* pattern, 1959.
(Checklist no. 34).

▲ Fig. 3–15. Vuokko
Nurmesniemi. *Leikki*
dress; *Pirput parput*
pattern, 1959.
(Checklist no. 33).

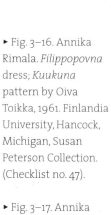

▸ Fig. 3–16. Annika Rimala. *Filippopovna* dress; *Kuukuna* pattern by Oiva Toikka, 1961. Finlandia University, Hancock, Michigan, Susan Peterson Collection. (Checklist no. 47).

▸ Fig. 3–17. Annika Rimala. Dress and cap; *Hamppu* pattern by Oiva Toikka, 1960.

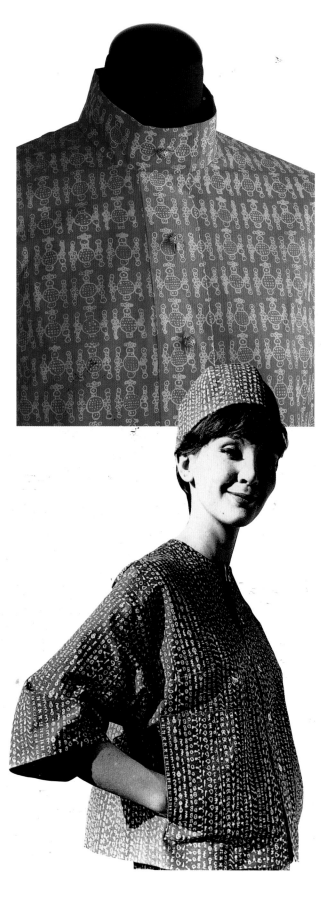

In 1960 two designers — graphic designer Annika Rimala and textile designer Liisa Suvanto — were hired by Marimekko to continue Nurmesniemi's work. Rimala had started as the manager of Muksula, Marimekko's children's clothing store in Helsinki, and transferred to the factory in 1960 as Nurmesniemi's last collection for the firm was being manufactured.[34] When Rimala and Suvanto arrived at Marimekko they faced a very different situation from that which Nurmesniemi had encountered. By the 1960s the fashion concept that Nurmesniemi and Ratia had created in the 1950s had been firmly established.

For the Finnish textile industry — and Finnish economy in general — the 1960s were a time of vigorous growth. In 1951, when Marimekko had been founded, some two-thirds of the population lived in rural Finland, but by the end of the 1960s there were almost as many people living in the cities as in rural areas.[35] The increased migration from the country to the cities and to southern Finland intensified as the postwar baby-boom generation began to enter universities and the job market. It was also a time of social upheaval. Young people began to reject the "establishment," represented by the traditions of their parents. They staged protests, developed countercultures, proposed alternative viewpoints, demanded free education, challenged middle-class attitudes, and became involved in politics. The 1960s were the era of Op Art and Pop Art, and of the Beatles. There were parallels with the rhythmic qualities of jazz and the colorful expressionism of art and life in the 1920s. Just as in the 1920s fashion had probed the limits of convention with short skirts, in the 1960s young people again pushed the boundaries of fashion.[36] Television, cinema, print media, and the possibility of travel abroad widened the average

Finn's picture of the world and conferred the freedom to try out new ideas.[37]

In the beginning Rimala found it difficult to establish her own style, and her first collection was seamlessly connected to Nurmesniemi (fig. 3–18). The induction of new designers was facilitated by group work, which was a part of Ratia's ideology to unite people in a mutual mission. Rimala designed her first personal collection in collaboration with Oiva Toikka (figs. 3–16, 3–17), a ceramist, who later became a glass artist.[38] It was shown as part of Marimekko's tenth anniversary celebrations in May 1961, by which time there was already talk of a "Marimekko School" and of the "Marimekko tradition."[39] Rimala's first fabrics included patterns with small figures and restrained colors, for example *Hilla* (cloudberry), *Härkki* (chickweed) and *Sametti-ruusu* (velvet rose). Only later, after traveling abroad with Ratia, did Rimala find the self-confidence to use strong bright colors and bold patterns. One of her first fashion designs was *Kuun varjoa* (moon shadow, 1961), a wide knee-length dress with a small collar and half-length sleeves. Rimala in-creased the volume of the dresses, favoring spa-ciousness and comfort, especially at the sleeves and shoulders. Rimala began the debate on fashion versus function, or ergonomic design in clothing, which intensified at the end of the decade.[40] In her view clothes needed to be designed so that it was possible to move freely in them — to run, jump, and sit — a humorous example of which is the *Ryppypeppu* jumpsuit (1967; fig. 3–19) made of *Iso suomu* (big scale) fabric. Rimala always created fabrics to suit her fashion designs, while for Nur-mesniemi the garments had served more or less as frames to display fabrics.

Even in the early 1960s Rimala gained interna-tional recognition. The major American magazines

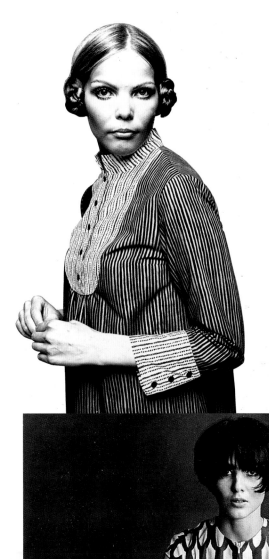

◄ Fig. 3–18. Annika Rimala. *Ludmila* dress, 1963. *Helmipitsi* and *Varvunraita* patterns by Vuokko Nurmes-niemi, 1959. (Checklist no. 51).

▼ Fig. 3–19. Annika Rimala. *Ryppypeppu* jumpsuit; *Iso suomu* pattern, 1965. (Checklist no. 67).

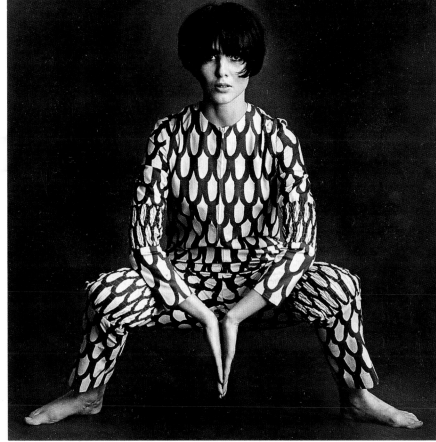

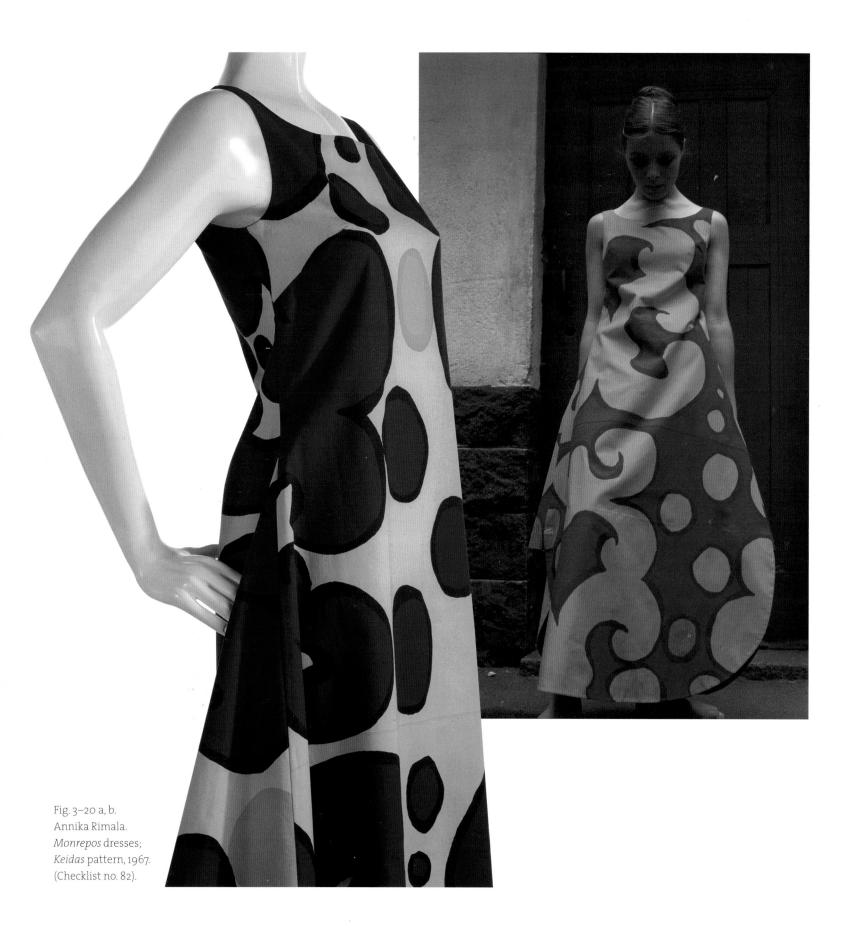

Fig. 3–20 a, b.
Annika Rimala.
*Monrepos* dresses;
*Keidas* pattern, 1967.
(Checklist no. 82).

had already featured her colorful dresses, and the fashion editors of New York's leading newspapers were present at her first show in the United States in 1963. The publicity generated was enormous. Eugenia Sheppard of the *New York Herald Tribune* dubbed Marimekko the "uniform for intellectuals," an association that suited Ratia and seemed a continuation of her choice of college-student models four years earlier in Cambridge.[41] Dresses made of fabrics such as *Laine* (wave, 1965), *Lanketti,* or the long *Monrepos* dress in *Keidas* (oasis, 1966; fig.3–20) fabric, with a scalloped hem, were published in international magazines and newspapers. In 1967 the Swedish newspaper *Dagens Nyheter* named Rimala one of the ten most important fashion designers in the world.[42]

By the late 1960s Marimekko had truly become the uniform of the radical intelligentsia. In the autumn of 1968, responding to the rallying cry of student riots in West Berlin, Paris, and Prague, a group of Finnish students took over the student union building in the heart of Helsinki, and announced that the revolution had begun.[43] Nurmesniemi's *Jokapoika* shirt became a symbol of radicalism in the academic world. *Hufvudstadsbladet,* the most important Swedish-language daily newspaper published in Helsinki, enthusiastically discussed the clothing of the occupiers, attracted by the idea that Ratia probably had no idea that left-wing radicals had infiltrated her corps of designers.[44] "You should design something that would sell in thousands," Ratia said to Rimala when she read the news.[45]

From its inception Marimekko had provided clothes for independent, educated women who kept a watchful eye on the mood of the times, irrespective of age. The Marimekko woman liked to be portrayed as an academic and an independent professional. Marimekko offered clothes that were different. Even if these designs were sold in large numbers, the women who wore Marimekko believed they were asserting their own sense of independence.[46]

The social and political climate was becoming more serious and left-wing radicalism was on the rise. Uniformity and lack of humor were also reflected in clothing, and warning signs of Marimekko's own economic crisis and power struggle were already apparent.[47] Blue jeans, which had been the mark of youthful rebellion or bohemianism in the 1950s through their association with, for example, the films of James Dean and Elvis Presley, became widely accepted as leisure clothes in the 1960s and 1970s. They combined a mood of freedom and

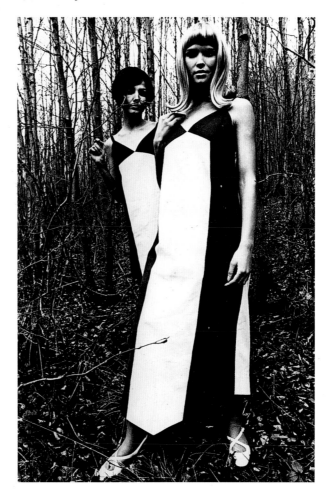

Fig. 3–21. Annika Rimala. Dress; *Kisko* pattern, 1967.

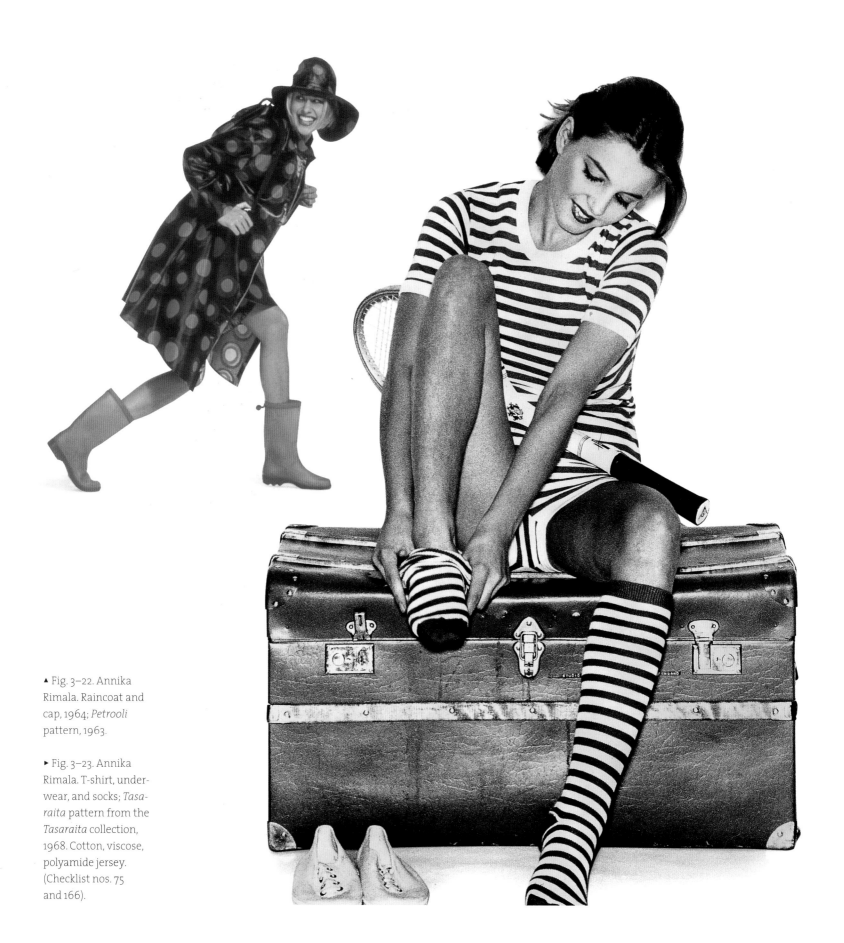

▲ Fig. 3–22. Annika Rimala. Raincoat and cap, 1964; *Petrooli* pattern, 1963.

▸ Fig. 3–23. Annika Rimala. T-shirt, underwear, and socks; *Tasaraita* pattern from the *Tasaraita* collection, 1968. Cotton, viscose, polyamide jersey. (Checklist nos. 75 and 166).

masculinity with social conscience. Because of their derivation from working clothes, they suited the protest against middle-class values. At Marimekko, instead of attempting to compete with the denim revolution, Rimala designed a complementary fashion — striped *Tasaraita* jersey (fig. 3–23). The idea was kindled by an Andy Warhol exhibition held at Stockholm's Moderna Museet in late 1967 and early 1968, and Rimala focused all her attention on it for several weeks. "It just had to be done," she explained, describing the intense pace of her work.[48] Ratia was sceptical, even hostile, toward the project but finally allowed it, telling Rimala to "take full responsibility."[49]

The striped dresses, T-shirts, underwear, and nightshirts were actually daytime clothes that looked like nightwear. This was not a completely new idea; there were precedents and there have been successors.[50] In the 1920s and 1930s the petticoat and pajama look was transferred to flowing dresses and cullottes, and to the long jersey trousers of Coco Chanel. More recently Jean-Paul Gaultier, the *enfant terrible* of Paris fashion, made corsets an important part of his everyday and evening wear creations in the 1980s and 1990s.

*Tasaraita* jersey came onto the market in early spring 1968, shortly before the student riots in West Berlin and Paris. The designs were enthusiastically received and the demand for them was such that the spring collection went out of stock.[51] With *Tasaraita*, Rimala dressed every generation of the family, from grandfather to baby, "everyone, irrespective of age and gender," and it became a modern Finnish national costume. Thirty years later the striped jersey appeared in a series of postage stamps honoring the essential classics of Finnish design.[52]

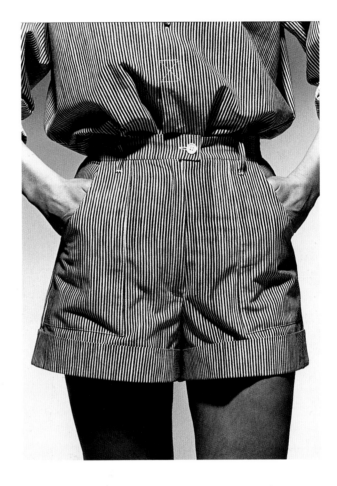

Fig. 3–24. Annika Rimala. Shirt and *Nopsa* shorts, 1975; *Viiriäinen* pattern, 1969. (Checklist no. 114).

The *Tasaraita* designs and sports jersey live on in the Marimekko Classic Collection. Dresses that were very successful in their own time, such as *Rakkauskirje* and *Monrepos*, have been reproduced in larger dress sizes that suit women of the early twenty-first century. The exhilarating *Ryppypeppu* jumpsuit of 1967 is still made to order and is worn as a "uniform" by new students at the University of Technology during orientation week. Contrary to contemporary custom, however, the designer's name is not included on the labels. Rimala holds to the principle of anonymity and believes in letting the product speak for itself. Rimala also anticipated a new direction — a leaning toward long series — and in the 1970s she concentrated increasingly on developing knitted clothes to be combined with fabric garments.[53]

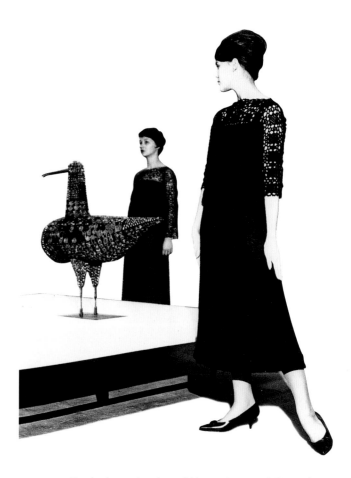

▶ Fig. 3–25. Liisa Suvanto. *Iltainen ajatus* dress, 1960. Wool and linen, wool lace.

Liisa Suvanto was brought in around the same time as Rimala to help diversify the Marimekko line. Despite early attempts to do this, Marimekko fabrics were generally cotton and had been principally associated with summer. In the mid-1950s Nurmesniemi had designed a collection of felted wool jackets, but these too were for summer. Then, at the beginning of the 1960s Marimekko's production expanded permanently to include woollen garments. Suvanto, who had previously worked in the field of woven fabrics, was an experienced interior textile designer specializing in public spaces and ships. She began her clothing design work with her colleagues Maggi Kaipianen and Inkeri Pylkkänen.[54] They profiled a target group for the collection — career women — focusing on their lifestyles and clothing needs, and on the practical realization of the patterns. Suvanto derived the ideas for her fabrics and color schemes from solitary autumn walks. An elegant collection of wool clothing was the result (fig. 3–1). Suvanto designed hand-woven fabrics from which she created woollen garments that showed some affinity with the work of the Paris-based Spanish designer Cristobal Balenciaga.[55] Known as a fashion architect, Balenciaga viewed the creation of independent artistic forms as the designer's primary task, rather than serving a particular female clientele. Suvanto, however, designed clothes for career women who wanted to be noticed in what was then a man's world. She was a pioneer in the design of clothes for the working woman. [Figs. 3–26, 3–27, 3–28.]

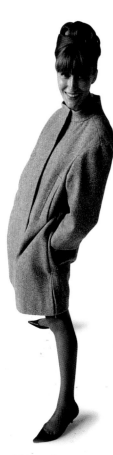

▲ Fig. 3–26. Liisa Suvanto. Coat, 1972. Wool. Courtesy of Tony Vaccaro.

▶▶ Fig. 3–27. Liisa Suvanto. Dress, 1972. Wool. Courtesy of Tony Vaccaro.

Suvanto's first "wool Marimekkos" were shown in the 1960s. They were meant to "open a new path," employing the concept of "basic black." Their line and cut were based on the Marimekko sheathdress, but in a reduced version. The elegant lines were particularly praised, and the colors and Finnish names for the designs were markedly different from the imitations of French fashion that were generally in vogue at the time.[56] Enthusiasm was not universal; some critics considered the collection to be more concerned with design than fashion, an impression reinforced by the choice of the Helsinki Art Hall as the venue for launching the collection, where it was surrounded by the "bird" sculptures of artist Birger Kaipiainen (fig. 3–25).[57] A few years later a national newspaper categorized them as industrial art and situated them somewhere between serial production and atelier fashion, "but closer to atelier fashion."[58]

In the first collections Suvanto favored black and white and restrained natural tones, but later she expanded her palette to include greens, yellows, blues, and even glaring neon colors. Patterns

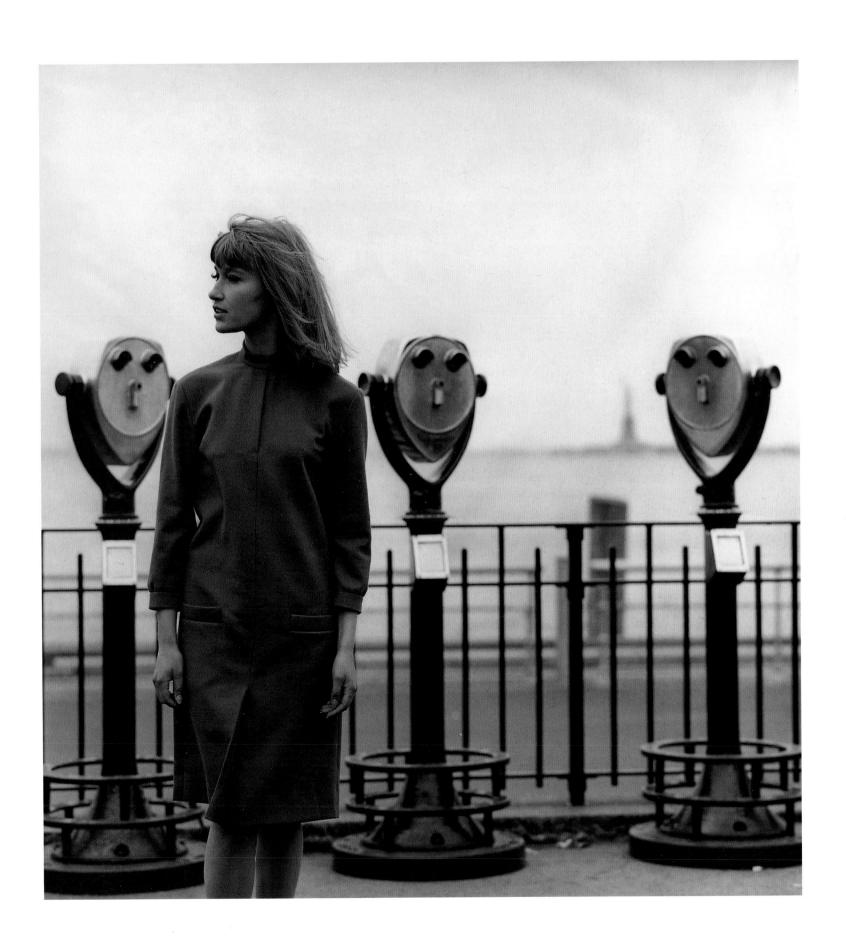

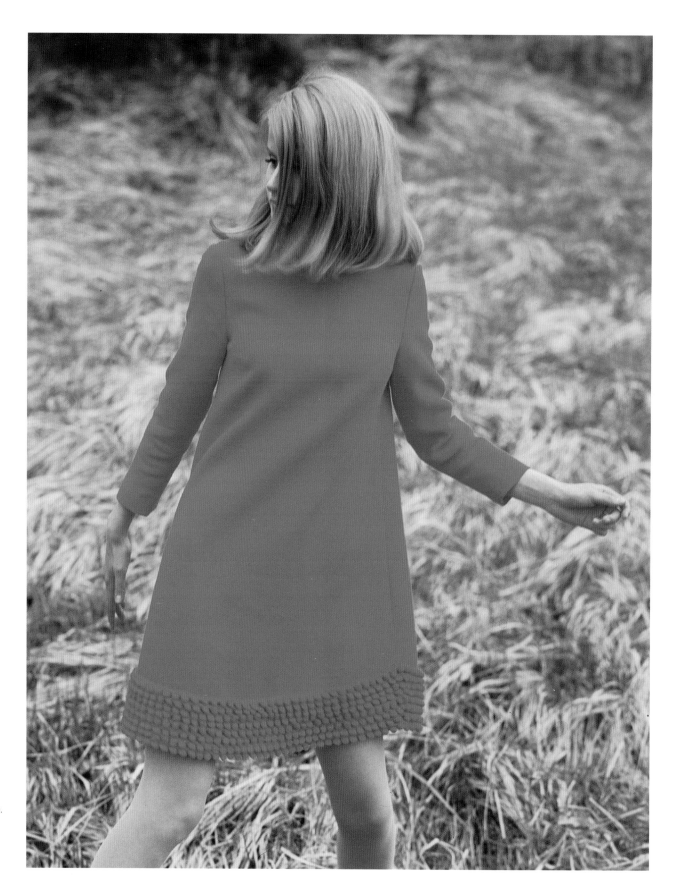

Fig. 3–28. Liisa Suvanto.
*Sepeli* dress, 1963.
Handwoven wool.
(Checklist no. 54).

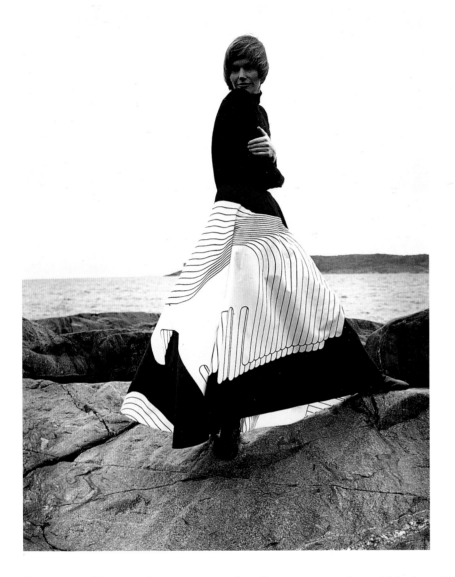

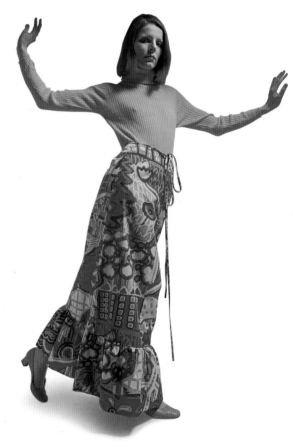

from one collection often reappeared in the next, but Suvanto usually changed the material or created a new impression by repositioning a decorative detail.[59] The drape of the fabric was especially important to her. To achieve the right effect she often emphasized the hem of the dress with a special finish or ornament.

From the beginning of the 1970s onward Suvanto also designed a number of splendid evening gowns, either with strong geometric graphic designs or sculptural effects (fig. 3–29). Although she herself designed the first printed fabric patterns for the cotton garments of her winter collections in the late 1960s, she soon regularly collaborated with the Japanese fabric designer Katsuji Wakisaka, who was then at Marimekko. Together they formed a new kind of working partnership. Wakisaka designed the materials from which Suvanto made the clothing designs. The result came to be called "fairytale dress"— sophisticated ensembles that showed individual dress design at its best.[60] Illness in the mid-1970s forced Suvanto to retire from Marimekko.

▾ Fig. 3–29.
Liisa Suvanto. *Kentauri* dress; *Troija* pattern, 1973.

▴ Fig. 3–30.
Liisa Suvanto. Skirt; *Eve* pattern by Katsuji Wakisaka, 1971.

By the end of the 1960s there were already signs of problems looming at Marimekko, which affected the fashion line. Even the vitally important American market began to decline, partly because of Design Research's financial problems and change of ownership. Neiman-Marcus was the only department store in the United States to which Armi Ratia had agreed to sell her Marimekko clothes. Ratia was the first Scandinavian to "influence the development of fashion" so decisively that the store awarded her its annual fashion prize in 1968.[61]

The ground-breaking design initiatives of Marimekko's early years had stalled. Executives inside the company made decisions based on the outcome of target groups. There was greater insistence on producing bigger collections that could be made in larger quanities, and specialized work groups were established.[62] Even some fashion journalists criticized Marimekko's impractical artistic output and called for specifically ergonomic clothing, including maternity clothes. During Ratia's final years Marimekko sometimes became the subject of some fairly harsh criticism. In 1978, for example, an Associated Press article criticized Finnish design in general and singled out Marimekko, noting that the firm was "selling its very old, daring designs, but the new spring line follows romantic European lines." Writing under a Helsinki by-line, Seth Mydans partly blamed politics for distracting students of the Institute of Industrial Arts from their studies. He commented that "the school is only now awakening from the 1960s worldwide radicalization of youth."[63] Activism had become a buzzword among European students, and commercialism the worst obscenity in design production. The clothing industry, on the other hand, ignored the trend towards anti-commercialism,

because clothes were made to be sold, after all. The era of star designers was over, although designers' names were always mentioned in connection with Marimekko fashion shows. Even then, it was clear, however, that only Ratia could handle the press; she was the sole spokesperson for the company.

In the late 1960s Marimekko's staff had been strengthened by the addition of two fabric designers: Katsuji Wakisaka and Pentti Rinta, a young Finnish fashion designer who joined the team in 1969. Employing Japanese designers (Wakisaka and Fujiwo Ishimoto) was a visionary move, anticipating the success of Kenzo Tagada and Issey Miyake, who had settled in Paris and were the vanguard of a Japanese fashion and design invasion that began in the 1980s. At Marimekko the presence of Japanese designers may also have been an indirect way of later facilitating the licensing agreements between the company and its Japanese counterparts.

A new round of innovations was already evident in the spring collection of 1970. Gone were simplicity and playfulness, replaced by functional, practical clothing. Although there were three designers — Annika Rimala, Pentti Rinta, and Kerstin Ratia (Ratia's daughter-in-law) — the collection was unified.[64] It was a sign of a new artistic and economic resurgence.

Competition in the clothing market increased in the late 1970s and early 1980s. At that time the clothing market in Finland had almost reached a saturation point. Gradually, changes in tariffs in Europe facilitated exports but also meant more competitors, including well-known companies that could sell in domestic markets. It was increasingly possible to buy the products of French-made designer fashions and ready-to-wear clothes in Helsinki and many other large Finnish cities.

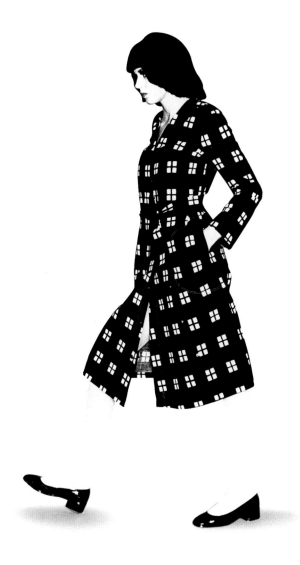

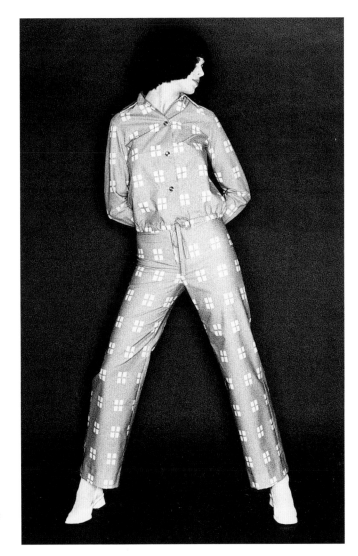

◄◄ Fig. 3–31. Pentti Rinta. *Voltti* dress; *Ikkuna* pattern, 1970.

◄ Fig. 3–32. Pentti Rinta. *Jatke* jacket and slacks; *Ikkuna* pattern, 1970.

Virtually unrestricted competition lay ahead, as the last agreements about the production of fabrics and garments outside Europe unraveled in the mid-1980s.[65] At Marimekko those changes meant increased competitiveness, concentrating on its clothing exports in Western Europe and licensed sales of its interior fabrics and bedlinen lines in the United States and Japan, where it achieved real growth.[66]

Fashions and social customs were changing. Sports and leisure clothing began to influence city clothes. There were urban adaptations of après-ski outfits, jeans had almost become a classic, and colorful aerobics outfits began to move into the mainstream to be combined with blazers and sneakers.[67]

Following Armi Ratia's death in 1979, Marimekko was run for a few years by her heirs and then became part of the Amer Group conglomerate. In this new corporate milieu Marimekkos were referred to simply as "clothes" and Marimekko itself became merely one company among many, starting on a downward spiral. It made a former Marimekko employee complain that "all they produce are nondescript cotton dresses, knitwear, and silk clothes which are meant for the Armani crowd."[68]

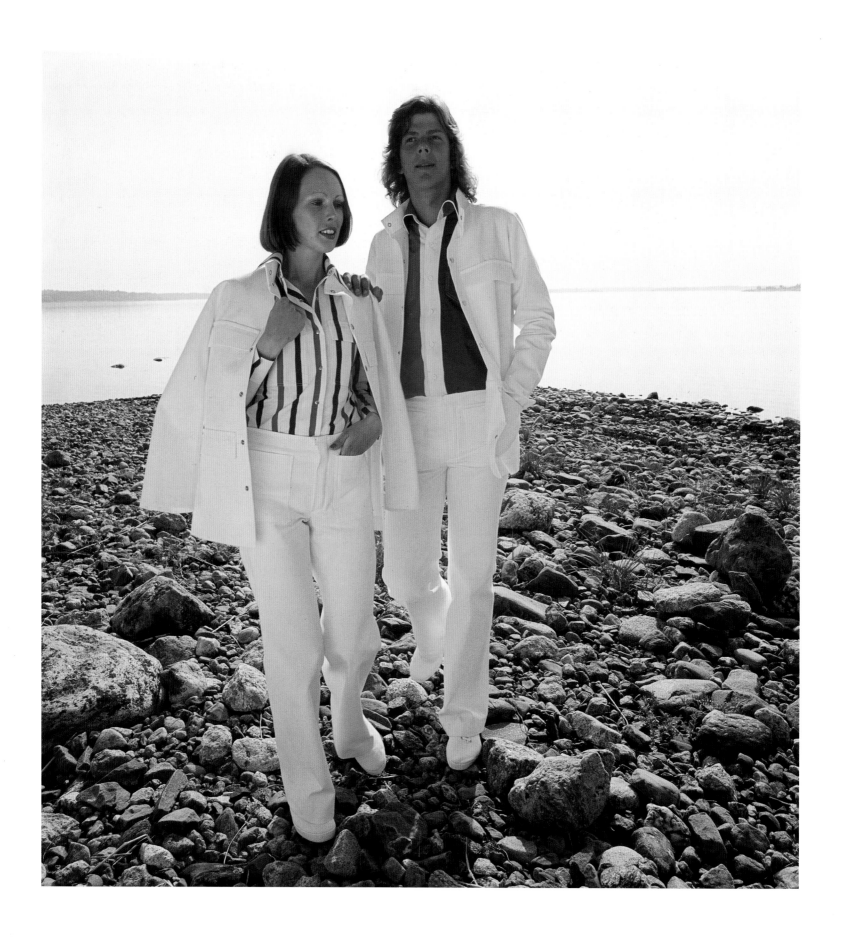

During this difficult time, as the company was deteriorating, Eeva Kaarakka, who had started out as a maker and designer of accessories and had worked in various lines of clothing, was required to adapt designs bought from freelance designers so that they fit in the Marimekko line. When Amer Group took over, Kaarakka moved to teaching.

Hilkka Rahikainen also tried to keep the Marimekko spirit alive during the company's breakup and changes of ownership. She became design manager after Ratia's death, eventually retiring in 2000. She had spent her career at the company, beginning as a young textile artist hired to create the Marimekko look for display windows and continuing as a designer primarily of various small items such as kitchenware and to a limited extent, clothing. She developed publicity and advertising, and above all the look of the printed fabrics, in collaboration with the designers. She also belonged to Armi Ratia's "staff" when the Japanese licensing agreements were finalized.

Pentti Rinta adapted the clothing patterns and dresses to the demands of a new and economical kind of industrial production (figs. 3–31, 3–32). As a Marimekko designer, Rinta made his real breakthrough with his summer collection of 1975. In it he produced a new version of the classic shirt dress that suited young and old, and a wide range of body types. These were literally clothes for all, designed so that the wearers could combine them as they wished.[69] Rinta primarily designed fabrics with small patterns, although for wide full-length dresses he used fabrics with bold colors and big patterns.

If in the early years of Marimekko Nurmesniemi had liberated women from the restrictive clothing of the era, then in the 1970s Rinta freed men from the yoke of the pinstripe suit with his *Kuskipuku*

(coachman suit, 1972; fig.3–33), which may resemble the Nehru jacket, but is probably closer to a traditional Finnish peasant *riihipaita*, for it originated at a time when collectors were beginning to take an interest in Finnish vernacular artifacts.[70] Ostensibly, the design developed out of necessity. Rinta was leaving for Paris and had made himself a comfortable black corduroy suit to wear on the journey. When Ratia saw it, she told him: "Put it into production!" The name derives from the days of horse-drawn travel.

The *Kuski* suit became the uniform of architects, artists, editors, and other professionals. It was later made in fabrics other than corduroy and was adapted for women.[71] Rinta also designed unisex jumpsuits, jackets, and outdoor wear, including the *Renki* (farmhand, 1972) overalls. By 1979, the year of Ratia's death, Rinta had begun to withdraw from the company. He continued to work for Marimekko as a freelance designer even after Amer Group took over, but later — being a versatile artist, like most of Marimekko's designers — he switched from fashion design to painting.

In the last few months of her life Armi Ratia hired Marja Suna, an experienced fashion designer, to help rejuvenate the Marimekko line. Unlike Marimekko's earlier designers, Suna had already proven herself in the clothing industry, especially as a designer of fur coats, jackets, and knitwear. She had created an elegant look for each of her two previous employers, Herrala Clothing Factory (1958–75) and Silo (1975–79), as chief designer. Ratia lived to see Suna's opening show — the mid-autumn collection of 1979 — but there was no time for a real dialogue between the two about the future reorganization of the company. It was only clear that Ratia planned change and reform, something as yet unfamiliar to Marimekko.[72]

◄ Fig. 3–33. Pentti Rinta. *Kuski* suit, 1973. Canvas. (Checklist no. 102).

Suna began to develop her own identity with knitwear and jackets, and she reshaped Marimekko in the light of international fashion, while at the same time keeping faith with the proven classics, both patterns and fashion designs, of the company's early years.[73] The rise of knitwear to a position equal to that of woven fabrics can in many ways be credited to Paris designer Sonia Rykiel, the so-called "Knitwear Queen."[74] The influence of her stylish, comfortable designs was reflected in the development of Finnish knitwear in the late 1970s and early 1980s. Like Rykiel, Suna designed the colors and styles of her new patterns in such a way that the clothes of her earlier collections can be combined with more recent ones. The hallmarks of her work are the vibrant, "three-dimensional" surfaces of her monochrome knitted garments (fig. 3–34).

Fig. 3–34. Marja Suna. *Ilmapallo* sweater, 2002. Knitwear.

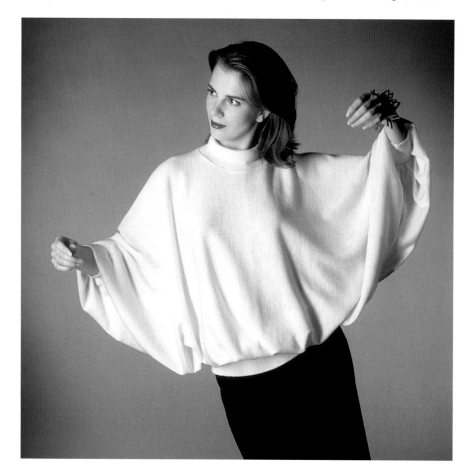

In 1991 Kirsti Paakkanen became director of Marimekko. She sold her groundbreaking advertising agency, Womena, which she had founded to protest the discrimination toward women in advertising. Womena had employed only women. Paakkanen and Ratia had actually discussed the future look of Marimekko fashion in 1979, but it was not until 1991 that Paakkanen could act on their discussion. Many consider Paakkanen to be Ratia's reincarnation, a characterization she willingly accepts, while in terms of the national heritage she is thought of as Marimekko's savior.[75]

Ratia created Marimekko in her own image and used the clothes as adornment, both to be worn and exhibited. Journalist Juha Tanttu captured her persona when he wrote: "For us her nature was alternately that of a unique PR woman, a visionary, an energetic managing director, the proprietor of a Karelian inn, and a person who both longed for individuality and feared it."[76] Paakkanen chose to respect the legacy of Ratia by continuing to search for a balance between tradition and innovation. Referring to Ratia she declared: "Marimekko is a design house and the whole organization is in the service of design. Each product, utility item though it may be, must have a redeemable design value."[77] She focused on Marimekko's clothing design, expanding production and strengthening the team of fashion designers. She built showrooms and salerooms at the head office building. There were no more Slavic-style all-night parties at the Marimekko manor house at Bökars. Instead there was intensive selling and marketing, but still leavened with dinners and evenings at the theater or opera. The fashion shows and photo sessions, however, remained the same celebrations they had always been.

Paakkanen cleaned house, making her own program for recovery. As part of her reorganization,

she eliminated everything that did not (in her opinion) belong to Marimekko; instead she brought the dressmaking workshop and production rooms back to the corporate headquarters and factory in Herttoniemi. In many ways Paakkanen resembled Ratia but there were also clear differences. She decided to discontinue the "Karelian romanticism" that was an important part of Ratia's Marimekko, but she put back into production fabric patterns and collections that had been dropped — a move that was in tune with the prevailing retro style of the turn of the century.

Ratia developed the concept of a Marimekko lifestyle, but Paakkanen built the Marimekko brand. In the modern world the brand, the trademark, which signifies a certain style and quality, has replaced the concept of lifestyle. When the customer chooses a certain product by its brand name, she is also buying the social distinction associated with the product.[78] Paakkanen's Marimekko brand is like a large umbrella sheltering a design firm that not only sells interior fabrics, bedlinens, and accessories, among other products, but also offers seven collections of clothes. Marimekko no longer presents its collections as a unified look; instead, the buyers select from them a Marimekko that corresponds to the views of their own circle of clients.

To realize her vision Paakkanen has hired several fashion designers, each of whom has his or her own clearly differentiated place in the design team. Marja Suna represents the continuation of the designer corps, as she alone had contact with Ratia. She develops the basic Marimekko styles, especially knitwear and jackets. The first new designer to join Marimekko during the 1990s was Jukka Rintala who had worked at Marimekko briefly in the 1980s. His first new collection, *Karjalan marjat* (Karelian berries), which was introduced in 1991, made

Fig. 3–35. The newly elected Finnish president, Tarja Halonen, wearing a Marimekko woolen cape and dress designed by Ritva Falla. She is accompanied by president Martti Ahtisaari, outside the presidential palace, Helsinki, March 1, 2000. Lehtikuva Oy.

reference to the Marimekko history. Rintala spent the summer of 1991 in Paris, painting watercolors for an exhibition and developing new fashion ideas. The connection between paintings and fashion led to designs that had affinities with Yves Saint Laurent's *Mondrian* outfits,[79] as well as Akseli Gallen-Kallela, one of Finland's seminal artists, whose paintings capture the world of the Finnish epic, *Kalevala*.[80] As the twenty-first century begins, Rintala is shaping a new Marimekko style "with a broad brush," giving it posture and volume, and a feeling of luxury. He chooses the patterns, squares, and stripes of his fabrics in such a way that, from a distance, an optical illusion turns them into the old familiar Marimekko patterns.

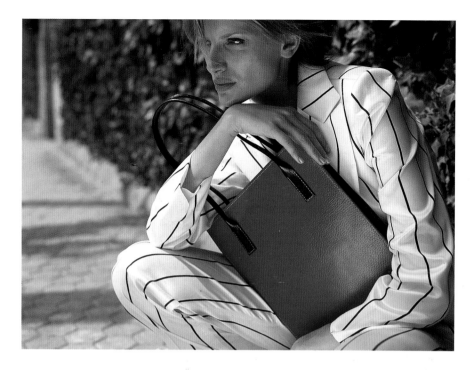

Fig. 3–36. Ritva Falla. *Babe* jacket and *Forex* slacks, 2002. Cotton and polyamide. Bag, 2002. Leather. Courtesy of Marimekko Oyj.

▶ Fig. 3–37. Matti Seppänen. *Ossi* shirt and *Sauli* trousers, 2003. *Tasaraita* pattern by Annika Rimala, 1968. Cotton jersey. Courtesy of Marimekko Oyj.

Perhaps the most international in her approach to fashion is Jaana Parkkila, who was hired as a freelance designer in 1993. She combines Japanese designer Issey Miyake's treatment of materials with the luxury of Italian salon fashion in her sculptural everyday and evening wear.

Ritva Falla also had a history with Marimekko, having designed fabric patterns in 1990–91. When Paakkanen hired her in 1997, however, she was given a free hand, and that year the Ritva Falla Collection was created. Its focus was on clothes for professional women whose work involved travel and attending meetings, and who preferred office clothes that differed from leisure wear (fig 3–36).[81] The collection has a classical elegance in many ways reminiscent of the elitist style of Marimekko's early days. Sophisticated taste is shown not by ostentation and glamour but by an apparent simplicity, a reduced, almost ascetic general effect, skillful cuts, high-quality materials, and superb workmanship. In other words, it represents fashion that is not conspicuous, but is remarkable in its

details, and fully appreciated when the clothes are touched or worn.[82] [Fig. 3–35.]

Matti Seppänen, who joined the company in 1999, was the first fashion designer to be awarded the honorary title of Professor of Art by the Finnish government. He has been charged with reorganizing Marimekko menswear, which began with Nurmesniemi's *Jokapoika* shirt and was continued by Pentti Rinta. Seppänen has a similar approach to Rinta's, designing for those who appreciate clothes that are both classical and avant garde. After providing a new version of Rinta's *Kuski* suit with his *Matti* collection, he is now lightening the traditions of men's business dress and adding color to the accessories.

Today (2003) an important change to the basic idea of Marimekko fashion is that the designers choose the most suitable fabric for their design, quite often from an outside producer. There is, however, one designer in the fashion group who works in the traditional Marimekko way by starting from the fabric. Mika Piirainen unites the past and present most vividly (figs. 3–38, 3–39). He became

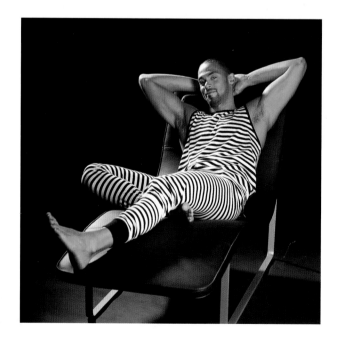

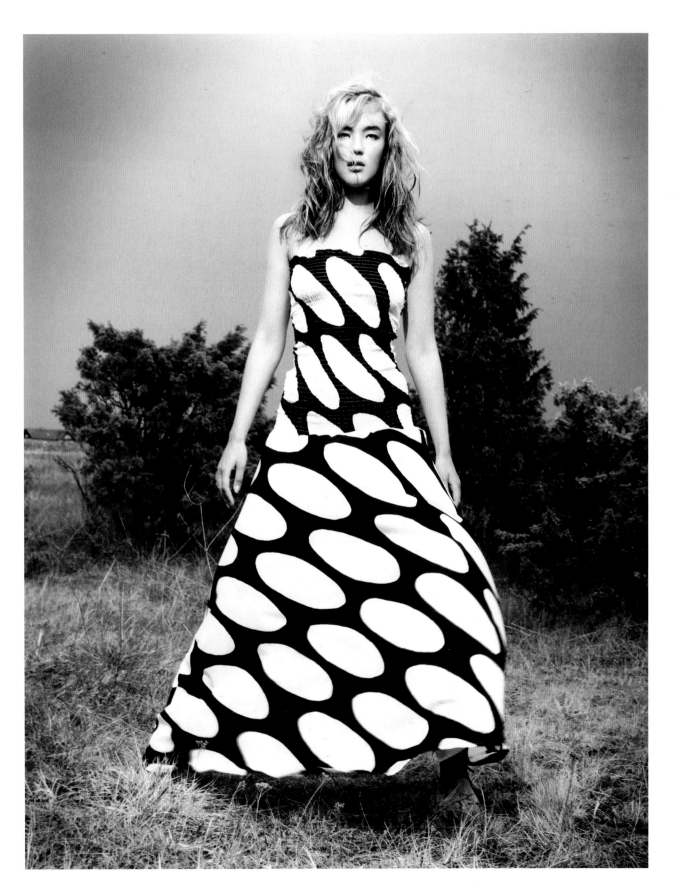

Fig. 3–38.
Mika Piirainen.
Dress, 2003; *Linssi*
pattern by Kaarina
Kellomäki, 1966.
Courtesy of Mari-
mekko Oyj.

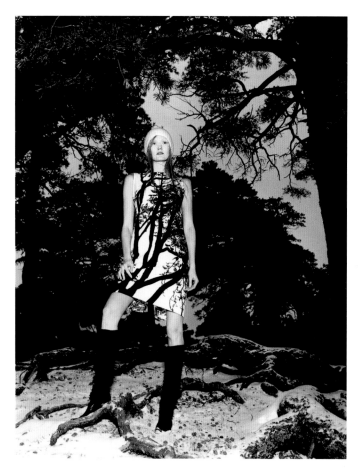

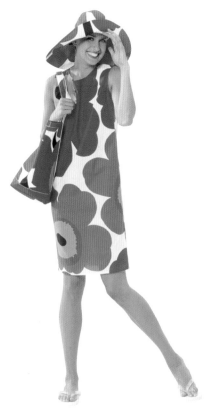

► Fig. 3–39.
Mika Piirainen. Dress,
2003; *Tuuli* pattern by
Maija Isola, 1972.
Courtesy of Mari-
mekko Oyj.

►► Fig. 3–40.
Juha Marttila. Dress
and hat, 2003; *Unikko*
pattern by Maija Isola,
1964. Courtesy of
Marimekko Oyj.

a trainee at Marimekko in 1994 and started as an assistant to the production manager. He reworked old Marimekko patterns, reduced them on a photo-copier and presented miniature versions on card-board female figures in order to convince Paakka-nen of the value of his ideas.[83]

Piirainen transfers the patterns of interior textiles by Maija Isola to modern clothes (fig. 3–39). First came *Lokki*, then the *Mansikkavuoret*, and in the summer of 2002, *Kaivo* and *Seireeni*. In summer 2003 Piirainen is moving on to Kaarina Kellomäki's collection and will restore the *Linssi* pattern (fig. 3–38), and in winter 2003–4 Annika Rimala's *Viiriäinen* pattern will be revived. Piirainen works with the original designers or copyright owners, such as Isola's daughter Kristina, on patterns and colors that are suitable for today's printing technology.

While patterns have to be adapted for modern techniques and new designs, in his fashion photo-graphs Piirainen seeks to evoke the period when the pattern was first introduced, re-creating the inner tension and atmosphere of the picture, its simplicity.[84]

In summer 2000 Juha Marttila adapted *Unikko*, Maija Isola's 1964 interiors fabric pattern, to clothes, and since then *Unikko* has spread to a wide range of uses, not just as a pattern for interior furnishings, but for tablecloths, kitchenware, television sets, portable radios, computer keyboards and mice, book jackets and covers.[85] Piirainen participated by designing accessories, mainly bags. The pattern has become so widely recognized around the world that it may be said to unite Kirsti Paakkanen's goal of a brand identity with Armi Ratia's original mission — to create a specifically Finnish lifestyle for each new generation.

1 Annika Rimala, interviewed by the author, 19 September 2002; Anna-Liisa Wiikeri, "Marimekko ja muoti" (Marimekko and fashion), in *Phenomenon Marimekko*, ed. Pekka Suhonen and Juhani Pallasmaa (Espoo: Weilin & Göös, 1986).

2 Pentti Rinta, interviewed by the author, 14 October 2002.

3 Tetta Kannel, "Tekstiilitaide ja suomalainen tekstiiliteollisuus" (Textile art and the Finnish textile industry), in *Suomen tekstiiliteollisuus 250 vuotta, 1738–1988* (250 years of the Finnish textile industry, 1738–1988), ed. Marjatta Salonen (Helsinki: Tekstiiliteollisuusliitto, 1988).

4 Throughout Finland dressmakers came into people's homes and stayed a day or two making new clothes and making alterations to old clothes (ibid.).

5 Ritva Koskennurmi-Sivonen, "Creating a Unique Dress: A Study of Riitta Immonen's Creations in the Finnish Fashion House Tradition," Ph. D. diss., University of Helsinki, Akatiimi, 1998.

6 Marilyn Hoffman, "Finnish Fashion Borrow Decor Gaiety," *Christian Science Monitor* (1 November 1954): 4.

7 Ritva Koskennurmi-Sivonen, "Suomalaisen muodin vaiheita" (Phases of Finnish fashion), in *Puoli vuosisataa. Mitä Missä Milloin juhlakirja* (What, where, when — the fiftieth anniversary edition) (Helsinki: Otava, 1999): 5–11. For further details of the founding of Marimekko, see chaps. 1 and 6 in this volume.

8 Viljo Ratia, interviewed by the author, 19 August 2002. Initially very few tickets were sold but through word of mouth among Immonen's clients they eventually sold out.

9 Sirkka Kopisto, *Moderni Chic Nainen: Muodin vuosikymmenet 1920–1960* (The modern chic woman; the fashion decades 1920–1960) (Helsinki: Museovirasto, 1997): 142.

10 Ibid., pp. 59–61; Koskennurmi-Sivonen, "Suomalaisen muodin vaiheita" (1999); Gertrud Lehnert, *1900 -luvun muodin historia* (History of 20th century fashion),

Finnish trans. by Kirsi Niemi (Cologne: Könemann, 2001): 41.

11 Elisabeth Flory, ed., *Homage à Christian Dior 1947–1957* (Paris, Union des Arts décoratifs, 1986).

12 [Maija-Liisa Heini], "Taideteollista leimaa kesän pukeutumisessa" (Industrial-art look to summer fashion) *Helsingin Sanomat* (22 May 1951).

13 [T-a], "Kesäistä väriheleyttä" (Summer warmth of color), *Uusi Suomi* (23 May 1951).

14 Riitta Anttikoski, "Jäähyväiset salongille: Riitta Immosen viimeinen muotinäytös onkin uusien suunnitelmien alku" (Farewell to a salon, Riitta Immonen's last fashion show is also the beginning of new plans), *Helsingin Sanomat* (28 October 1984); Koskennurmi-Sivonen, "Creating a Unique Dress" (1998): 133–34.

15 The early years of Marimekko indicate that successful publicity does not automatically mean financial success. In 1951 Printex went bankrupt and reorganized under the same name, but the future of Marimekko was also in doubt. Again Ratia defied expectations: instead of filing for bankruptcy, she aggressively sought artists to work as textile and clothing designers.

16 Anttikoski, "Jäähyväiset salongille" (1984).

17 Vuokko Nurmesniemi, interviewed by the author, 2002

18 Leena Ilmari, "Dior 60. leveyspiiriltä" (Dior from the 60th parallel), *Hopeapeili* (Silver mirror) 1960, clipping in the Designmuseo Archive.

19 Jörn Donner , "Dreams and Reality" in *Phenomenon Marimekko* (Helsinki: Marimekko, 1986): 8. The two archetypal figures — Männistön muorin Venla and Vuohenkalman Anna — were created by Aleksis Kivi, the pioneer of Finnish literature.

20 C. L., "Marimekko: Fashion's Status Symbol for the Intellectual," *American Fabrics Magazine* (Fall–Winter 1963).

21 Juha Tanttu, "Marimekon Vanha Äiti Kuollut" (Marimekko's old mother [is] dead), *Helsingin Sanomat* (4 October 1979).

22 Anna-Liisa Ahtiluoto, "Naisemme New Yorkissa" (Our lady in New York), *Hopeapeili* 1 (1964): 14.

23 "Kläder i klass med konstindustrin" (Garments in the class of design), *Hufvudstadsbladet* (28 April 1956).

24 [R.S.] "Kevään Marimekko" (Marimekko of the spring) *Kaunis Koti* (Beautiful home) (March 1956).

25 Henry Harald Hansen, *Muotipuku kautta aikojen: Pukuhistoriallinen värikuvasto* (Fashionable dress through the ages: color atlas of fashion history] (Porvoo-Helsinki: WSOY, 1957): 146–148.

26 Mirja Sassi, "Lähellä luontoa" (Close to the nature), *Hopeapeili* 8 (1957).

27 For example *Kaarnapaita* (bark shirt) in the collection of Designmuseo.

28 Mirja Sassi, "Lähellä luontoa" (Close to nature), *Hopeapeili* 8 (1957).

29 Nurmesniemi interview, 2002.

30 Maija-Liisa Heini "Suomi tarvitsee oman näyteikkunan nopeasti Amerikkaan" (Finland needs an immediate display window of its own in America), *Uusi Suomi*, no. 205 (1959): 13.

31 "Suomalainen taideteollisuusnäyttely ensi kerran Amerikkaan" (A Finnish industrial art exhibition for the first time in America), *Suomen Sosialidemokraatti* (23 May 1959).

32 *Sports Illustrated* (December 1960): cover (photographed by David Drew Zingg). She actually bought nine dresses but returned one. The Kennedy story is one of the most frequently cited and has become part of the Marimekko mythology. Aside from the *Sports Illustrated* cover, however, there is little hard information about how Marimekko actually realized this advertising coup or gained the attention of such an important client. Further research has provided noteworthy information but many questions remain unanswered. Jacqueline Kennedy apparently wore the Marimekko dresses as maternity clothes — at least the *Sports Illustrated* photograph was taken when she was pregnant with John Kennedy Jr. (born in November 1960): A group of

Marimekko dresses appeared in the summer of 2003 at auction, two of which are now in the collection of Designmuseo. According to Susan Ward, a Research Fellow at the Museum of Fine Arts, Boston, the Marimekko dresses sold at DR can be dated based on the label system that had been devised between Thompson and Ratia, although the system was not identified in a written agreement until 1961. Thompson would send labels bearing the Design Research company name to Finland where they would be sewn into the dresses. The long blue dress that belonged to Mrs. Kennedy and is now in the Museum collection is the only one that has a Marimekko label; this could date it to 1960 prior to the agreement. The fact that the dress sizes (10 and 14) were larger than what would have been Mrs. Kennedy's regular size makes dating them all to 1960 a possibility. Moreover, it is not known how precise the label system actually was. Vuokko Nurmesniemi has recently recalled that the Kennedy order was placed either late in 1959 or early 1960 (conversation with Marianne Aav, August 2003). Further research by Ms. Ward may shed light on the Kennedy/Marimekko story and on other aspects of Design Research.

33 "Nu kan vi också köpa Jackies favoritkläder" (Now we can also buy Jackie's favorite dresses), clippling in a Swedish magazine in the Designmuseo Archive.

34 Rimala interview, 19 September 2002; Eeva Kaarakka, interviewed by the author, 2 December 2002. Muksula opened in 1958, when the Finnish children's clothing industry was in its inception, and concentrated mostly on outdoor wear.

35 Kaarina Vattula, ed., Suomen taloushistoria, vol. 3 Historiallinen tilasto (Economic history of Finland, vol. 3, Historical statistics) (Helsinki: Kustannusosakeyhtiö Tammi, 1983): 23.

36 Kopisto, Moderni Chic Nainen (1997): 105.

37 Pekka Tarkka, "Taistelut kulttuurista" (Fighting for culture), in Suomen historia (Finnish history), vol. 8, ed. Pekka Tarkka (Espoo: Weilin & Göös, 1988): 346–47.

38 Leena Maunula, "Annika Rimala: 40 vuotta tektiilisuunnitelua" (Annika Rimala: 40 years of textile design), in Annika Rimala, 1960–2000: Väriä arkeen Färg på vardagen Color on our life (Helsinki: Libris, 2000); Rebecka Tarschys, "Färg på vardagen," Color on our life ibid. Oiva Toikka later designed sets for opera and theatre, and Annika Rimala also designed sets and costumes for theater productions on a freelance basis, together with her third husband, the architect Ilkka Rimala.

39 [Kerttu Vaartila], "Marimekko tänään — yhä uusi ja tuore (Marimekko today — still new and fresh), Helsingin Sanomat (17 May 1961); Ritva Roine-Hildebrand, "Aiheena kuukuna eli maa[n]muna" (The puffball or earthball theme), Ilta-Sanomat (18 May 1961).

40 Rimala interview, 19 September 2002. Rinta interview, 14 October 2002.

41 Maunula, "Annika Rimala" (2000); Rimala interview, 19 September 2002; Eugenia Sheppard, "Uniform for Intellectuals," New York Herald Tribune (13 November 1963).

42 "Suomalainenkin määrää kansainvälistä muotia" (Even a Finn determines international fashion), Helsingin Sanomat (25 January 1967).

43 "Ylioppilaskunnan valtaus uhkaa satavuotisjuhlaa" (Occupation of student union threatens centenary celebrations), Helsingin Sanomat (26 November 1968); John Lagerbohm, "Myyttinen hulabaloo" (Mythical hullabaloo) Helsingin Sanomat (22 November 1998).

44 Rimala interview, 19 September 2002.

45 Ibid.

46 Donner, "Dreams and Reality" (1986).

47 Ibid.; Maunula, "Annika Rimala" (2000).

48 Maunula, "Annika Rimala" (2000); Rimala interview, 19 September 2002.

49 Ibid.

50 Koskennurmi-Sivonen, "Suomalaisen muodin vaiheita" (1999).

51 Anna-Liisa Ahtiluoto, "Vaatteita juuri tätä päivää varten" (Clothes for today), Helsingin Sanomat (24 March 1968).

52 Maunula, "Annika Rimala" (2000).

53 Rimala interview, 19 September 2002.

54 The economist Maggi Kaipiainen was married to ceramic artist Birger Kaipiainen and was a trusted personal friend of Armi Ratia. She worked in the clothing business, including a stint in the factory of Pukeva, a prominent Helsinki clothing store at the time. From there she became head buyer for the women's clothing department of the prestigious Stockmann department store. She was known for her sharp eye for detail. Rimala recalled that "she knew everything about the structure of sleeves, and especially their spacing." Inkeri Pylkänen, a highly skilled professional cutter, came to Marimekko with Kaipiainen; where she developed an intuitive understanding of the designers' concepts (Rimala interview, 19 September 2002).

55 Kerttu Niilonen, "Mari-nainen pukeutuu marivillaan" (The Mari-woman dressed in Mari wool), Omin käsin (With one's own hands) (1961):1.

56 Lehnert, 1900 (2001): 51; Charlotte Seeling, Fashion: The Century of the Designer, 1900–1999, trans. Neil and Ting Morris and Karen Waloschek (Cologne: Könemann, 1999): 214.

57 Niilonen, "Mari-nainen" (1961). Kaipiainen worked for almost fifty years for the Finnish Arabia porcelain factory and is perhaps best known internationally for "Sea of Violets," designed for the Montreal Expo of 1967; his "trademark" color is a deep violet blue.

58 Kerttu Vaartila, "Syksyn villaa marimekkolaisittain" (Wool in the autumn à la Marimekko), Helsingin Sanomat (16 August 1962).

59 See, e.g., Kukko (1961; fig. 7–39; checklist no. 46); Suden suitset (1962; fig. 7–38; checklist no. 48) and Sepeli (1963; fig. 7–40; checklist no. 54).

60 Anna-Liisa Wiikeri, "Mekko kuin satu" (A dress like a fairytale), Helsingin Sanomat (27 October 1973).

61 "Suomalainen muoti palkittu Amerikas-

sa" (Finnish fashion awarded in America), Helsingin Sanomat (17 February 1968).

[62] Rinta interview, 14 October 2002.

[63] [Helena Ylänen], "Suomalainen muotoilu petti" (Finnish design disappoints), *Helsingin Sanomat* (1 April 1978); "Suomalainen muotoilu kuolemassa" (Finnish design dying), *Ilta-Sanomat* (15 February 1978).

[64] Anna-Liisa Wiikeri, "Aina aikaansa edellä" (Always before her time) *Helsingin Sanomat* (20 Februray 1970). Kerstin Ratia was married to Ristomatti Ratia and belonged to the design team from 1966 to 1979.

[65] Pellervo Alanen, "Vaate ja tekstiili käännekohdassa" (Clothing and textiles at a turning-point), *Helsingin Sanomat* (8 December 1981); Jussi Peitsara, interviewed by the author, 4 December 2002.

[66] Anna-Liisa Wiikeri, "Muuttuuko Marimekko" (Is Marimekko changing?) *Helsingin Sanomat* (13 February 1983).

[67] Riitta Anttikoski, "Kuka kukin on" (Who's who) *Helsingin Sanomat* (19 April 1980); Koskennurmi-Sivonen, "Suomalaisen muodin vaiheita" (1999). In the 1980s windbreakers, the real democratizers of Finnish dressing, appeared on the street scene, and their popularity as everyday wear has persisted.

[68] Eeva-Kaarina Aronen, "Menneisyys Mari-ihmisenä, vastenmielisiä ilmiöitä" (The past of a Marimekko employee, unpleasant phenomena), *Helsingin Sanomat* (17 May 1986); Wiikeri, "Muuttuuko Marimekko" (13 February 1983).

[69] Anna-Liisa Wiikeri, "Uusi marimekko on Pentti Rinnan läpimurto" (New Marimekko is Pentti Rinta's breakthrough), *Helsingin Sanomat* (13 October 1974).

[70] Juha Tanttu, *Tyylimies, pukeutumisen aakkosia* (The man of style, the ABC of fashion). (Helsinki–Juva–Porvoo: WSOY, 1988): 127–28.

[71] Rinta interview, 14 October 2002.

[72] Wiikeri, "Muuttuuko Marimekko" (13 February 1983).

[73] Anna-Liisa Wiikeri, "Marimekon uusi kevät" (Marimekko's new spring), *Helsingin Sanomat* (6 December 1981).

[74] Sonia Rykiel, of Romanian-Russian descent, began to design clothes when, as a young mother, she could not find any that she liked. She went into business with her husband, until establishing her own firm, which has grown into an internationally recognized, trendsetting design house, specializing in knitwear. Lehnert, *1900* (2001): 78.

[75] Eeva-Kaarina Aronen, "Kauneus ei katoa" (Beauty does not vanish), in *Marimekko täyttää 50 vuotta mutta on yhtä iätön kuin sen pelastaja Kirsti Paakkanen* (Marimekko is 50, but is just as ageless as its saviour Kirsti Paakkanen), *Helsingin Sanomat*, supplement (2001):5. In recognition for her contributions to Marimekko, Paakkanen received an honorary doctorate from the University of Art and Design in 2001. Ratia has not been accorded similar recognition, albeit postmortem, for her considerable contribution to Finnish culture by being buried on the artists' hill of Helsinki's Hietaniemi Cemetery. Ristomatti Ratia, *Paha poika* (Bad boy) (Keuruu: Otava, 2002): 100; *Helsingin Sanomat* (12 January 1980).

[76] Juha Tanttu "A Day in Armi Ratia's Life," in *Phenomenon Marimekko* (1986): 91.

[77] Eeva-Kaarina Aronen, "Kauneus ei katoa" (Beauty does not vanish), in *Marimekko täyttää* (2001):5.

[78] Lehnert, *1900* (2001): 103.

[79] Riitta Anttikoski, "Materiaalien mestari" (Master of materials), in *Jukka Rintala* (Keuruu: Otava, 1999); Georgina O´Hara, *The Encyclopaedia of Fashion* (London: Thames and Hudson, 1986): 203; Yves Saint Laurent et al., *Yves Saint Laurent*, exhib. cat. (New York: The Metropolitan Museum of Art and Thames and Hudson, 1984): 84–85.

[80] Jukka Rintala, interviewed by the author, 22 November 2002.

[81] Koskennurmi-Sivonen, "Suomalaisen muodin vaiheita" (1999).

[82] Lehnert, *1900* (2001): 103–5.

[83] Mika Piirainen, interviewed by the author, 27 November 2002.

[84] Piirainen, Mika. 2002. Viljo Ratia, "Alkuvuosien kiemuroita" (Circuitous paths of the early years), in *Phenomenon Marimekko* (1986). Marimekko was famed for using both top models and amateurs, who were chosen from a wide variety including Marimekko employees or even the photographer's assistant.

[85] Miska Rantanen, "Uniikki unikko" (The unique Unikko), *Helsingin Sanomat* (21 June 2002).

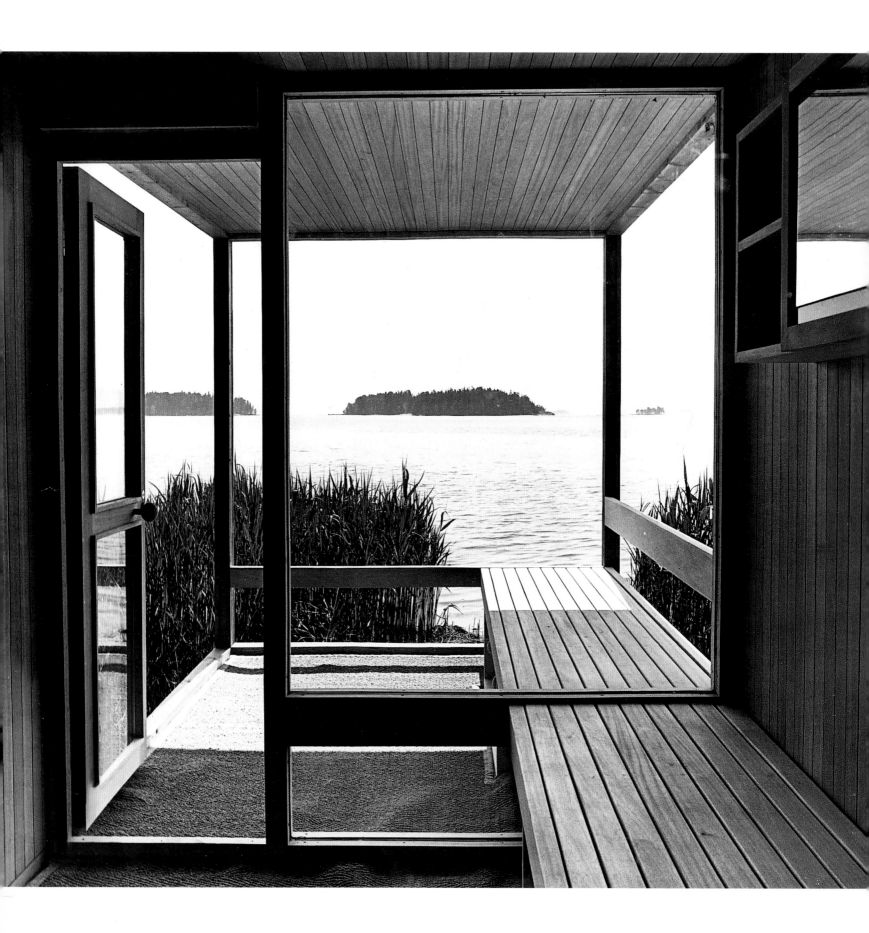

# 4. The Marimekko Vision of Architecture and Interior Spaces Riitta Nikula

*So what will the factory actually do?, was the first question I asked myself. Will it make dresses at all? Of course it will make dresses, I thought. But it will make many other things as well. Even houses. In my opinion that's quite a normal development. I've always hated unnecessary tucks, pleats and buttons on clothes. In the same way, houses can be made simpler. That's what I'm going to do. . . . This village that is to be built in Porvoo will be the first, but it won't even be worth designing it unless more are built. At least ten in Finland and more abroad. . . . Houses have always interested me. Now it's time to start making them.* — Armi Ratia, 1967[1]

By the summer of 1967, some sixteen years after the founding of Marimekko, Armi Ratia was about to launch the company's first major residential building project. In an interview in *Uudenmaan Sanomat*, a local newspaper, she hinted at the company's broader scope, at Marimekko's wide vision. It was unusual, to say the least, for a fabric and fashion firm to be embarking on architecture, yet Marimekko planned to construct both a village, Marikylä, and a Marimekko factory. It would cover about twenty acres (8 hectares) in Porvoo's Gäddrag district and almost seventy-five acres (30 hectares) in nearby Bökars, about forty miles (60–70 kilometers) east of Helsinki. Ratia, who was to act as project director, told the newspaper, with characteristic spontaneity, that she had previously bought land only in flowerpots.

After applying the Marimekko aesthetic to many aspects of the human environment, it seemed the next logical step to embrace architecture itself. In fact, it was almost as though this had always been part of the Marimekko program.

◄ Fig. 4–1. View from the Marisauna, Karhusaari, 1966.

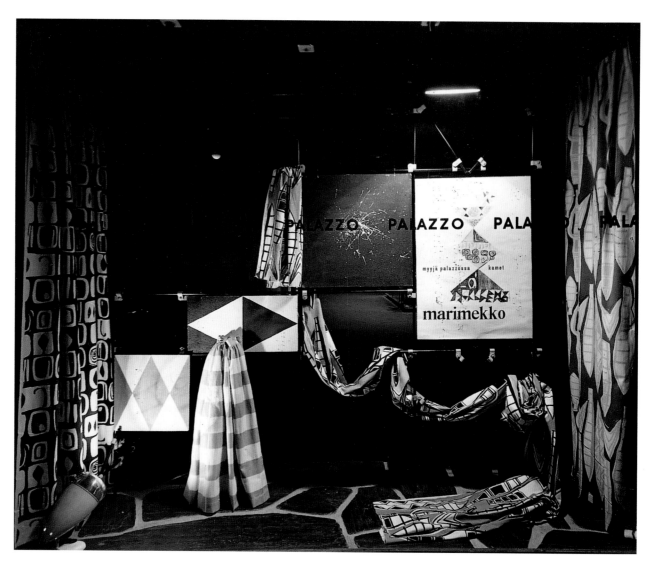

Fig. 4–2. Marimekko's
ground-floor display at
the Palace Hotel, early
1950s.

Since the early days of the company, Armi Ratia
had focused on detail, making certain that the
Marimekko environment was part of the same
*Gesamtkunstwerk*. The company's shops were
prominent on the main streets of towns and cities
in many countries, shelter magazines presented
Marimekko textiles as an integral part of home
furnishing, while in Finland the women's maga-
zines routinely incorporated Marimekko fabrics,
dresses, and objects in holiday features before
Christmas and early summer festivities. Yet, despite
the attention locally, and the extensive interna-
tional bibliography focusing on Ratia and the

Marimekko saga,[2] very little has been written on
Marimekko's venture into the design of architec-
ture.

In 1967 Armi Ratia described Marimekko as
"a view of life and a philosophy. It looks for solu-
tions to people's problems, represents the endless
struggle of an individual's soul and spirit. The
human soul cannot and must not get rid of poetry.
…It's a roar of laughter in the face of officialdom,
and an important human resource. Marimekko
markets the products it makes in the form of a
solution to human problems. — The Marimekko
dresses and the whole Marimekko line, which

presently embraces not only dresses and fabrics, but also shirts, candles, glasses, trays, bags, slippers, blankets, toys, hats and goodness knows what else, represents a completely unique line, which is entirely independent of foreign influences. We want to give people products that are conceived 'à la Marimekko'. They must be linked to the idea of progress in such a way that everyone who uses them experiences the same joy with which the products are made. Marimekko is a way of thinking characteristic of the busy person. . . . Every product, letter, card, floral message, indeed everything that leaves our hands, must represent our line. So we have also opened numerous shops of our own, to give the products maximum publicity. . . . We don't ask what the customers want, but we direct development ourselves. So we're always a few steps ahead of them. And we always create something new that hasn't been seen before, something that by virtue of its unconventional qualities draws our customers along with it and creates new ones."[3]

With all its eloquence, Armi Ratia's business concept was clear in an international context. She created a modern design culture that included her own vision of modern architecture at a time when brand names were not yet common.

## New concepts in architecture

The early days of Marimekko were not easy, as described in Tuula Saarikoski's 1977 biography of Armi Ratia.[4] Although there is nothing in the book about architecture per se, Saarikoski includes a lively discussion of Marimekko's modest business premises, the shortage of materials, and the primitive working methods that characterized the company's early years. Despite the struggle, the first fashion show, the one that virtually launched the company, was held in grand style in the spring of

1951 at the Kalastajatorppa restaurant, the finest in Helsinki. The event was an unparalleled success, a foreshadowing of the genius that was to be Marimekko.

Marimekko's first "factory" was little more than a workshop in the Pitäjänmäki industrial district of Helsinki, but the company soon added to this by leasing an office in a new building, one that epitomized avant-garde Finnish architecture. In 1952, the year the Summer Olympics were held in Finland, the Palace Hotel and office building (fig. 4–3)

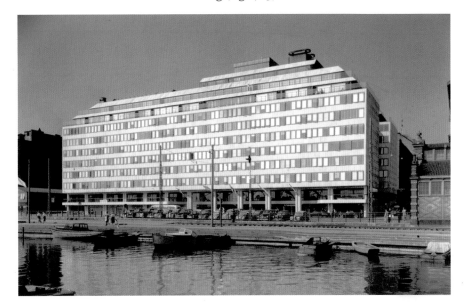

opened at Eteläranta 10, in Helsinki's central harbor district. It had been designed by two prominent young architects, Viljo Revell and Keijo Petäjä, and was hailed as the most modern office building in Finland.[5] The Palace's interiors had been designed by Antti Nurmesniemi, who was the husband of Vuokko Eskolin-Nurmesniemi, the principal designer of clothes and dress fabrics at Marimekko from 1953 to 1960. They were all among the creators of Finnish modernism, which was altogether a small interconnected group. With the Palace as its first address, Marimekko had the best possible starting point for its world conquest of new design.[6]

Fig. 4–3. Viljo Revell and Keijo Petäjä. The Palace Hotel, Eteläranta 10, Helsinki, 1952. Museum of Finnish Architecture, Helsinki.

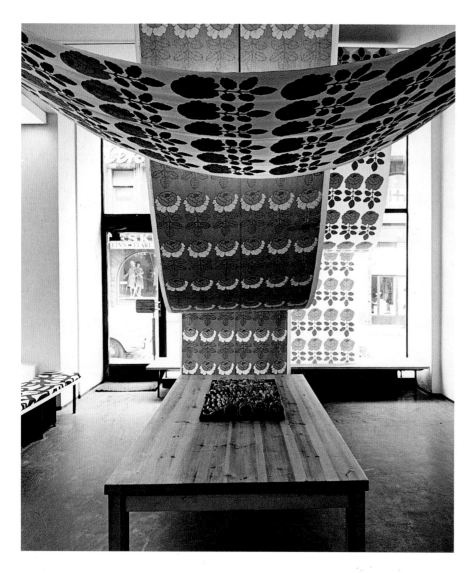

▲ Fig. 4–4. Interior of Piironki, Fabianinkatu 31, Helsinki, with *Maalaisruusu* fabric, 1963.

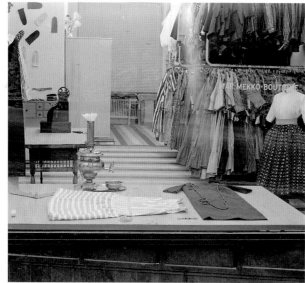

▶ Fig. 4–5. Interior of Boutique, Kasarmikatu 42, Helsinki, 1964.

In 1953 the first Marimekko shop was opened in Tunturikatu, Töölö, a quiet area near the center of Helsinki. The combined workshop and sales room covered a mere 215 square feet (20 square meters). Viljo Ratia, Armi Ratia's husband, recalled that the shop employed a single cutter and one dress-pattern maker; industrial manufacture was out of the question, and production was in the hands of freelance seamstresses.[7] As the company grew, new shops were opened in the central parts of Helsinki. Most were professionally designed and perfectly combined international modernism and the Finnish tradition. This merging of new and old is integral to the Marimekko aesthetic and was strongly present even in the earliest shops.

The Marimekko store interiors and their designers have largely been overlooked by architectural magazines. With the exception of Pekka Suhonen's brief essay, "Environments, Architecture," in *Phenomenon Marimekko*[8], they are known mainly through period photos. So, it was a nice surprise to discover that a series of architectural drawings for five shops had been carefully preserved in the drawing archives of architect Aarno Ruusuvuori.[9] During the 1960s his office was primarily responsible for this commercially important part of the Marimekko environment, for the stores and workshops, as well as for some of the firm's larger architectural projects. Architect Juhani Pallasmaa, who was a close friend of Ruusuvuori and his collaborators, recalled that staff architect Pentti Piha was almost solely charged with the design of the Marimekko shops.[10]

Each Marimekko shop in Helsinki was named to reflect its speciality or its location: Muksula (opened 1958) for children's clothing; Kammari (chamber; opened 1960) for fabrics and a wide selection of little items; Piironki (chest of drawers; opened 1960; fig. 4–4) for fabrics; Mittamari

(measure Mari; opened 1962) for custom clothes; Boutique (opened 1964; fig. 4–5) for the finest dresses; and Vintti (attic; opened 1965; fig. 4–6) for its upstairs location.

According to drawings in the Ruusuvuori archives, the first commission the firm had from Marimekko was for the design of Mittamari (Pursimiehenkatu); its drawings have been dated from February to March 1962. The shop premises, in a typical basement in an ordinary 1930s apartment building, included an entrance and three display windows. In the new design, the original interior walls were removed, and fitting cubicles and new partitions were built from wallboard. Several sewing tables and a staff area were located in the rear of the premises, while the front of the shop consisted of a single white-painted display area that provided a dramatic backdrop for the colorful dresses and bolts of cloth.

Vintti (Keskuskatu, 1964–65) was located above Artek, the most prestigious and progressive design shop in Finland, in the Rautatalo Commercial Building (Iron House, Alvar Aalto 1955) opposite the Stockmann department store. The shop was reached by way of an airy staircase via a street entrance it shared with Artek. There was also a door that opened onto the atrium where the Rautatalo café was located. In Vintti, Piha introduced the most important new element in the Marimekko shop interiors: the clothes were hung from a steel grid that hung from the ceiling and floated above the entire display space. Pallasmaa has called this a "space grid." Its use allowed the dresses to dominate the interior space (fig 4–7, 4–9).[11] Piha's interior design was based on a precise metric modular plan. The cubicles were almost 2 feet (60 cm) wide, and the same module used in the space grid. The built-in shelving was based on another grid with units of

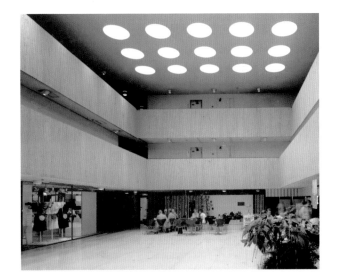

◄ Fig. 4–6. The covered atrium in the Rautatalo Commercial Building, Keskuskatu 3, Helsinki; designed by Alvar Aalto, 1951–55 Marimekko's Vintti display window is on the left. Museum of Finnish Architecture, Helsinki.

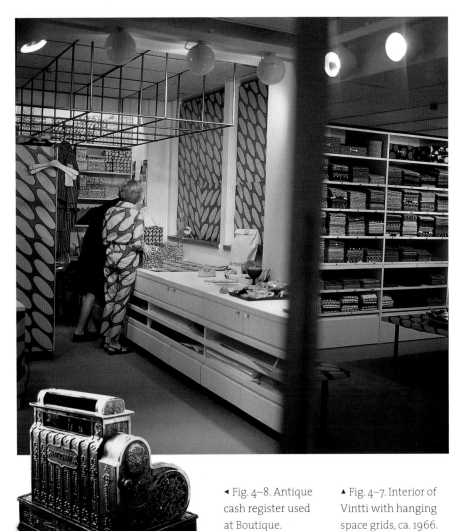

◄ Fig. 4–8. Antique cash register used at Boutique.

▲ Fig. 4–7. Interior of Vintti with hanging space grids, ca. 1966.

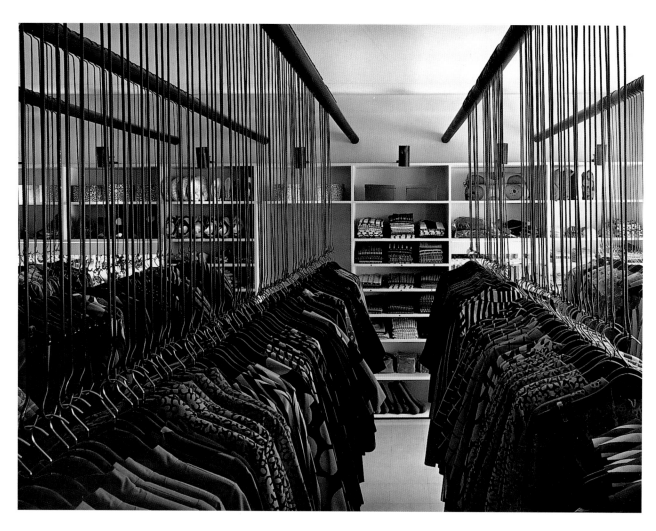

Fig. 4–9. Interior of the
Marimekko shop at
Linnankatu 16, Turku,
s.a.

about 1 by 2½ feet (30 by 80 cm), and the measure-
ments of the table surfaces were adapted to fit
them.[12]

All the Ruusuvuori project drawings are notable
for their careful consideration of the simple, basic
needs of each shop. The floor plan for Boutique
(Kasarmikatu, 1964), for example, includes the
handwritten annotation: "lamps / Muksula model
— bric à brac shelf and tabletop are also lit from the
clothes rack — clothes rack / Muksula model —
Philinea lamp for the dressing cubicles." The sales
counter was to be in careful alignment with a
window seat. In this space the original sales pre-
mises did not require major structural alterations.
Furnishing was kept simple: fixed shelves were

installed; a metal space grid suspended from the
ceiling to hang and display the clothes; and white
paint and modern lighting completed the installa-
tion. In Boutique a dominant feature of the sales
floor was a large rustic table, on which stood an
antique cash register.[13]

For students in the early 1960s in Helsinki (this
author included), the world of the future began at
the Rautatalo on Keskuskatu. The elegant café in
the atrium was the place to be seen if you were
interested in the arts. One climbed the stairs to
Vintti especially to study the latest dress designs,
which could be imitated in homemade versions.
Like the Artek shop, with all its Aalto furniture and
other icons of modern design, Vintti had more in

common with an art gallery than with the Stockmann department store, and in any case hanging out at the mall was unknown at the time. Most students did their actual shopping in the more modest Marimekko store on Tunturikatu in Töölö, which at one time specialized in remnants and seconds, or at Piironki in Fabianinkatu in the center, next to the university's main building.

Outside Helsinki the shops were more modest. Piha's drawings for Marimekko shops in other major cities in Finland include one in Jyväskylä (1963), a university town in central Finland, and another in Kuopio (1966) in northeastern Finland. They were both variations on the Helsinki stores: established shops were cleared and turned into brilliant white rooms as a backdrop for the multicolored fabrics and garments. The built-in shelving, suspended space grids, and new types of lamps made the Marimekko shops distinctive and instantly recognizable. The lighting was always designed and chosen with special care, from light fixtures that were mostly of standard manufacture. On the ceilings, Piha preferred Orno domestic lamps, whose installation he specified with minute precision in an annotation on his drawing: "must be inset so that the plastic glare shield projects half a centimeter below the surface of the ceiling." For the sewing tables he indicated black Luxoma architect's lights. Among the Jyväskylä drawings there is also a mention of new lighting "to be manufactured according to special designs by 'master metalworkers'."

Mysi Lahtinen, a multitalented designer who worked at Marimekko from 1959 to 1966, recalled the great variety of projects she worked on over the years.[14] Her career began immediately after school in Seinäjoki, a town in northwest Finland. Armi Ratia, a family friend, welcomed her to the company. Lahtinen recalled Ratia explaining that at Mari-
mekko everyone was a director, everyone was trusted to be able to do everything, and so they were and they did. The opening of Kammari (Kalevankatu, 1960), for example, represented a true team effort and was accomplished in a swift, improvisatory manner by the Marimekko staff rather than an architectural firm.

Before leaving on a business trip to the United States in 1960 Armi Ratia assigned Lahtinen the task of finding space for the Kammari shop in central Helsinki, mainly for the sale of fabrics. Ratia wanted the opening to be held soon after she returned from abroad that same year. Suitable premises were found opposite Kosmos, a fashionable restaurant in Helsinki frequented by artists. Ratia gave her approval by telephone, and Lahtinen and Mari Villanen, another Marimekko talent, set to work. According to Lahtinen, Villanen was a genius at staging shows at Marimekko no matter what the circumstances.

For the Kammari project, no plans were drawn up. The space was stripped clean and painted entirely in white. At the Marimekko factory there was a workshop where stored furniture could be altered to suit different locations. The impeccable craftsmanship of the fittings of all the Marimekko shops was one of the company's signatures. Marimekko's skilled carpenters Matti Varis and Eki Lappalainen, working with manager Arvo Nurmi, were largely responsible for maintaining the high quality. New shelves were made from old ones for the bolts of cloth to be displayed and sold at Kammari, and a sales counter was created from a white laminated board and tubular steel legs. Despite the recycling of furniture, the overall effect at Kammari was of a modernist interior. By the time Armi Ratia returned from America, the store was ready for its opening ceremony.[15]

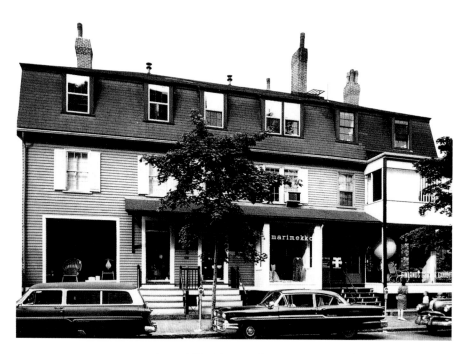

## Armi Ratia and Benjamin Thompson

Ratia's interest in modern architecture and its various cultural manifestations, as well as her belief in the importance of architecture, may have derived in part from her collaboration with the American architect Benjamin Thompson, who had been a pupil and associate of Walter Gropius and was professor of architecture at Harvard. In 1953 he had founded Design Research in Cambridge, Massachusetts, a retail establishment that offered beautifully designed and crafted household furnishings and objects. Under Thompson's direction, DR, as it was familiarly known, pursued a utopian goal — the complete modernization of design culture in the United States.

In 1959 Design Research became the American representative of Marimekko. In writing about the beginning of his involvement with Marimekko, Thompson recalled: "we made a little 'selling' shop on the second story of the old Design Research house on Brattle Street (fig. 4–10). Now we wanted to light the streets of Cambridge and Boston with color. The walls were white and pink. The exhibition was soon 'alive' with customers and salesgirls in bold colors. The Design Research store represented contemporary life. Marimekko *was* new freedom of movement — women in an equal rights world, breaking into a new life."[16]

In fact this lofty mission goals conflicted with the reality of the company. The Finnish writer Jörn Donner described his surprise at seeing Marimekko dresses in 1963 when he was living in Cambridge opposite DR: "Marimekko clothes are far from haute couture. These clothes are not made for people but for society, for a type. Outside Finland, however, Marimekko dresses are very expensive and they have become a mark of elitism and exclusivity. 'The uniform of the rich,' says a New York fashion editor."[17]

## Aarno Ruusuvuori and Marimekko factory designs

The first actual Marimekko factory in Helsinki was established in about 1963, at Vanha Talvitie 3, in the Verkkosaari district, on the top two floors of an old industrial building behind the city's abattoir. Ruusuvuori, now established as the firm's architect, designed the alterations to the office; drawings preserved in his archive date from February 1963 to February 1964. It was at this factory that Marimekko's textile printing began to flourish. According to Viljo Ratia, the "Marimekko spirit" was at its best there,[18] and Rebecka Tarschys, who has written enthusiastically about Marimekko since about 1958, when she was editor of the Swedish newspaper *Dagens Nyheter*, vividly described the atmosphere during an early visit to the first factory. She wrote in 1986 that "it was the factory itself that made the greatest personal impression on me. It was all so human, each employee was dressed in Marimekko clothes and in a corner for rest there

were heaps of cushions upholstered in Marimekko fabrics; at lunchtime the cook ladled the soup into ceramic bowls. The relations between people were friendly. The office's white interior decoration, which reached its climax in director Armi Ratia's study, held me spellbound. The large writing table and the fixed benches, the first of those wall-fixed shelves consisting of square boxes."[19]

Ruusuvuori had come within the Marimekko circle in the early 1960s. He and his staff of up-and-coming young architects — Erkki Kairamo, Pentti Piha, and Reijo Lahtinen (Mysi Lahtinen's husband) — met frequently with Ratia and the Marimekko designers at the manor house of Skjöldvik, near Porvoo (whose dilapidated main building is supposed to be haunted). The house had been rented by Marimekko and until 1963 was the center of

Armi Ratia's social life, her court, the locus of her perpetual longing to remain tied to her Karelian roots. When in the summer of 1963 Armi and Viljo Ratia purchased the manor house of Bökars, in the village of Gäddrag, near Porvoo, Armi Ratia's Karelian-inspired court acquired a permanent setting. At Bökars there was a manorial estate in a beautiful landscape with a main building, servants' hall, cowshed and barn, and a windmill and kiln farther off.[20] In this rural setting, which in many ways shaped Marimekko's history, a connection was forged between Ratia and Ruusuvuori, which in the mid-1960s produced an exciting series of interrelated ultramodern architectural designs.

There is no exact information about how Ratia and Ruusuvuori found each other, although in Finland it is often said that "everybody always

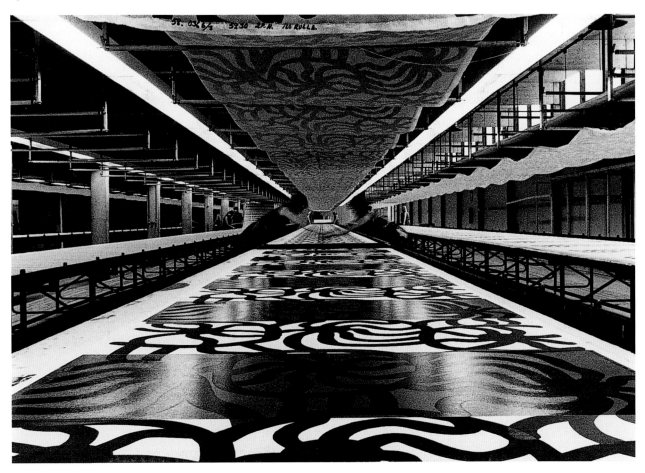

Fig. 4–11. Ruusuvuori office / Reijo Lahtinen and Bertel Ekengren. The Marimekko factory, Vanha Talvitie 6, Helsinki, 1967. Museum of Finnish Architecture, Helsinki.

knows everybody." They shared a strong faith in a kind of total modernism, their aesthetic ideals matching each other in a unique way. Their collaboration lasted until 1967, when it ended abruptly, although they continued to appear together in sales promotions. The exact reasons for the breakup are unknown, but Ratia and Ruusuvuori each had exceptionally uncompromising natures, and such people can seldom work together for very long.

Ruusuvuori's office represented the most utopian modernism in Finnish architecture at that time.[21] Ruusuvuori and "his boys" were critical of Alvar Aalto's organic architecture with its free forms. Instead they developed clear modular systems, taking an approach comparable to Mies van der Rohe. Yet Ruusuvuori's clear-cut system architecture — especially in his church designs — could be criticized as an incomprehensible, concrete brutalism. At the same time the asceticism and crystal-clear purity of his style can be appreciated as a strong response to commercialism, to the confused and gaudy forms prevalent in contemporary architecture. Ruusuvuori, the austere poet of a rigorous modernism, helped to define Ratia's architectural vision during the most active phase of his career.

Three churches by Ruusuvuori — Hyvinkää Church (1961), Huutoniemi Church (Vaasa, 1964), and Tapiola Church (1965) — form a unique series of sacred buildings in Finnish monumental architecture of the 1960s. Ruusuvuori was also a master of industrial architecture after designing a printing plant for the firm of Weilin & Göös in the garden

city of Tapiola (1964), west of Helsinki. The building is square in plan and fitted into the rock slope; its elegant construction of prefabricated concrete elements created a large and light framework for the printing process itself.[22]

In 1966 Ruusuvuori designed a factory for Marimekko in Tapiola, on the same street, Ahertajantie, as Weilin & Göös's printing plant. Tapiola, now part of the larger city of Espoo, was the most ambitious garden city project in Finland after World War II. It began as a special project in 1952, with an initial mission to include many workplaces, such as the printing plant and textile factory, in the outskirts of the garden city to make it self-sufficient. Yet this plan did not succeed, and from the beginning most of the inhabitants commuted to Helsinki to work. In the Ruusuvuori archive, a single drawing, that of the arrangement of the site on Ahertajantie, has survived. The project fell through, although hindsight suggests that the Marimekko print works would have been well suited to Tapiola's garden city image.

In 1967, after negotiations with the township of Espoo stalled, a new Marimekko factory was planned and constructed at Vanha Talvitie 6 in Helsinki. In Ruusuvuori's office the architect in charge was Reijo Lahtinen. A report in the Finnish architectural journal *Arkkitehti* emphasized that the print works was a temporary building, making it logical to use panel construction, which would later facilitate moving the building to a new location.[23] In the catalogue of Ruusuvuori's works,

Fig. 4–12. Ruusuvuori office / Reijo Lahtinen. Facade of the Marimekko factory, Vanha Talvitie 6, Helsinki, 1967. Pen and ink. Museum of Finnish Architecture, Helsinki.

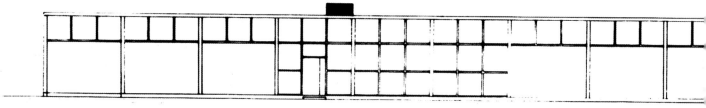

however, the print works is merely marked "demol-ished" and Lahtinen had no recollection of possible moves or reuses.[24]

The modular system of the print works was based on the dimensions of the printing table and the needs of the printing process. Both the vertical and horizontal dimensions of the module were set at about 5 feet (1.5 meters). The supporting pillars were made of reinforced concrete, the roof joints of wood, and the walls and roof of weatherproofed wood in ready-made panels. The volume of the long, low building was 353,000 cubic feet (10,000 cubic meters).

The structure of the print works was designed by Reijo Lahtinen and Bertel Ekengren. In the office an exact system was developed on the computer,[25] the merit of this being that the whole process of design and construction could be completed in six months, even though prefabricated elements were made on site.[26] The reason for the rush was not the usual practical necessity, Lahtinen recalled, but rather so that the factory would be ready for Mari-mekko's early Christmas celebrations.[27]

In Matti Saanio's sharp black-and-white photo-graphs the precision of the architectural details is contrasted with the exuberance of the fabrics (fig. 4–11). According to annotations on the factory drawings, the wooden panels of the outer walls were thinly painted in dark blue. Ruusuvuori liked to use artists as experts on color, and according to Lahtinen, the colors of the printing hall were chosen by the painter Anitra Lucander, who was later to

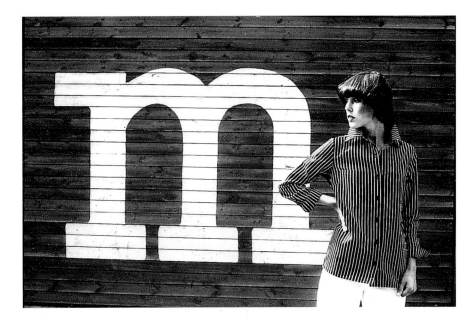

select the facade colors for Ruusuvuori's renovation of historical buildings near Helsinki's City Hall. On the printing plant's street facade the words "mari-mekko oy" were painted in white, one letter per building panel (fig. 4–12). This served a decorative as well as promotional function. Marimekko's graphic art stood out in the confused industrial landscape of the Verkkosaari area of northeastern Helsinki. In fact the light-structured Marimekko print works itself stood out from the nondescript buildings around it.

In the summer of 1968 an advertisement in *Helsinki-Viikko*, a travel magazine, invited the public to the opening of a retail shop in Marimekko's textile print works. The same advertisement listed the addresses of other Marimekko shops — Vintti, Boutique, Muksula, and the textile shops Kammari and Piironki. The firm's image in the streetscape of the capital was varied and absolutely modern.

Fig. 4–13. Vuokko Nurmesniemi's *Jokapoika* shirt (1956); *Piccolo* pattern (1956). Photographed outside the Marimekko factory, Vanha Talvitie 6, Helsinki.

## Marikylä and the experimental house

At the same time that Ruusuvuori was working on the textile printing plant, he was also making preliminary designs for one of Marimekko's most ambitious projects: Marikylä, a village planned for the leasehold property of Bemböle, in the northern outskirts of Espoo. There was to be housing for 3,500 inhabitants and a factory to employ many of them. The Marikylä corporation was founded in 1963, with Ruusuvuori as architect and Polar Osakeyhtiö to do the construction. The lease agreement with Espoo was considered to be solid, especially since Viljo Ratia's brother, engineer Urpo Ratia, was a coalition representative on the town council, and Armi Ratia had joined the Social Democratic Party as a guarantee of support from the other big party on the council. When the project was considered by the council in October 1964, however, it failed to gain approval because of resistance from the extreme left-wing Social Democratic People's Party (SKDL) and also because of confusion over the town planning.[28] Mysi Lahtinen recalled that at one time a multitude of tulip bulbs were planted in the Bemböle district, "so that at least there would be something there."

In the Ruusuvuori archive, the plans are vividly illustrated by photographs of the model (fig. 4–14). The back of one of the photographs is annotated: "scale model of Marikylä, planned for the south shore of Lake Bodom." Judging from the scale models, the first Marikylä would have been made up of two factory halls and three groups of residential houses. In the model two larger rectangles linked to the composition of the prefabricated and terraced houses can be interpreted as factory buildings.[29] The long, narrow apartment houses were arranged on the sloping landscape in relation to each other in such a way that they provided a setting for groups of low terraced houses. The composition was entirely freeform.

Once the arrangements with Espoo fell through, the search began for a Marikylä site to the east of Helsinki. At this stage Urpo Ratia became the production manager and a member of Marimekko's board of directors. When only Porvoo showed interest in the project, the plan expanded, changing from a predominantly residential district into an industrial village. In June 1966 the city of Porvoo and Marimekko Oy signed an agreement according to which the town granted Marimekko a factory site area of about 20 acres (8 hectares) and a residential area of roughly 17 acres (7 hectares).[30]

The event was widely and enthusiastically covered by the press, and in interviews Armi projected that Marikylä, the first 250-residence village, and its factory would be completed by 1970: *The building of the factory was decided some six years ago, and since then we have been looking for a suitable site. First I spun the globe round in my head and thought of America, Italy, and goodness knows where else. In spite of everything, I decided on Finland, as I like difficulties, you see... At first the cottage idea took hold of me, and in my mind I situated the factory close to Helsinki, about 30 kilometres away [about 18½ miles]. Then we searched for a suitable site in that area: we walked, skied, drove by car, and hung out of a helicopter, but it didn't look good. Just marsh and pine trees. We wondered how we could give the factory's environment a human face. The idea of building Marikylä was born. And then came Porvoo, and June 7, 1966. ... Coming to Porvoo was a very good idea. I felt very much at home here even before a single stone was in place.... The plan has succeeded and is sufficiently flexible. We're starting our own building work with Marikylä, which as I said will have 250 houses.*

▶ Fig. 4–14. Aarno Ruusuvuori. Scale model of Marikylä, Bemböle, Espoo, 1966. Museum of Finnish Architecture, Helsinki.

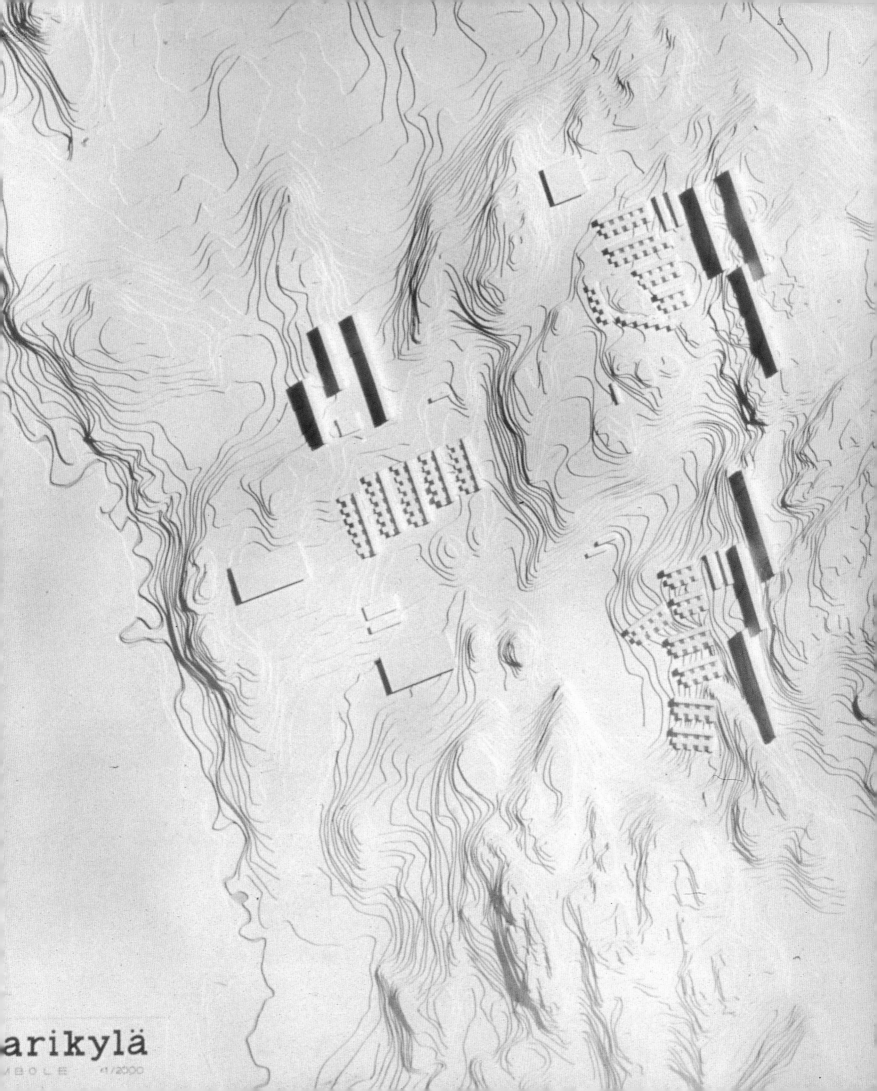

arikylä

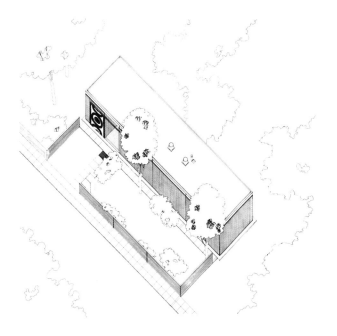

▸ Fig. 4–15. Aarno Ruusuvuori. The Marikylä experimental house known as the Marihouse, Bökars, Porvoo, 1966. Pen and ink. Museum of Finnish Architecture, Helsinki.

▸▸ Fig. 4–16. Armi Ratia on a Caterpillar during construction of the Marihouse, Bökars, Porvoo, 1966.

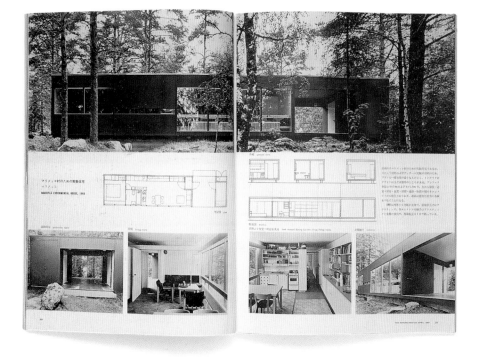

▴ Fig. 4–17. The Marihouse as it appeared in the Japanese design journal, *Kokusai-Kentiku* (April 1967): 30–31.

*The factory itself has an area of 40,000 square meters and it will be built in several stages. . . .First we'll build 6,000 square meters and in the first stage the whole of Marimekko's office, management and dressmaking department will move there.*[31]

At a celebratory dinner at Bökars, Ruusuvuori spoke about the future landscape of Marikylä, the glass-walled inner courtyards, the stone gardens in which water would flow. Armi Ratia said that the stones would be brought from across the border of the Soviet Union, from the region of her youth, Pamilonkoski in Karelia, and that on them would be engraved the names of those people who had believed in the project even in difficult times. Caught up in such rhetoric, one columnist described the coming of Marimekko to historic Porvoo as "a fresh transfusion of blood into the insipid, pale-blue plasma of the old aristocracy."[32] In more mundane language, this meant that Marimekko held out the promise of much-needed jobs for local residents.

Ruusuvuori introduced his designs for Marikylä and its experimental model house, known as the "Marihouse," in *Arkkitehti* (1966). The dimensions of the residential buildings were based on a 23½-inch (60-cm) module. The technology of the experimental house was developed in collaboration with engineers from the leading Finnish firms, Puutalo

Oy and Enso-Gutzeit. All the bearing constructions were designed as a cell framework, with veneers glued to each side. In his careful explanation of his structural solutions, Ruusuvuori emphasized that they depended on factory technology that was both very advanced and very precise, or as he explained, made to within "about one millimeter." In the Ruusuvuori office the plan was supervised by architect Paavo Mykkänen and architectural student Ilkka Salo, while the construction specialist was once again Bertel Ekengren.[33]

The first Marikylä experimental house (figs. 4–18 and 4–19) was assembled at Bökars from four prefabricated spatial units, each of which measured about 9 4/5 × 13 × 7 4/5 feet (3 × 4 × 2.4 m). One unit housed the bathroom and kitchen. Another unit, on one side, contained the bedroom, and on the other side, two units comprised the living room. Entry was through a small hallway partitioned off from a corner of the living room. Opposite it, situated under the same flat roof, were an entry terrace and a storeroom and a garage, the door of which was situated opposite the door of the dwelling.

Ruusuvuori called his 56½-square-foot (48 sq. m) experimental house a "minimum dwelling." The photographs, however, taken in the beautiful natural surroundings of Bökars, were interpreted in the international press as images of a luxury villa. The "Blue Submarine," as the house was called, glowed with strong Marimekko colors while birch and pine trees and boulders provided a dramatic backdrop, even when reflected in the windows. In the color photographs, taken at evening, the painted surfaces of the interiors and the red and yellow of the textiles were visible from outside, through the large windows of the dark blue exterior. The built-in closets, the built-in shelving and

interior design of the kitchen saved the small house from giving the impression of being cramped. The bathroom was enhanced by an unusual, horizontal window above the bathtub and washstand. Ruusuvuori's rigorous system of measurement was the perfect framework for Marimekko's strong colors and forms.

The international press was enthusiastic about Marimekko's conquest of new architectural territory. *Elle* in France and *Allt i Hemmet* in Sweden published color photographs by Roger Gain and Bruno Mylén, which were very different from the black-and-white compositions of Finnish architectural photographers. The Marihouse shown in the world press was less somber and more easily

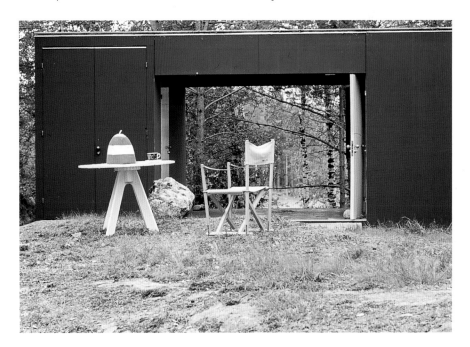

approachable, using more everyday light than in the Finnish photographs. Gain's photographs received wide distribution, and the Finnish women's magazines enthusiastically translated the texts.[34] A Swedish editor praised Marimekko's conquest of the world and the everyday luxury (*vardagslyx*) that Armi Ratia had been teaching

Fig. 4–18. Aarno Ruusuvuori. Entrance to the Marihouse, also nicknamed the Blue Submarine, Bökars, Porvoo, 1966.

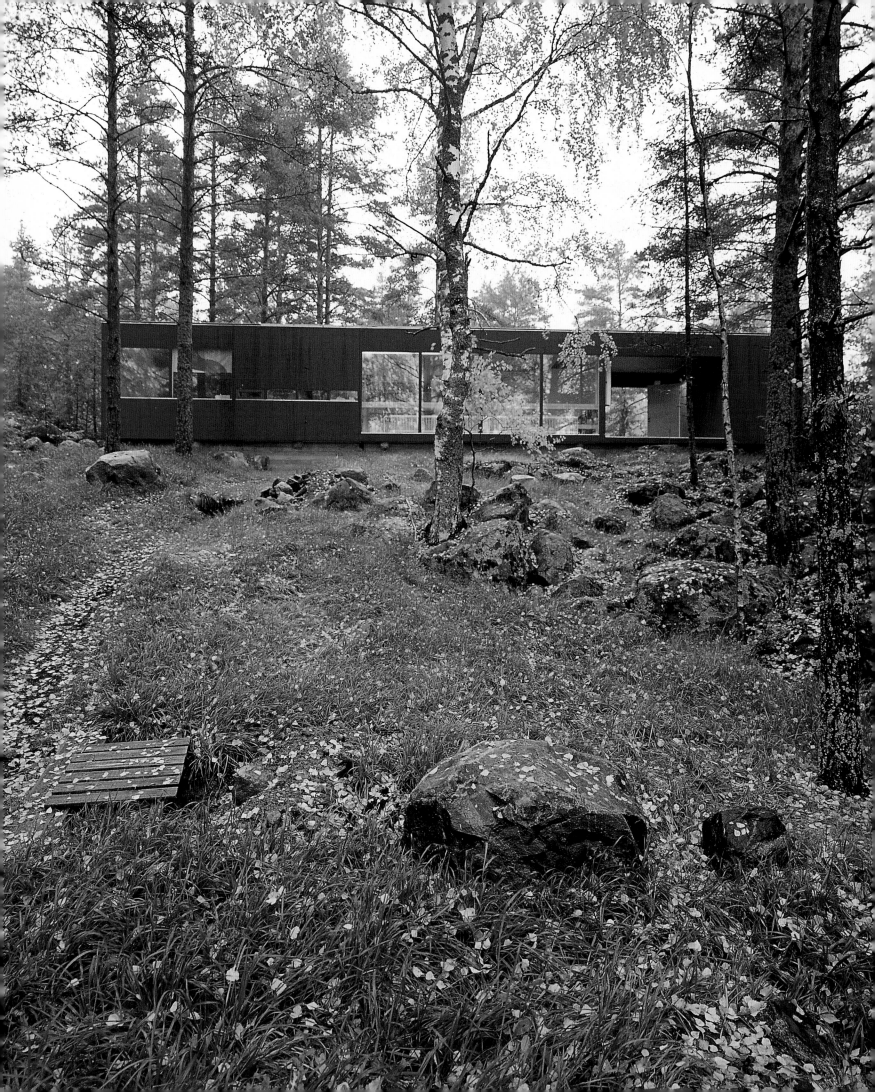

and selling to ordinary people for years. The Swedish interpretation emphasized enlightenment and education: the "Mary dress" (marimekko) followed naturally from the best tradition of Swedish design, the democratic philosophy of *vackrare vardagsvara* (more beautiful things for everyday life) that had been preached by Svenska Slöjdföreningen (Swedish Society of Crafts and Design) since the 1910s. The approval granted the Marihouse is particularly interesting in view of the fact that as late as 1958 the Marimekko sales exhibition in the Artek display rooms in Stockholm had radically conflicted with the conservatism of Swedish taste. Sales had been disappointing, and the newspapers had quipped, for example: "Are they having a joke at our expense?," and "Wishful thinking about the simplification of our way of life," and again, "Nothing like this has probably ever seen the light of day."[35]

The first inhabitants of the experimental house were Armi Ratia's son Ristomatti with his wife and young child. The space immediately revealed a basic flaw. Aesthetics aside, it felt cramped, especially the kitchen.[36] Armi Ratia explained that development was continuing, that the greatest problem from the point of view of comfort was that the house was too narrow, a limitation caused by the fact that the units had to be transported by truck and could be no wider than what the roads could handle.

The Marikylä community project was intended to consist of different-sized dwellings, most of them 645½ and 1,706 square feet (60 and 100 sq. m). In the scale model of the village (fig. 4–14), the houses rhythmically encircle small yards, some of which are inner courtyards, while others separate two houses from each other. The rhythmical composition of the volumes of the flat roofs with their fluctuating surfaces is lively. Marikylä, however, was never built.

Why did this carefully organized, ambitious project fail? Once again, everyday reality asserted itself as it had in so many other utopian urban dreams, stretching back to the time of the Renaissance.[37] In more recent times Alvar Aalto had also tried and failed to eliminate the stigma of social inequality from the factory community by architectural means when he designed Sunila in the 1930s.[38] The patriarchal spirit of Nordic factory villages and the social inequality associated with them were still fresh in the minds of the Finns in the 1930s as they were in the 1960s. It may be thought that the utopian tradition had encouraged the idealism of Armi Ratia and Aarno Ruusuvuori. There is evidence to show that both were serious about their own utopian project. Pallasmaa recalled a meeting at the Palace restaurant between the project leaders, from both Marimekko and from Ruusuvuori's offices, and two leading sociology professors, Paavo Koli and Yrjö Littunen, who had been invited to discuss their ideas on the sociological and psychological aspects of Marikylä.[39]

The press partly attributed the demise of the project to the apparent unwillingness of the Marimekko employees to move out of Helsinki to the countryside. Donner, who compared Marikylä to Ivres, the famous Italian community built in the 1930s by Olivetti,[40] suggested that the Marimekko project failed simply because Armi Ratia considered the experimental house a failure.[41] According to Donner, Marimekko experienced a severe economic crisis at the end of 1967, leading to fundamental changes in the company between 1968 and 1971. Finances grew tighter, there were cutbacks in staff, and Marikylä had to be shelved, even though the Porvoo town council did not want to give it up. Donner wrote: "None of this could have been done directly against Armi Ratia's wishes: she was openly

◄ Fig. 4–19. Aarno Ruusuvuori. The Marihouse, Bökars, Porvoo, 1966. Museum of Finnish Architecture, Helsinki.

► Fig. 4–20 a, b, c.
Interiors of the Mari-
sauna, 1966. Museum
of Finnish Architecture,
Helsinki.

*reluctant*. Her greatest dream, which was symbol-
ized in the idea of Marikylä, the idea of an ideology
of modern living, was breaking into fragments.
After this a new Marimekko was born, but it was
mainly a company devoted to textiles, not a manu-
facturer of tumblers and soap, houses and furniture,
etc."[42]

## The Marisauna

In August 1968 Armi Ratia and Ruusuvuori were
photographed on the front steps of a small prefab-
ricated building that had been erected beside the
central reflecting pool in Tapiola, near the new
church designed by Ruusuvuori.[43] The event was
part of an impressive marketing campaign for a
Marimekko sauna, which was being offered sepa-
rately from Marikylä. *Helsingin Sanomat,* which
covered the story, announced: "Stylish Marisauna
sold as luxury package to the USA."

The sauna was developed from a merging of the
experimental Marihouse and a sauna that Ruusu-
vuori had designed for his parents at Kerimäki in
1963. The Marisauna consisted of three sections,
with glass walls separating an outer terrace,
dressing room, and steam room from one another.
The outdoor space could easily be enclosed by
suspending sheets of canvas with snap fasteners.
In the example shown at Tapiola, Maija Isola's *Lokki*
fabric was used.

Ruusuvuori's original sauna for his parents had
been more modest, consisting of only two sections.
(It is still in use in 2003.) Photographs of the sauna
draw attention to the small closet alcove of the
open anteroom. Its hatchway unfolds, by means of
chains, and doubles as a table at which people can
have refreshments after their sauna. When the
hatch is closed, the wall is flat, and there are no
small objects to disturb the eye.

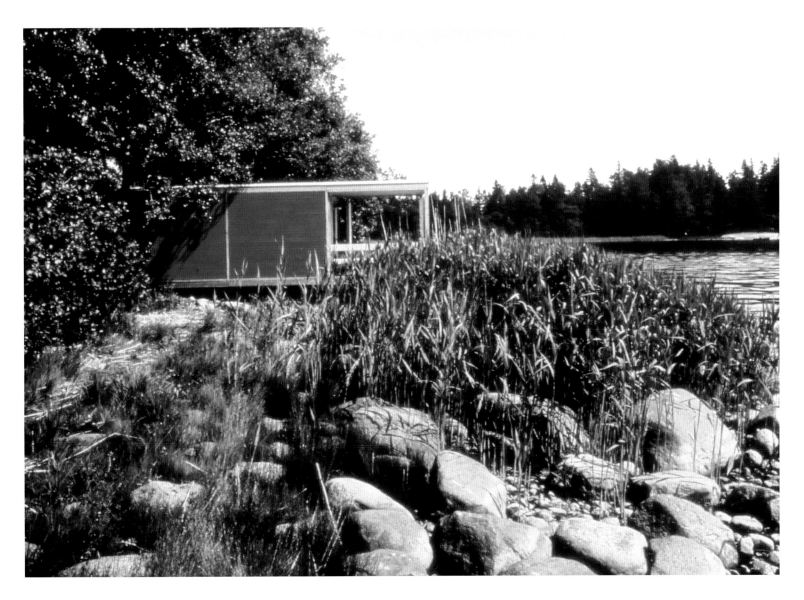

Working with the engineering office of Palo-heimo & Ollila, Ruusuvuori created the Marisauna to be a prefabricated product. Three roof units, three floor units, five opaque wall units, and two glass wall units could be assembled on supports or joists within the space of a single day. The material of the frame was weatherproofed pine, while that of the outer walls was painted or weatherproofed pine paneling. For the interiors either abachea or pine was offered, and for the floor there was plastic matting, on top of which coconut fiber matting was spread. [44]

Ruusuvuori explained that the sauna was meant to be situated near a body of water. He explained: "Shining water, the structure's open character, and the pale wood make the sauna an expression of purity, freedom and light."[45] In the same year, before the Tapiola presentation, a prototype of the sauna was displayed for a week on the shore of Espoo's Karhu-saari, an island near Tapiola. Simo Rista's iconic photograph, taken from inside the sauna, looking out to the sea, captures the lightness of this most beautiful architecture (fig. 4–1). It is as though the structure were merely an extension of the landscape.

Fig. 4–21. Aarno Ruusuvuori. Mari-sauna, Karhusaari, 1966. Museum of Finnish Architecture, Helsinki.

The Marisauna was offered in the United States, where it was thought the high price would not be a problem for wealthy clients. Marimekko's 1968 English-language brochure showed the Karhusaari shore and included drawings made to a scale of 1:100. It also offered a "Sauna Package" which included all the bathing requisites — the basins, scoops, brushes and soaps, as well as two bathrobes and a towel.[46] The managing director of Design Research International had ordered his sauna even before the prototype was ready.[47] This was the only foreign sale; in Finland, one went to Aarno Ruusuvuori's cousin Eero Ruusuvuori in Kemiö.[48] From the Finnish point of view the idea of buying a sauna as a ready-made product was obviously strange. The light elegance of Ruusuvuori's design was also far different from more traditional Finnish saunas, which were usually massive log constructions built according to vernacular traditions on waterfront properties. The designs for the Porvoo Marikylä and the Marisauna were to be the last collaboration between Marimekko and Ruusuvuori.

## A Swedish intermezzo

In September 1968 the Stockholm newspapers gave prominent coverage to the opening of Ringbaren, the first "Marimekko Restaurant," which was located in the center of a new Stockholm suburb, Skärholmen.[49] Surrounded by enormous concrete apartment houses Ringbaren added a touch of color. It comprised a bar, café, steakhouse, and street grill. The interiors were designed by Ristomatti Ratia, Simo Heikkilä (an emerging industrial designer), and Lars Carpner, a Swedish interior designer who coordinated the project. A new design division was established at Marimekko called Marimekko Interior Decoration (MID), of which Ratia and Heikkilä were directors. The Ringbaren color scheme was based on bright red, dark blue, yellow, and white firework patterns. Contemporary photographs reveal the reflective surfaces of laminated tables and plastic chairs with tubular metal legs, which mirrored the red and white ceiling, while round lamps suspended like ornaments and seemed part of the pattern of squares and stripes of the walls and curtains (fig. 4–23).[50]

▼ Fig. 4–22 a, b, c. Ruusuvuori office. Sections of Marisauna (scale 1:10), Helsinki, 1968. Pen and ink.

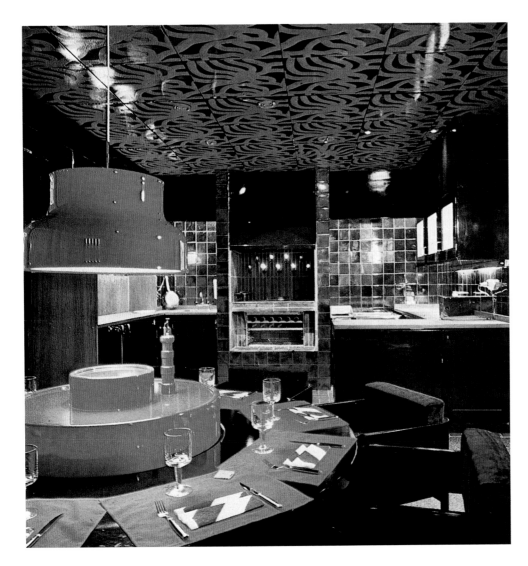

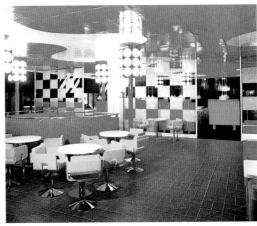

Distinguished industrial art editors, such as Åsa Wall, admired the wildly modernist interior of Ringbaren in eloquent language. Wall described it as a milieu for an open and informal lifestyle, which was expressly meant for a wide audience, not just the elite. Rebecka Tarschys, who was harshly critical of Skärholmen's boring residential architecture and the flat milieu of the shopping center, had nothing but praise for the Marimekko restaurant. Although both writers heralded the promised future collaboration between Marimekko and the restaurant chain, Ringbaren seems to have been the sole commission.

## The Herttoniemi factory

By the late 1960s and early 1970s the fiscal crisis at Marimekko had been resolved and there was renewed interest in building a factory. In 1972 the company signed an agreement with the Helsinki City Council for the lease of a large industrial site located in Herttoniemi, an industrial district not far from the city center.[51] Although the plan was simply for a large industrial plant, this project, like its failed predecessor, contained influential utopian features. The architect commissioned for the work was a modernist of the younger generation, Reijo Lahtinen, who had left Ruusuvuori's office in 1968

Fig. 4–23 a, b. Ristomatti Ratia, Simo Heikkilä, and Lars Carpner. Interior of the Ringbaren restaurant, Stockholm, Sweden, 1968. From *Restauratören* (1968):9.

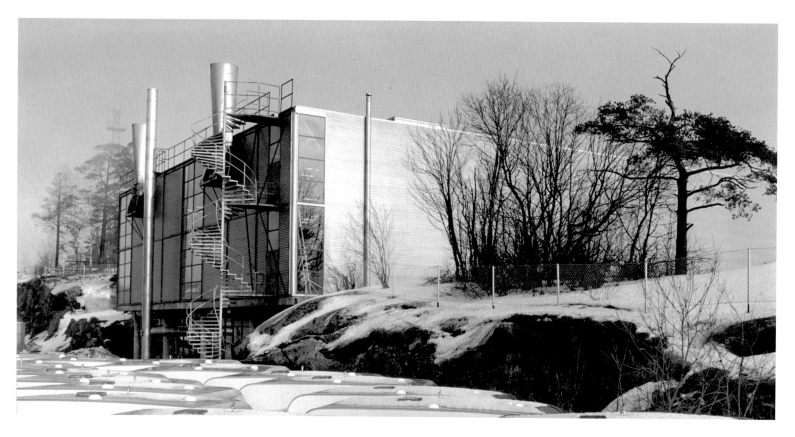

and like most of Ruusuvuori's earlier employees
had a small studio of his own.[52] Lahtinen chose to
work on the Herttoniemi factory project with Erkki
Kairamo, another former colleague from the
Ruusuvuori office.

Lahtinen first studied the site and made
preliminary sketches, which he presented to Armi
Ratia and Jaakko Lassila, an important bank director,
who was then chairman of the Marimekko board.
At the presentation meeting Lassila raised the
subject of finances, and as Lahtinen recalled: "Then
Armi exploded. 'If you don't give us the money, I'll
use the sales promotion funds! The new factory
must be a sight of as much value as the Temppeli-
aukio Church'."[53] This last comment referred to the
"cave church" in the heart of Töölö in Helsinki,
which was designed by Timo and Tuomo Suoma-
lainen and has been a tourist attraction since its
completion in 1969.[54]

According to Lahtinen, the new factory was
designed by Kairamo, while Lahtinen himself super-
vised the project. Pertti Hokkanen also assisted and
was responsible for the beautiful final drawings. The
main idea of the factory plan was optimum flexi-
bility. A large part of the surface area, therefore, was
a single, integrated factory floor. Armi Ratia demand-
ed that the factory be capable of manufacturing a
wide range of items — anything from potholders to
houses. Operations not connected with production
were to be located either above or beneath the main
factory floor, although some of the offices, design
studios, and other work spaces were directly con-
nected. With the exception of closets and wash-
rooms, staff spaces were situated on the roof, which
compensated for land surface lost to the building
footprint. In the large-scale model the roof is seen
to accommodate a children's playground, tennis
courts, and a swimming pool with its own sauna.[55]

The original plan of the Marimekko factory comprised a total of 74,130 cubic feet (21,000 cubic m). The first part, which was completed in 1974, contained a printing machine, storeroom, and a room for utilities, and was only 33,356 square feet (3,100 sq. m) in area. The color scheme was chosen by the artist Jorma Hautala. The factory building was constructed of steel tubes and concrete plates based on a precise metric system where different parts are composed of elements measuring 4.5 by 4.5 meters, 9 by 9 meters, and 9 by 18 meters. The facade was formed by exhaust tubes and spiral stairs as emergency exits, which form strong vertical accents; the windows are protected from the sun by racks of awnings, which would also be used to test fabrics. The surface of the facade is made of profiled aluminum sheets.[56] (In 1981 an extension to the factory was designed by architect Ilkka Salo in an entirely different spirit, as an ordinary factory, a simple closed cube lacking a distinctive character.[57])

Kairamo's architecture is dynamic and vigorous. It was evidently inspired by the aesthetics of 1920s constructivism, although the overall design of the building is markedly new and personal. The impression of the factory is wonderfully cheerful and buoyant. In fact the earliest sketches for the Herttoniemi factory in Kairamo's archive date from 1971 and are lively delineations of the basic themes of the plan.

Although similarities between the architecture of Ruusuvuori and Kairamo have often been emphasized, the differences are also clear. Ruusuvuori's architecture is always ascetic, quiet, and reserved, while Kairamo's constructivism is vivid, even jarring at times. Their design methods also differed completely from one another. The development of Ruusuvuori's designs cannot be followed

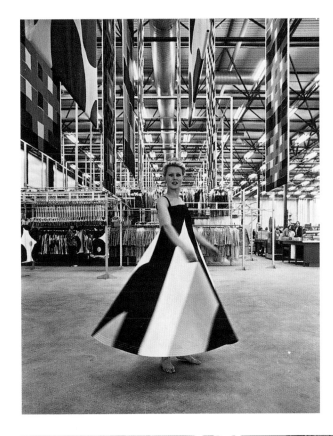

◄ Fig. 4–25. Annika Rimala. *Kruuvi* dress in *Ramina* pattern, 1968. Photographed inside the Marimekko factory in Herttoniemi, mid-1970s.

Fig. 4–26. Erkki Kairamo and Reijo Lahtinen. Printing Hall of the Marimekko factory in Herttoniemi, 1972–74. Museum of Finnish Architecture, Helsinki.

Fig. 4–27 . Erkki Kairamo and Reijo Lahtinen. External stairway, the Marimekko factory in Herttoniemi, Helsinki, 1972–74. Museum of Finnish Architecture, Helsinki.

he said: "I myself would prefer to use the word *lyricist*, because lyrical architecture is my goal, even though it has perhaps not yet been realized, and constructivism is one architectural means of achieving it. But don't these definitions really belong to others, not the designer. In the division you present, I certainly belong to the expressive half. I have very little to do with the Chicago tradition of constructivism, because the starting point of what I do is dynamics, the meeting point of dynamic lines of force and the possibilities dictated by it. I need to move the houses around in my mind, or point them in some direction. . . . Rather than an act of homage to technology and machines, I would prefer to see my work as an act of homage to man. Factories are the temples of our time, they produce the welfare of mankind, often working 24 hours a day, whereas people only go to church at most for a couple of hours on Sunday. I try to make them as good an architectural and working environment as I possibly can, consciously using those elements that are offered by the production plant to help me. Let lyricism be born from the process, the machines, the tubular bridges, the air conditioners or even the fire escapes, they must only help to serve the demands of beauty." [60]

Kairamo called the decorative elements of his industrial buildings — the spiral staircases, smokestacks, and fire escapes — "the poetry of statutory requirements." [61]

## The Context of Marimekko architecture

In 1966 *Arkkitehti* presented the Marimekko experimental house in an issue entirely devoted to compact single-family housing. [62] The editorial stated that the building of single-family houses after World War II had concentrated on the individual unit, and that interest in coordinating housing with

from the sketches, because he developed his designs mostly in his mind and drew very little. Kairamo made many sketches and drawings and carefully preserved them. [58]

Kairamo has been described as an expressive constructivist, but he was more content with the appellation "lyrical constructivist." He discussed his definition of architecture with his close friend, architect Kirmo Mikkola, in the catalogue accompanying *Form and Structure*, an exhibition shown in 1981 at the Ateneum Art Museum in Helsinki. [59] In it

town planning had been minimal at best. The journal called for a new approach to urban design and published a wide selection of industrial, single-family house plans, including some rare built examples.

As a background to the Finnish examples, an interview about industrial building was published, in which the international authorities Serge Chermayeff, Sverre Fehn, and Henning Larsen dealt more extensively with the views of Finnish architects. The new architectural philosophy being sought was called a "scientific approach." It can be better understood if one considers the fact that the same issue contained a Finnish translation of Christoffer Alexander's article "City is not a tree,"[63] Alexander's essay was later quoted in countless articles and lectures, becoming one of the most important texts in architectural discussions of the 1960s. The younger generation of architects wanted to design cities as total artifacts so that single houses were parts of a bigger system, sharing a structural logic and harmonious proportions. Prefabrication was considered the natural way of achieving this new kind of harmony.

Industrial building had already been the theme of an earlier issue of *Arkkitehti* that same year, in which were presented "several architects closely associated with a rationalist philosophy, for whom construction . . . is an essential part of the architectonic whole."[64] To promote industrial building in Finland some questions had been posed to several notable architects — Jean-Marc Lamunière, Frei Otto, Pierre Koenig, Bruno and Fritz Haller, and Franz Fueg — and their answers were published extensively. Alongside examples of non-Finnish works, the journal showed distinctly modern Finnish wooden architecture by Kirmo Mikkola and Juhani Pallasmaa, designed and built in 1965, and partly consisting of unfinished single-family homes. These demonstrated "technical and aesthetic experiments

with the structure of varying, industrially manufactured wooden single family houses." In expostulating their formulated ideas about the foundations of architecture, Mikkola and Pallasmaa wrote: " The effect of architecture is born from predefined relations. The effect of architecture comes from predefined relationships. Disciplined architecture, with its straightforward, 'neutral' constructions, emphasizes the meaning of its environment and the activities taking place in the building, not the plastic-artistic expression. The building's identity in the architectural system that is presented is born from the special conditions of the building task. Architecture that aims at form is a set of inward-turned, internal relations. Architecture that is based on structure receives its content from its relation to factors that exist outside it; it is in constant interaction with its surroundings. In architecture the harmonic and organized presence of realities is more important than subjective and particular ideas or plastic-artistic expression."[65]

The ideas of Mikkola and Pallasmaa perhaps best explain the suitability of Aarno Ruusuvuori's minimalist architecture to Marimekko's production

Fig. 4–28. The Marihouse as it appeared in *Arkkitehti* (July–August 1966): 116–17.

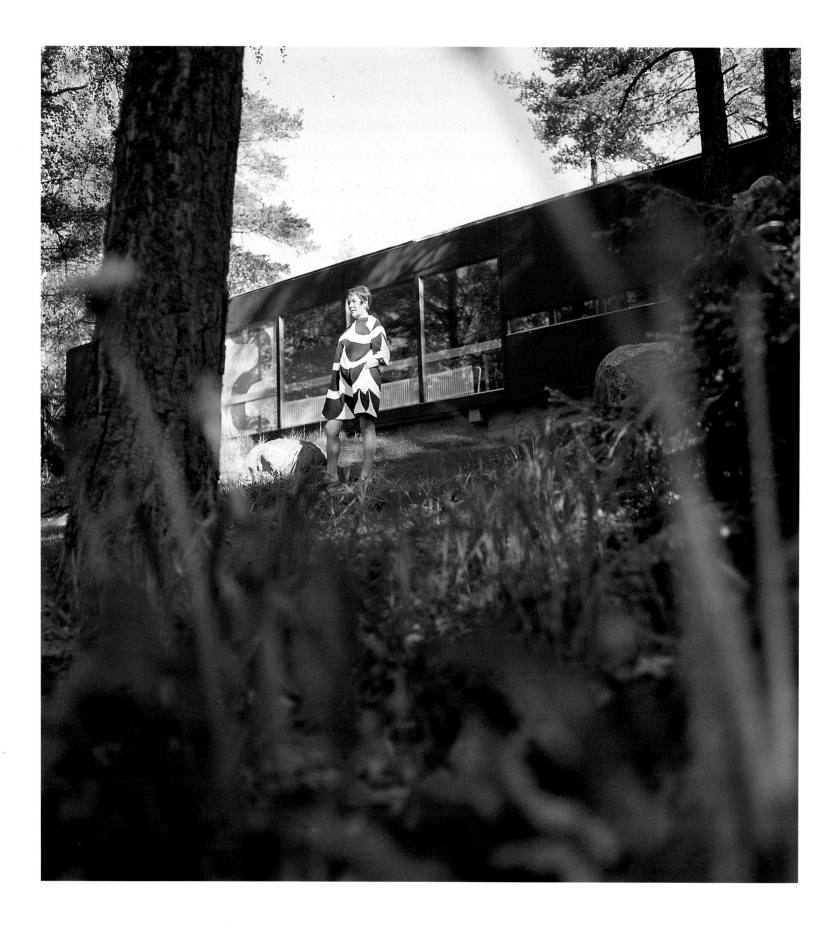

ideology. Ruusuvuori's architecture, which aimed at objectivity and clarity, was visually without reference to European architectural history in the same way that Armi Ratia's designs broke away from the traditions of European couture and pattern design. Ruusuvuori's architecture was able to form the framework of Marimekko's production world, a very special place in the world of modernism. Ruusuvuori himself spoke of architectonic form as a cage that he sketched in his mind as he walked about and listened to music — not something made at a drawing board.[66] Ruusuvuori's cage was entirely suitable for Armi Ratia's Marimekko.

The 1971 factory designed by Kairamo and Lahtinen belonged to the next phase of industrial building. In it metal has replaced the light wooden constructions; the look of the products and brands became dominated by the seemingly infinite size, speed, and splendor of industrial production, and no longer by silence and modesty. The whole production and marketing of design had entered a new, larger world.

Armi Ratia loved Finnish nature and the myths of lost worlds — Karelia, Byzantium. She did not feel at home in European culture. She created a total image of modernism based on her own interpretation of nature and history. Her biographer, Tuula Saarikoski, gives important hints about the world that did *not* belong to Ratia's Marimekko aesthetic: traditional European fashion culture, the normative world, where clothes were made as before and people dressed as etiquette commanded. Ratia sought to conquer and overthrow this world. The international customs of social intercourse were always a problem for Ratia. On her first visit to England, the girl from the Karelian countryside, dressed in the wrong clothes, had to overcome a

sense of inferiority. Ironically, perhaps because of this early experience, to the end of her life she traveled the world with many suitcases of generally "approved" couture clothes from elite fashion houses.[67]

A violent liberation of women's social position and clothing, freed from the dictates of convention and traditional good taste, was possible only through the experience of the "outsider." Saarikoski wrote: "Even now one sees in her a fear of European social conventions. In America, where different national customs live alongside one another and the upper class fashion world is small, there is no need to feel such a fear. In the East, where history consists of strange elements, the European is not expected to know customs. But to be a European in Europe, and not know how to be one, is like living in Koivisto in the family of a non-local merchant. In the United States Armi Ratia is self-assured and influential, in Japanese business circles she is dignified and warm. But even in Stockholm she begins to shrink, in Copenhagen she is strange, in Paris she is diffident and weird."[68]

In all the design fields, the masters of modernism fought their own battles against the traditions of the old world. The mutual respect and communication between the masters of Finnish and American architecture were natural because on both sides there was an eagerness to identify with the pioneers. I would argue that the philosophy that united Armi Ratia and the group of architects working with Aarno Ruusuvuori might be found in vitalism, a mystical view of nature and a strong belief in the heroism of the individual. Because of this shared philosophy between client and architect, Marimekko architecture demands inclusion both in the history of Finnish modernism and in discussions about visionary corporate architecture.

◄ Fig. 4–29. Armi Ratia and the Marihouse, Bökars, Porvoo, 1967.

1 Uudenmaan Sanomat (22 July 1967).

2 A wide selection of these articles is in the Marimekko archive, Designmuseo.

3 Tehostaja (April 1967): 36–37.

4 Tuula Saarikoski, Armi Ratia: legenda jo eläessään (Armi Ratia: a legend in her lifetime) (Porvoo: WSOY, 1977).

5 Revell and Petäjä won the architectural competition for the Palace building in 1949. Viljo Revell's international break-through happened when he won the Toronto city-hall design competition in 1958. The Palace is included in the list of architectural masterpieces of Finnish modernism prepared by DOCOMOMO (DOcumentation and COnservation of buildings, sites and neighborhoods of the MOdern MOvement). For more about Revell in English, see the leaflet in Arkkitehti (April 1996).

6 Saarikoski, Armi Ratia (1977): 50–64.

7 Viljo Ratia, "Alkuvuosien kiemuroita" (Circuitous paths of the early years), in Phenomenon Marimekko, ed. Pekka Suhonen and Juhani Pallasmaa (Espoo: Amer Group Ltd. / Weilin & Göös, 1986): 24.

8 Pekka Suhonen, "Ympäristöt, arkkitehtuuri" (Environments, architecture), ibid., 78.

9 Interior design drawings of the five Marimekko shops are now in the Aarno Ruusuvuori archives, Museum of Finnish Architecture, Puistokatu 4, Helsinki. I thank Anna Ruusuvuori for her friendly, generous, and expert assistance.

10 Juhani Pallasmaa, verbal communication, February 2003. Pentti Piha worked for a long time in Aarno Ruusuvuori's office. He was married to Annika Rimala who designed Marimekko's successful cotton knits.

11 For another photo of this system see Phenomenon Marimekko (1986): 80, photo 11.

12 Drawings in the Ruusuvuori archives, Museum of Finnish Architecture.

13 See Phenomenon Marimekko (1986): 79, photo 3.

14 Mysi Lahtinen, interviewed by the author, 12 and 19 December 2002. I met with her in Elli, her gift and card shop in the heart of Helsinki.

15 Mysi Lahtinen, interviewed by the author, 12 and 19 December 2002; and Suhonen, "Ympäristöt, arkkitehtuuri," in Phenomenon Marimekko (1986): 78.

16 Benjamin Thompson, "Scenes from a Friendship," ibid., p. 110.

17 Jörn Donner, Uusi Maammekirja (A new book about our land) (Otava, 1967): 380.

18 V. Ratia, "Alkuvuosien kiemuroita," in Phenomenon Marimekko (1986): 29.

19 Rebecka Tarschys, "Siivoustakista arki-puvuksi ja juhla-asuksi" (The Overall as everyday garment and festive dress), ibid., p. 101.

20 Saarikoski, Armi Ratia (1977): 111.

21 For the basic facts of Ruusuvuori's life and career, see Marja-Riitta Norri and Maija Kärkkäinen, eds., Aarno Ruusu-vuori: Structure is the Key to Beauty / Järjestys on Kauneuden avain, exh. cat. (Helsinki: Museum of Finnish Architecture, 1992).

22 Ibid., pp. 7–9; and Arkkitehti (July–August 1964): 126–35. The scale model of the first stage of this printing works is now in the collection of the Museum of Modern Art, New York.

23 Arkkitehti (January 1968): 59.

24 Reijo Lahtinen, interviewed by the author, 22 October 2002.

25 This is significant because computers as we know them were not available then.

26 Arkkitehti (January 1968): 59.

27 Reijo Lahtinen, interviewed by the author, 22 October 2002.

28 Saarikoski, Armi Ratia (1977): 114–16. In Finland all town plans must be accepted by the community council and nothing can be built without a legal town plan.

29 Drawings and photographs in the Ruusuvuori archive, Museum of Finnish Architecture, Helsinki.

30 Saarikoski, Armi Ratia (1977): 114–16.

31 Uudenmaan Sanomat (22 July 1967).

32 Saarikoski, Armi Ratia (1977): 117.

33 Arkkitehti (July–August 1966): 116; Norri and Kärkkäinen, eds., Aarno Ruusuvuori (1992): 12.

34 Hopeapeili 23 (1967) reproduced color photographs from Elle and Allt i Hemmet.

35 Saarikoski, Armi Ratia (1977): 66–67.

36 Anna-Liisa Ahtiluoto, Suomi-tori New Yorkissa täysosuma (Finland square smash hit in New York), Helsingin Sanomat, 12 April 1967.

37 See Helen Rosenau, The Ideal City: Its Architectural Evolution, 2nd ed. (London: Studio Vista, 1974); Hanno-Walter Kruft, Städte in Utopia: Die Idealstadt vom 15. bis zum 18. Jahrhundert (Munich: C. H. Beck, 1989).

38 Riitta Nikula, Architecture and Landscape: The Building of Finland, trans. Timothy Binham (Helsinki: Otava, 1993): 132.

39 Juhani Pallasmaa, communication via email, 7 March 2003.

40 For Ivres see, e.g., Kenneth Frampton, Modern Architecture: A Critical History (London: Thames & Hudson, 1992): 208.

41 Donner, Uusi Maammekirja (1967): 383.

42 Donner, "Unelmat ja todellisuus" (Dreams and reality), in Phenomenon Marimekko (1986): 10. In December 1967 Donner had been elected a member of the Marimekko board of directors, lending authority to what he wrote then and in 1986.

43 Helsingin Sanomat (16 August 1968); Uusi Suomi (16 August 1968); Avotakka (September 1968): 4-9.

44 Suomi Rakentaa (Finland builds) 4, exh. cat. (Helsinki: Museum of Finnish Architecture, 1970): no. 39.

45 Ibid.

46 Marimekko, sauna, promotional brochure, 1968, copy in the Aarno Ruusuvuori archives, Museum of Finnish Architecture, Helsinki.

47 Helsingin Sanomat (16 August 1968). The managing director is identified only as "Mr. Horchow"; no further information could be found.

48 Anna Ruusuvuori, interviewed by the author, 25 October 2002.

49 Svenska Dagbladet (6 September 1968); Dagens Nyheter (7 September 1968); Bild-Expressen (6 September 1968).

50 *Restauratören* (September 1968).

51 Donner, "Unelmat ja todellisuus,"
in *Phenomenon Marimekko* (1986): 17.

52 Reijo Lahtinen, interviewed by the
author, 22 October 2002.

53 Ibid.

54 See Marja-Riitta Norri, Elina
Standertskjöld, and Wilfried Wang,
eds., *Twentieth-Century Architecture:
Finland* (Munich: Prestel, 2000): 255.

55 *Suomi rakentaa* (Finland builds) 5,
exh. cat. (Helsinki, Museum of Finnish
Architecture, 1976): no. 70.

56 Ibid.

57 Ibid.; and Katri Koski, "Marimekon teh-
dasrakennus: Arkkitehtuuritutkielma"
(The Marimekko factory building:
a study in architecture), University of
Art and Design, Helsinki, 1997.

58 An exhibition of Kairamo's drawings
was arranged in 1997, after his death;
for the Marimekko factory see *Erkki
Kairamo: Luonnoksia Sketches* (Helsinki:
Museum of Finnish Architecture, 1997):
18–21.

59 This exhibition had been organized by
the Museum of Finnish Architecture
and the Finnish Association of Art and
Design, and first shown in Vienna,
Nuremberg, Budapest, Madrid, Barce-
lona, and Lisbon, before the Helsinki
venue. See Kirmo Mikkola and Erkki
Kairamo, "Ikuinen arkkitehtuuri ja kon-
struktivismin hetki" (Eternal architec-
ture and the moment of constructivism),
in *Muoto ja rakenne, konstruktivismi
Suomen modernissa arkkitehtuurissa,
kuvataiteessa ja taideteollisuudessa*
(Form and structure, constructivism in
modern Finnish architecture, pictorial
and industrial art), exh. cat. (Helsinki:
Ateneumin taidemuseo, 1981).

60 Ibid., p. 18.

61 From his student days onward, Kairamo
was especially interested in industrial
architecture. His diploma work of 1963
was a project for a glassworks in Naan-
tali. It was awarded first prize in the
Finnish diploma competitions and was
sent to the Seventh Architectural
Student Biennial at São Paolo (*Erkki
Kairamo: Luonnoksia Sketches* [1997]: 14).

62 Christopher Alexander, "City is not a
tree," Finnish translation by Leena
Maunula, *Arkkitehti* (July–August 1966).

63 Ibid., pp. 120–26.

64 *Arkkitehti* (March 1966): 25-37.

65 Ibid., p. 44.

66 Norri and Kärkkäinen, eds.,
*Aarno Ruusuvuori* (1992): 53.

67 Saarikoski, *Armi Ratia* (1977): 106.

68 Ibid., p. 23.

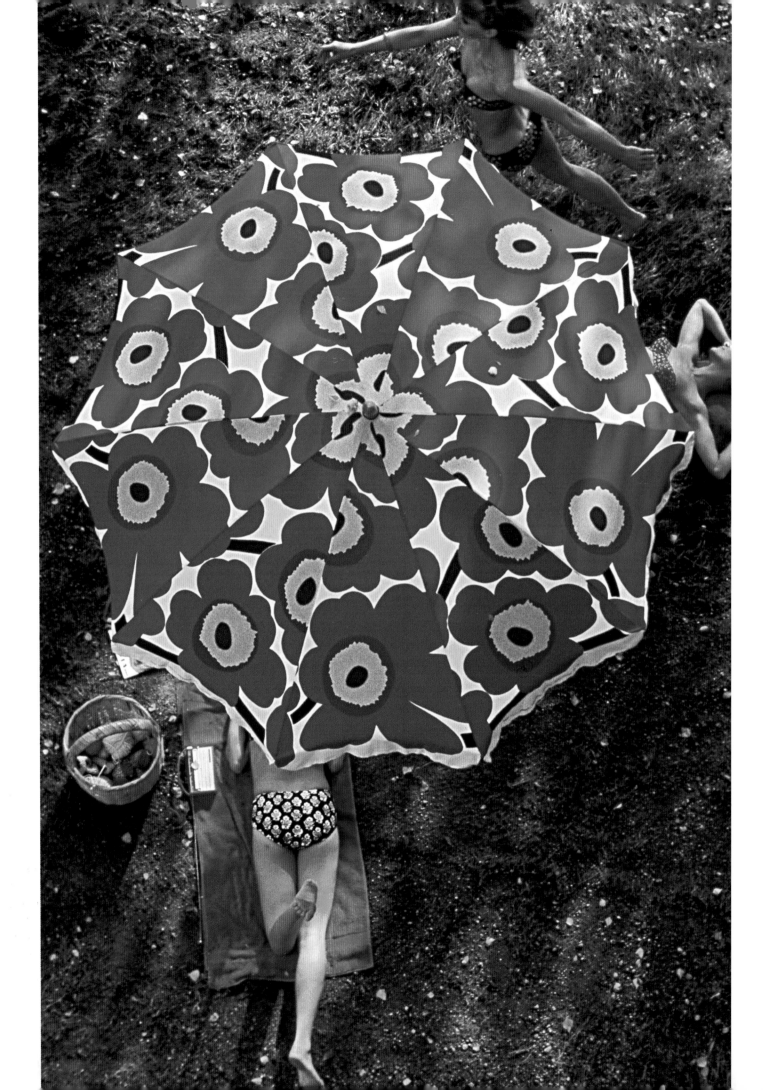

# 5. Thoughts on the International Reception of Marimekko

Hedvig Hedqvist and Rebecka Tarschys

As the twenty-first century gets underway, Marimekko is experiencing a resurgence of interest and appreciation — a true revival. Maija Isola's *Unikko* (poppy, fig. 5–1) pattern, designed almost forty years ago, blooms as never before. With new colors and sizes, Isola's exuberant flower, which was introduced in 1964, the same year as Andy Warhol's cerise and yellow *Flower* paintings, has acquired a new, broadly based audience and market. Marimekko has always been surprising. The company's original emergence in the international marketplace of the 1960s and 70s reveals a tangle of success, euphoria, and the uneasiness that often accompanies radical design philosophies. Marimekko has always existed on a roller coaster. Its progressive fashion sense, utopian design vision, and uncompromising ambition have been key to both its successes and its failures, including at least one near-bankruptcy.[1]

◄ Fig. 5–1.
Beach umbrella; *Unikko* pattern by Maija Isola, 1964. Courtesy of Tony Vaccaro/*Life*. (Checklist no. 63).

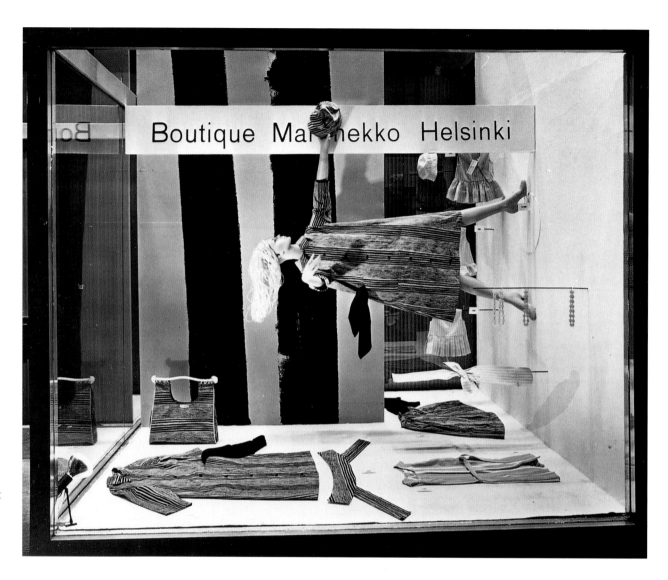

The Marimekko conquest of the international market began in the mid-1950s. As did almost everything else about Marimekko, the vision to expand beyond Finland came largely from founder and director Armi Ratia. Her persona — her unique energy and strong character — maintained and even enhanced the company's international reputation for more than twenty years. Despite the economic challenges, for importers of Marimekko, especially for Americans, direct contact with Ratia was frequently an unforgettable experience.

During the 1960s and 70s, at the height of its success, Marimekko achieved the status of a world leader in the creation and production of printed textiles and became an international trendsetter in the fashion industry. Its image outside the Nordic world was first established with Maija Isola's printed textile patterns. Isola had been designing for the company since its early days. Ratia first noticed her work in 1949 when Isola was a student at the Institute of Industrial Arts in Helsinki. Eventually Marimekko would commission Isola to create anywhere from eight to ten patterns a year. Ratia and her colleagues visited Isola's studio twice a year, selecting a range of patterns, from those considered commercially viable to ones more

difficult to market. While the production of each new design would be a major financial investment for the fledgling company, cost alone did not dictate their selection.

Isola was prolific and always maintained her design independence, often challenging Ratia's decidedly modernist vision. The renowned *Unikko* pattern, for example, was likely to have been created after Ratia had declared that she hated floral patterns. Isola's response was provocative; she challenged the traditional conventions of floral ornament and created the single most successful poppy design, with its lively form and color. This "collaboration" between Ratia and her designer typifies the unusual creative power game that existed between them; it contributed substantially to the vitality and inventiveness of Marimekko and to its international reception.[2]

Finland constituted the primary market for Marimekko printed textiles and clothing in the 1950s, although the company began to be more widely known beyond Finnish borders by mid-decade. In 1954 Marimekko was included in the *Design in Scandinavia* exhibition (fig. 5–4) that toured the United States. That same year the company was represented in the Tenth Milan Triennial. It was exhibited again three years later in the Eleventh Milan Triennial of 1957, but a Marimekko fashion show that had been planned was transformed instead into a window display by the then-window dresser Giorgio Armani at the Rinascente department store (fig. 5–2).[3] In both Milan expositions, however, Marimekko was largely overshadowed by other Finnish products — glass, ceramics, and furniture — whose manufacturers and designers received most of the press attention. Among the international clientele and press, however, there were a few exceptions who focused on

the newcomer from Helsinki. Marion Best, for example, after seeing the Marimekko display in Milan in 1954, became the first known importer of Marimekko fabrics to Australia (fig. 5–3).[4] And after the 1957 exposition *Craft Horizons* reported on the designs by Vuokko Nurmesniemi which had been

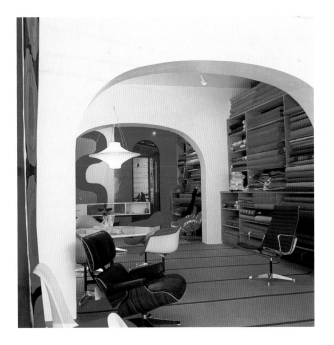

Fig. 5–3. Marion Best's design showroom, Sydney, Australia, 1965, displaying design classics such as *Seireeni* pattern by Maija Isola (1964), lamp by Yki Nummi (1960), and chairs by Eero Saarinen and Charles Eames.

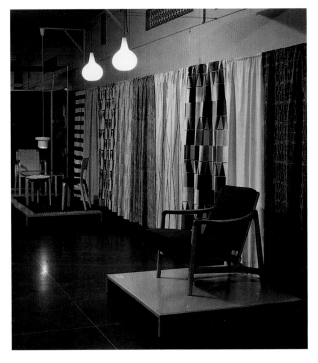

Fig. 5–4. Part of the *Design in Scandinavia* exhibition, 1954.

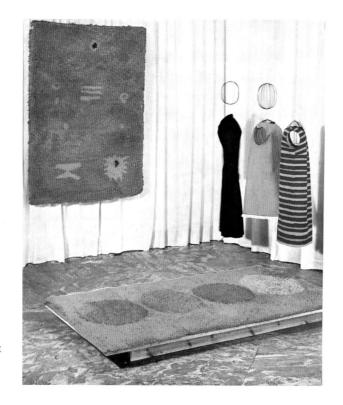

▶ Fig. 5–5. Marimekko dresses and *ryijy* rugs by Vuokko Nurmesniemi exhibited in Copenhagen, Denmark 1959. Courtesy of Vuokko Nurmesniemi.

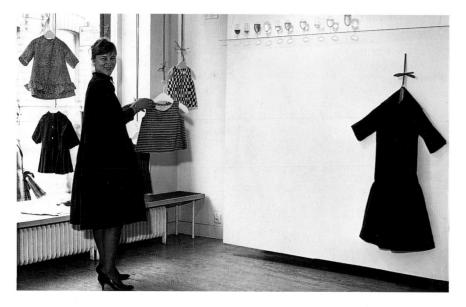

▲ Fig. 5–6. Vuokko Nurmesniemi completing the installation of Marimekko at the Artek gallery, Stockholm, 1958. Courtesy of Vuokko Nurmesniemi.

There were other showings that contributed to the growing international reception of Marimekko. In 1958 the Brussels World's Fair provided an important venue, especially since the young women who worked as waitresses in the restaurant (exhibition guides) wore Marimekko-designed dresses that were dubbed "anti-uniforms" and had been chosen by one of Finland's premier designers, Tapio Wirkkala, who also designed the restaurant.[7] The austere boarded walls were given color by the printed fabrics of Vuokko Nurmesniemi and Maija Isola (fig. 5–9), and by Timo Sarpaneva's factory-made cotton fabrics. Perhaps the most successful early sale and promotion of Marimekko, however, occurred in the autumn of 1958, when the company's designs were shown in an art gallery that the prestigious design firm Artek rented in Stockholm (fig. 5–6).[8] The exhibition was a resounding success. Marimekko clothing, with its bold designs, striking color combinations, and innovative simplicity, was truly unique in Sweden. The Stockholm press applauded Marimekko, describing the dresses as the first aesthetic house smocks![9] Neither Ratia or Nurmesniemi spoke Swedish, but they nevertheless found a way to communicate with prospective customers: Ratia was a lively promoter of the collection while Nurmesniemi remained silent and used sign language.[10] This rather unusual sales strategy claimed many years of international success in bridging language barriers.

In 2002, forty-four years after the Artek exhibition, Nurmesniemi acknowledged the influence that Swedish textile design had had on her work.[11] Swedish textiles, then in their ascendancy, were distributed by the special textile division of Nordiska Kompaniet (NK), the leading Stockholm department store. When NK Textilkammare, the design studio, featured *Oomph* (fig. 2–6),

shown in Milan.[5] Three years later, at the Twelfth Milan Triennial (1960) Nurmesniemi's husband, industrial designer Antti Nurmesniemi, designed Marimekko's installation and established a Marimekko tradition: the display of printed fabrics as large panels that divided the space rhythmically.[6]

an abstract pattern by Viola Gråsten, Ratia gave three yards of it to Nurmesniemi.[12] Its "forbidden" combination of blue and green opened up new possibilities in an era characterized by more cautious textile color schemes. Ultimately Nurmesniemi made use of the strong palette in new and distinctive ways, creating new patterns such as the popular stripes with overlapping repeats that could be infinitely varied. These and other Nurmesniemi designs from the period are part of Marimekko's twenty-first-century revival.

Among the notable visitors to Marimekko's exhibition at Artek Stockholm in 1958 was the American textile designer Jack Lenor Larsen.[13] Ratia's greeting, "you with the funny hat," initiated a friendship that lasted for more than twenty years. Yet despite their companionability, Ratia declined Larsen's offer to be her American business partner. His company did not have a retail shop, and by the end of the 1950s, Ratia clearly had greater ambitions and expectations for promoting Marimekko in the American market.

Soon afterward Marimekko found an appropriate retail dealer in the United States: Design Research, familiarly known as DR, in Cambridge, Massachusetts (figs. 4–10, 5–7). The architect Benjamin Thompson had started this pioneering store in 1953 to provide "good design" for modern homes. Thompson was a partner in TAC (The Architects' Collaborative), with other architects, including Walter Gropius. From 1963 to 1967 he was also chair of the Department of Architecture in the Harvard Graduate School of Design, and in 1966 he started his own architect's office with his new wife and partner, Jane McC. Thompson, the former design curator and journalist (fig. 5–8).

The DR business philosophy insisted that art was to be found in everyday life, an approach that

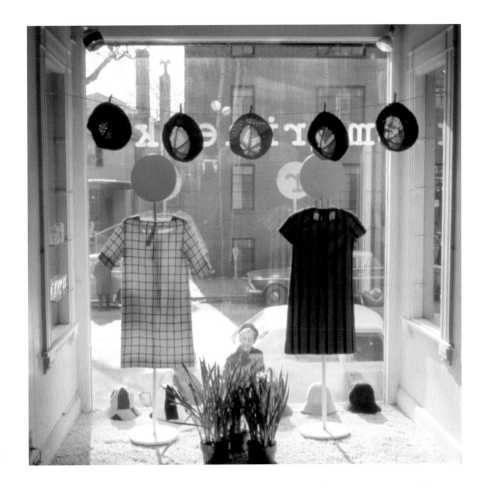

▲ Fig. 5–7. Window display, Design Research, Cambridge, Massachusetts, mid-1960s. Marimekko dresses by Annika Rimala. Courtesy of Jane McC. Thompson.

◄ Fig. 5–8. Architect Benjamin Thompson, director of Design Research, and Jane McC. Thompson. Courtesy of Jane McC. Thompson.

also shaped Ratia's vision of Marimekko. The selection of DR products and the distinctive method of display at the famed DR store in Cambridge clearly reflected this philosophy. Household goods and accessories were shown in a modern family home setting, where clients could wander freely in the kitchen, living room, and bedroom installations. In this way customers were literally shown how to live with and how to use the DR merchandise, rather than just encouraged to buy various products. As a leader in the sale of modern furniture, DR featured many designs by Thompson, including "The Sofa," which was among the most widely published items in the store.[14]

Most of the products in the Design Research product line were individually selected by Thompson from European companies. Thompson had discovered Marimekko at the Brussels World's Fair in 1958, where he was known to have admired the

colorful Marimekko fabrics and fashion, including the Marimekko designs worn by the young guides at the exposition.[15] The impact of Marimekko in Brussels went hand-in-hand with the generally high reputation of Finnish applied arts among international designers. In 1959 DR organized a Finnish exhibition, inviting many of the leading applied arts firms, including Marimekko, to present samples from their collections. Ratia and Nurmesniemi arrived in Cambridge with two cardboard boxes filled with fabrics and clothing.[16] This modest start initiated one of the most influential and creative design and retail collaborations of the following year.

Customers were immediately attracted to the distinctive colors and cut of the Marimekko dresses. They were said to liberate the body and the mind.[17] The university atmosphere in Cambridge and Boston fostered a receptive clientele for progressive fashion and household designs, and the response to the Marimekko display at DR was immediate and favorable. The *Sunday Globe,* for example, reported that "Color-mad, wonderful shades alone and in superb, off-beat combinations — that's the outstanding characteristic of the Finnish fashions presently on view in Cambridge, at Design Research, Inc."[18] The exhibition also received attention from newspapers outside Boston. The *Herald Tribune* in New York, like earlier Swedish newspapers, while enthusiastic was also somewhat uncertain about how the clothing would be worn and about the actual function of the fabrics in the home: "The objects in the Finnish show and those in the numerous shops that have suddenly popped up in Boston and Cambridge clearly demonstrate why this area, the hub of all that is traditional, has fallen for modern," the *Tribune* reporter explained. "In a New Englander's estimation,

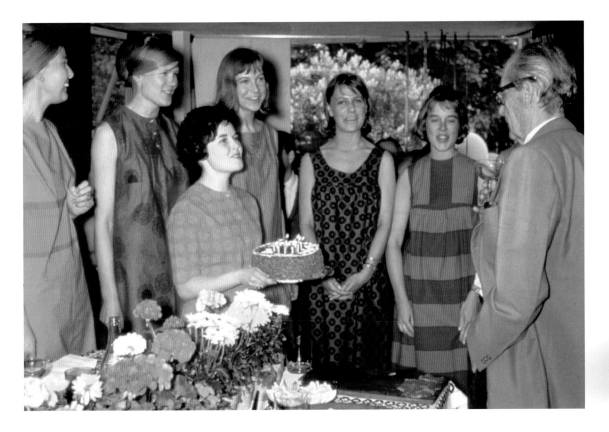

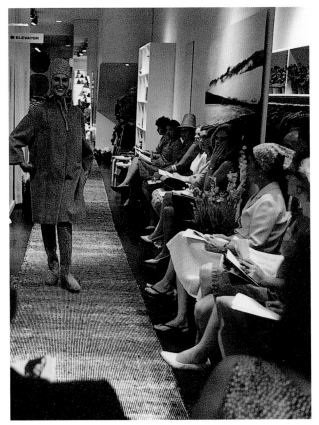

a furnishing is beautiful only if it is first useful. And the Finnish pieces are just that.... These fashions should appeal to a New Englander's sense of the practical, for, although pretty enough to wear downtown, all are meant to be used as house-dresses, smocks or other cover-ups for doing work in the house or garden."[19]

During the postwar period progressive design initiatives in the United States had come via the influx of European artists and designers and their presence at various American academic institutions, such as Harvard University, where Gropius began teaching in 1937, and Cranbrook Academy of Art, which had prominent Finnish faculty members, including the first president, architect Eliel Saarinen, textile designer Marianne Strengell, and ceramist Maija Grotell. The reception and success of Marimekko in the United States must be understood in this context. Textile designer Jack Lenor Larsen, who

▾ Fig. 5–10. Design Research staffers wearing Marimekko dresses at a birthday celebration for Walter Gropius (right), early 1960s. Courtesy of Jane McC. Thompson.

▴ Fig. 5–11. A Design Research Marimekko brochure, 1964.

◂ Fig. 5–12. Fashion show at Design Research, New York, 1964. Courtesy of Tony Vaccaro.

was a student at Cranbrook, recalled the impact that Scandinavian textiles had on his work.[20] The dissemination of Scandinavian design and the response among the design community in the United States came from the more progressive companies and retail establishments. Printed textiles with distinctive patterns were already present in the home furnishings market at the time. In the 1950s the furniture company Herman Miller introduced geometrical and stylized patterns in strong colors by architect Alexander Girard. The fabrics were used for furniture designs by Charles and Ray Eames. Girard had traveled with the Eameses to Mexico, and in 1959 he designed the interior of La Fonda del Sol, a restaurant in the Time-Life Building, New York (fig. 5–13). Its checkerboard-square tables, tablecloths and napkins, and striped porcelain dinnerware, all in bright, folkloric colors, must have been an inspiration for Marimekko. Knoll International, another progressive American design firm, also used Swedish textile prints, including the geometric *Pythagoras* pattern

by architect Sven Markelius, which hangs in the United Nations headquarters.

The presence of Marimekko in the United States increased with the success of Design Research and its expansion to locations outside Cambridge. In 1963 DR opened its shop in New York City, in a converted townhouse on East Fifty-seventh Street (fig. 5–15). Marimekko's *Hanoi* fabric, designed by Mysi Lahtinen, was hung throughout the building and even draped out the windows during the opening reception. The San Francisco shop, which opened in 1964, located in a renovated clocktower in Ghirardelli Square, brought Marimekko to the West Coast (fig. 5–14), where the expressive patterns and rich colors of Marimekko fabrics were soon adopted by the avant garde.[21] Ten years later the fabrics also appeared in far more conservative West Coast interiors. Architect William Turnbull, who worked for Marimekko in California, became a "Marimekko ambassador." In 1974, for example, he specified Marimekko fabric by Maija Isola for curtains throughout the World Bank offices in

▸ Fig. 5–13. Interior of La Fonda del Sol, New York, designed by architect Alexander Girard, 1959. Courtesy of Herman Miller Inc.

▸▸ Fig. 5–14. The San Francisco branch of Design Research, which opened in 1964. Courtesy of Jane McC. Thompson.

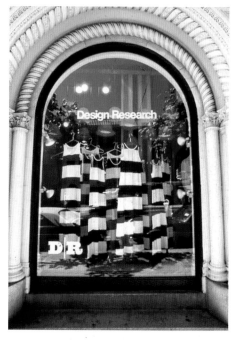

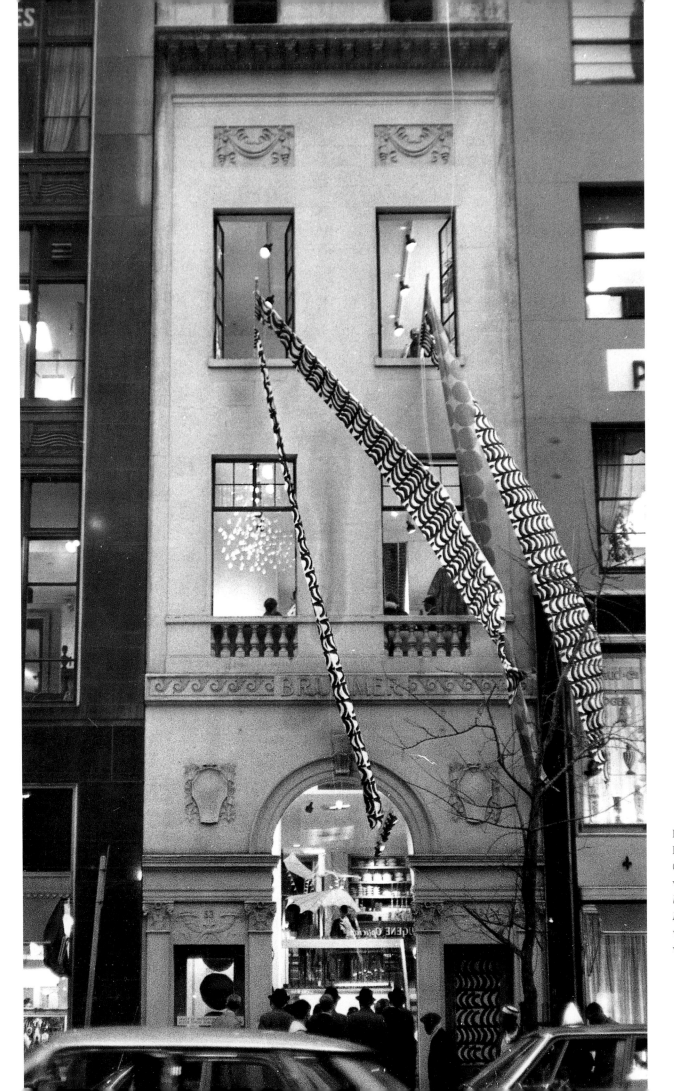

Fig. 5–15. Design Research, New York City, 1963. Maija Isola's variation of *Silkki-kuikka* pattern and *Kivet* pattern (barely visible) hang from the windows.

San Francisco, thereby giving Marimekko even greater international visibility. As Thompson later explained: "Nothing like it had been seen in America. It matched the mood of the times.... Every designer and architect knew about Marimekko and Design Research."[22]

DR served as more than a mere retailer of Marimekko products: the company also helped shape the appearance of imported goods to the United States. At Marimekko some color schemes were dictated by the demands of the American marketplace. Cultural events also played a role in the creation of new fashion trends. When Matisse and Léger exhibitions toured the United States and Europe in the early 1970s they affected the palette of clothing and textile design. As Marimekko became more popular, it also became a staple in outlets other than DR. In the peak period of the 1960s and 70s, Marimekko was available from fifty retail dealers in the United States, while prominent department stores such as Bergdorff-Goodman and Bloomingdales had their own Marimekko departments.[23] The crowning achievement came in 1968 when Armi Ratia, along with Oscar de la Renta and Roland Jourdain, received the prestigious Neiman-Marcus Fashion Award.

Changes in fashion during the 1970s led to a waning of interest in Marimekko. Annika Rimala's striped patterns for knitwear and cotton clothes were Marimekko's answer to the era's informal jeans fashion. The creative exchange between Annika Rimala and Sungja Cho, dress buyer for DR from 1967 to 1979, is reflected in the simpler-cut clothes that entered the collection.[24] Their well-timed ideas for the basic design suited the competition, the low-priced chain stores, who worked in a similar style. This had a negative impact on the marketing of Marimekko by upsetting the

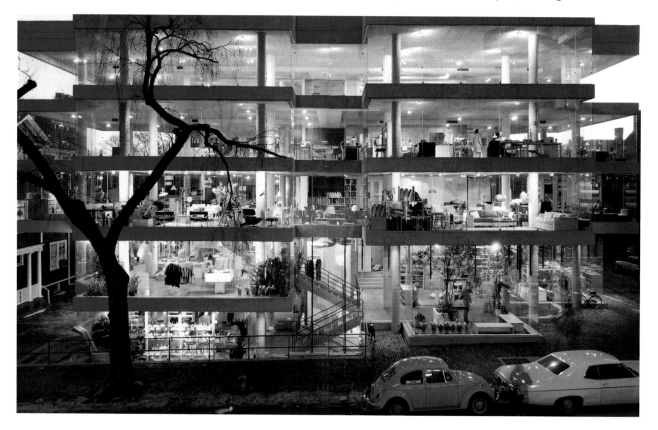

Fig. 5–16. Design Research headquarters, Cambridge, designed and built by BTA, 1966–69. From "The 'Design Research' Prophesy," *Process: Architecture*, no. 89 (June 1990): 18–19. Courtesy of Jane McC. Thompson.

**D|R**

LIFE TO BE
LIVED TO ITS
FULLEST
DEDICATED
TO THE TRUE
BRILLIANCE
OF THIS NOW
GLOWING
ORBITING
WORLD AND
ITS MAGIC
MOMENTS

CAMBRIDGE
NEW YORK
SAN FRANCISCO

marimekko

Design Research

Cambridge    New York    San Francisco

**DR — The Building**

Eventually, in 1966-69, BTA designed and built a new headquarters store for DR across the street from its original Cambridge home. It was to be the building that wasn't there — nothing but untinted glass between the products and the customers. No clutter of glaring bars, no signs, no window displays, were to separate the store from the street. The "DR" sign, in huge neon letters *on a rear wall*, was to be seen *through* the store. The activity, the life, the displaying and purchasing of merchandise within the store had to continue right up to the glaring and still look attractive. The whole store was the display.

Nonetheless, the DR building is no "glass box." It has a carefully proportioned double-cruciform plan with slightly unequal arms, producing five full-height free-standing bays. In addition, the four reentrant corners were partially filled by mediating wall segments set at 45° angles. Transparency is that much more evident when seen through corners. And, if the principal surfaces are reflective under certain conditions, then there will always be other surfaces which are clear.

DR — the store, not the building — has been endlessly emulated, to great commercial success, as the audience for well designed household furnishings has expanded exponentially. But it has never been recreated in any real sense, no matter how many merchants claim to have been "inspired" by it. DR was a coherent personal statement of design ideas and standards, executed without compromise. It was a great success because it pioneered, took risks, made statements about quality and value in the material culture — and about the quality of life.

The demise of DR, as the result of a hostile inside takeover in the late 1960's, had nothing to do with the validity of its concept, quality, or sales potential, and everything to do with the fact that design retailing rests on talent, expertise, and knowledge of the product and the customer, and not on myopic "bottom line" of Wall Street schemes. But DR's death is not the important part of the story. DR was a fresh breeze blowing through post-war America. For twenty years it stimulated an awakening awareness of good design in the U.S.

16

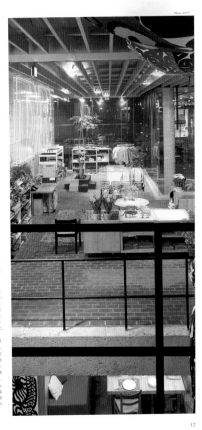

17

Fig. 5–17. Marimekko is prominent in a story on Design Research. From "The 'Design Research' Prophesy," *Process: Architecture*, no. 89 (June 1990): 16–17. Courtesy of Jane McC. Thompson.

company's pricing system. Although the fashions were in tune with the new simplicity and jeans-style look, the prices were not. Marimekko was high priced because of its fine quality and expensive production. This often put Marimekko fashions out of reach of the average consumer who shopped in these retail chains. The difficulties intensified in the 1970s with the socio-economic crisis, as well as Annika Rimala's illness which led to her eventual departure from Marimekko in 1976.[25]

DR's expansion and its new Thompson-designed all-glass building in Cambridge built in 1970 (fig. 5–16; owned by Crate & Barrel since 1975) led to a shortage of capital. In 1970 Thompson was forced to relinquish his company in a takeover. While the spontaneous affection between Ratia and Thompson continued until her death in 1979, their business relationship came to an end. Thompson's and Ratia's ups and downs often ran on parallel lines; business worries coincided with their respective divorces. The one major drawback to their friendship proved to be the signing of the contract that gave DR the sole rights to sell Marimekko's products to retail dealers in the United States — for thirteen years, from 1959 to 1972.[26]

According to Jack Lenor Larsen many of the design stores that had opened in the 1960s and had been enthusiastic about Marimekko struggled to survive the combination of economic fluctuations and changes in fashion.[27] After the oil crisis of 1973 the progressive design community directed its gaze toward Italian design although conventional floral patterns were still popular with the general public. Marimekko in the United States was championed by Gordon Segal, who in 1962 had founded Crate & Barrel (C&B) in Chicago.[28] The interest in

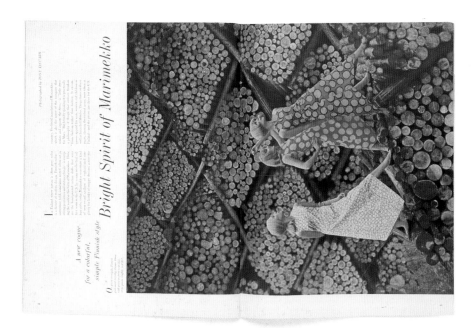

Fig. 5–18. Marimekko in *Life* magazine (June 24, 1966), photos by Tony Vaccaro. Dresses and patterns designed by Annika Rimala: right, *Petrooli* pattern; left *Kukka* pattern.

Scandinavian design in the early 1960s led Segal to Denmark where he met Torben Ørskov, owner of Form & Farve store, a retailer of Marimekko. As Marimekko was not then available in Illinois, C&B began a long-term collaboration.

In 1965 Crate & Barrel presented the first Marimekko fabric collections, followed a few years later by a clothing line. The Chicago press published a series of articles on Marimekko, and it seemed that the company's success story would have a new chapter. The labels "modernists and university people" also characterized the Chicago clientele. There was even a new succession of famous women wearing Marimekko: Lady Bird Johnson and her daughter Linda, Princess Grace's daughter Caroline, and Princess Margaret belonged to the club.[29] Then, in the early 1970s when interest in the clothes declined, C&B used Marimekko fabrics as decoration in their shops, helping to assure the future of an American market for Marimekko. In 2003, with 170 stores, C&B remains the most successful retailer of *Unikko* and other classic Marimekko patterns.

When the contract between DR and Marimekko expired in 1972 new licensing agreements could be pursued, as a means of reaching a wider public. Armi Ratia's son, designer Ristomatti Ratia, was sent from Finland to the United States to develop design and licensing for the company. He worked with Raymond Waites, who had been DR's art director for several years and had been an inspired promoter of Marimekko; one of his innovations was to enlarge the stripes of the *Tasaraita* apparel into "super super graphics."[30] Under new licensing agreements orchestrated by Ristomatti Ratia and Waites, stripes, squares, and small flowers ended up on paper napkins, quilt covers, dishtowels and wallpaper, and spread over the whole continent. Marimekko was launched as American Country Style, and its licensed manufacturers included Fieldcrest, Dan River, Motif Designs, and Pfaltzgraff. Ristomatti Ratia furnished his own house in New Canaan, Connecticut, with the products, and the press documented it from every angle.[31]

In addition to DR's ever-increasing promotion of Marimekko, the firm became the focus of leading design journals worldwide. In the 1960s and early 1970s, many extraordinary fashion spreads featured Marimekko, not just in shelter and fashion magazines, but also in general lifestyle magazines. *Life*, for example, reported on the Marimekko invasion in an evocative and memorable article entitled "Bright Spirit of Marimekko."[32] This photo essay by Tony Vaccaro was shot on location in Finland, with fashion models in lush natural settings and the vernacular wood architecture that Americans associated with Finland (figs. 5–18, 5–19). Sultry women with distinctly modern and colorful patterned dresses contrasted with the dramatic backdrops, just as both traditionalism and modernism were present in the Marimekko image.

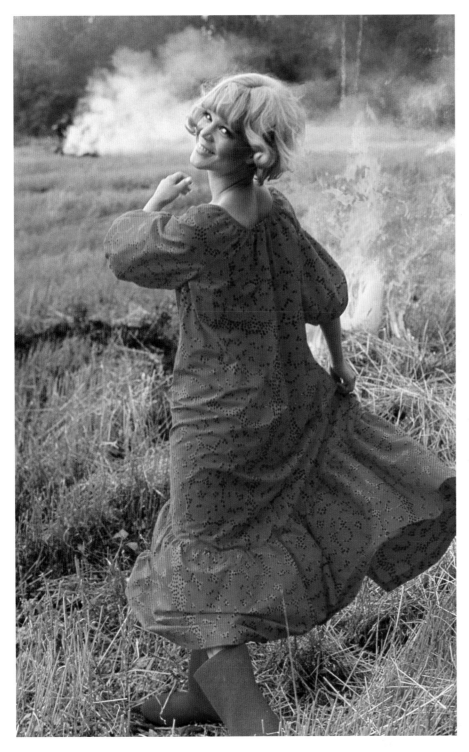

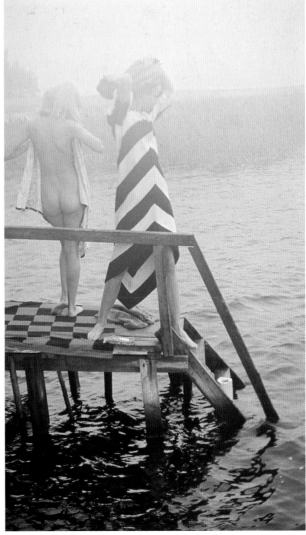

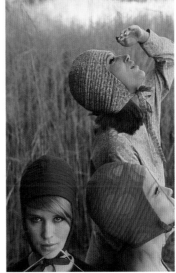

Fig. 5–19 a, b, c. Images from the *Life* magazine photo shoot in Finland, September 1965. Far left, Annika Rimala's *Rakkauskirje* dress in *Tarha* pattern (1963); above, Annika Rimala's *Linjaviitta* dress (1966) in *Galleria* pattern (1954) by Vuokko Nurmesniemi; and left, caps in *Hilla* (1961) and *Petrooli* (1963) patterns by Annika Rimala. Courtesy of Tony Vaccaro/*Life*.

SPORT ON THE NEW FRONTIER by JOHN F. KENNEDY

Fig. 5–20. Jacqueline Kennedy and John F. Kennedy on the cover of *Sports Illustrated* (December 26, 1960), photo by David Drew Zingg.

Marimekko received what was perhaps its greatest promotional boost when Jacqueline Kennedy purchased eight Marimekko dresses and was featured on the cover of *Sports Illustrated* in 1960 wearing a Marimekko sundress (fig. 5–20).[33] Later she was a frequent visitor at the DR shop in Cambridge.[34] Marimekko fashion became the kind of sensation previously associated solely with haute couture. Two years later, *Look* featured Armi Ratia's personal wardrobe, thereby identifying her as an international fashion leader.[35]

Among American fashion magazines, the most ambitious promotional ploy occurred in 1965 when Marimekko created a line of clothing and other items specially for *Vogue*, including everything from shoes and boots to pillowcases (fig. 5–22). The text stated: "Pure of line, true of color, bold of spirit: the Marimekko idea is modern young Finland to

the life.... Smart, easy, happy designs snapped out with punch and backbone...springing up like a fresh wind."[36] Gordon Parks photographed the so-called reindeer-tundra of Finnish Lapland — a gray-green iridescence of moss, fern, and rock, with sexy Marimekko models wearing pattern-laden bikinis and matching go-go boots or bell bottom pants or low-cut mini-dresses. These sensuous, mythic period pieces, these daring Marimekko designs that exposed as much of the woman's body as possible, coexisted with their opposite — Marimekko clothing that reflected an equally keen fashion sense but was characterized by notions of comfort, simplicity, and even modesty. The fashion for the Marimekko smock remained steady. This was a dress line that women clearly adored, but that the fashion press approached with considerable ambivalence. "By any name — still a sack" was the title of an article in *Life* bemoaning the prevalence of the smock dress among American college students (fig. 5–21). According to the article, "The jubilant male who thought he had killed the decade's most controversial fashion — the chemise, also called the sack or bag — is now discovering that victory has eluded him. To spare his feelings the name is different — muumuu, or shifts or Marimekko. But by any name this year's popular straight-hanging, figure-concealing dress is distressingly the same shape as the sack. The Marimekko, a Finnish import whose name is derived from an old word meaning little girl's dress, is becoming an enveloping fad with eastern college girls."[37]

The so-called sack took on mythic proportions and conferred new status on the wearer. Writing for the *Herald Tribune*, Eugenia Sheppard coined the phrase "uniform for intellectuals." She explained that "what Lilly Pulitzer has done for socialites,

162

a charming, fresh-faced Finnish woman, Armi Ratia, has done for intellectuals — given them a uniform. …The Marimekko is a much more intellectual performance than the Lilly…. The hand-screened prints aren't just prints. According to Ratia, they have the value of thinking. Some are like paintings, others are graphic art. The Lilly may be fashion, but Marimekko is design."[38] Sheppard went on to declare that Marimekko fashion had become an international phenomenon, that "fashion is no longer national. Designers everywhere are all tuned on the same wavelength. The new Marimekkos at Design Research were worn by bouncy long-haired little girls, and bigger, older girls, but they all carried the same message: A simple uncomplicated uniform for busy contemporary women."[39]

The American media not only focused on the cut and the image of the clothing, but also acknowledged individual Marimekko designers, particularly Annika (Piha) Rimala, who frequently

**By Any Name—Still a Sack**

The jubilant male who thought he had killed the decade's most controversial fashion—the chemise, also called the sack or bag—is now discovering that victory has eluded him. To spare his feelings the name is different—muumuus, or shifts or Marimekko. But by any name this year's popular straight-hanging, figure-concealing dress is distressingly the same shape as the sack. The Marimekko, a Finnish import whose name is derived from an old word meaning little girl's dress, is becoming an enveloping fad with eastern college girls (next page). Made of hand-screened cotton prints, it comes sometimes with flounces or yokes, but it is always unfitted through the waist. Matching tie belts are provided for the timid but usually wind up on the wearer's hair instead of around her waist. The brave and comfort-loving girls who wear Marimekkos for dates as well as classes hope to avoid any revival of the male unpleasantness by chopping the dresses off at the knee to show a pretty leg.

CONTINUED

◄ Fig. 5–21. Marimekko in *Life* magazine (June 15, 1962), photos by Milton H. Greene. Courtesy of Milton H. Green Archives.

▼ Fig. 5–22. Marimekko in *Vogue* (November 15, 1965), photos by Gordon Parks. Left, Annika Rimala's *Tiira* dress in *Laine* pattern (1965); center, an ensemble in *Iso suomu* pattern (1965); and far right, Vuokko Nurmesniemi's *Galleria* pattern (1954).

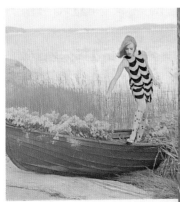

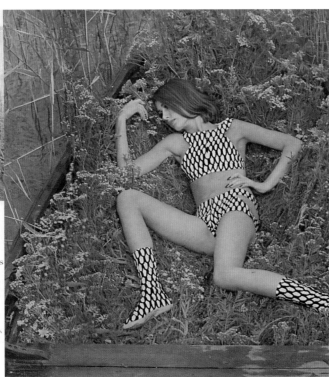

**NEW VERVE FROM FINLAND**
THE MARIMEKKO IDEA—BOOTS, SHOES, THE WORKS

Pure of line, true of colour, bold of spirit: the Marimekko idea in modern young Finland to the life…. Stark, easy, happy designs snapped out with punch and backbone … springing up like a fresh-laid in everything from fashion to pillow slips, toys to table linens, candles to houses…. The news now from Marimekko, starting here—shoes and boots, and a collection of clothes, all designed specially for Vogue, and photographed in Finland on Finnish models. In the background on these two pages: grounds around the country house, near Helsinki, of Armi Ratia—the remarkable woman who is founder and director of Marimekko.
Dress in waves, criss-cross clogs, above, of heavy cotton, hand-printed (as are all Marimekko fabric designs) in brightest yellow, darkest blue. The dress printed in waves, short and small with wide neck, deep armholes. About $45. Clogs with black lacquered wood soles, laced to the knees in yellow-and-blue striped cotton straps. About $15. Side-slit bikini and boots, opposite, of black-and-white fish-scales, hand-printed on cotton. The top, high at the neck, slanting low at the sides—showing a hint of bosom; the pants, with horizontal slits. Bikini, About $20. Boots of the same fabric, zipped up the back, with soft bright-yellow soles. About $15. Everything by Marimekko; at Design Research, Neiman-Marcus. For notes on Helsinki: page 61.

**THE MARIMEKKO IDEA**

Blanket-boots, opposite above, cut from handwoven wool blankets in pink-and-orange parquet print, with laces up the back… stacked heels. About $60. The wearing of the blanket, opposite below : tiny top, wide-legged hip-pants cut from the same wool as above. About $80…. Quilted ankle-boots of shocking-green suéded calfskin ; black stacked heels. Leather by Leather's Best. About $55. Shiny new stripe of Oxford, left : good honest walking-shoe shape all slicked up in blue patent leather, yellow kid stripes ; solid little Marimekko heel of black stacked leather. Leather by Polypot. About $40. Flummy cotton knit stockings, about $10. V for overblouse, green for clogs, above : black-and-white striped cotton top. V'd out front and back. About $15. Lacquered black wood clogs with parrot-green taps of suéded calfskin. About $15. Everything by Marimekko. Design Research, Neiman-Marcus. Setting : the reindeer-tundra of Finnish Lapland—a green-grey iridescence of moss, fern, rock.

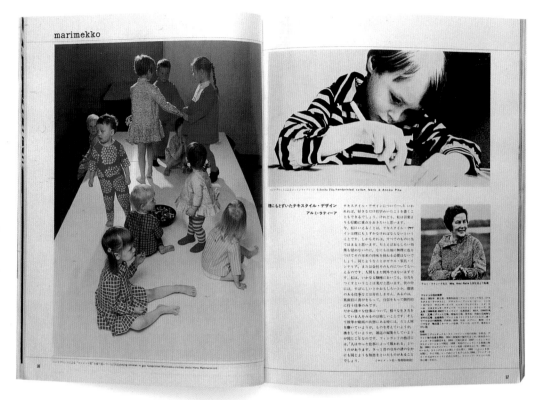

▶ Fig. 5–23. Marimekko in Japan Interior Design, no. 106 (January 1968), photos by Hans Hammarskjöld.

▼ Fig. 5–24. Marimekko hat and bag, Annika Rimala's *Aita* pattern (early 1960s), on the cover of Gioia, no. 14 (April 7, 1965).

◀ Fig. 5–25. Marimekko in *Gioia* (January 22, 1966): Annika Rimala's *Petrooli* pattern (1963).

▶ Fig. 5–26. Marimekko on the cover of *Bellezza* (August 1965): Annika Rimala's *Tarha* pattern (1963).

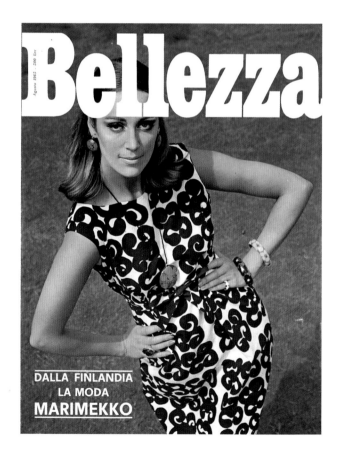

accompanied Ratia on her trips to the United States. Rimala was singled out by Thompson in his remarks at the opening of Design Research in New York. She translated her overt disdain for the stereotypical Finnish nature myth into innovative dress designs, and the press praised the congenial combinations of patterns and the inventive cuts of the clothing.[40]

## Japan

The Japanese were at least as fond of the *Unikko* pattern in 2002 as Americans, if the goods on display in Tokyo's department stores are any indication. Marimekko's ambitious licensing agreement in Japan was established in 1972 with Nishikawa-Sangyo, a six-hundred-year-old textile house. During the late 1960s Jinguro Nishikawa, president and owner of the company, had been captivated by Marimekko's black-and-white patterns when he came across them in Paris. He traveled to Helsinki and succeeded in contacting Armi Ratia, who went to Tokyo the same year. Marimekko had to revise its patterns and packaging to accommodate the requirements of a Japanese clientele and Japanese market. While they successfully created a special line of household accessories for the Japanese market, they never succeeded in finding a Japanese market for Marimekko clothing due to sizing difficulties. Textile designers Katsuji Wakisaka, and later Fujiwo Ishimoto, worked at Marimekko in Finland which facilitated the collaboration, and Marimekko became greatly admired by emergent designers in Japan. Nishikawa-Sangyo employed at least fifty designers, and when each new recruit was asked "Why do you want to work here?" the answer almost invariably was the attraction of Marimekko. In a 2002 interview, the elderly, courteous Nishikawa brightened noticeably when talking about his affection for Armi Ratia. He clearly enjoyed recalling

that in settling the licensing agreement she succeeded in raising the royalty from five to six percent by asserting that the number six is a more beautiful graphic form.[41]

## Other markets

While Marimekko conquered the retail markets in the United States, it was also active in other countries. Although Scandinavia in general was almost like the home market, the company only had one store in the Nordic world beyond Finland. The Stockholm shop, founded in 1960, created a sensation. A small shop opened in Malmö in 1964, and in 1976 a larger and more ambitious Swedish Marimekko shop opened in Malmö, designed by Finnish architect Ilkka Salo along with Ristomatti Ratia. Inspired by the Marimekko shop located on Esplanadi in Helsinki, the Stockholm outlet projected an image of luxury, with marble counters, special lighting, and specially designed display furniture. In the early 1970s Marimekko also started

Fig. 5–27. Marimekko dress in Annika Rimala's *Keidas* pattern (1967), worn by Susan Peterson as a "design object" on an episode of her television series, "Wheels, Kilns, and Clay," broadcast on CBS-KNXT-TV, Los Angeles, 1967–68. Courtesy of Susan Peterson.

to collaborate with the Swedish cooperative KF Interior. Together they made the first licensed bedlinen line in Scandinavia. The first stripe and square patterns were designed by Annika Rimala and Ristomatti Ratia. Ratia also designed other household and fashion accessories that were produced under the Décembre brand, including a line of classic handbags in collaboration with Fujiwo Ishimoto.[42]

In Denmark the Marimekko style, its textiles and fashion designs, were disseminated through extensive coverage in *Mobilia*, such as the May 1966 issue, which was devoted entirely to Design Research.[43] Since the Danish design magazine was translated into four languages — French, German, English, and sometimes Finnish — it was widely read among the international design community. In 1953 Torben Ørskov, a young Danish entrepreneur, had opened Form & Farve in Copenhagen, a stone's throw from Strøget, the central shopping street and seven years later the store began to display and sell Marimekko.[44]

The design-conscious public had access to Marimekko in France, Holland, Italy, Germany, and the United Kingdom, although Europe always remained a

secondary market. With Marimekko, the European buying pattern was similar to the American one: a cadre of design-oriented shop owners would introduce Marimekko to their clients through Marimekko collections in their stores. In the swinging London of the 1960s, for example, Terence Conran imported Marimekko fabrics to Habitat, the furniture and household equipment store, which was on Fulham Road, founded in 1964. He later expanded, opening a chain of stores inspired by DR. Conran also used the fabrics in his own home at St. Andrew's Place, London, which was widely publicized.[45] Another avant-garde Londoner of the 1960s, designer Mary Quant was among the first to wear Marimekko clothes in England. Having young, radical trendsetters in London choose Marimekko especially pleased Armi Ratia.

Progressive retailers and designers almost invariably traveled to the Marimekko factory in Helsinki, and from there went on to visit Bökars, Marimekko's magnificent, picturesque corporate estate, with its manor house, converted farm buildings, and a sauna on the Gulf of Finland.[46] They were certain to see the Marihouse, a model house for the planned Marimekko village, Marikylä, designed by renowned Finnish architect Aarno

Fig. 5–28. Marimekko in *Mobilia* (January 1964): spread, left, details of Maija Isola's *Fandango* (1962) and *Silkkikuikka* (1961) patterns; far right, Annika Rimala's dress in *Tarha* pattern (1963).

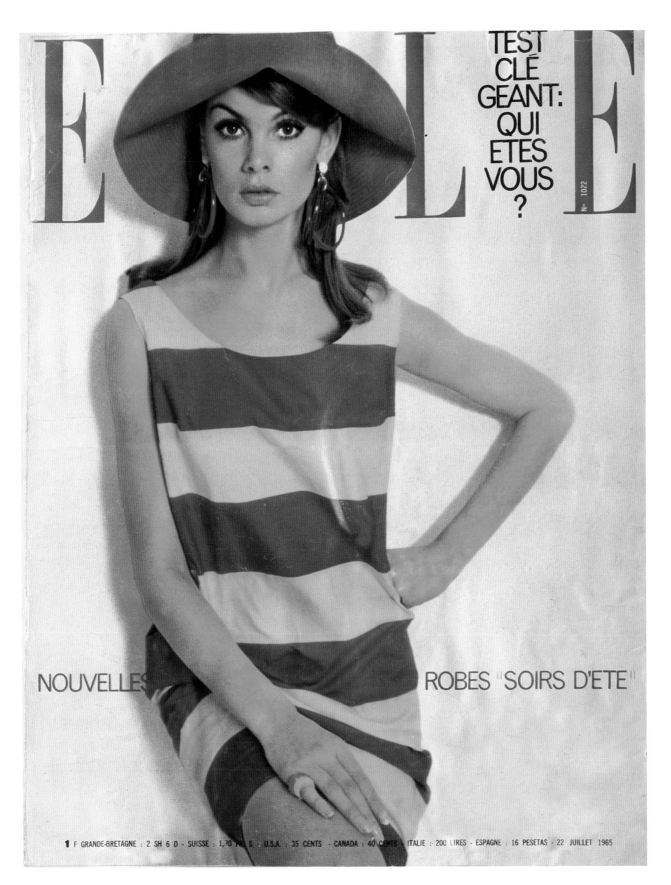

ELLE

TEST
CLÉ
GEANT:
QUI
ETES
VOUS
?

N° 1022

NOUVELLES          ROBES "SOIRS D'ETE"

1 F GRANDE-BRETAGNE : 2 SH 6 D · SUISSE : 1,30 FR S. · U.S.A. : 35 CENTS · CANADA : 40 CENTS · ITALIE : 200 LIRES · ESPAGNE : 16 PESETAS · 22 JUILLET 1965

Fig. 5–29. Dress by
Annika Rimala on the
cover of *Elle* (July 22,
1965): Vuokko Nurmes-
niemi's *Galleria* pattern
(1954).

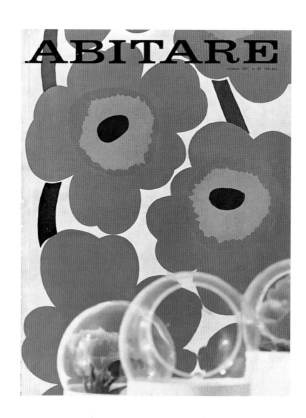

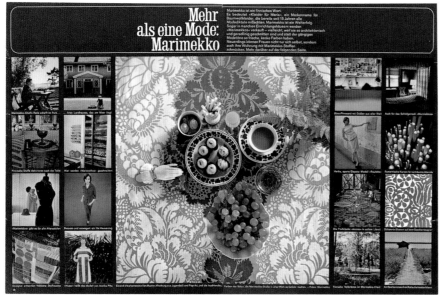

stream of visitors, by no means all businessmen, but [celebrities] from Finland and abroad."[47] The guests covered a wide range: President Urho Kekkonen, who brought friends; executives from the World Bank; literary lights such as Truman Capote; as well as regular visitors from among the Finnish designer elite — Kaj Franck and Birger Kaipiainen among others. Viljo Ratia further maintained that Marimekko had almost served as an ambassador for Finland, taking sole responsibility for the promotion of Finland abroad.[48]

Marimekko's products were published in the leading European fashion and interior design magazines. Especially influential were the Italian *Abitare* (fig. 5–30) and the German *Schöner Wohnen* (fig. 5–31). In 1962 the German daily press reported on a Marimekko fashion show in Stuttgart, while in Paris, Forme Finlandaise, a design shop supported by the Finnish Chamber of Commerce, sold Marimekko products and clothing, although the more prestigious address was the avant-garde Boutique Victoire on the Place de la Victoire. In the mid-1960s a cover of the trendsetting fashion magazine *Elle* (July 22, 1965) featured a model wearing a simple striped Marimekko dress (fig. 5–29), which set the pace for fashion for the following year.[49] Micheline Fried, the editor of *Elle* in the 1960s and 70s, recalled that while the strong colors caught the attention of readers, the use of cotton as a year-round material had an even greater impact. The cut of the clothes, however, never really conformed to French taste. Fried, who made the pilgrimage to Bökars in the late 1960s, was not as enthusiastic about her visit as others had been. She recalled that immediately upon arrival women guests had to change into the long dresses that were worn in the house, and later in the evening all guests were expected to take a sauna and a dip in the sea.[50]

Ruusuvuori. One of Armi Ratia's social projects, Marikylä, like its Italian counterpart built by Olivetti in the 1930s, was widely discussed in the international press. Years later, Viljo Ratia, Armi Ratia's husband and the co-owner of Marimekko, recalled the atmosphere at Bökars: "There was a constant

In Toronto the young Latvian-Canadian architect Janis Kravis had been entranced by a merchandise catalogue of Finnish designs, and in 1959 he and his wife Helga started the Karelia furniture and design boutique in Toronto, located in the lobby of a ladies' hairdressers.[51] From that small beginning, the enterprise grew into a network of four branches, all in Canada. Karelia sold Marimekko designs and also used Marimekko fabrics to make Karelia garments and other products. Like many other design stores, however, Karelia fell victim to its own expansion, and in 1981 it went bankrupt.[52]

In 2002 Benjamin C. Thompson died and a memorial was held in Quincy Market, Boston, which had been one of his urban renewal projects. The invitation to this event read: "There will be a large Marimekko alumnae delegation of course all in appropriately loose-fitting mekkodresses and shirts. Many slides, and we will serve aquavit and herring."[53] Thompson's sensitivity to the human need for stimulating environments, such as Quincy Market, had been a recurrent theme in his work, as it had in Armi Ratia's. When one critic complained that the market had been designed for the middle class, Thompson replied: "I always thought the middle class should be given some place to go."[54]

In the new century the magnificent *Unikko* pattern, originally hand-printed in Marimekko's Helsinki factory, has been resized to fit production in Finland, Japan, and Mexico. The flower recurs on dresses, sheets, towels, napkins, tableware, furniture, and more. In 2001 the *New York Times* announced: "As unfaded as songs from the 1960s and 70s the vivid Marimekko pop bloom and squiggles (and electric blues, magentas, scarlets, and yellows) are bursting onto the fashion and home furnishings scene again."[55]

Fig. 5–32. Kirsti Paakkanen, president of Marimekko Oyj since 1991. Courtesy of Marimekko Oyj.

The article emphasized the topicality by reporting that designers such as Anna Sui "have been buying vintage Marimekko yardage." Sui also collects dresses from the 1960s, which are reworked into new models. This recycling of the past formed part of the marketing strategy used by the present managing director of Marimekko, Kirsti Paakkanen (fig. 5–32), in her efforts to rescue the company. By the early 1990s Marimekko's comeback was already underway, concurrent with the "discovery" of vintage clothing from the 1950s, 60s, and 70s.[56] For the original importers of Marimekko in the international market, contact and dialogue with Armi Ratia had been compelling and unforgettable. Without Ratia to nurture the market, the revival of Marimekko — one of Pakkanen's most effective marketing strategies —speaks eloquently for itself, with all its original vitality and brilliance.

1 Marimekko was founded in 1951 and experienced near-bankruptcy during its first year. It was bailed out by Printex. For further details, see chap. 6 in this volume.

2 Türkan Hasan Ågren, verbal communication, Stockholm, November 2002. Hasan Ågren was in charge of textile yardage from 1962 to 1974. She and Armi Ratia visited Maija Isola together and chose patterns for the collection.

3 Vuokko Nurmesniemi, interviewed by Marianne Aav, 4 March 2003.

4 Michaela Richards, *The Best Style: Marion Hall Best and Australian Interior Design, 1935–1975* (New York: Art and Australia books G+B Arts International Ltd., 1993).

5 *Craft Horizon* (March–April 1958), clipping, Marimekko archive, Designmuseo.

6 Antti Nurmesniemi, interviewed by Marianne Aav, 9 April 2003.

7 Peter B. MacKeith and Kerstin Smeds, *Finland at the Universal Expositions, 1900–1992: The Finland Pavilions* (Tampere: Kustannus OY City, 1993): 78, 82–83. The term "anti-uniforms" reflects the new anti-design movement that emerged in the late 1950s on the Continent and in Britain and Scandinavia.

8 Artek had been founded in 1935 in Helsinki by progressive designers Alvar and Aino Aalto, art critic Nils-Gustav Hahl, and Maire Gullichsen, a visionary proponent of modern design, who provided financing. Its purpose was to display and sell designs by Alvar Aalto, but it soon became a primary venue for the most important progressive designers. Galerie Artek (est. 1950) showed paintings and other works by the leading modern artists, such as Picasso and Léger.

9 "Finsk klädvisning spännande i färg" (Finnish fashion show with exciting colors) *Svenska Dagbladet* (29 August 1958); [Elisabeth Falk], "Kläder med färg och sisu inspirerade från Karelen" (Clothes with color and stamina inspired by Karelia), *Stockholmstidningen, Beys Rond* (29 August 1958); Rebecka Tarschys, "Vackra finska vardagskläder" (Beautiful Finnish everyday clothes),

*Dagens Nyheter* (29 August 1958). NK Textilkammare (1936–71) was an independent design studio founded by Astrid Sampe and associated with the department store. It collaborated on an international level with many leading artists, architects, and designers.

10 Vuokko Nurmesniemi, verbal communication, Helsinki, August 2002.

11 Ibid.

12 Viola Gråsten (1910–1994) was a Finnish textile designer who emigrated to Sweden in the end of 1930s and worked for NK Textilkammare and Mölnlycke AB.

13 Jack Lenor Larsen, verbal communication, East Hampton, NY, November 2002.

14 Rebecka Tarschys, "Design Research," *Mobilia* (May 1966).

15 Benjamin Thompson, "Scenes from a friendship," in *Phenomenon Marimekko*, ed. Pekka Suhonen and Juhani Pallasmaa (Espoo: Amer Group Ltd. / Weilin & Göös, 1986).

16 Ibid.

17 "Clothes that liberate" was a recurrent statement in interviews with Armi Ratia.

18 Elizabeth Bernkopf, "Finnish Fashions Bright and Mad," [Boston] *Sunday Globe* (14 June 1959).

19 "A Cross Section of the Finnish Home," *New York Herald Tribune* (1 July 1959).

20 Jack Lenor Larsen, verbal communication, East Hampton, NY, November 2002.

21 Deborah Sussman, verbal communication, November 2002. Sussman was a graphic designer employed by Charles and Ray Eames in the 1960s.

22 Benjamin Thompson, "Scenes from a friendship," in *Phenomenon Marimekko* (1986).

23 Sungja Cho, verbal communication, Ardsley, NY, October 2002.

24 Ibid.

25 Rimala was in poor health throughout the early 1970s; she left Marimekko in 1976 but continued to work on the *Tasaraita* Collection until 1981.

26 Benjamin Thompson, "Scenes from a friendship," in *Phenomenon Marimekko* (1986).

27 Jack Lenor Larsen, verbal communication, East Hampton, New York, November 2002.

28 Gordon Segal, verbal communication, Chicago, November 2002.

29 Barbara Varro, "Marimekko Puts You in the Decor," *Chicago Sun-Times* (20 February 1968).

30 Ristomatti Ratia, verbal communication, Helsinki, August 2002.

31 Ristomatti Ratia, verbal communication, Helsinki, August 2002; Raymond Waites, verbal communication, New York, October 2002.

32 "Bright Spirit of Marimekko: A New vogue for a Colorful, Simple, Finnish Style," *Life* (24 June 1966): 60–71.

33 Jane Thompson, verbal communication, October 2002. *Sports Illustrated* (December 1960): cover (photographed by David Drew Zingg). Kennedy actually purchased nine dresses; one was returned.

34 Jane Thompson, verbal communication, October 2002. Jackie Kennedy also visited the small summer shop in Hyannis that DR operated.

35 "The Finnish Look," *Look* (4 December 1962): 68–75.

36 "New Verve from Finland: The Marimekko Idea — Boots, Shoes, the Works," *Vogue* (15 November 1965): 140–45 (photographed by Gordon Parks). This mutual "promotion" between Marimekko and *Vogue* probably came about through *Vogue* editor Kay Hayes who visited Armi Ratia at Bökars.

37 "By Any Name — Still a Sack," *Life* (15 June 1962): 47–53 (photographed by Milton H. Greene).

38 Eugenia Sheppard, "Uniform for Intellectuals," *New York Herald Tribune* (13 November 1963).

39 Ibid.

40 Annika Rimala, verbal communication, Salo, Finland, August 2002.

41 Jinguro Nishikawa, verbal communication, Tokyo, October 2002.

42 In 1983 Marimekko took over production from the Décembre company and changed the label.

43 Rebecka Tarschys, "Marimekko," *Mobilia* (January 1964 and January 1968).

44 Torben Ørskov, verbal communication, Helsingør, Denmark, December 2002

45 Nicholas Ind, *Terence Conran: The Authorised Biography* (London: Sidgwick & Jackson, 1995). I visited his home at St Andrews Place several times in the late 1960s and well remember the Marimekko textiles. — H.H.

46 The old farm buildings were gradually converted to new uses, such as a dance floor built in an old barn. Armi Ratia even moved her father's old house in Karelia to Bökars (author's recollection — H.H.)

47 Viljo Ratia, "Early Recollections," in *Phenomenon Marimekko* (1986).

48 Ibid.

49 "Nouvelles robes — Soir d'eté," *Elle* (22 July 1965). Micheline Fried, verbal communication, New York, October 2002.

50 Ibid.

51 Janis and Helga Kravis, verbal communication, November 2002. The "catalogue" was probably from DR, which served as their model retail shop.

52 The Kravises have preserved a private Karelia "archive," in which the Marimekko papers are impressive (ibid.).

53 Invitation to Benjamin Thompson's Memorial, 20 October 2002.

54 Thompson's comment was quoted by architect Robert Campbell, architecture critic of the Boston *Globe*, at the Thompson memorial service (authors' recollection).

55 Kimberly Stevens and William L. Hamilton, "Trying On Those Supergraphics Again," *New York Times* (31 July 2001).

56 Jeffrey J. Osborne (design consultant), Suzanne Slesin (journalist), and others, verbal communication, New York, October 2002.

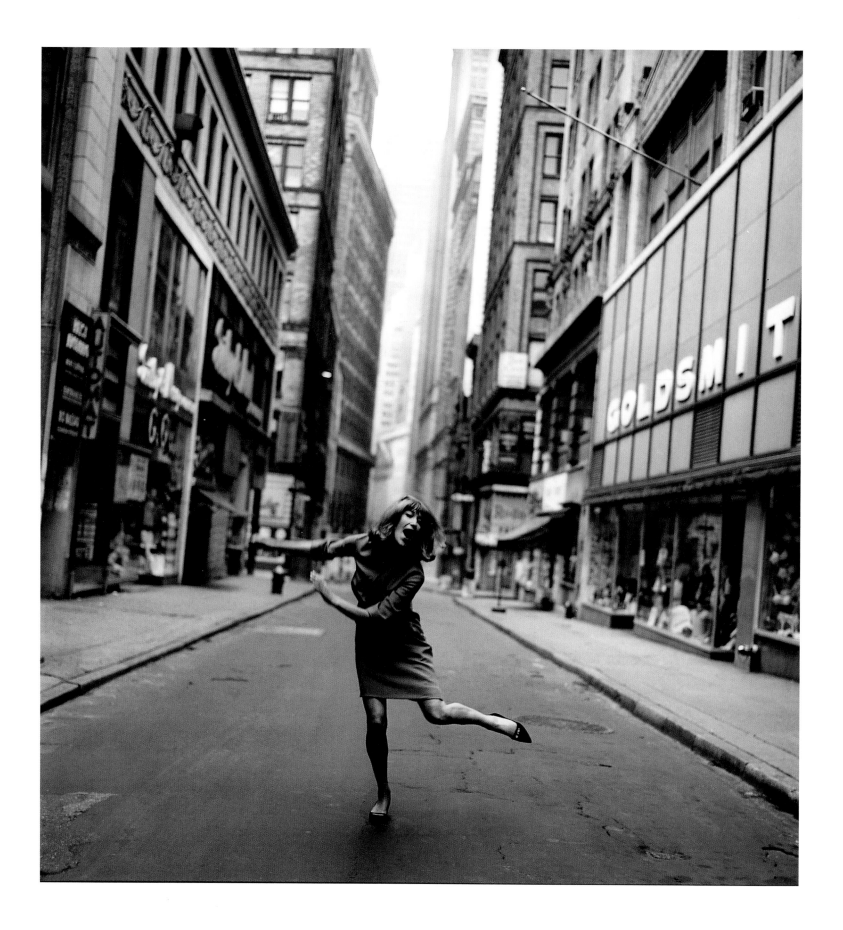

# 6. Various Causes of Corporate Success

Antti Ainamo

Since its earliest days, Marimekko has been a conduit for new ideas about design and new approaches to lifestyle within Finland and in the international arena. The firm encouraged its designers — Vuokko Nurmes-niemi, Maija Isola, Annika Rimala, Fujiwo Ishimoto, and many others — to experiment within a wide range of avant-garde influences in art, design, and fashion. Many scholars have studied and analyzed the company's contributions to design and its cultural history, but one aspect of Mari-mekko, its corporate history, has attracted less attention. There have been few systematic studies of the profitability of Marimekko, even though the company is firmly in the black more than a half century after its founding, a considerable accomplishment for a firm largely built on the charisma of its founder.[1]

◄ Fig. 6–1. Marimekko in New York, 1960s. Courtesy of Tony Vaccaro.

Fig. 6–2. Armi Ratia
wearing a smock in
*Tiiliskivi* pattern, 1952.
Finlandia Archives,
Oy Amanita Ltd.,
Somerniemi.

## The Early Days, 1949–56

The story begins in 1949 when Finland was undergoing a traumatic period of reconstruction after World War II. Everyday life, not to mention business, was hampered by restrictions on imported goods and services, while demand for them was high. Many Finnish companies worked to assimilate developments in international design and innovations in technology. One of these firms was Printex, a small manufacturer of oilcloth. The company had been acquired in 1949 by Viljo Ratia, a former military officer and lecturer at the Finnish Military Academy.[2] As is often the case with firms under new, relatively inexperienced management seeking new directions, it was a struggle to keep Printex afloat, especially in light of the pervasive economic difficulties throughout Finland. With lagging sales and little capital, Viljo Ratia asked his wife, Armi, who had studied textile design at the Institute of Industrial Arts, Helsinki, to create some floral patterns for cotton similar to the designs of successful competitors. Armi was a copywriter at Erva-Latvala, an American-style advertising agency. Her connections in the Finnish art, design, and fashion communities, coupled with her charisma and relentless tenacity, contributed to an almost immediate and intuitive sense of innovation. She rejected the idea of designing floral patterns, suggesting instead that she create something unique and original. Moreover, after initial trepidation, she appointed herself the chief art and design director. Nevertheless, the tension between Viljo's military, old world style and Armi's artistic intuitiveness and creative sensibility, which first surfaced in Armi's initial contact with Printex, would continue in the years to come and have an impact on the corporate stability of Marimekko.

Marimekko was founded in 1951. Between 1952 and 1995 its financial status was highly volatile. Productivity and periods of innovation in design developed in what resembles a cyclical evolution — a roller coaster. Paradoxically, profitability often went down when the product line was more adventurous and perhaps even more visible internationally. Conversely, when a design status quo was maintained, profitability improved. This raises some interesting questions. What caused the cyclical swings in profitability? What role did the CEO and managers play? How involved were the designers in the ups and downs of Marimekko's fortunes? This chapter focuses on the tensions between these questions — between the "who" and the "why." It examines the shifts from innovation to adaptation and decline. Finally, it shows why a new CEO was able to lead Marimekko to new trajectories of design and profitability in the 1990s.

From the beginning, rather than simply designing textile patterns, Armi Ratia worked to formulate a vision of the modern woman and her needs. She hired Maija Isola, a young textile designer, to work for Printex. She herself primarily worked to coordinate development, design, and marketing strategies, while Isola and freelancers pursued new products and designs. Unfortunately, Printex sales did not match projections.

In 1951 Armi Ratia and her associates decided to try another direction. One of their acquaintances, Riitta Immonen, had an independent fashion studio, modeled on French haute couture. To promote sales of its modern fabrics, Printex would present its fabrics in dress fashions, which would be designed by Immonen.[3] These dresses were merely to demonstrate the possibilities already inherent in Printex fabrics, not to be considered part of a fashion line. By hosting a fashion show, Printex hoped to generate positive media coverage and to attract a wider market among Finnish women, who would buy the Printex textiles to make their own clothes.

Immonen was not overly enthusiastic about the project, but she ended up designing the stage set for the fashion show, while others actually made the simple clothing samples she had designed to be worn at the presentation. Armi Ratia called this publicity campaign the *Marimekko-projekti* (Marimekko project): "Mari," a woman's name very close to her own, and "mekko," meaning a girl's dress.[4] Armi Ratia's enthusiasm for the project and the new name was infectious. She registered the new company as Marimekko Oy, an independent legal entity and a companion firm to Printex. The two would work in tandem: Marimekko was to develop, design, and market textiles; Printex would manufacture them. Armi Ratia and Riitta Immonen were

the two majority owners; their husbands, Viljo Ratia and Viljo Immonen, were minority owners.

The first Marimekko fashion show was held at the popular Kalastajatorppa restaurant in Helsinki in May 1951. In the final analysis, the work may not have been especially innovative, yet for the Finnish audience, the fashion show represented a positive response to contemporary demands. As one of Finland's first postwar fashion shows, it also represented the most extensive knowledge of cutting-edge textile design in Finland.[5] At midcentury Finland was still in the somber colors of the postwar era, and there was a thirst for the bright colors and fresh approach that Marimekko represented. Marimekko was different from conventional Finnish manufacturers who simply copied textile patterns and fashions from abroad.

Fig. 6–3. Viljo Ratia and unidentified "friend," near Kassel, Germany, July 20, 1957. Photo G. Bruchmüller. Kassel, West-Germany.

Rather than following international trends, Marimekko sought to become one of the trend-setters. It was a small but visionary firm, not averse to risk-taking, unlike most contemporary Finnish firms. More remarkably, it competed on the basis of its design prowess at a time when other Finnish companies for the most part did not. The fashion show was a cultural event that received much favorable media attention in Finland, raising awareness of the nascent company and its designs. This event helped Printex and Marimekko not only to present a new avant-garde identity, but also to make important contacts with customers, celebrities, and the press. By the end of the year, Tapio Wirkkala, Finland's premier industrial designer, was proudly wearing a handmade shirt by Marimekko, and the seeds of future prosperity for Armi Ratia's Marimekko had been sown.

Unfortunately, immediate financial success did not follow Marimekko's media triumph. In fact, the fashion show had had an unintended result. It had created a demand not for fabric by the yard as was expected, but for the fashion designs themselves, which existed only as runway samples.[6] There was no way Marimekko could mass-produce a clothing line; it had neither the technology nor the resources. Bankruptcy was avoided only with financing from Printex, which was itself hard-pressed.

Many conventional entrepreneurs would have lost momentum after such a development, but Armi Ratia insisted that Printex and Marimekko continue to pursue their roles as industry trendsetters. While Viljo Ratia was as willing as his wife to face adverse odds, he was less certain than his wife that Marimekko would survive.[7] Not wanting to be responsible for inflicting financial hardship on the Immonens, should the company fail, he discreetly negotiated with them to transfer their shares to Armi Ratia.

In 1952 Armi Ratia rented a small office and display window for Marimekko at the Palace Hotel (figs. 4–2, 4–3), then being used as the headquarters and hotel for international press and officials during the Summer Olympics, which were being held in Helsinki. This was an ideal location from which to study international trends and to make new contacts. With financial backing from Printex, Marimekko managed to show a small profit that year, and Armi Ratia hired Vuokko Nurmesniemi, an up-and-coming avant-garde designer, to work full-time for Printex. During Nurmesniemi's first year at the firm, many of her products demonstrated her gift for combining architectural and sculptural forms in both textiles and clothing in complex ways, a talent that few individual artists working in Finland could match.[8]

The new arrangement was for Printex to manufacture and market modern textiles, while Marimekko became the brand name for the marketing of clothing. Under the inspired leadership of Armi Ratia, the two designers — Isola and Nurmesniemi — stretched the meager resources of Printex and Marimekko to the limit. Isola was influenced by geometrical abstraction (constructivism) in figurative arts. Nurmesniemi developed Marimekko's initial design concept into an ideology that was believed to potentially free people, especially women, from the Finnish right-wing establishment whereby "home, religion, and the Fatherland" were considered paramount. Such freedom had special significance in Finland, because the nation had fought for independence in 1918 in a civil war between right- and left-wing coalitions, the wounds of which had only begun to heal. This was the voice of a new and increasingly international generation.

Despite the promise of imminent success, Printex went bankrupt in 1953. It was soon reorganized

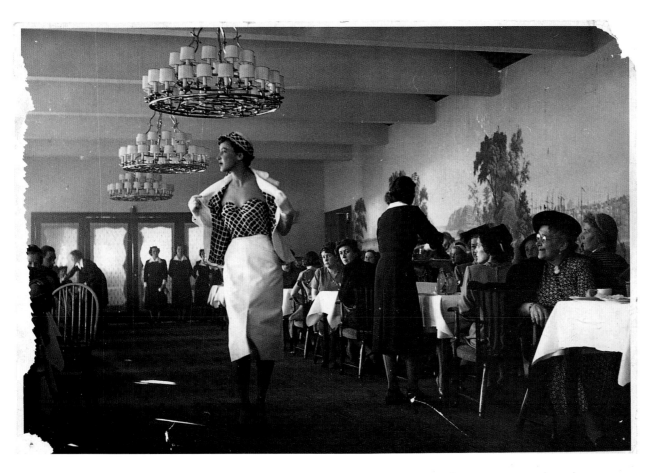

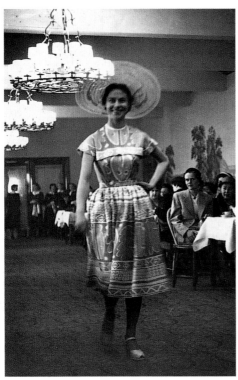

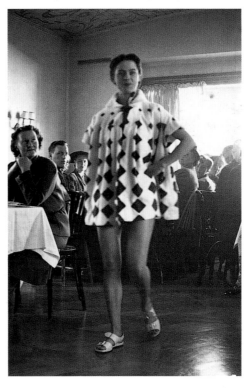

Fig. 6–4 a, b, c. The first Marimekko fashion show at the Kalastajatorppa restaurant, May 20, 1951, featuring dresses designed by Riitta Immonen: *Suez* pattern by Per-Olof Nyström (above); *Leppäkerttu* (left) and *Harlekiini* (right) patterns by Maija Isola.

under the same name with Armi Ratia as co-owner. She commissioned Helge Mether-Borgström, a graphic artist, to design a new logo for Marimekko. The result used Courier, a standard typewriter typefont, in lowercase letters suggesting that Marimekko was designed to be a collective concept, rather than part of the contemporary individualism of the 1950s. In the best graphic tradition the logo was used not only on corporate letterheads, but also on fabric selvage (with Printex), reinforcing "Marimekko" as a brandname. There was still no capital for even the smallest investment in manufacturing, but in 1954 Armi Ratia scrounged up the resources to organize another fashion show. Around 1954 Printex's products began to be more widely known in progressive design circles. In Finland Marimekko and Printex found new markets outside the Helsinki area, although the Stockmann department store in Helsinki continued to account for 70 percent of all sales. The next year, sales outside Helsinki increased. When productivity remained at the same level as before, Marimekko's equity moved clearly into the black. For the first time, Marimekko and Printex were out of a perpetual financial crisis.

Armi Ratia took advantage of this new prosperity by purchasing machinery for cut-and-sew apparel production in 1955. With this significant investment, the firm began to move away from pure handcraft production of fabric and clothing to batch production. Whether by luck or intuition, the timing was perfect. Higher volume increased awareness of Marimekko's designs, and Marimekko and Printex entered a golden age of design that would continue until 1966 for Printex and 1968 for Marimekko. Throughout this time both firms were at the forefront of progressive design.

## The Marimekko Model, 1956–71

Despite increasing success, Printex and Marimekko only barely avoided bankruptcy in 1957, the same year an image of a woman in a dress designed by Vuokko Nurmesniemi was chosen as the symbol for "Finnish Design," a marketing campaign for Finland's design-intensive exports (fig. 7–22). A year later, however, the financial outlook appeared brighter. In 1958 a Printex / Marimekko exhibition was held in Stockholm to a blitz of media attention. Marimekko's net sales increased by three quarters that year.[9] Only taxes hindered the Ratias from showing a hefty profit on their accounts. In 1958 the company received an even bigger boost when Printex textiles and Marimekko fashions were exhibited at the Brussels World's Fair, where the restaurant waitresses wore Marimekko dresses. There Armi and Viljo Ratia met Benjamin Thompson, an American architect who had founded Design Research in Cambridge, Massachusetts. During the 1950s, DR was pivotal in promoting modern design through its retail outlet and in shaping American taste for Scandinavian and Asian design. Thompson had worked with Walter Gropius, founder of the Bauhaus in Germany, another important influence on Marimekko.

In Finland it became a "must" in many fashionable homes to have "curtains by Marimekko," so called even though they were manufactured under the Printex label. From early on, consumers had difficulty in making the distinction between the two companies. The name "Marimekko" was equated with "looking Finnish," and so "Marimekko" was almost universally used, whether for yard goods or fashion. Because Marimekko products combined elements of international and Finnish art and design, they were often considered both international and uniquely Finnish.

In 1959 Armi Ratia hired a new designer, Annika Rimala, who drew from geometric and architectonic sources of inspiration and favored large-scale patterns, an emergent trend in international art and design.[10] That Marimekko designers were linked to the larger art scene was not surprising. Many of them were themselves active in other areas of the arts, and all of them were knowledgeable about developments in painting, sculpture, and architecture in Finland and in the international arena. Most also had connections to areas usually considered outside the design community, such as business, journalism, popular culture, or politics.

In 1960, with business thriving, Viljo Ratia hired his brother Urpo Ratia to help run Printex and Marimekko. While Ratia believed firmly in the entrepreneurial strength and equality that he and Armi shared, he also recognized the need for a more systematic administrator. One of Urpo Ratia's first contributions was to convince Armi Ratia to concentrate on design and marketing and leave the day-to-day administration to him. Initially reluctant because of her insecurities about dealing with foreigners, she soon came into her own and "proved a natural."

Also in 1960, while a young U.S. senator from Massachusetts was running for president, his glamorous wife, Jacqueline Kennedy, purchased eight Marimekko dresses. Few clients could have provided better publicity for Marimekko. Exports accounted for 10 percent of the company's net sales. With this favorable development, Armi Ratia insisted that investments in strengthening Marimekko's design process be doubled. One important change that also occurred in 1960 was the departure of Vuokko Nurmesniemi after recurrent disagreements with Armi Ratia. Annika Rimala became Marimekko's chief fashion designer,

and another new designer, Liisa Suvanto, was hired. Suvanto's first project was to work on Marimekko's corporate identity in photographs, exhibitions, and fashion shows, using such "Finnish Design" techniques as incorporating backdrops of straw and stones representative of the harmony between Finnish nature and Finnish art, design, and culture. This kind of corporate identity aligned Marimekko with other icons of Finnish design, especially Tapio Wirkkala.

In 1961 and 1962 Printex / Marimekko held exhibitions in Boston, New York, Paris, Stuttgart, and Stockholm. A subsidiary was established in Sweden and several new shops were opened in Finland under the Marimekko name, which was by now clearly better known than Printex.[11] It was also Marimekko fashion rather than Printex that the New York *Herald Tribune* called the "uniform for the intellectual."[12] And it was Marimekko, not Printex, that was featured in American *Vogue*.

Around 1967 as Armi Ratia became increasingly sure of her intuition and vision, she started considering a new project: a "Marikylä" (mari-village). This Marshall McLuhan-esque social experiment would be a modern "global village," where "mari-people" would pursue a new "lifestyle." The village was to include a Marimekko factory and provide homes for employees. It would also serve as a "research laboratory" for new Marimekko products. The concept developed through discussions with Ratia's architect friends, primarily Aarno Ruusuvuori, one of Finland's premier architects, who was to work on the project (see Chap. 4).

The Marikylä project was widely covered by the international press, with great enthusiasm. Many other firms were interested in collaborating and contributing to the creation of the new lifestyle it represented. The project grew in every direction,

including not only innovative residential architecture but everything from textiles and clothing to candles, glassware, ceramics, and even jewelry. As the new products developed, such diversification made the retail shops increasingly important to Marimekko.

The increased press coverage also translated into a manifold increase in Marimekko's exports. The firm was truly solvent, and its share capital rose. Armi Ratia continued to distance Marimekko from purely material products and to focus more and more on social or lifestyle issues. She said in an interview in 1964 that "a woman is sexy . . . not a dress"[13] A Finnish journalist wrote: "Marimekko is a charming challenge to all conventional codes. The challenge is directed to young girls and grandmothers, at play and at work, in the office, at home and at school. The challenge encompasses everyday life. The challenger is Marimekko . . . a flying banner against all conventions and codes."[14] There were persistent rumors that an American millionaire was trying to buy the Marimekko brand from the Ratias.[15] One California newspaper ran an article declaring "Happiness is a Marimekko."[16] There were features in American *Vogue* and *Life*, and a Marimekko dress designed by Annika Rimala appeared on the covers of French *Elle*, British *Queen*, and Italian *Bellezza*.[17] Isola's textiles at Printex remained important. Her geometric dress, reminiscent of Op Art, and Annika Rimala's Pop Art-inspired *Ryppypeppu* jumpsuit were widely acclaimed for their innovative design, verging on art.[18]

However, this general interest in Marimekko design was also a sign that the ideas on which the company had been founded were rapidly diffusing into popular culture. The meaning of Marimekko's design was changing. Not surprisingly, the materialization of Armi Ratia's vision was strongest in

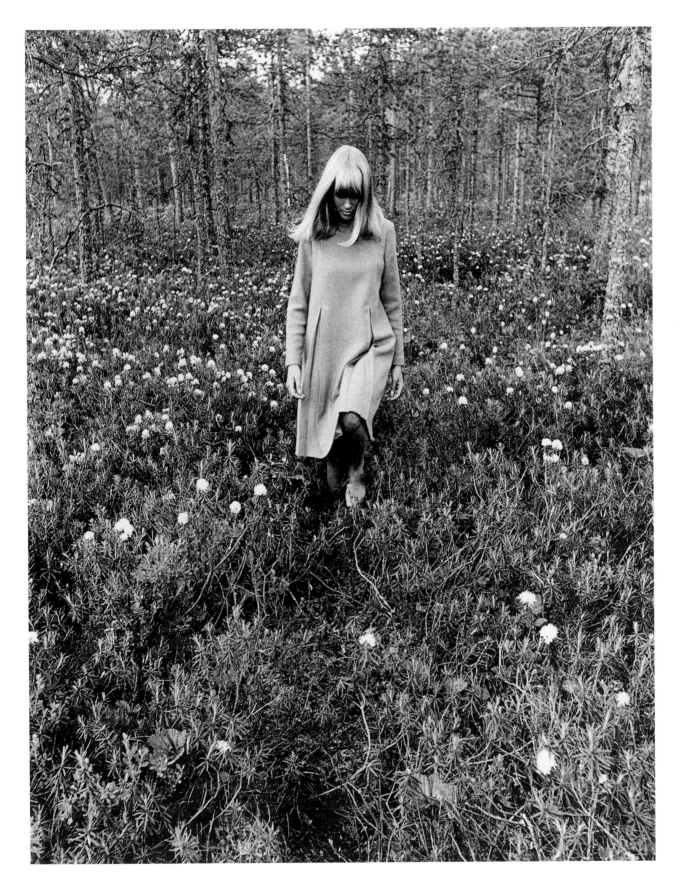

Fig. 6–6. Liisa Suvanto.
Wool dress, early 1960s.

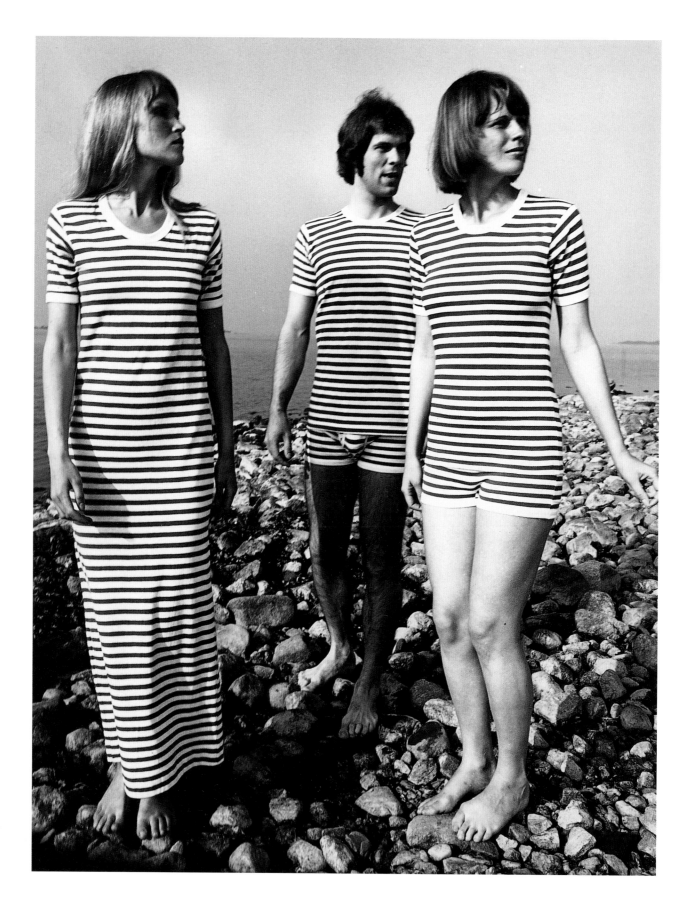

Fig. 6–7. Annika
Rimala. T-shirts and
underwear; *Tasaraita*
pattern, 1968. Cotton,
polyester jersey.

Finland, where Marimekko's style was strongest. The "social revolution" of the 1960s was coming to an end and Marimekko's style was becoming outmoded as a representative of the avant garde.

Viljo Ratia became concerned that Armi Ratia's total commitment to the Marikylä project, with the attendant publicity it generated, was putting a strain not only on the company, but also on their working relationship. Their disagreements over the project may in fact have contributed to the breakup of their marriage; in any event they did begin divorce proceedings around this time. As Armi Ratia sought to maintain the company's momentum by finding new ways to implement its design philosophy, much of her attention focused on Marikylä. She had an experimental Marikylä house ("Marihouse") and a sauna ("Marisauna") built in 1966, the same year that the Printex accounts were merged with Marimekko and Viljo Ratia became a minority shareholder.[19] The merger allowed Marimekko to show record profits at 8 percent of net sales. Their son Ristomatti Ratia was hired as a full-time designer.

Annika Rimala, Marimekko's most prominent designer at that time, continued to focus on innovative fabric and fashion design, still an important aspect of the Marimekko line. In an interview she said that "there must be freedom of movement. If one feels like running, there must be freedom to run; if sitting, there must be freedom to sit."[20] She began to work in a new direction — jersey. In 1968 she presented the *Tasaraita* collection, a new line of clothing made of striped cotton jersey, which not only helped to rejuvenate the Marimekko look, but also the firm itself. *Tasaraita* was a continuation of the Marikylä project — clothing for a new lifestyle. It combined nineteenth-century Mediterranean influences with Marimekko's own design heritage and printing technology. The result was a kind of "Maoist uniform": unisex clothing for men, women, and children, with signature striped patterns. In the international marketplace, *Tasaraita* started a new trend and was quickly adopted by designers, intellectuals, and progressive consumers, especially in the Nordic countries. Marimekko received the prestigious Neiman-Marcus Fashion Award for design in 1968.

Armi Ratia believed that the social and economic demand for Marimekko's traditional product design was declining. The global "social revolution" of student and labor unrest in 1968 had fundamentally changed the nature of Marimekko's environmental context. Ratia hired Katsuji Wakisaka, a young Japanese designer, and Pentti Rinta, newly graduated from the Institute of Industrial Arts, in an attempt to shake up the Marimekko design program. The Japanese aesthetic was a totally new component in Marimekko's design, and Wakisaka soon began working with Liisa Suvanto on new design concepts.

Marimekko can be said to have overturned their initial design concept with Annika Rimala's *Tasaraita*. *Tasaraita*, and by extension Marimekko itself, became linked to a kind of depersonalized anonymity then being discussed in design and society in the German model of *Gleichschaltung*. Intellectual thought in Finnish society in the 1970s and early 1980s was focused on standardization, and there was diminishing appreciation for the kind of "elitist" design that Marimekko had represented throughout its history. The *Tasaraita* "uniform," therefore, represented a departure for the company. Net sales in 1968 increased 30 percent and profits remained at the new record-high level that had been reached the previous year, but Marimekko's design impetus and the nature of its business and its clientele had irreversibly changed.

In 1968 diffusion of postwar elitist ideas about socialism into the mass market coincided with the expansion of markets for any given product. Indeed, Marimekko's sales and productivity reached their highest-ever level, at 10 percent of net sales. Following the Ratias' divorce, business administrators were brought in from outside the immediate family to analyze the profit-and-loss sheets with a vigor previously unknown at Marimekko. As a result, banks that financed the company decided that changes in management were needed to assure a yield on their investments in Marimekko over the years. Urpo Ratia left the firm, and with Viljo also gone, professional managers were hired. One of the first casualties was the Marikylä project. Work at the site was terminated once and for all.

In 1970 Décembre Oy was set up as an independent firm, wholly owned by Ristomatti Ratia, and Armi Ratia began to organize a transfer of Marimekko products, which had been designed by Ristomatti, to the new firm. This separation would allow both companies the freedom to explore new opportunities and to offer larger product lines within their specialties. While Marimekko's new managers sought to streamline the existing industrial and financial setups, Décembre explored new products and markets, focusing on plastics and other new materials, its principal production including plastic shelves for books, coat hangers, bags, and other peripherals. Décembre's bags, designed originally at Marimekko in 1968, became a huge success and were later ranked among the top twenty-five of the "world's best products" by *Fortune Magazine*.

Marimekko's twentieth-anniversary fashion show was held at the site of its inaugural 1951 show, the Kalastajatorppa restaurant in Helsinki. *Tasaraita* designs were presented under the slogan "Everyone into *Tasaraita*." Marimekko continued to broaden its design base. Wakisaka had already established a reputation for fabric patterns that used powerful colors to create a kinetic impression and fluidity of movement and boldness, and with these fabrics Suvanto designed unusual outfits for men. These experiments failed to sell, although a man's suit designed by Pentti Rinta became a true "uniform" for the intellectual man. It appealed to male designers, intellectuals, and trendsetters who had risen to social or political prominence during the social turbulence of the 1960s and who refused to wear conventional suits for men. Rinta's suit design was a commercial success and remained in production for a decade. It sold particularly well in Finland. Also successful in 1971 was the *Pallo* collection, another series of cotton jersey designs by Annika Rimala. A leading Finnish newspaper announced "Everyone into *Pallo* tricots," echoing the *Tasaraita* campaign. Net sales in 1971 continued to grow, and profits hit a new all-time high.

## The Finance-Driven Company, 1972–mid-1980s

In the early 1970s, Rimala adapted her *Tasaraita* designs to accommodate industrial mass production, which was playing a greater role at Marimekko. Maija Isola and Pentti Rinta attempted, without commercial success, to return to a minimalist design aesthetic at Marimekko. Products produced by Décembre and marketed by Marimekko sold particularly well around the world in 1972. Profitability remained at a satisfactory level. The same year, Armi Ratia negotiated a licensing agreement for manufacturing textiles in the United States, and a year later additional licensing agreements were negotiated with American and Japanese companies. In 1973 licensing royalties from both

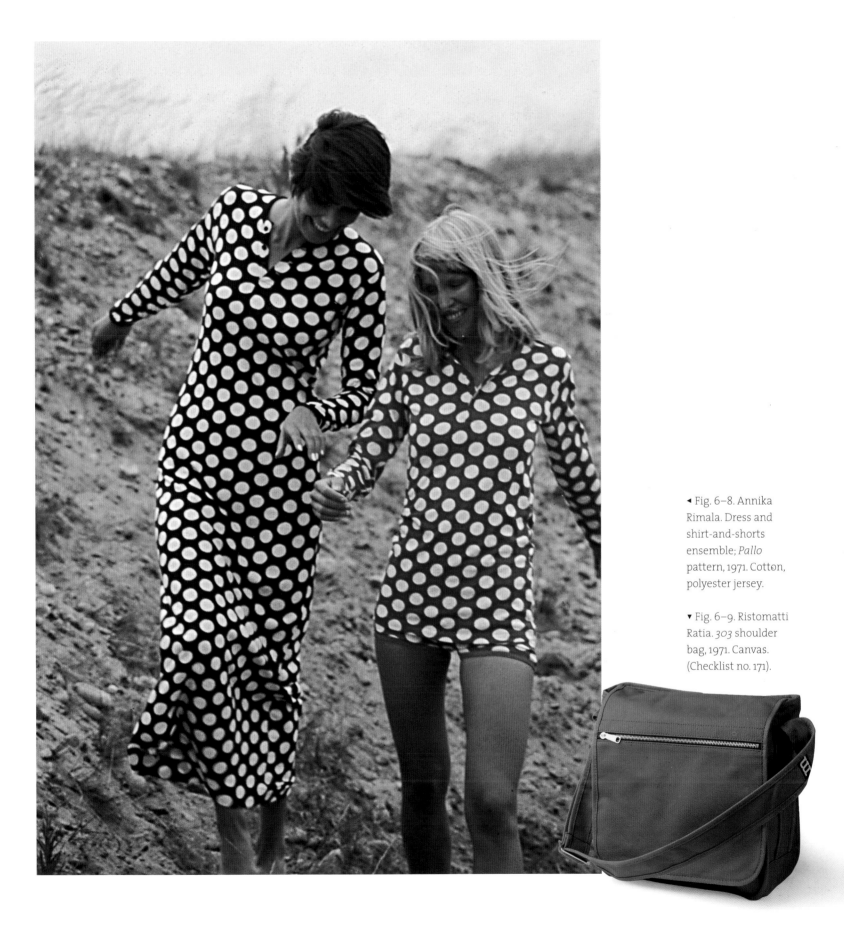

◄ Fig. 6–8. Annika Rimala. Dress and shirt-and-shorts ensemble; *Pallo* pattern, 1971. Cotton, polyester jersey.

▼ Fig. 6–9. Ristomatti Ratia. *303* shoulder bag, 1971. Canvas. (Checklist no. 171).

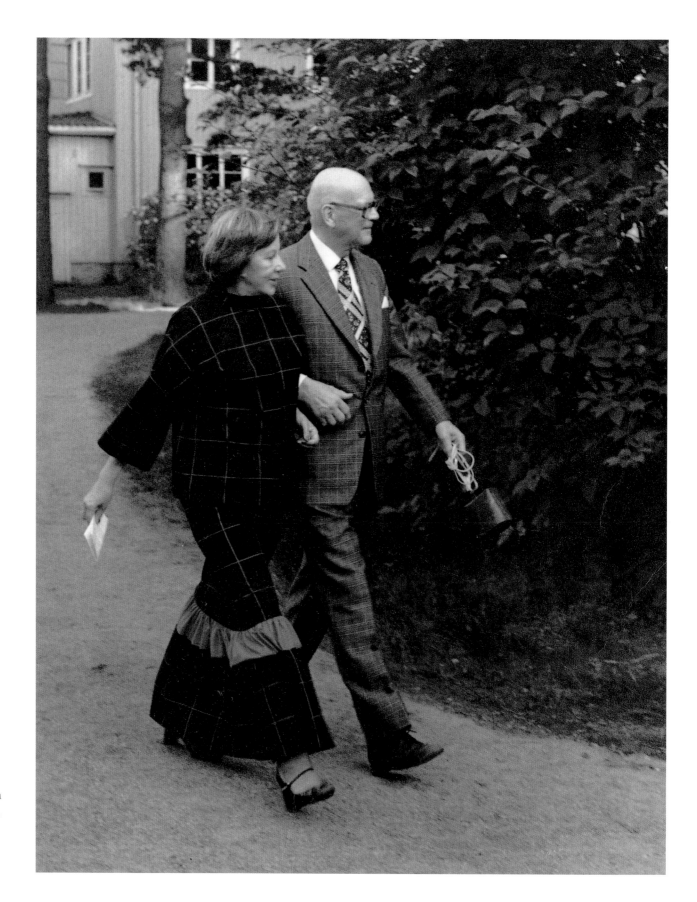

Fig. 6–10. Armi Ratia and Urho Kekkonen, president of the Finnish Republic, at Bökars, mid-1970s.

countries represented half of the book value's net profit. Otherwise, profits declined from 12 to 7 percent of net sales. In 1974, at Armi Ratia's initiative, Marimekko was listed on the Helsinki Stock Exchange, as if it was being donated to the people of Finland.[21]

Also in 1974 Katsuji Wakisaka designed a naivist textile pattern, based on cars. It was a continuation of the Marimekko lifestyle concept and was an immediate success, both artistically and commercially, especially in the United States. Suvanto designed wool dresses that also received favorable criticism but sold less well. In 1974 Armi Ratia employed Fujiwo Ishimoto, another male Japanese designer, to offer new insights into designing women's fashion.

In Finland demand and appreciation for Marimekko's design reached new heights in 1974. A new flagship shop was opened on Helsinki's Esplanadi, the city's most exclusive shopping street. Urho Kaleva Kekkonen, the president of Finland, opened a new multipurpose facility in Bökars, and net sales increased by more than a half. Profitability bounced back to a "normal" level of 13 percent of net sales, up from the disappointing 7 percent of the previous year.

The utopia that Marimekko had promised in the 1960s seemed to be a market reality in the mid-1970s. In Finland Marimekko was ubiquitous, an integral part of the Finnish lifestyle; when an old Marimekko shirt wore out, for example, a new one could readily be found in the nearest Marimekko store, of which there were many. As Marimekko became more familiar, it struggled to maintain its distinctiveness and to remain socially meaningful. The progressive architectural influences that had affected Marimekko's design since the 1950s had become common elements within industry across the Western world in the mid-1970s. Social demand had permanently changed. Marimekko's original design philosophy was in need of total rejuvenation: *Tasaraita* was not enough.

One approach to marketing Marimekko had always centered on cultivating an influential clientele. The Marimekko corporate estate in Bökars served as a venue for many social/promotional gatherings, which often included a stellar guest list from an ever wider social circle. President Urho Kaleva Kekkonen, for example, was a fairly frequent visitor. He had aligned himself with intellectuals and other politicians whose rise coincided with the upheavals of 1968. As a result, Kekkonen's presence at Bökars assured the presence of the post-1968 elite. Profitability remained at a high level.

The firm's exports increased in 1975, accounting for nearly half the net sales. The firm also developed its international operation, opening a franchise shop in Amsterdam. The same year, in the wake of these accomplishments, Marimekko received the Presidential Export Award, which was given each year by President Kekkonen to a Finnish firm that was highly successful in foreign markets and could serve as a model for other firms.

A sales subsidiary was established in Germany in 1975, followed by another in the United States. Exports in 1976 outpaced sales in Finland, measuring 45 percent of net sales. Wakisaka and Suvanto collaborated on a series of clothing designs, for which Wakisaka designed the textiles and Suvanto the dresses. Wakisaka similarly collaborated with Rinta. A design and marketing branch was also established in the United States, where one of Fujiwo Ishimoto's designs — *Seitsemän kukkaa* (seven flowers) — was both an artistic and commercial success. All in all it seemed that Mari-

mekko's healthy profit performance, which reached new record levels in 1976 as a result of international sales, was to be permanent, and therefore investments in new designs for an integrated corporate identity for production, offices, and retail shops were made that year.

For three years Marimekko maintained its sales performance under its new corporate image. Then, in 1979, after a brief illness, Armi Ratia died. Not surprisingly, without the company's charismatic leader, Marimekko's profits that year dropped temporarily to 5 percent of net sales, although net sales grew to FIM 51.3 million. While it was impossible to replace Armi Ratia, Hilkka Rahikainen, one of the more recently employed female designers, became the new art director. Marja Suna, another female designer and among the last personally chosen by Ratia before her illness, was given the task of rejuvenating the women's clothing line. The firm had opened a flagship retail shop in New York, and under a license agreement, a Swedish firm, Borås Wäfveri, had started making Marimekko bed linens.

In 1980 new Marimekko franchise shops were opened abroad. The strategy was to focus on three main markets: Finland, Northern Europe, and the United States. Total net sales grew by more than 25 percent and amounted to FIM 66 million. There were new product lines, including men's shirts and wool clothing for women, while the older, standard cotton knits continued to sell well. Profitability set a new record high of 14 percent of net sales. Licensing was growing three times as fast as conventional exports, and licensing income grew by a third, with the increase coming mainly from the United States. Germany grew into a larger export market than the United States, where market position stabilized. Two new retail shops were opened in Finland. All in all, Marimekko's design maintained its momentum.

The 1980s were marked by new design initiatives being made in the international design arena. Marimekko's products were no longer unique, nor were they as progressive as they had been in the 1950s, 1960s, and early 1970s. The loss of the company's strong-willed founder left a void. Yet within this difficult context Marimekko proved to be a highly resilient firm. By continuing to adapt its production and improve its industrial efficiency, it enhanced its profitability and reached a new record level in 1981. Net sales grew significantly, amounting to FIM 75 million. Return on investment that year topped all the firms listed on the Helsinki Stock Exchange, and Marimekko was accordingly named best firm for 1981. Through its strong corporate identity, Marimekko had reached a position where it was not vulnerable to small, temporary changes in its markets.

## Decline and Drift, mid-1980s – 1990

At the same time, however, Marimekko began to lose momentum in the development of new designs. In 1983 the company reacquired Décembre, the spin-off established in 1970, which had successfully manufactured and marketed Ristomatti Ratia's bags and knapsacks. Such internalizing of good design provided Marimekko with design solutions from which to expand its business. In the 1980s, apart from a few isolated cases, such as Fujiwo Ishimoto, Marimekko's best designers failed to produce products that were critically acclaimed and also sold well. Toward the end of 1985, the Ratias' children — Ristomatti Ratia, Antti Ratia, and Eriika Gummerus — decided to sell their shares of Marimekko to Amer Group Ltd., a Finnish conglomerate that soon owned 95 percent of Marimekko.

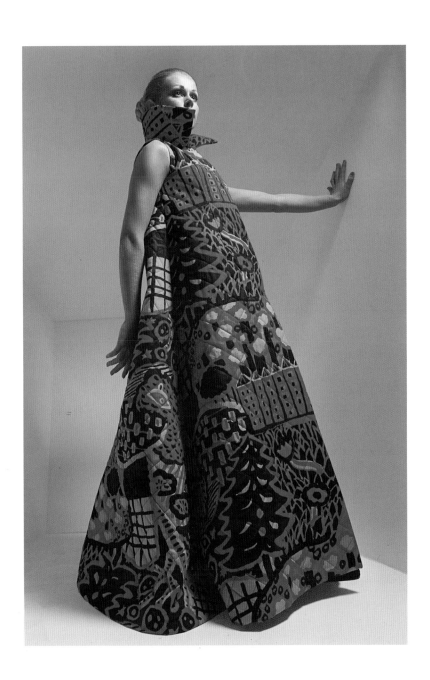

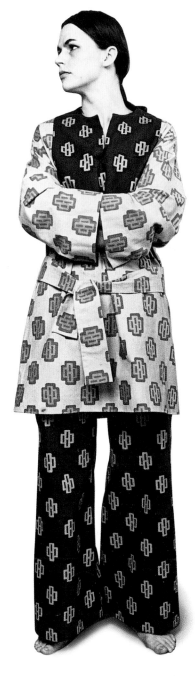

◄◄ Fig. 6–11.
Liisa Suvanto. Dress;
*Eve* pattern by Katsuji
Wakisaka, 1971.

◄ Fig. 6–12. Pentti Rinta.
*Lesti* dress and trousers;
*Solmu* pattern by
Katsuji Wakisaka, 1970.
Cotton flannel.

Fig. 6–13. Ana Pullinen.
*Marimekko Fabrics*, 1986.
The Finnish Museum of
Photography, Helsinki.

To many Finns, Amer Group was identified with the tobacco industry (it licensed Marlboro cigarettes, for example, from Philip Morris). Such American-style mass marketing was not perceived to be compatible with Marimekko's design philosophy.

Amer Group's plan was to exploit the company's quality identity and reputation and to establish an international franchising chain of interior decoration and fashion stores. Instead Marimekko almost immediately entered a vicious cycle of decline in its business and reputation. With its glorious history of success but a memory, Marimekko's net losses in the late 1980s and early 1990s amounted to 20 percent of its net sales.

It soon became apparent to Amer Group that, despite Marimekko's reputation and impressive recent track record of commercial activities and profits, the company had actually been declining sharply for some time. Amer Group took swift action. It shortened Marimekko's fiscal year from twelve to six months, ostensibly to synchronize Marimekko's accounts with its own. According to Marimekko's annual report for 1985, demand conditions were temporarily unfavorable, but profitability was expected to rise from its current level to 4 percent of net sales. Amer Group's belief that design stagnation could be subjected to scientific appraisal failed to revive the company's reputation for quality design. Instead, Marimekko's design lost its emotional resonance and individualistic expression. In 1986, when the Design Museum in Helsinki organized the "Phenomenon Marimekko" exhibition, some saw it signifying the decline of Marimekko, because it emphasized Marimekko's golden age, the mid-1950s to late 1960s. The design direction for the future seemed weak by comparison.

Marimekko was clearly on the decline in 1986. Its reputation as a progressive design firm vanished and profitability rapidly sank to minus 38 percent of net sales. Amer Group's 1986 annual report claimed that there was still potential for the Finnish branches of Marimekko, which continued to be well positioned, despite the increase in imports. The downward spiral continued in 1987, however, and the demise of the firm seemed imminent. Exports and licensing royalties that year decreased, and Amer Group's annual report again lamented that consumer demand in Finland was unfavorable; at the same time, Marimekko's new management remained optimistic that the market would soon improve. Marimekko would focus on the establishment of a franchise network in Sweden, Germany, and the United States. There was another change in the length of the fiscal year, partly to cover up the firm's losses. Net sales in 1988, for the six-month financial year, were roughly the same as during the previous six-month time span (now FIM 51 million, or about $ 8.6 million), but profitability was negative by over FIM 7.1 million (about $ 1.2 million).

## New Beginnings in 1991

By 1990 net sales and profitability remained about the same, but there appeared little to celebrate as Marimekko neared its fortieth anniversary. Employees had been warned that they would be laid off for two weeks in July, an alarming development in the firm. Because of the huge losses, Amer Group could no longer find a ready buyer for Marimekko, nor could Marimekko simply be closed down, not when it was considered a national institution. A way out was found in 1991, however, when Amer Group accepted a nominal sum for the company from Kirsti Paakkanen, the charismatic cofounder of Womena, an advertising agency that specialized in selling to women.[22]

Paakkanen possessed both the determination and personality to turn Marimekko around. She had been prepared to invest her own profits from the sale of Womena into the project, but this was not necessary. Her approach to the revival of Marimekko took off in several directions. She sought to restore Marimekko's reputation, which had been damaged during Amer Group's ownership, and to reassure the public that a reorganized Marimekko could be a vital company, once again a symbol of Finland and of Finnish potential. Quoting freely from Armi Ratia's speeches from the mid-1970s, she emphasized the need for a more effective, efficient operation. Even a small upswing in fortunes would allow for the possibility of taking new design initiatives, a hallmark of Marimekko's glorious past. She made it clear that "it is useless to manufacture shirts [e.g. *Tasaraita* cotton jersey] in an affluent country like Finland where labor is expensive and then try to sell them in a high-street shop profitably." She also announced that it was time to manage the firm, rather than simply let it drift. She talked about changes in the administrative hierarchy, of putting designers, who were closest to the users of Marimekko's products, at the helm. A talented orator, she blamed much of the nation's economic recession on the loss of entrepreneurial initiative in Finland (rather than on the collapse of the Soviet Union) and on diminished respect for designers and workers. Marimekko had been just one of many victims, although poor administration by the Amer Group had also been a factor.

One of her first projects as owner-manager of Marimekko went a long way to reestablishing respect for the venerable firm. Paakkanen organized a fashion show at Svenska Teatern, the main Swedish theatre in the center of Helsinki. The presentation, which was held in 1992, was modeled on the Marimekko extravaganzas of earlier times. Opera singer Margareta Haverinen performed, signifying the merging of art forms within Marimekko's design. The show was a resounding success, with a large audience and favorable media coverage. It signaled a company intent on renewal. Paakkanen herself became a popular lecturer and served as a spokeswoman for new Finnish industrial policy and a role model for Finnish managers.

Kirsti Paakkanen's public and media appearances influenced the position of the company on the Helsinki Stock Exchange, and the company's executives were understandably concerned about the fluctuations. Thus, in an effort to create stability, she took Marimekko off the Helsinki Stock Exchange, where the firm had been listed since 1974. And by scaling down design projects to match manufacturing and marketing capabilities and implementing Amer Group's plans to relocate clothing production to Estonia and the Far East, Marimekko actually showed a small profit in 1992 under Paakkanen's new leadership. The balance sheets continued to improve in the years that followed. When in the mid-1990s the Nokia Corporation catapulted from a Finnish conglomerate to a global leader in the manufacture of mobile phones, Paakkanen compared its success to the Marimekko model of the 1960s and 1970s, when bold moves had been made in internationalization.

The story of Marimekko reveals the evolution of a mid-twentieth-century fashion and design company from its origins in handcraft traditions to its development into mass production. Central to the firm's early growth and success was innova-

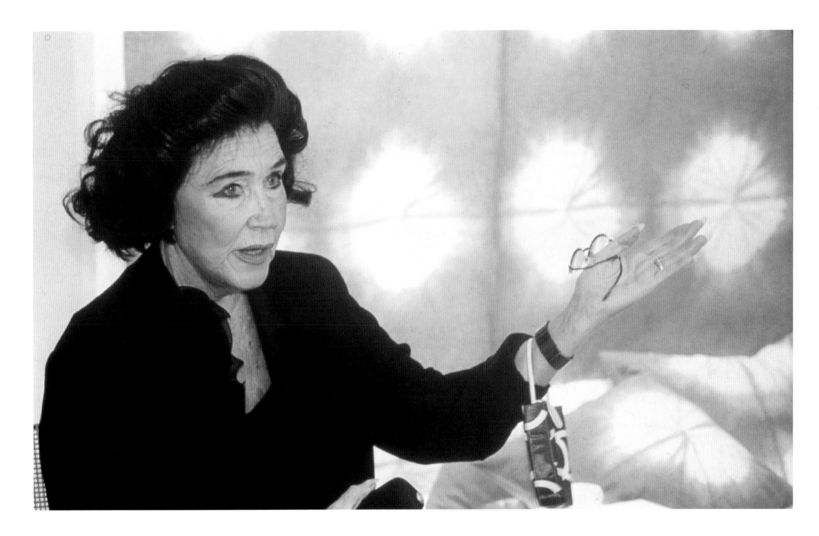

tive design as well as the ability to stay on the cutting edge, acknowledging and mirroring social changes of the times. It took charisma, determination, talent, and little else for the company to become a model of internationalization for other Finnish companies.[23] According to the bold vision of Armi Ratia, design could be built into a core philosophy made visible, becoming a prime source of individual identity. By associating its progressive design with the avant garde, with international trendsetters, Marimekko created a unique, bold corporate identity, which became widely recognized.

Marimekko's decline and eventual rejuvenation serve as a corporate model in the design field. Too much success, coupled with changes in ownership, whether through the loss of a figurehead or the sale of the company, can actually be detrimental, dulling the impetus toward exploring new design initiatives and straining the company's ability to keep pace with demand. Ostensibly, design in the initial stage of corporate development may be the moving force, the critical factor, but it loses momentum over time, and for success to continue it becomes essential to re-create the initial excitement and forward motion. Part of this renewal may require the leadership of a single CEO as charismatic and determined as the original founder. In this, Marimekko was indeed fortunate to be guided into a new century by Kirsti Paakkanen, who brought the company back from the brink of bankruptcy.

Fig. 6–14.
Kirsti Paakkanen, President of Marimekko Oyj, 2003. Courtesy of Marimekko Oyj.

1 Ritva Karling, "Finnish Design Houses: Marimekko and Hackman," in *Financial analysis report* (Helsinki: Conventum, 2000).

2 Ratia resigned from the academy because of pressures to teach war history that was politically correct from the perspective of the Soviet Union. Viljo Ratia, verbal communication, Helsinki, 7 February 1992. In 1948 the Treaty of Friendship, Cooperation and Mutual Assistance, included a far-reaching postwar control of public and educational media by the Soviet Union via the Soviet Embassy in Helsinki.

3 Immonen was the fashion designer; the textiles themselves were the work of seven artists and designers (not Immonen). Suhonen, Pekka, and Juhani Pallasmaa, eds. *Phenomenon Marimekko* (Espoo: Amer Group Ltd. / Weilin & Göös, 1986): 36.

4 There have been several explanations for the name "Marimekko" and its origins (see the editor's note at the end of the introduction).

5 The fashion show was made memorable to the people present by the overall stage design of coordinated sequences of textiles, clothes, models, lights, and graphics. Marimekko used the best visual techniques. The products themselves were not that unique, but the "stage design" (exterior and interior architecture and props) was co-coordinated to convey the impression of design concept of integrity and artistic sensitivity.

6 Riitta Immonen was actually embarrassed to be linked to "ready-made" designs that attracted such commercial interest. Viljo Ratia, verbal communication April 1996.

7 During World War II, Ratia had been an officer in the Finnish army and knew well the maxim that "if there is only a 10 percent chance of success, and the consequences of failure would be tragic, it is better to act on the basis of that 10 percent." Ibid.

8 Nurmesniemi had already designed for Printex and Marimekko on a freelance basis; among other early projects, she had been responsible for Marimekko's window display at the Palace Hotel.

9 In this essay, growth of net sales is always compared to the previous financial year (not calendar year) unless otherwise noted. The distinction is important where lengths of financial years vary.

10 Annika Rimala, born Tegengren, married Reunanen, Piha, Rimala; "Annika Rimala" is used throughout this essay.

11 By 1962 wholly owned retail shops in Finland and Sweden were responsible for 50 percent of Marimekko's sales.

12 Eugenia Sheppard, "Uniform for Intellectuals," *New York Herald Tribune* (13 November 1963).

13 Ninka, "Alle vi kvinder er ulykkelige" (All of us ladies are unlucky), *Politiken* (13 September 1964):10.

14 Antti Ainamo, *Industrial Design and Busines Performance: A Case Study of Design Management in a Finnish Fashion Firm* (Helsinki School of Economics and Business Administration, 1996): 141; *Pohjolan työ* (Nordic work) (25 April 1964).

15 Ainamo, *Industrial Design* (1996): 141.

16 *San Francisco Chronicle*, clipping in the Designmuseo Archive.

17 *American Vogue* (April, 1964), *Life* (June 24, 1966) French *Elle* (July 1965), British *Queen* (1965), Italian *Bellezza* (August, 1965), copies in the Designmuseo Archive.

18 Rimala's design was especially close to Pop Art, an art movement that regarded contemporary everyday objects as works of art, such as Andy Warhol's Campbell's Soup paintings or Roy Lichtenstein's Comic Book paintings Op Art was a parallel movement whereby geometrical abstraction emphasized optical phenomenon, such as Cunningham's staircase that collapses into itself or Vasarely's black-and-white painting of embracing zebras.

19 Armi Ratia had come to own a substantial number of Printex shares. Viljo Ratia originally had very few Marimekko shares. Thus, upon merging the accounts, she became the majority shareholder. The Printex name was dropped.

20 *Hopeapeili* 8 (1967).

21 Ainamo, *Industrial Design* (1996): 182.

22 Amer Group chose to divest itself of the firm and to refuse to make public the terms of divestment. Marimekko was considered a small and insignificant part of the Amer Group, and not of major concern to investors. Its accounts could be delivered to public registrars after a time lag, and this made it into less of a public concern. Thus, it did not become publicly known that Marimekko continued to follow the strategic choices made by the administrators of Amer Group, as well as receive intellectual, material, and financial support supplied from the Group. Even after Amer Group sold Marimekko to Kirsti Paakkanen Amer Group's financial officer continued to be Marimekko's chairman, until he resigned from Amer to work only for Marimekko.

23 Marimekko's net sales, profitability, and internationalization: 1951–1994.

| Net sales | Profitability | (EBDIT) | Internationalization |
| --- | --- | --- | --- |
| 1951 | N.A. | -5,840 | International media attention 1951. |
| 1956 | 209,159 | 11,408 | Exports to Sweden 1954, Swedish subsidiary 1956. |
| 1961 | 2,178,633 | 141,812 | Breakthrough in exports, incl. America, 1959. |
| 1966 | 11,578,242 | 720,662 | Licensing begins 1963, Retail shop in Denmark. |
| 1971 | 17,709,249 | 2,268,416 | International licensing 1972 in America and Japan. |
| 1976 | 45,535,574 | 2,255,848 | German subsidiary 1976, American subsidiary 1977. |
| 1981 | 75,362,400 | 12,702,000 | Licensing royalties from FIM 7.4 million in 1980 to FIM 12 million in 1984. |
| 1986 | 94,427,000 | -12,657,000 | Franchising begun, Flagship in New York 1986. |
| 1991 | 73,694,000 | -15,585,000 | New less international strategy 1991. |
| 1992 | 85,934,000 | 1,496,000 | Increasing international subcontracting 1992. |
| 1993 | 96,535,000 | 3,910,000 | Focus on domestic retail shops 1993. |
| 1994 | 90,256,000 | 14,367,000 | Increasing amount of retail shops in Helsinki 1994. |

# marimekko®

# 7. Marimekko: Fabrics, Fashion, Architecture

Marianne Aav with Maria Härkäpää and Eeva Viljanen

Editor's note: This chapter illustrates a selection of the objects featured in the exhibition "Marimekko: Fabrics, Fashion, Architecture." It is a celebration of Marimekko from 1949 to 2003. Since the company's founding in 1951, it has been especially attentive to choreographing the photography and other advertising and marketing materials that have presented Marimekko products to the public. When viewed as a whole the archival photographs serve as a remarkable record of the different collections and the individual artistic visions. In the 1950s the collections were presented in an austere manner, like still-lifes, yet with a deliberate homeyness. In the 1960s Annika Rimala chose to show her designs against a backdrop of the modern world and as part of the youth culture. In contrast Liisa Suvanto found that nature and the Finnish landscape complemented the clean lines of her woolen clothing. In addition to period photographs, many new ones were taken specifically for this book. They are juxtaposed with the archival material to capture the distinct character and feeling of Marimekko at various stages of its development. The archival photographs, unless otherwise noted, are from the Marimekko archive in the Design Museum, Finland. While the actual photographers are known, it is not always possible to match the photographers with their work.

The works are arranged in chronological order for the most part, although the selection of illustrations is based primarily on the individuals who helped to shape the company. Certain illustrations are accompanied by descriptions of the work or the collection. In addition, information about the designers represented in this chapter is provided in brief biographical profiles. Some of the works in the exhibition have been illustrated in the preceding chapters and are not repeated here. In the captions we have not translated the Finnish fabric pattern and fashion names. Such translations, where they exist, will be found in the checklist. These translations are complicated. Some Marimekko names have a clear meaning, while others were chosen simply for their sound or associations. Some names are deliberate misspellings to make them sound old-fashioned or humorous. Others are in a Finnish dialect or are old adages or sayings that are unfamiliar even to many Finns today, making them especially difficult to translate into other languages. In this case, however, the name will still have a phonetic impact or emotional resonance for most Finns. The references for the designers biographies appear after the bibliography.

▶ Fig. 7–1. Maija Isola.
*Amfora* pattern, 1949.
(Checklist no. 1).

The amphora was a popular ornamental
motif in the 1940s and 1950s. Isola produced
this interpretation for a competition at the
Institute of Industrial Arts in 1949. The spirited
line suggests Matisse as an influence. Isola also
made a few preliminary versions of *Amfora*,
three of which were purchased by Armi Ratia.
She returned to this theme in her *Tuhat yötä*
(thousand nights, 1966) and *Teehuone* (tea-
room, 1967) patterns.

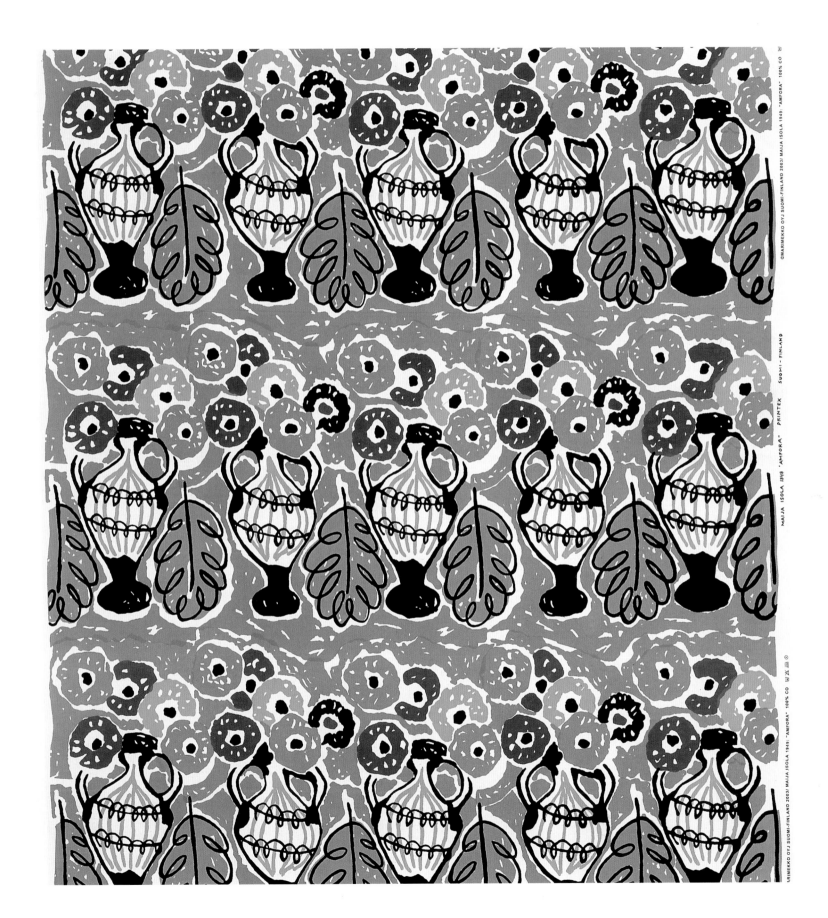

© MARIMEKKO OYJ SUOMI-FINLAND 2003/ MAIJA ISOLA 1949/ "AMFORA" 100% CO ⑯

SUOMI - FINLAND

MAIJA ISOLA 1949 "AMFORA" PRINTEX

ARIMEKKO OYJ SUOMI-FINLAND 2003/ MAIJA ISOLA 1949/ "AMFORA" 100% CO ⑰ 🗵 🏢 ℗

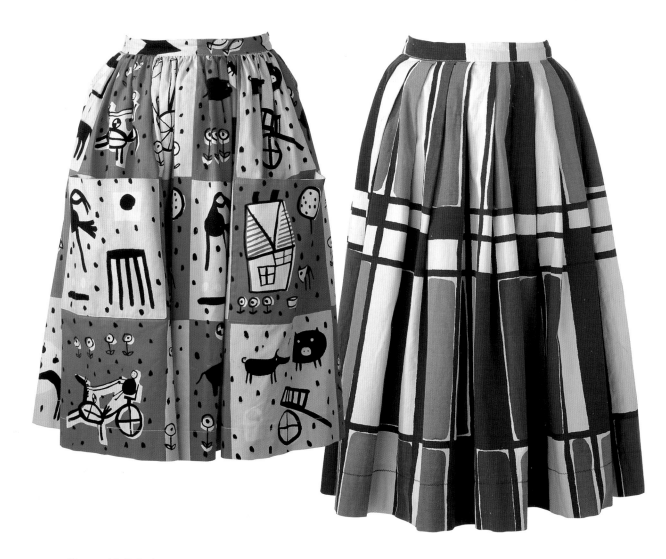

Fig. 7–2. Maija Isola.
Skirt; *Musta lammas* pattern,
1950. (Checklist no. 3).

Fig. 7–3. Maija Isola.
Skirt; *City* pattern, 1950.
(Checklist no. 4).

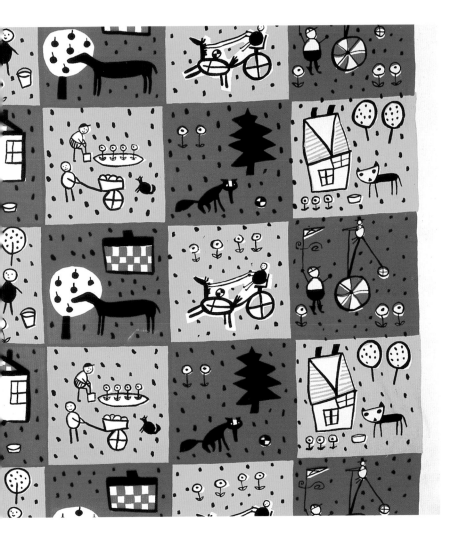

Fig. 7–4. Maija Isola.
*Musta lammas* pattern, 1950.
(Checklist no. 2).

The cartoonlike characters of the *Musta lammas* (1950) pattern are strongly linked to the resurgence of naïve or vernacular art in the 1950s. At the same time, Isola's patterns have a spontaneous drawing style that is characteristic of her design work and became dominant in the *Ornamentti* and *Joonas* series in the 1960s.

Fig. 7–5. Vuokko Nurmesniemi.
*Kaappikello* pattern, 1958.
(Checklist no. 26).

In the late 1950s Vuokko Nurmesniemi designed a few patterns in a naïve, graphic style. These include *Kaappikello* (1958) and *Muksunhylly* (1959; fig. 2–27). During the same period, she also created the layout and wrote the text for the Marimekko newspaper advertisements.

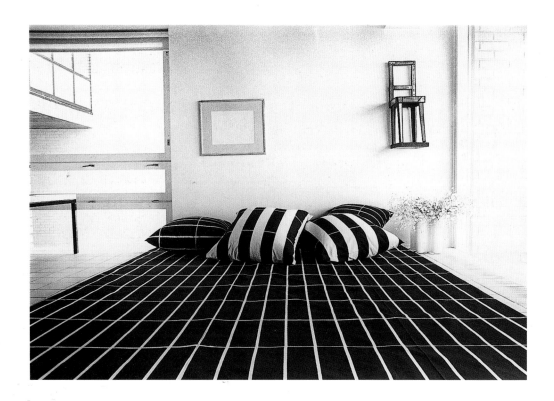

Fig. 7–6. Interior textiles;
*Tiiliskivi* and *Faruk* patterns.

The geometric structure and minimal color scheme of the *Tiiliskivi* pattern reveals a striking modern design aesthetic consistent with the character of progressive Finnish design in the 1950s. It is noteworthy that the rectangular repeat pattern composed of a stark, black background with a white grid resembles geometric patterns that Alvar Aalto designed in the 1950s with his second wife, Elissa, such as the *Siena*, *Varjosiena*, and *E.A.* patterns. It also bears comparison to the patterns that Elissa Aalto designed on her own during the same period, including *Patio* and *H55*. Aalto gave considerable importance to the role of textiles in the modern interior, insisting that

they served to heighten the human element. The textiles he designed on his own in the 1920s and then later in the 1930s in collaboration with his first wife, Aino, were less somber than the patterns from the 1950s and in certain examples were based on motifs from the natural world.

▸ Fig. 7–7. Armi Ratia. *Tiiliskivi* pattern, 1952. (Checklist no. 6).

▸▸ Fig. 7–8. Armi Ratia. *Faruk* pattern, 1952 and 1986. (Checklist no. 7).

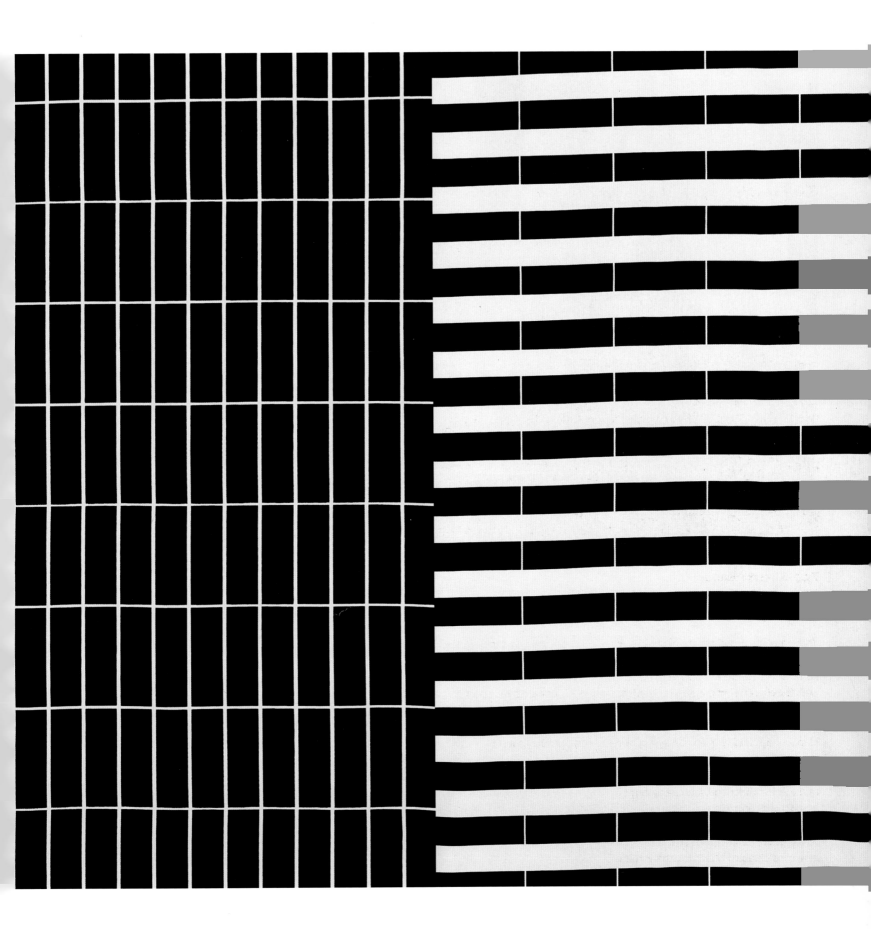

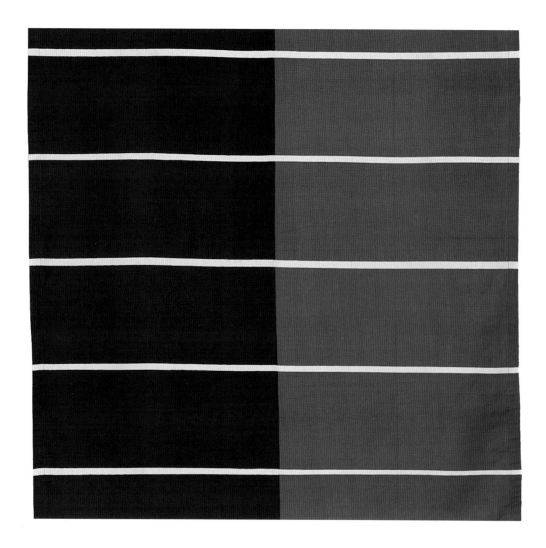

Fig. 7–9. Vuokko Nurmesniemi.
*Tiibet* pattern, 1953. (Checklist no. 8).

*Tiibet* was the first fabric that Vuokko Nurmesniemi designed for Printex. Armi Ratia had given her a swatch of the *Oomph* pattern designed by Viola Gråsten, a Finnish-born designer working in Sweden. Geometrical and brightly colored, *Oomph* was firmly aligned with the abstract art of the 1950s: it was radical, modern, and young. Nurmesniemi hung the sample on her wall to prevent direct imitation. *Tiibet* was to be different, but still abstract in its design idiom. From the perspective of the 1950s, what was new about *Tiibet* was its geometrical simplicity and large areas of flat color. The name of the pattern suggests a wide, deserted landscape.

The *Tiibet* pattern was inherently difficult for Printex production technology at the time. Initially, color flaws resulting both from a broken steamer and from the composition of the printing ink were more evident in large patterns such as *Tiibet* than in smaller ones. Printex's technical director Arvo Nurmi thought at first that the fabric was actually unprintable. However, repairs to the steamer and advice from Swiss engineers about the composition of the ink, allowed the fabric to be printed successfully.

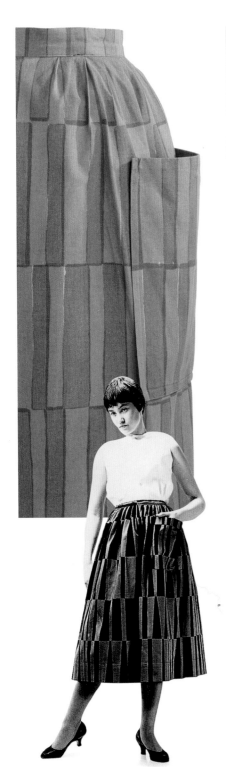

◄ Fig. 7–10. Vuokko Nurmesniemi.
Wraparound skirt; *Pohjanakka*
pattern, 1954. (Checklist no. 9).

Fig. 7–11. Vuokko Nurmesniemi.
*Rötti* pattern, 1954.
Susan Ward Collection, Boston.
(Checklist no. 10).

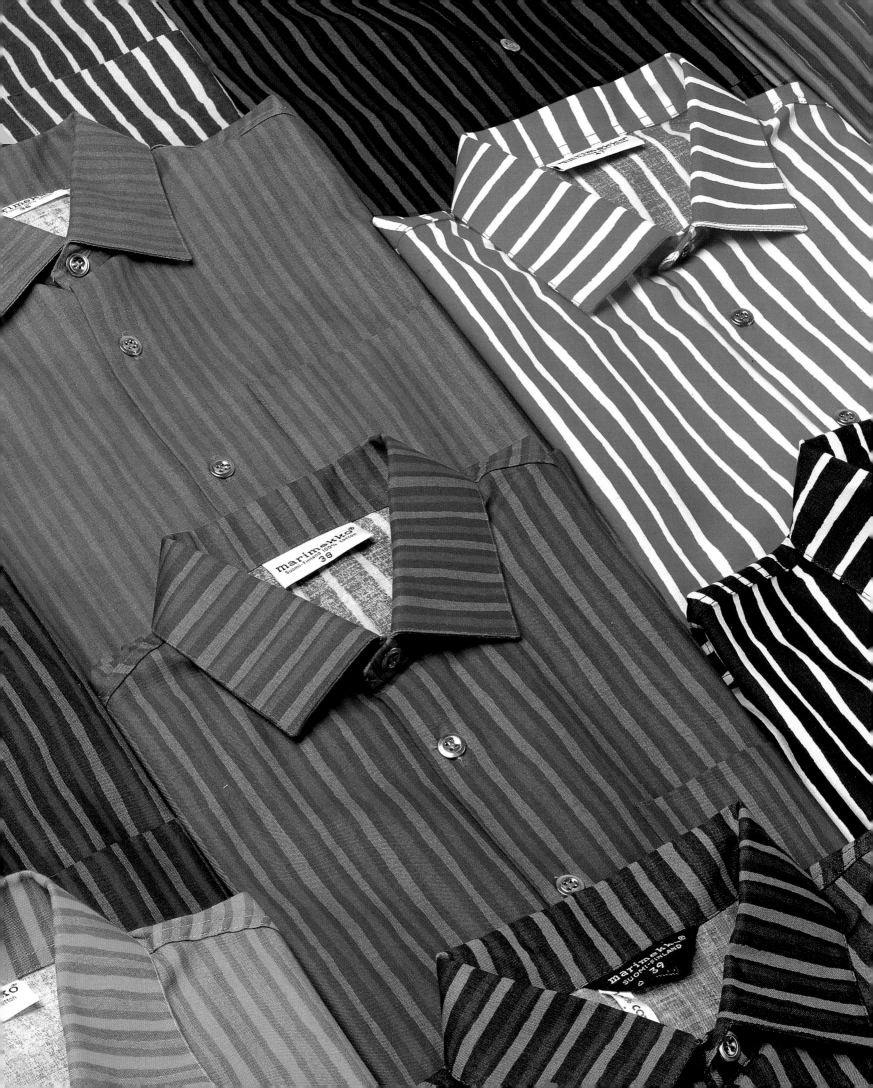

◄ Fig. 7–12. Vuokko Nurmesniemi. *Jokapoika* shirt, 1956; *Piccolo* and *Ristipiccolo* patterns, 1953. (Checklist no. 15).

In 1956 Marimekko introduced the *Jokapoika* shirt by Vuokko Nurmesniemi, the company's first garment for men. It was made with the *Piccolo* fabric Nurmesniemi had created in 1953. In the *Piccolo* pattern two stripes of different colors overlap to form a third stripe. The amount of overlap varied, allowing for great range in the pattern. Nurmesniemi designed more than 300 colorways for *Piccolo*, including some that were inspired by the "Mediterranean" colors that Nurmesniemi had encountered on a trip to Italy.

    *Piccolo* had previously been used for women's garments such as *Kivijalkamekko* (fig. 7–22). At first Nurmesniemi considered designing a men's jacket featuring *Piccolo* but ultimately decided on the simple *Jokapoika* shirt. The loose roll-up sleeves and breast pocket of the design make it especially appropriate for leisure wear. The design was astonishing at the time but soon became popular, particularly with men working in creative professions. Today *Jokapoika* is considered a classic and is still in production, primarily in colors that coordinate with Annika Rimala's *Tasaraita* (fig. 7–66) shirts.

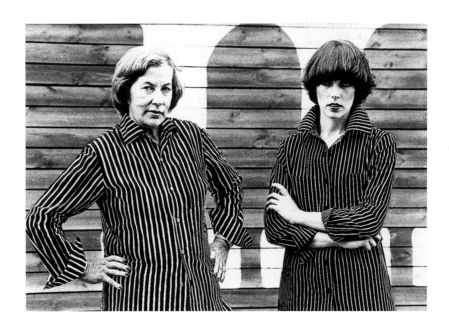

Fig. 7–13. Armi Ratia and a model wearing *Jokapoika* shirts, late 1960s.

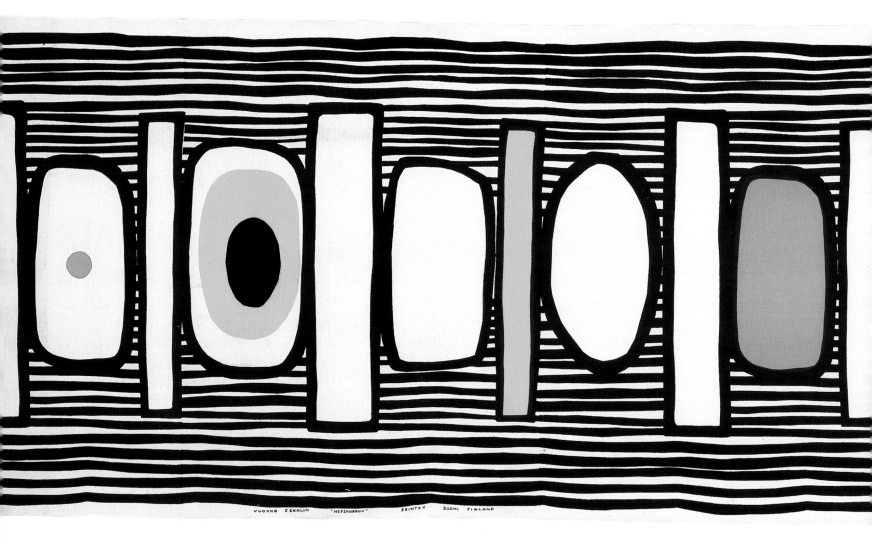

Fig. 7–14. Vuokko Nurmesniemi.
*Hepskukkuu* pattern, 1956.
(Checklist no. 16).

*Hepskukkuu* is one of the few furnishing fabrics
that Vuokko Nurmesniemi designed for Printex,
for which she invariably used bright colors and a
large scale. Like *Tiibet* (fig. 7–9) the *Hepskukkuu*
pattern reflects contemporary abstract art, with
an organic and rhythmic composition.

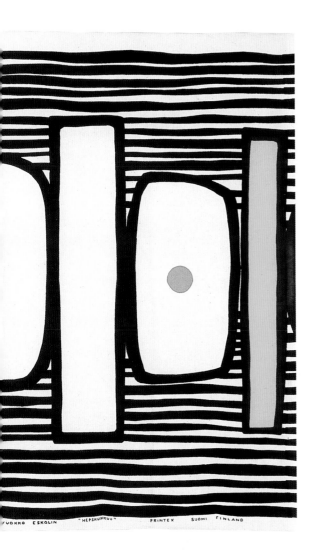

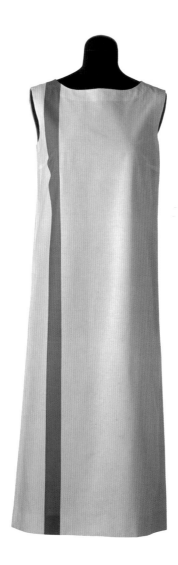

Fig. 7–15. Vuokko Nurmesniemi.
Dress; *Elämänlanka* pattern,
1956. (Checklist no. 14).

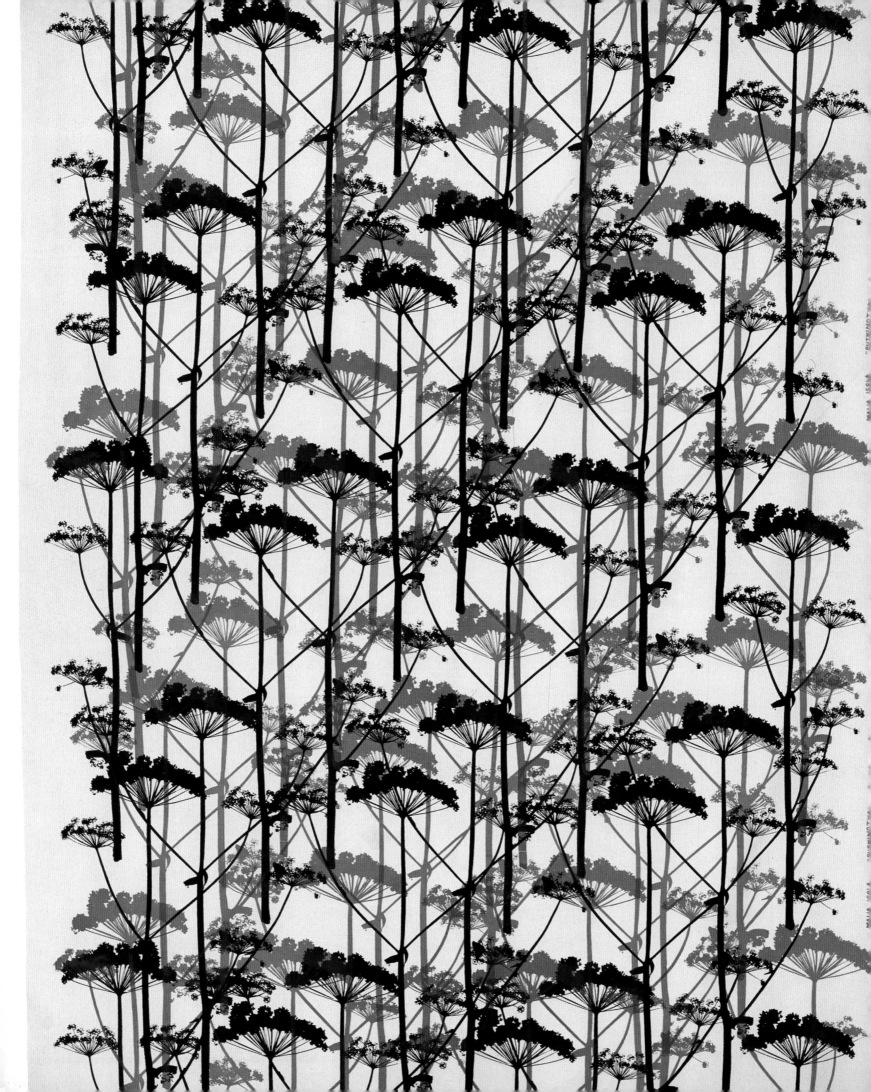

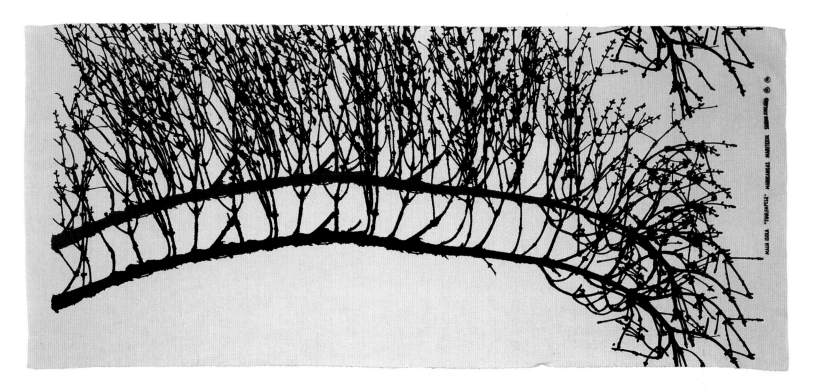

▲ Fig. 7–17. Maija Isola. *Tuulenpesä* pattern from the *Luonto* series, 1957–59. (Checklist no. 21).

◄ Fig. 7–16. Maija Isola. *Putkinotko* pattern from the *Luonto* series, 1957–59. (Checklist no. 20).

In the *Luonto* series of plant-themed patterns, Maija Isola used a film-printing technique. Instead of drawings of plants, real leaves and twigs were projected onto a transparent plate or paper and were arranged by Isola into a pattern. This was then exposed onto a printing stencil. The outlines of real plants are visible on the finished fabric, and in several examples, the patterns partly overlap, giving an impression of shading or transparency. The patterns of the *Luonto* series, with a total of twenty-four in all, were printed on a white ground, most often with broken colors.

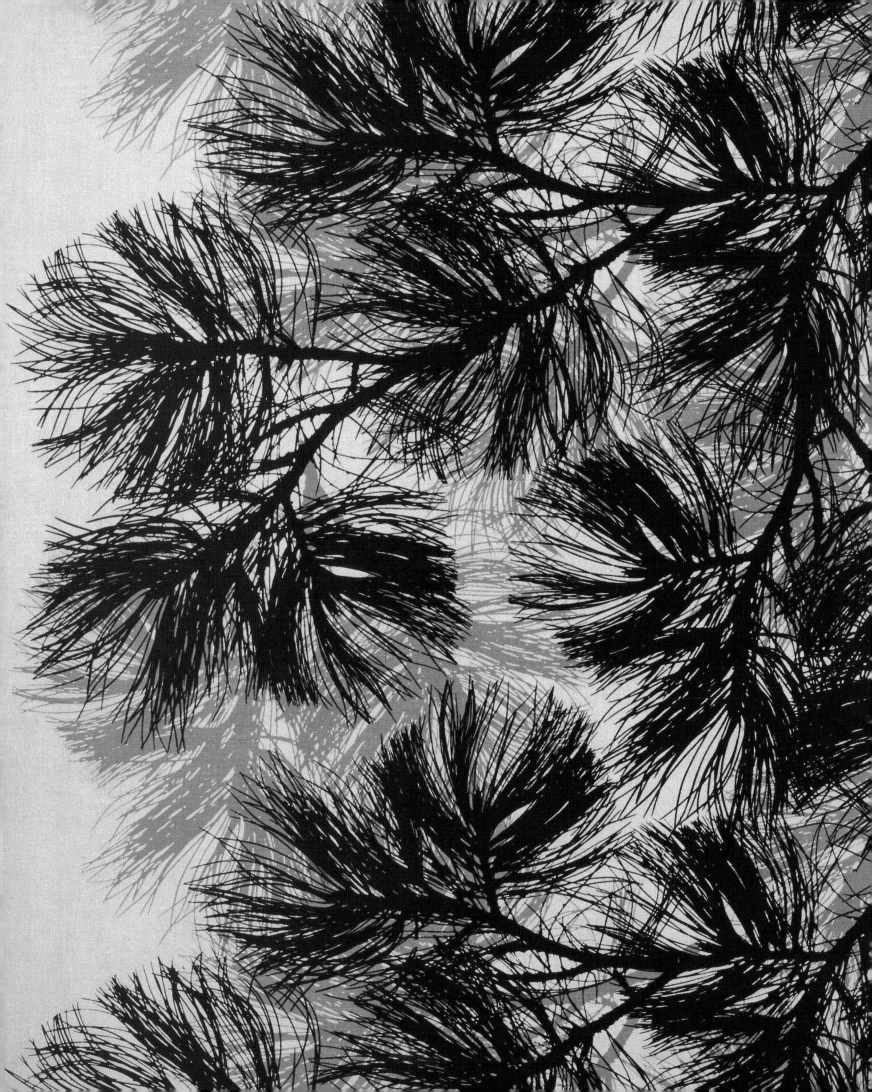

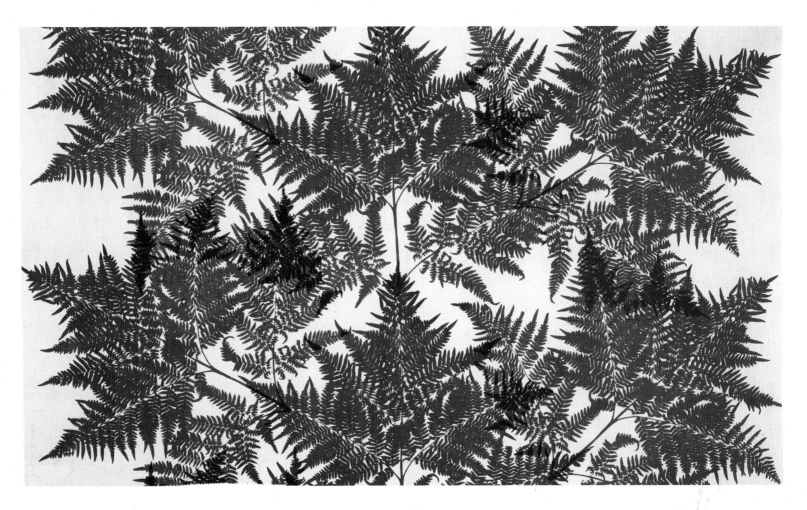

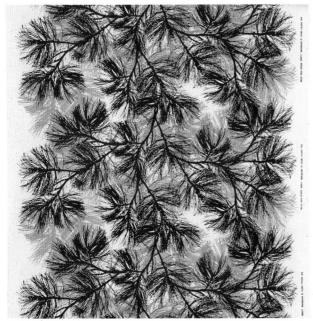

◄◄ Fig. 7–18. Maija Isola. *Mänty* pattern and detail from the *Luonto* series, 1957–59. (Checklist no. 23).

▲ Fig. 7–19. Maija Isola. *Sananjalka* pattern from the *Luonto* series, 1957–59. (Checklist no. 22).

Fig. 7–20. Maija Isola.
*Saunakukka* pattern from
the *Luonto* series, 1957–59.
(Checklist no. 19).

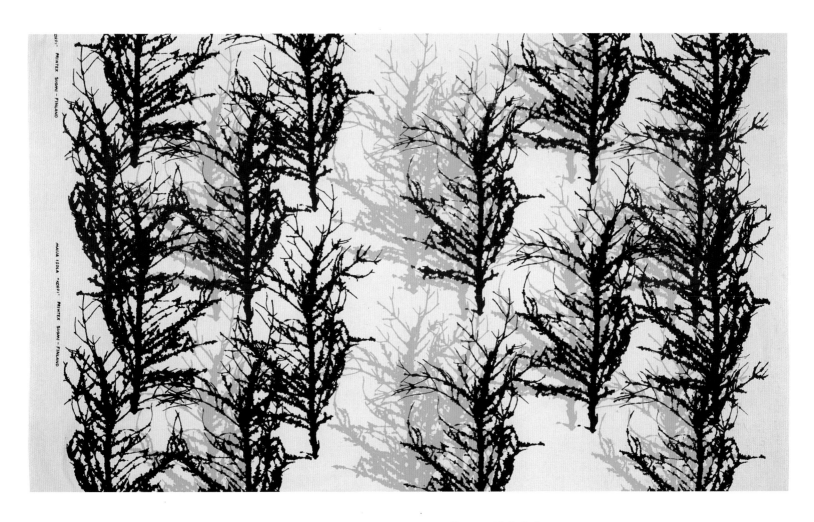

Fig. 7–21. Maija Isola.
*Korpi* pattern from the
*Luonto* series, 1957–59.
(Checklist no. 18).

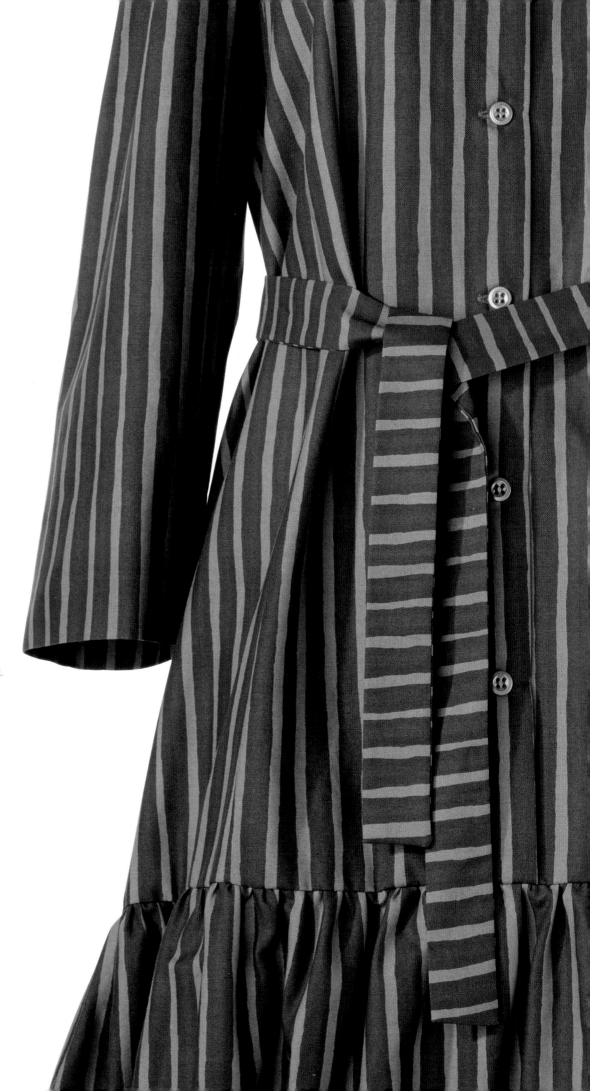

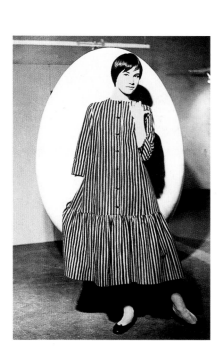

▲ ▶ Fig. 7–22. Vuokko Nurmesniemi.
*Kivijalkamekko* dress, 1957; *Piccolo* pattern, 1953.
The "egg" sculpture is by Ilmari Tapiovaara.
This photograph was chosen as the symbol
of "Finnish Design" by Finnish exporters.
(Checklist no. 25).

*Kivijalkamekko* successfully crystallizes
the radical line of Marimekko clothing in the
1950s. Nurmesniemi's designs broke away
from the prevalent fashions of the 1950s,
which emphasized the waist and followed the
lines of the body. In *Kivijalkamekko* Nurmes-
niemi concealed the wasp waist, minimized
the use of form-fitting darts, and shifted the
garment's focus from waist to hem — the
"foundation" of its name. *Kivijalkamekko*
was made in different lengths and a variety
of fabrics.

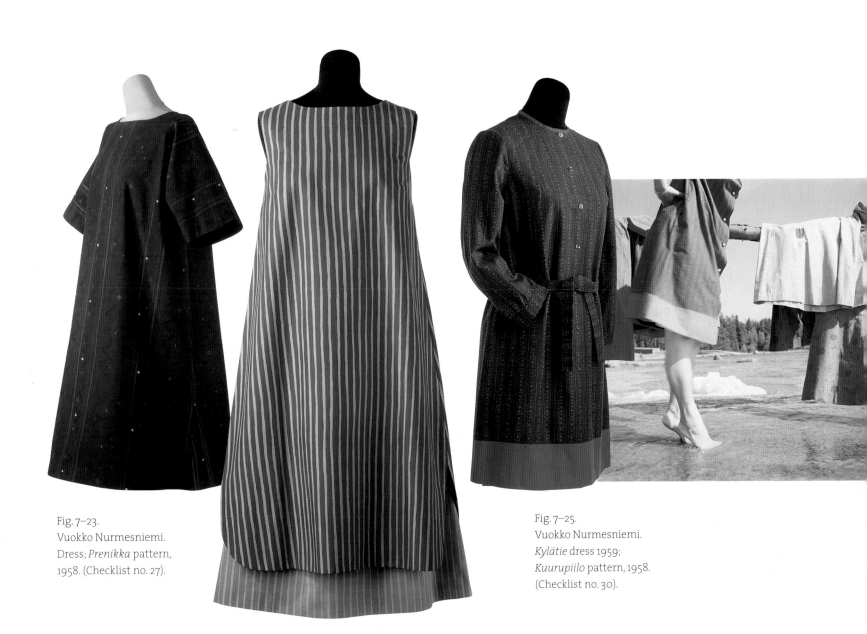

Fig. 7–23.
Vuokko Nurmesniemi.
Dress; *Prenikka* pattern,
1958. (Checklist no. 27).

Fig. 7–25.
Vuokko Nurmesniemi.
*Kylätie* dress 1959;
*Kuurupiilo* pattern, 1958.
(Checklist no. 30).

Fig. 7–24.
Vuokko Nurmesniemi.
*Krookus* dress, 1959;
*Piccolo* pattern, 1953.
(Checklist no. 31).

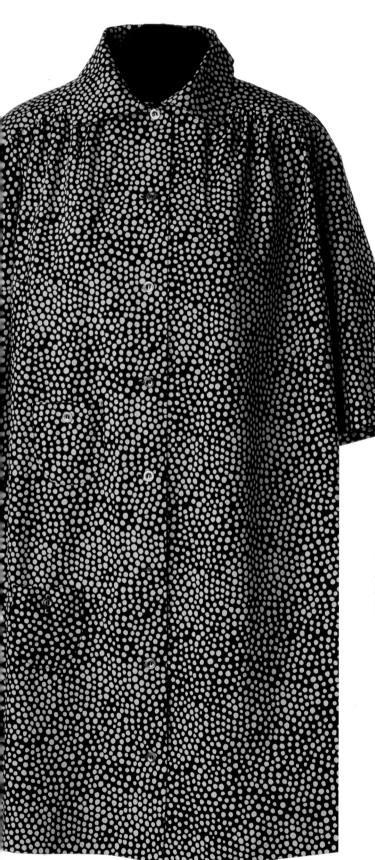

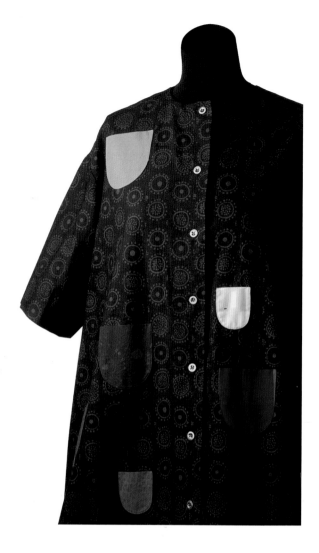

◄ Fig. 7–26. Vuokko Nurmesniemi.
*Kihlatasku* dress, 1960;
*Pirput parput* pattern, 1957.
(Checklist no. 39).

▲ Fig. 7–27. Vuokko Nurmesniemi.
*Iloinen takki* dress, 1960;
*Nadja* pattern, 1959.
(Checklist no. 40).

The *Kihlatasku* and *Iloinen takki* dresses are
the culmination of Marimekko's deliberate,
childlike unconventionality in the 1950s and
1960s, a feature found throughout Vuokko
Nurmesniemi's fashion designs and graphics
in the 1950s, from advertising to exhibition
displays. The small, asymmetrically arranged
pockets of the *Iloinen takki* dress are more
aesthetic than practical, while the pockets of
*Kihlatasku* were meant to serve a more playful
function: according to Nurmesniemi they were
for surprise gifts from the wearer's suitor.

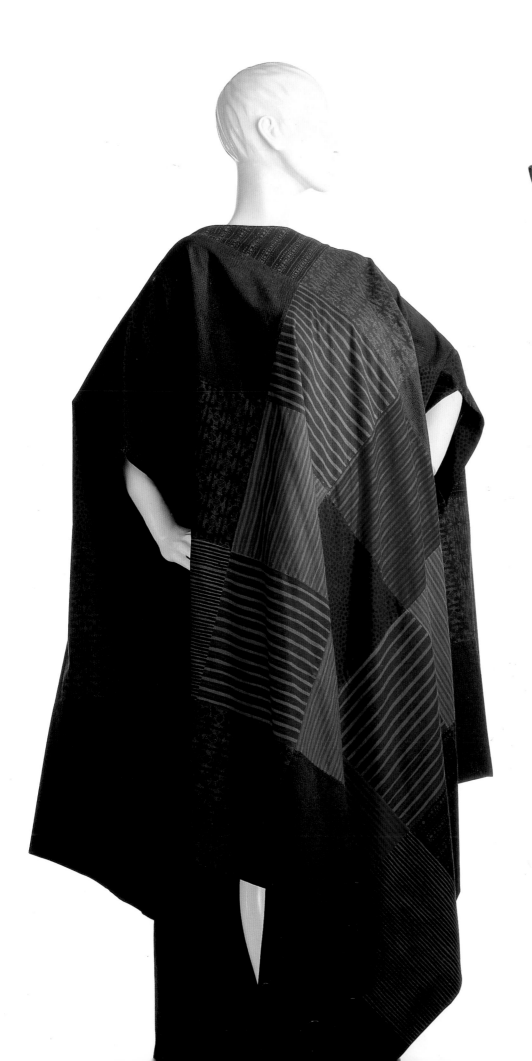

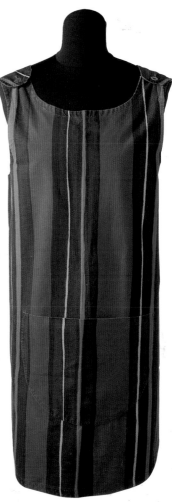

▲ Fig. 7–29. Vuokko Nurmesniemi. *Ritsa* apron; *Raituli* pattern, 1959. (Checklist no. 32).

◄ Fig. 7–28. Vuokko Nurmesniemi. Cape, 1960; *Piccolo,* 1953, *Pirput parput,* 1957, and *Varvunraita,* 1959 patterns, 1960. (Checklist no. 41).

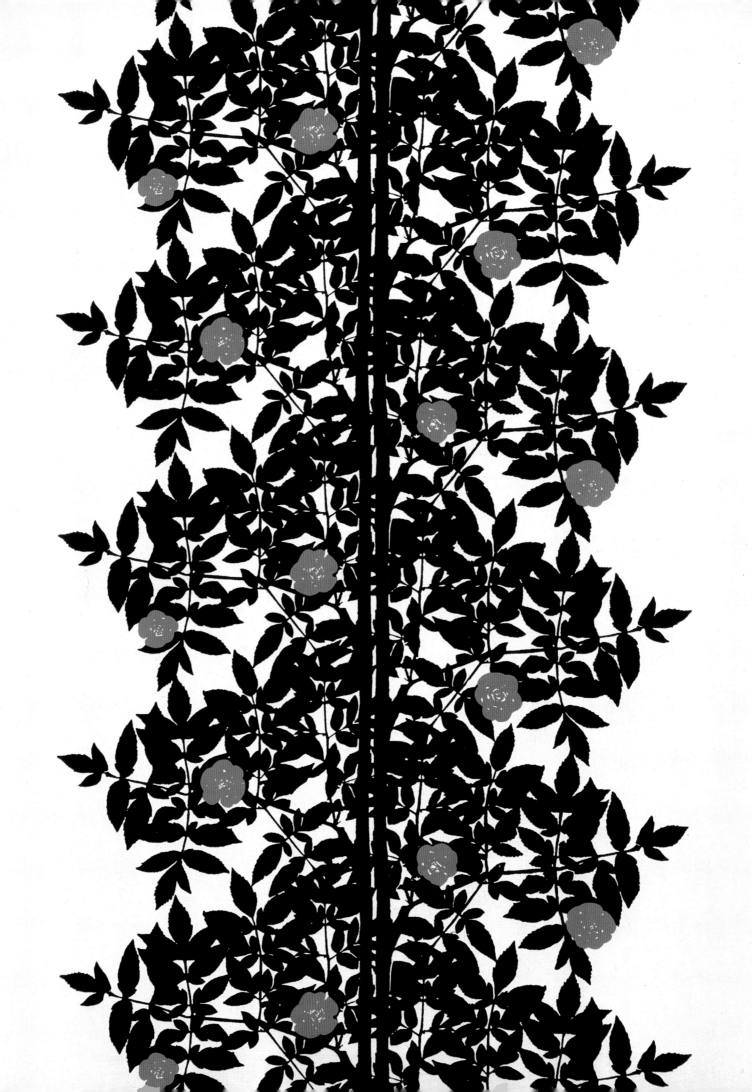

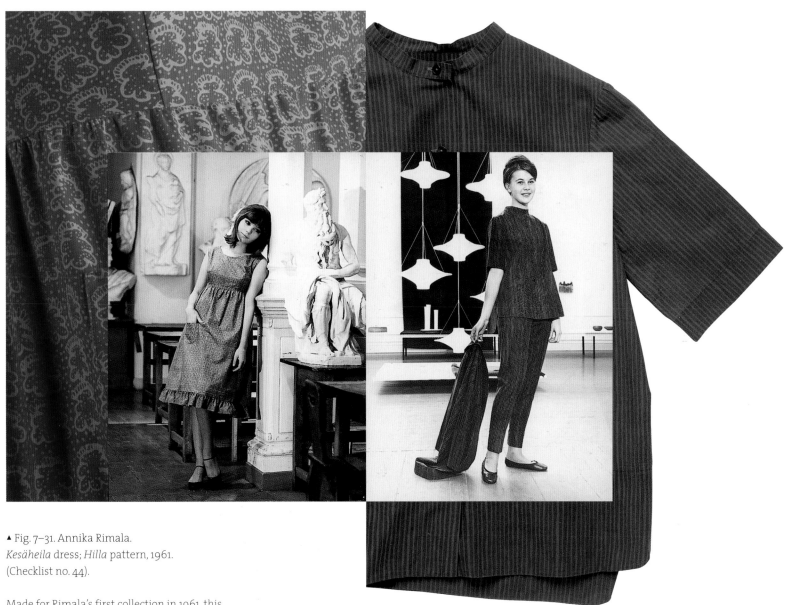

▲ Fig. 7–31. Annika Rimala.
*Kesäheila* dress; *Hilla* pattern, 1961.
(Checklist no. 44).

Made for Rimala's first collection in 1961, this garment, with its pockets and pretty flounced hem, still exudes the girlishness found in clothing designed by Nurmesniemi in the 1950s. During the 1960s, Annika Rimala's clothes became more straightforward; small details were eliminated and the patterns became enlarged.

◄ Fig. 7–30. Maija Isola.
*Ruusupuu* pattern, 1957.
(Checklist no. 24).

▲ Fig. 7–32. Liisa Suvanto.
*Garçon-tytön pyjama*, 1960;
*Varvunraita* pattern by Vuokko
Nurmesniemi, 1959. (Checklist no. 35).

Fig. 7–33. Maija Isola.
*Pidot* pattern, 1960.
(Checklist no. 36).

*Pidot* is part of the *Ornamentti* series of about
thirty patterns created in 1958–60. Maija Isola
was inspired by Slovakian folk textiles, mainly
lace and embroidered cloths. The *Pidot* pattern is
based on a lace model. Other fabrics in the series
include *Tamara* (1960; fig. 2–13) and *Tantsu*.

▶ Fig. 7–34. Maija Isola.
*Tantsu* pattern, 1960.
(Checklist no. 38).

MAIJA ISOLA    "TANTSU" MARIMEKKO O

"TANTSU" MARIMEKKO OY SUOMI FINLAND 1960

MAIJA ISOLA

MAIJA ISOLA    "TANTSU" MARIMEKKO OY SUOMI FINLAND 1960

MAIJA ISOLA

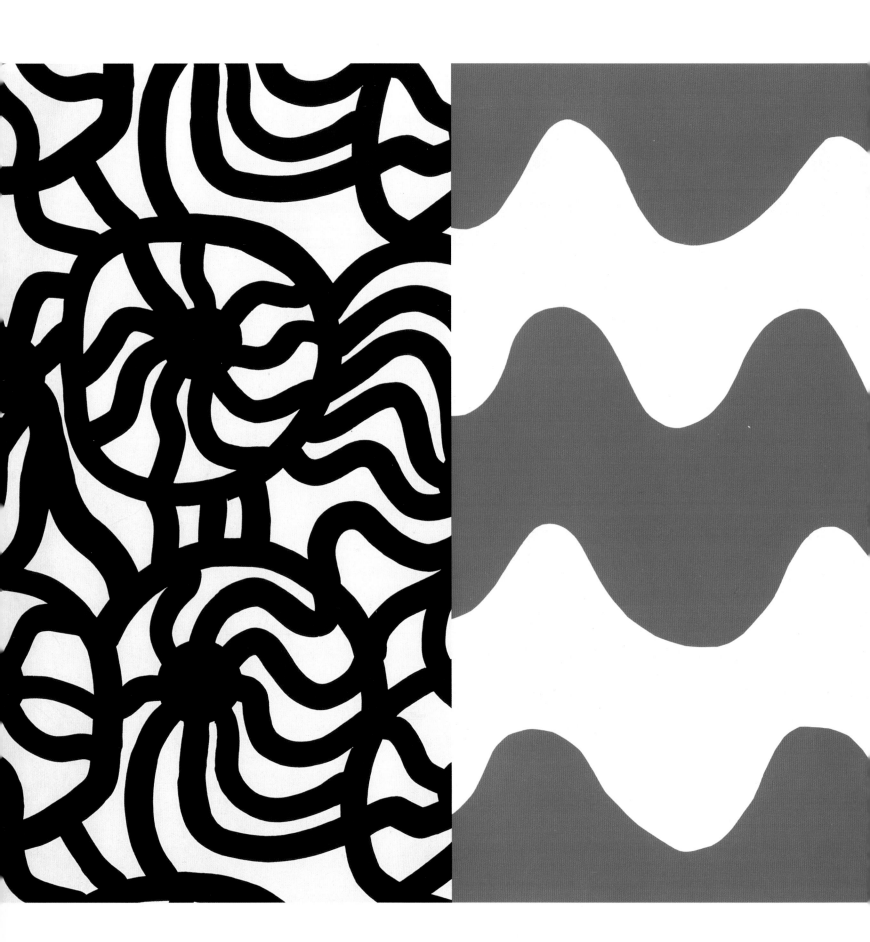

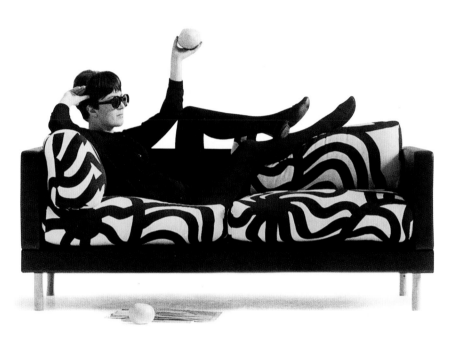

◀◀ Fig. 7–35. Maija Isola.
*Joonas* pattern, 1961.
(Checklist no. 42).

◀ Fig. 7–36. Maija Isola.
*Lokki* pattern, 1961.
(Checklist no. 43).

▲ Fig. 7–37. Torsten Laakso.
*Kameleontti* sofa; *Joonas*
pattern by Maija Isola.
Skanno Oy, Helsinki.

*Joonas* is part of a series of the same name that Isola designed in 1961–62. The subjects may not always relate, but the series is linked by large, linear patterns and a similar drawing style. Isola, who usually worked at home, produced the series in the factory's printing hall. On a long printing table, she made a black-and-white sketch of each pattern, some 98 feet (30 m) in length. From this she chose the most pleasing section and made a stencil from it. The patterns of the *Joonas* series were Isola's first truly large-scale designs. Their printing was facilitated by new, better-quality cotton. The patterns were originally printed in black or brown on a white background. Other colors were introduced later. *Joonas*, like its variation *Nooa* (fig. 2–16), was one of the last models of the series that came into production. The *Joonas* series also includes *Silkkikuikka* (fig. 2–1).

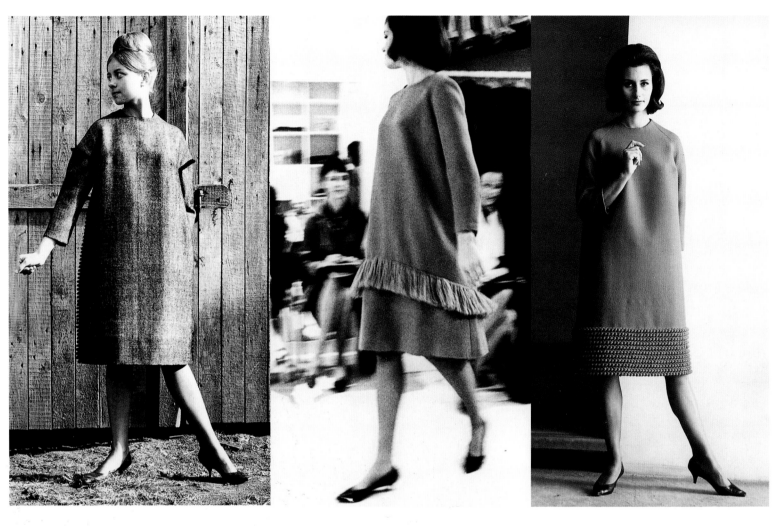

◄◄◄ Fig. 7–38.
Liisa Suvanto.
*Sudensuitset* dress and
detail (below), 1962.
Handwoven wool.
(Checklist no. 48).

◄◄ Fig. 7–39.
Liisa Suvanto.
*Kukko* dress and
detail (below), 1961.
Handwoven wool.
(Checklist no. 46).

◄ Fig. 7–40.
Liisa Suvanto.
*Marikko* dress, 1962.
Detail (below):
*Sepeli* dress, 1963.
Handwoven wool.
(Checklist no. 54).

► Fig. 7–41.
Liisa Suvanto.
*Kaarimekko* dress, 1964.
Handwoven wool.
(Checklist no. 57).

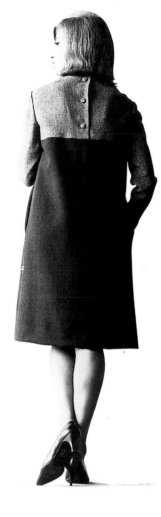

Liisa Suvanto's woolen collection brought a
new elegance to Marimekko fashion. Suvanto
chose a high-quality, handwoven wool that
added to the quality and refinement of the
dresses. As a textile designer, Suvanto designed
not only the fabrics — starting with the weave
— but also the clothing. She often made a
number of variations on a single garment. She
used fringes and gathers to achieve dramatic
accents on what were otherwise simple
clothing designs. The triangle which is the
basis for *Kukko* is split with fringes, as it is in
the variation *Kana*. Suvanto's world of color is
full of surprises. For example, in her 1961
collection (of which *Kukko* is a part), the colors
were black-and-white, black-and-brown, and
grey, but there was also a bright blue and
yellow.

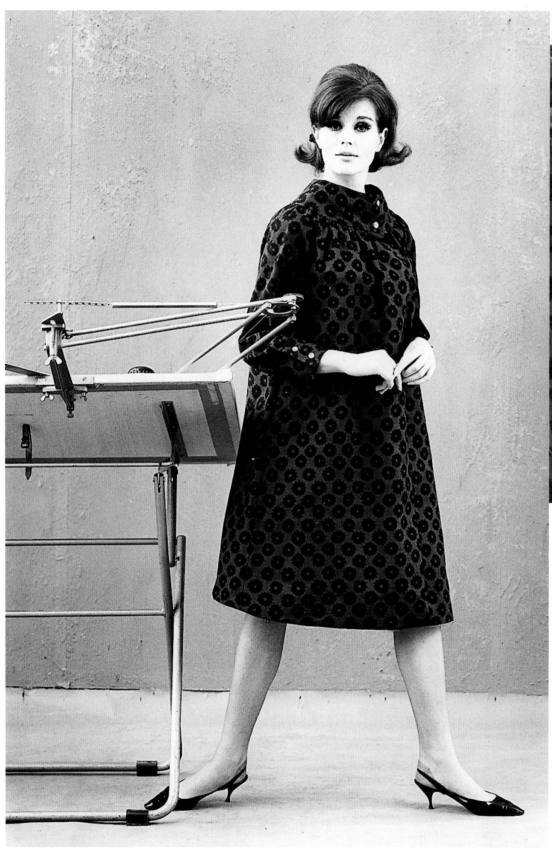

Fig. 7–42. Annika Rimala.
*Barokkipaita* dress, 1963;
*Samettiruusu* pattern, 1962.
(Checklist no. 53).

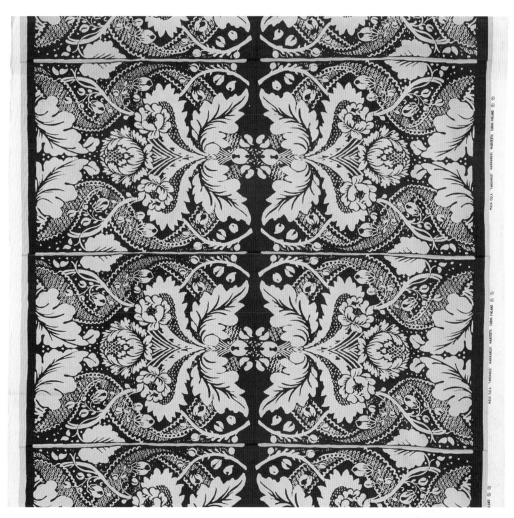

Fig. 7–43. Annika Rimala.
*Sokkeli* dress; *Luukku* pattern,
1963. (Checklist no. 50).

Fig. 7–44. Maija Isola.
*Fandango* pattern, 1962.
(Checklist no. 49).

This fabric is part of the *Barokki* series.
Begun in 1962, the series continued the
romantic themes of the *Ornamentti* series.
*Barokki* was dominated by rich plant
themes and was related to the patterns
of Italian brocades from the seventeenth
and eighteenth centuries.

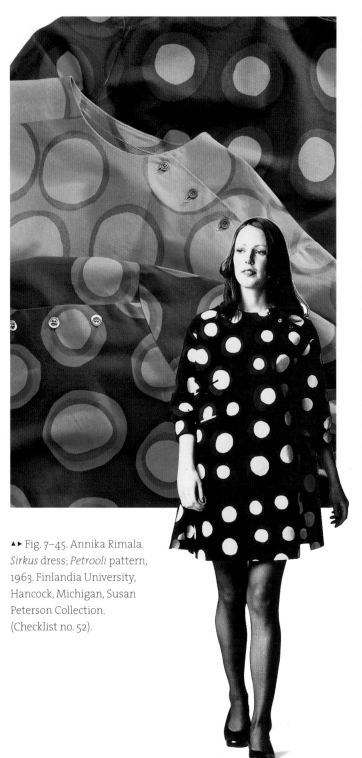

▲▶ Fig. 7–45. Annika Rimala.
*Sirkus* dress; *Petrooli* pattern,
1963. Finlandia University,
Hancock, Michigan, Susan
Peterson Collection.
(Checklist no. 52).

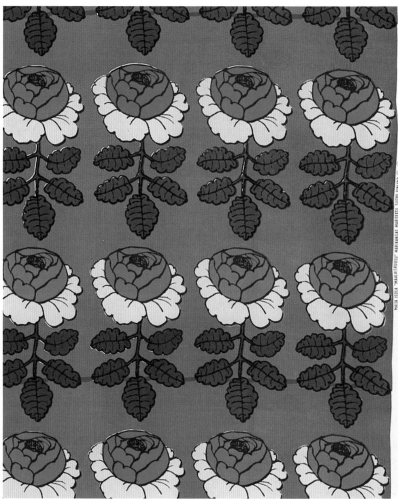

Fig. 7–46. Maija Isola.
*Maalaisruusu* pattern, 1964.
(Checklist no. 56b).

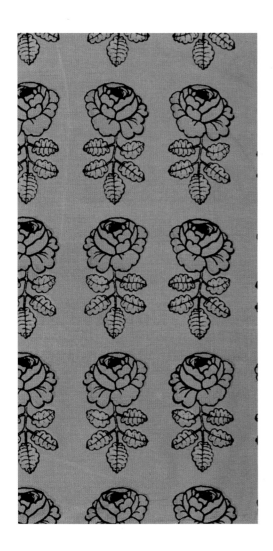

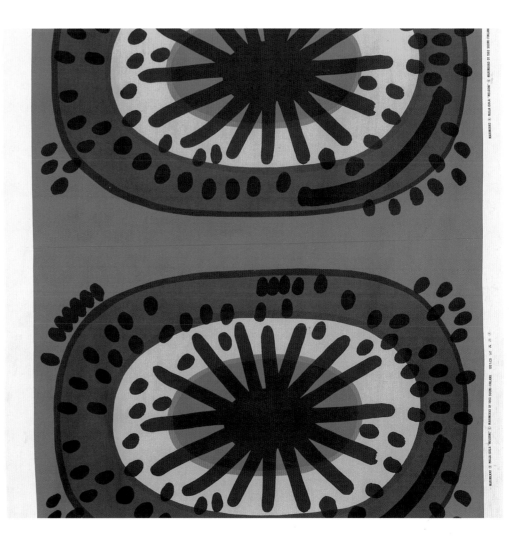

Fig. 7–47. Maija Isola.
*Vihkiruusu* pattern, 1964.
(Checklist no. 56a).

Fig. 7–48. Maija Isola.
*Melooni II* pattern, 1963.
(Checklist no. 55).

In addition to the more ornamental themes
in Maija Isola's oeuvre, in the early 1960s she
began to introduce a more subdued expression
and large, color surfaces. In *Melooni II*, the subject
is recognizable, but in *Melooni I* the melon has
been simplified into nested, colored rings (see
fig. 2–21). *Melooni* is part of the *Arkkitehti* series.
In this case the company, not the designer,
named the series and chose the patterns that
would form it. It includes about seventeen of
Isola's patterns created from 1959 to 1965, among
them *Lokki* (fig. 7–36), *Seireeni* (fig. 7–53), *Kaivo*
(fig. 7–54), *Kivet* (fig. 2–12), and *Unikko* (fig. 7–55).

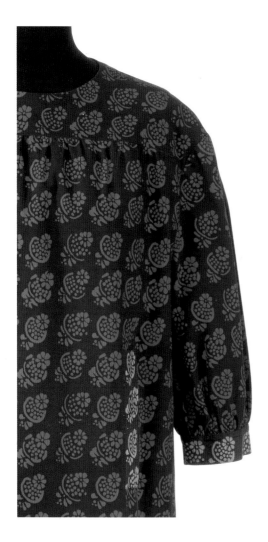

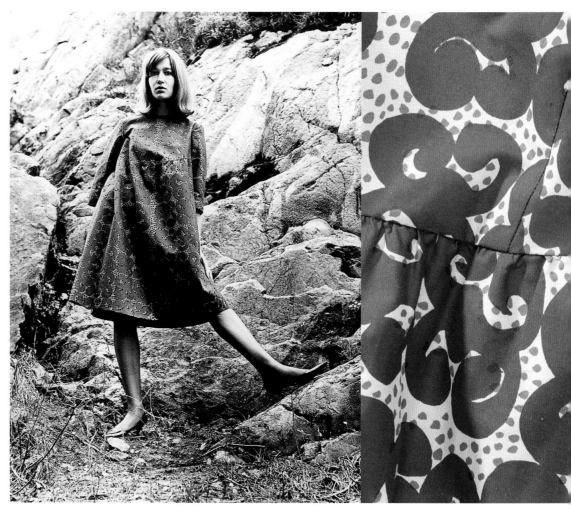

Fig. 7–49. Annika Rimala.
*Tamma* dress, 1964; *Hedelmäkori*
pattern, early 1960s. (Checklist no. 58).

Fig. 7–50. Annika Rimala.
*Lupiini* dress, 1964; *Tarha* pattern, 1963.
(Checklist no. 59).

A typical feature of Rimala's fabric patterns is
a change in the scale of the pattern based on
the cut of the garment. The *Lupiini* dress is the
first version of the meandering *Tarha* pattern.
The next, larger variation of *Tarha* is *Keidas*,
shown on the *Monrepos* dress (fig. 3–20). The
last is the *Jokeri* fabric (fig. 7–100), in which a
single motif of the pattern fills the entire
width of the fabric.

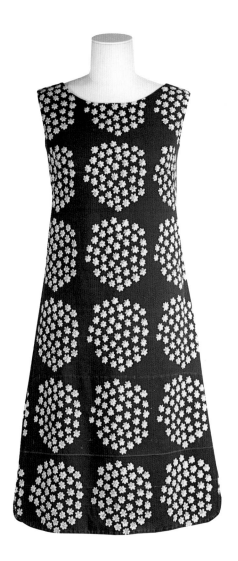

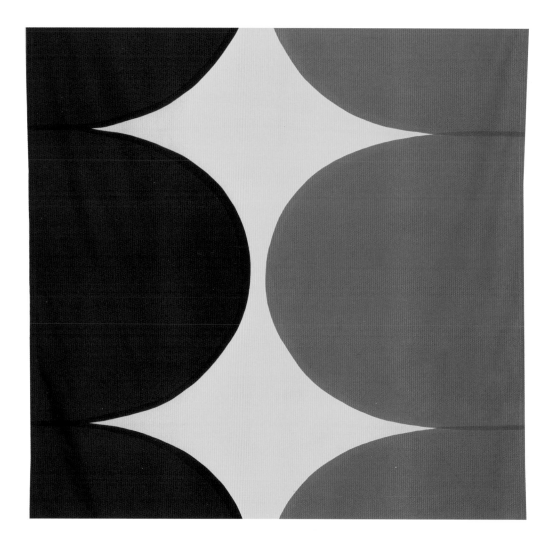

Fig. 7–51. Annika Rimala.
Dress; *Puketti* pattern, 1964.
Susan Ward Collection, Boston.
(Checklist no. 60).

Fig. 7–52. Maija Isola.
*Istuva härkä* pattern, 1966.
(Checklist no. 71).

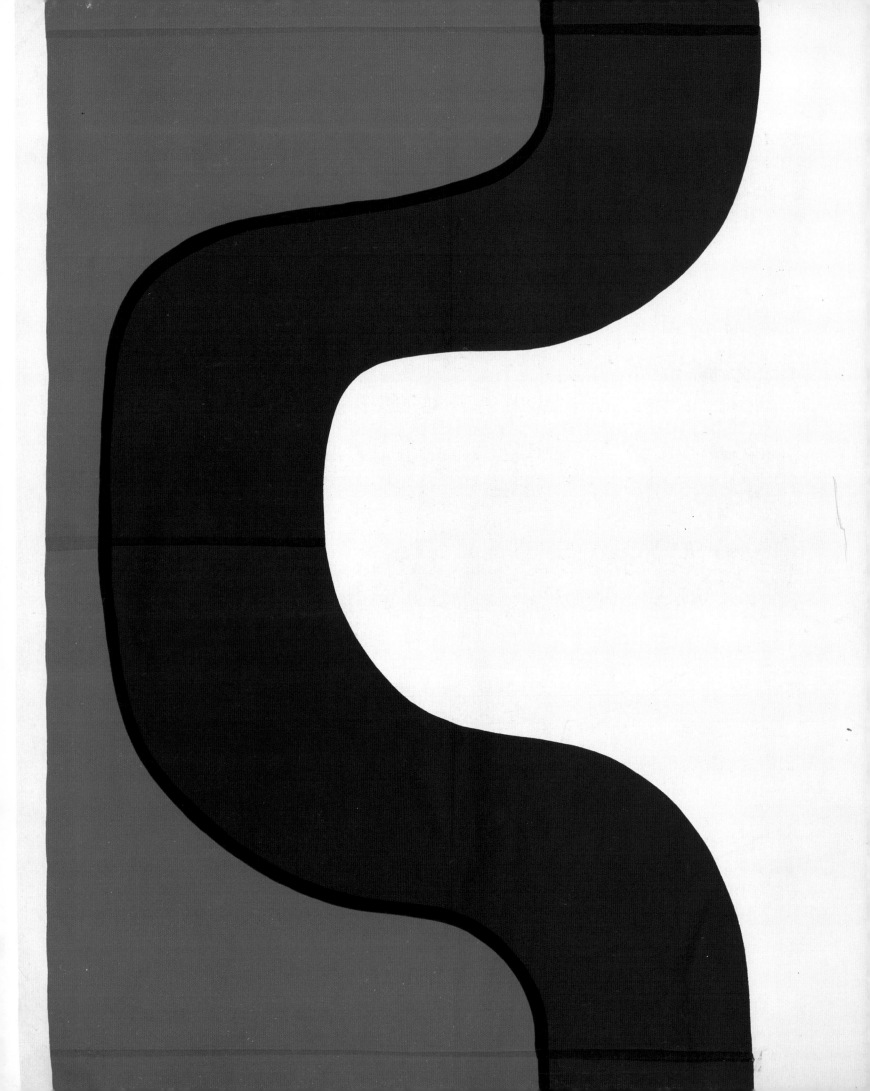

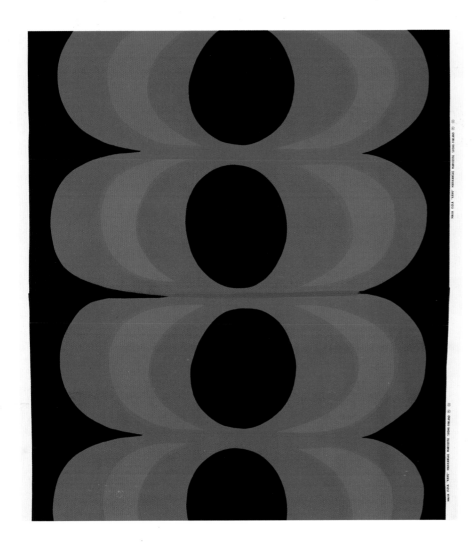

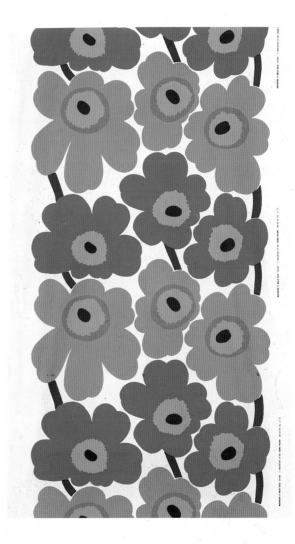

▲ Fig. 7–54. Maija Isola.
*Kaivo* pattern, 1964.
(Checklist no. 62).

◄ Fig. 7–53. Maija Isola.
*Seireeni* pattern, 1964.
Susan Ward Collection,
Boston. (Checklist no. 61).

Fig. 7–55. Maija Isola.
*Unikko* pattern, 1964.
(Checklist no. 63).

In the early days of Printex, floral patterns
were avoided. Maija Isola designed a number
of patterns, however, in which flowers were
treated in an unconventional way. Prettiness
was shed from her works around the 1960s,
when she increased the scale to gigantic
proportions. Later in the 1960s, she minimized
her flowers, however, as she did with her other
patterns. *Unikko* evokes the Flower Power that
was part of the era's overdone, splattered
world of pattern. Today (2003) *Unikko* is one
of Marimekko's most popular patterns. It is
found in the greatest variety of products,
from garments to mugs, trays, mouse pads,
televisions, memo pads, and even credit cards.

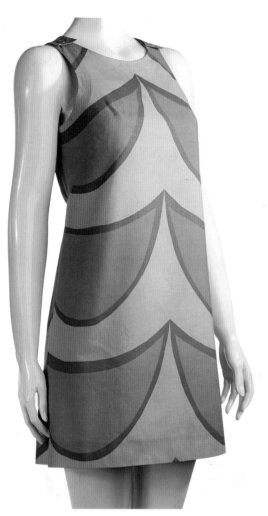

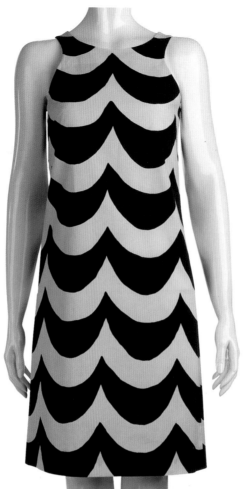

Fig. 7–56. Annika Rimala.
*Tiira* dress; *Iso laine* pattern,
1965. (Checklist no. 65).

Fig. 7–57. Annika Rimala.
*Tiira* dress; *Laine* pattern,
1965. (Checklist no. 64).

Fig. 7–58. Annika Rimala.
*Maininki* dress; *Laine* pattern,
1965. (Checklist no. 66).

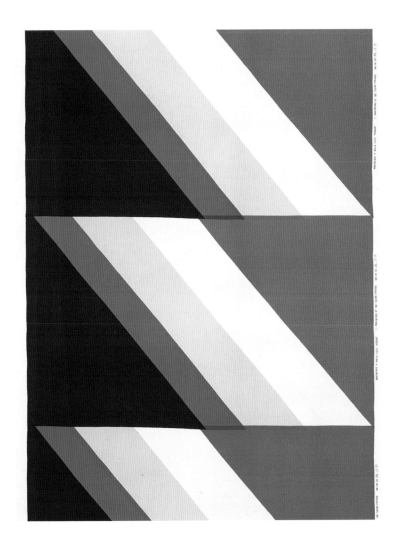

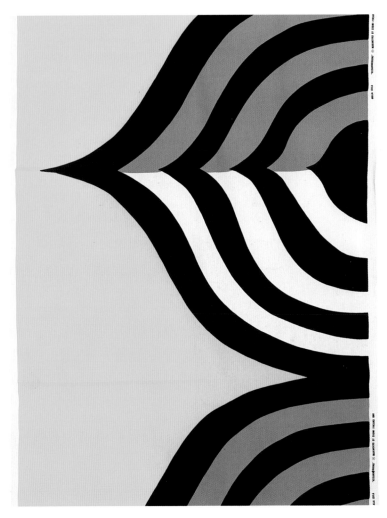

Fig. 7–59. Maija Isola.
*Husaari* pattern, 1966.
(Checklist no. 72).

Fig. 7–60. Maija Isola.
*Keisarinkruunu* pattern,
1966. (Checklist no. 73).

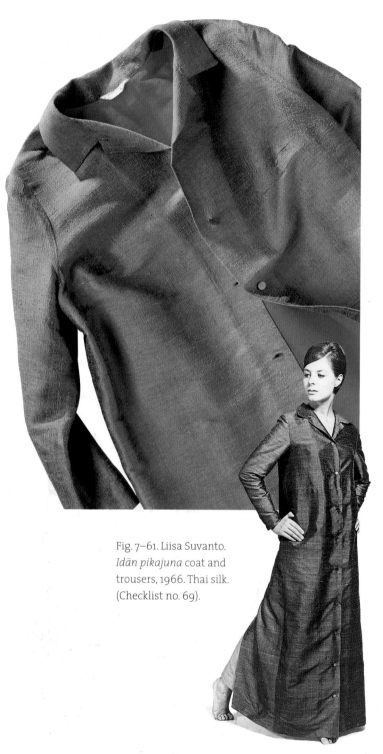

Fig. 7–61. Liisa Suvanto.
*Idän pikajuna* coat and
trousers, 1966. Thai silk.
(Checklist no. 69).

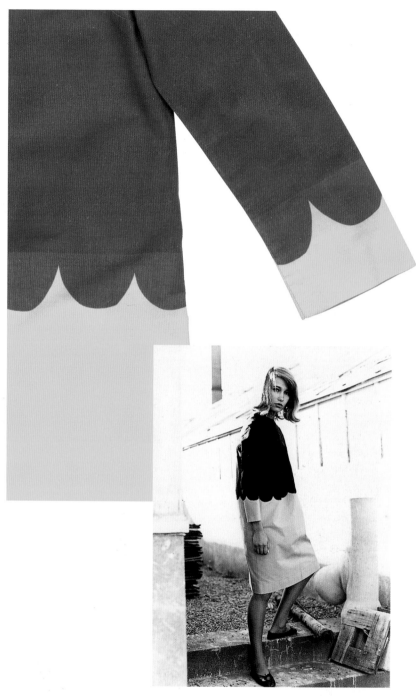

▲ Fig. 7–62. Annika Rimala.
*Saniainen* dress; *Pilvi* pattern,
1966. (Checklist no. 68).

▶ Fig. 7–63. Maija Isola.
*Mansikkavuoret* pattern, 1969.
Susan Ward Collection, Boston.
(Checklist no. 90).

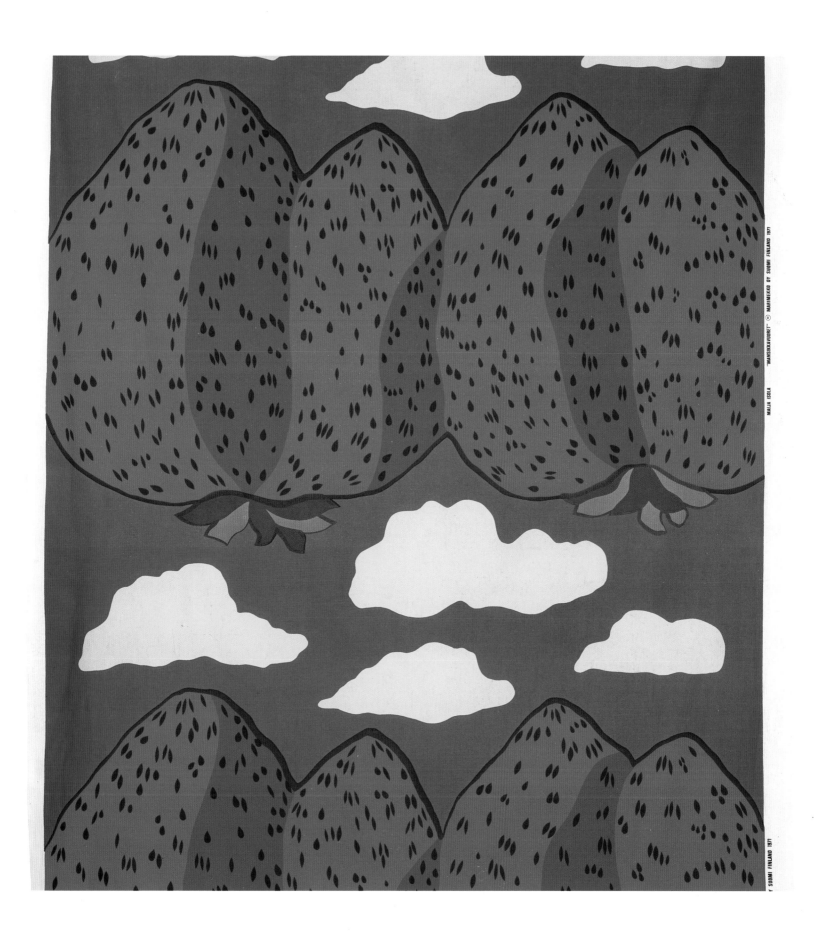

MAIJA ISOLA   "MANSIKKAVUORET"   © MARIMEKKO OY SUOMI FINLAND 1971

SUOMI FINLAND 1971

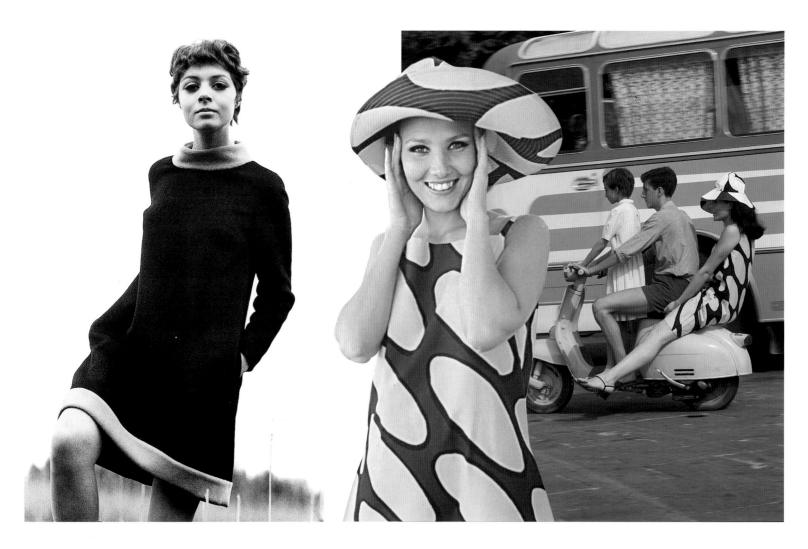

Fig. 7–64. Liisa Suvanto.
*Nunatakki* dress, 1966.
Wool felt. (Checklist no. 70).

Fig. 7–65. Annika Rimala.
*Piilo* dress; *Linssi* pattern
by Kaarina Kellomäki, 1966.
(Checklist no. 74).

When the wearing of bluejeans spread into the mainstream from the youth culture of the 1960s, Annika Rimala's response was a product that became as ubiquitous as jeans. The *Tasaraita* shirt was Marimekko's first jersey product, and was followed by Rimala's designs for jersey nightshirts, underwear, and socks. The original colors were red, yellow, green, and blue, combined with white, but over the years very different color variations were made. The point of departure for *Tasaraita* was a T-shirt worn by American coal miners in the early 1900s.

Fig. 7–66. Annika Rimala. *Tasaraita* T-shirts, 1967–68. Cotton, polyester jersey. (Checklist no. 75).

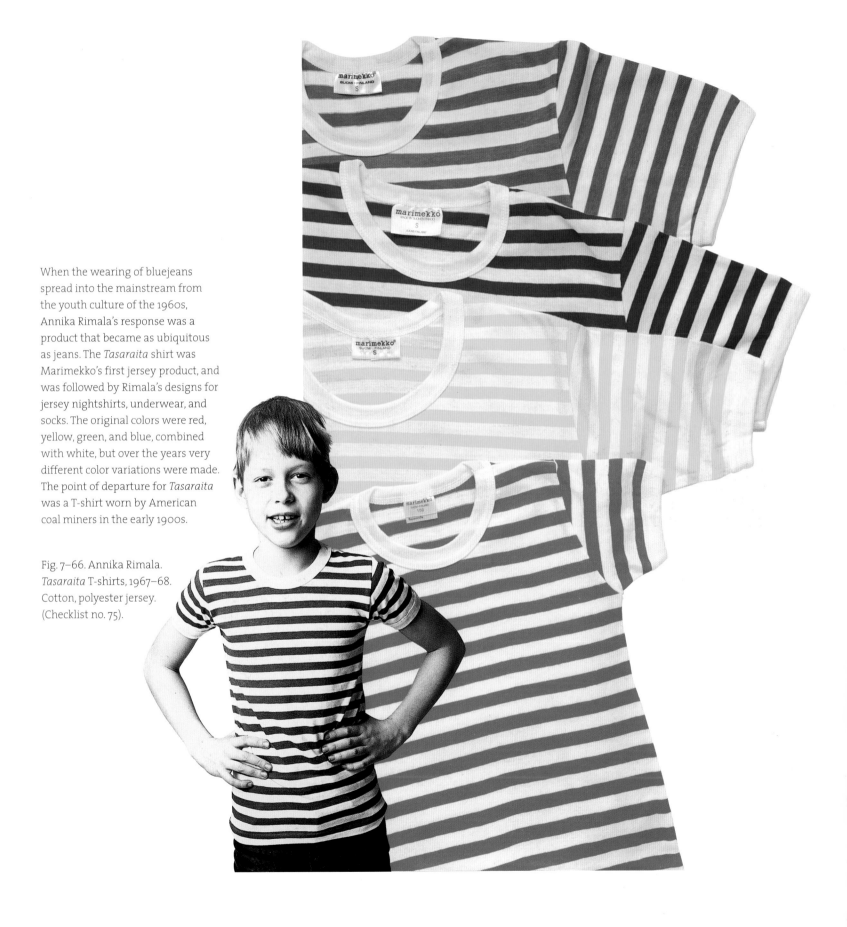

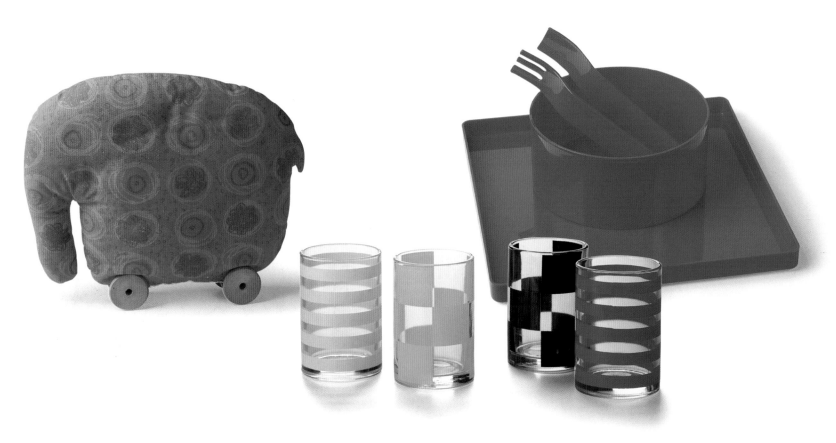

Fig. 7–67. Annika Rimala.
*Möhköfantti* toy, 1959;
*Linjaarirattaat* pattern by
Vuokko Nurmesniemi, 1959.
(Checklist no. 156).

Fig. 7–68. Hilkka Rahikainen.
Drinking glasses, 1960s.
(Checklist no. 167).

▲▲ Fig. 7–69. Hilkka Rahikainen
and Ristomatti Ratia. Tray and salad
bowl, 1972. Ismo Kajander. Salad tongs,
1972. (Checklist nos. 172–174).

Fig. 7–70. Pouches, 1980s: *Puketti* pattern 1964 by Annika Rimala, 1964; *Nadja* pattern by Vuokko Nurmesniemi, 1959. (Checklist no. 177).

Fig. 7–71. Annika Rimala. *Tasaraita* socks, 1968. (Checklist no. 166).

Fig. 7–72. Ristomatti Ratia. *Peruskassi* tote bag, 1971. Canvas. (Checklist no. 170).

As early as the 1950s, Marimekko expanded its product line to include a variety of accessories and small household objects to accompany its fabrics and fashions. Bags were perhaps the most popular accessories and many have remained in production. Among them the *Peruskassi* tote bag. Variations included the *Matkuri*, a travel bag, and the *303*, a shoulderbag.

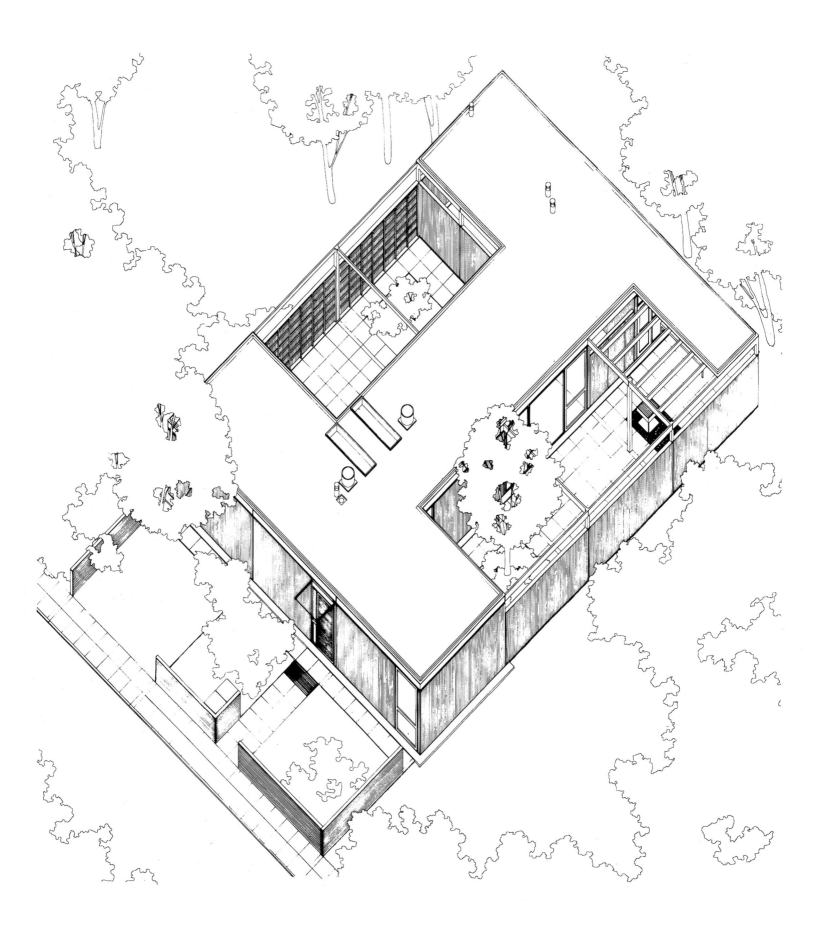

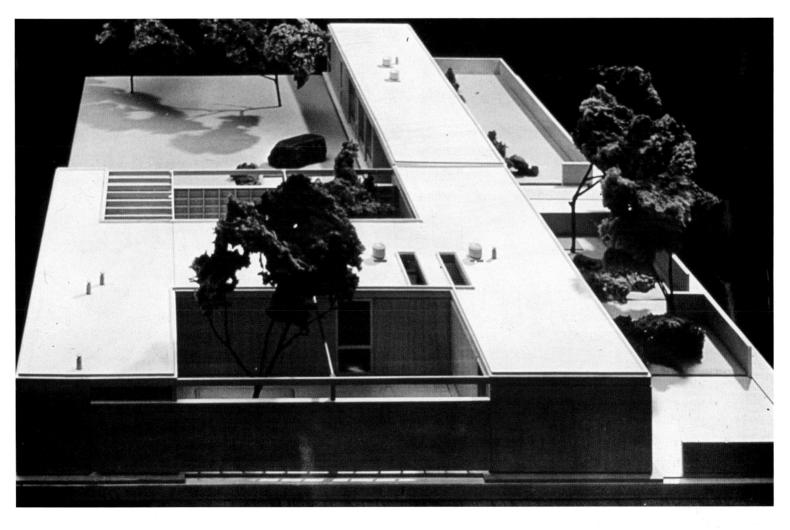

◄ Fig. 7–73.
Aarno Ruusuvuori.
Experimental Marihouse,
1966. Museum of Finnish
Architecture, Helsinki.

▲ Fig. 7–74.
Aarno Ruusuvuori.
Scale model of the
Experimental Marihouse,
1966. Museum of Finnish
Architecture, Helsinki.
(Checklist no. 178).

► Fig. 7–75.
Aarno Ruusuvuori.
Experimental Marihouse,
Bökars, Porvoo, 1966.
Museum of Finnish
Architecture, Helsinki.

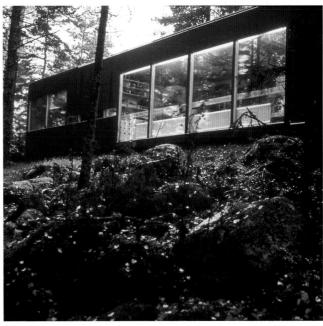

▸ Fig. 7–76. Bathroom in the Experimental Marihouse. Museum of Finnish Architecture, Helsinki.

▸▸ Fig. 7–77. Bedroom in the Experimental Marihouse. Maija Isola, *Lokki* pattern bedcover, 1961. Museum of Finnish Architecture, Helsinki.

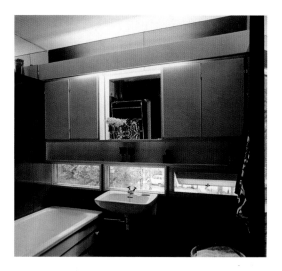

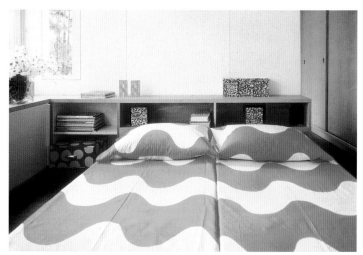

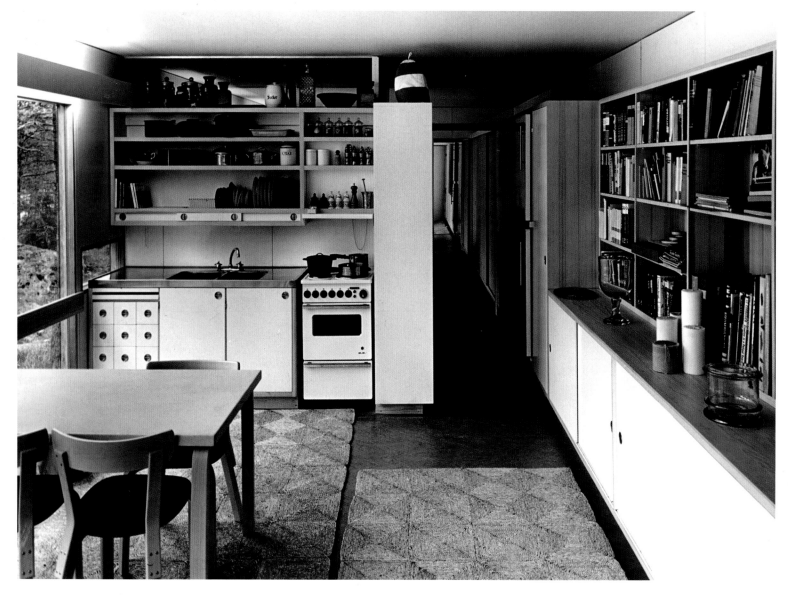

◄ Fig. 7–78.
Kitchen in the
Experimental Marihouse.
Museum of Finnish
Architecture, Helsinki.

▲ Fig. 7–79.
Living room in the
Experimental Mari-
house. Museum of
Finnish Architecture,
Helsinki.

◄ Fig. 7–80 a, b.
Kitchen details in the
Experimental Mari-
house.

Fig. 7–81. Erkki Kairamo and
Reijo Lahtinen. Scale model
of the Marimekko factory in
Herttoniemi, 1973. Museum
of Finnish Architecture,
Helsinki. (Checklist no. 179).

Fig. 7–82. Annika Rimala. *Kytkin* trousers and jacket; *Kisko* pattern, 1967. Photographed on the Herttoniemi factory staircase in the 1970s.

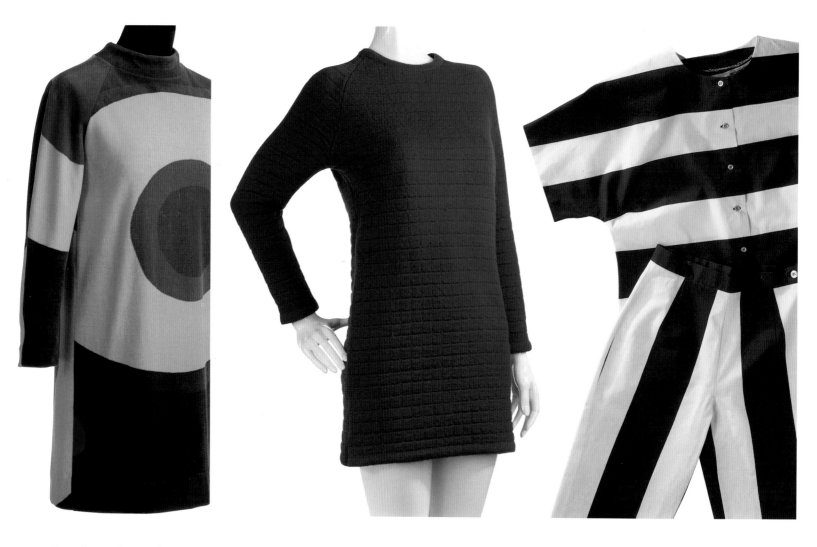

Fig. 7–83. Annika Rimala.
*Passi* dress; *Klaava* pattern,
1967. Cotton velour.
(Checklist no. 76).

Fig. 7–84. Liisa Suvanto.
*Tarkiainen* dress, 1967.
Wool doubleknit.
(Checklist no. 77).

Fig. 7–86. Annika Rimala.
*Kytkin* trousers and jacket;
*Kisko* pattern, 1967.
(Checklist nos. 79–80).

*Tarkiainen* is Liisa Suvanto's
Finnish version of the ubiqui-
tous minidress fashion, but
made with a thick woolen
knit. It could be augmented
with trousers, a cap, or a scarf.
In deference to the Finnish
climate Suvanto designed
matching felt boots.

◀ Fig. 7–85. Liisa Suvanto.
*Hiljaset* boots, 1967.
(Checklist no. 165).

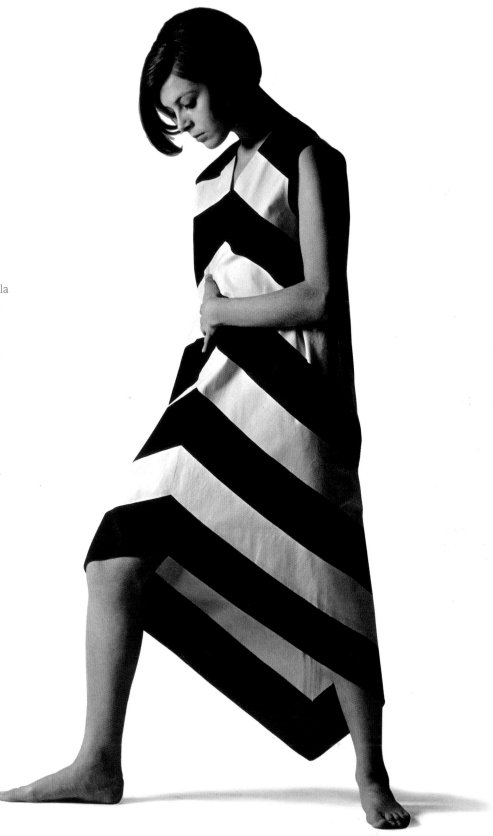

Vuokko Nurmesniemi's *Galleria* fabric was used to make many different garments, and in the early stages Rimala also designed with it. Different cutting methods made the striped fabric look completely different. There is a story behind the long hem of *Linjaviitta*. The first version of the garment was made from an old tie belonging to Rimala's husband; Rimala cut holes in it for the neck and arms. The next day she went to the factory and showed the cut necktie. The long hem of *Linjaviitta* and its pattern, folded from the central seam, retain traces of the original tie.

Fig. 7–87. Annika Rimala. *Linjaviitta* dress, 1967; *Galleria* pattern by Vuokko Nurmesniemi, 1954. (Checklist no. 78).

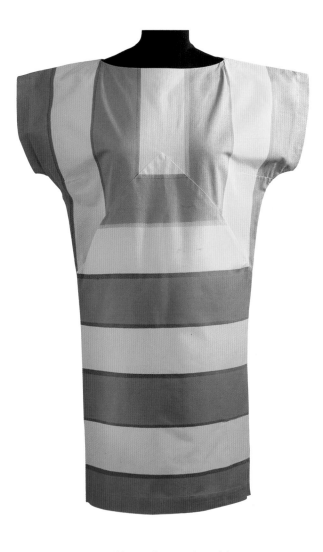

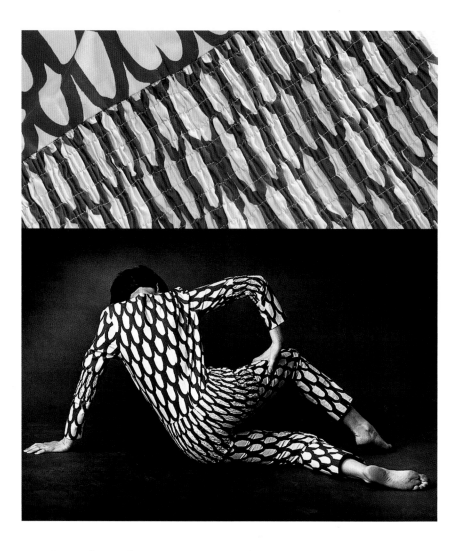

Fig. 7–88. Annika Rimala. *Takila*
dress, 1967; *Galleria* pattern by
Vuokko Nurmesniemi, 1954.
(Checklist no. 81).

Fig. 7–89. Annika Rimala.
*Ryppypeppu* jumpsuit;
*Iso suomu* pattern, 1965.
(Checklist no. 67).

This jumpsuit was designed for photo
shoots to promote sales of other clothing
in the collection. The revealing cut garnered
much attention, and the jumpsuit was
published in many fashion magazines.
*Ryppypeppu* is an example of Marimekko's
experimental fashion of the 1960s, others
included the large floppy hats made for
fashion shows and a water-resistant mini-
skirt made of oilcloth.

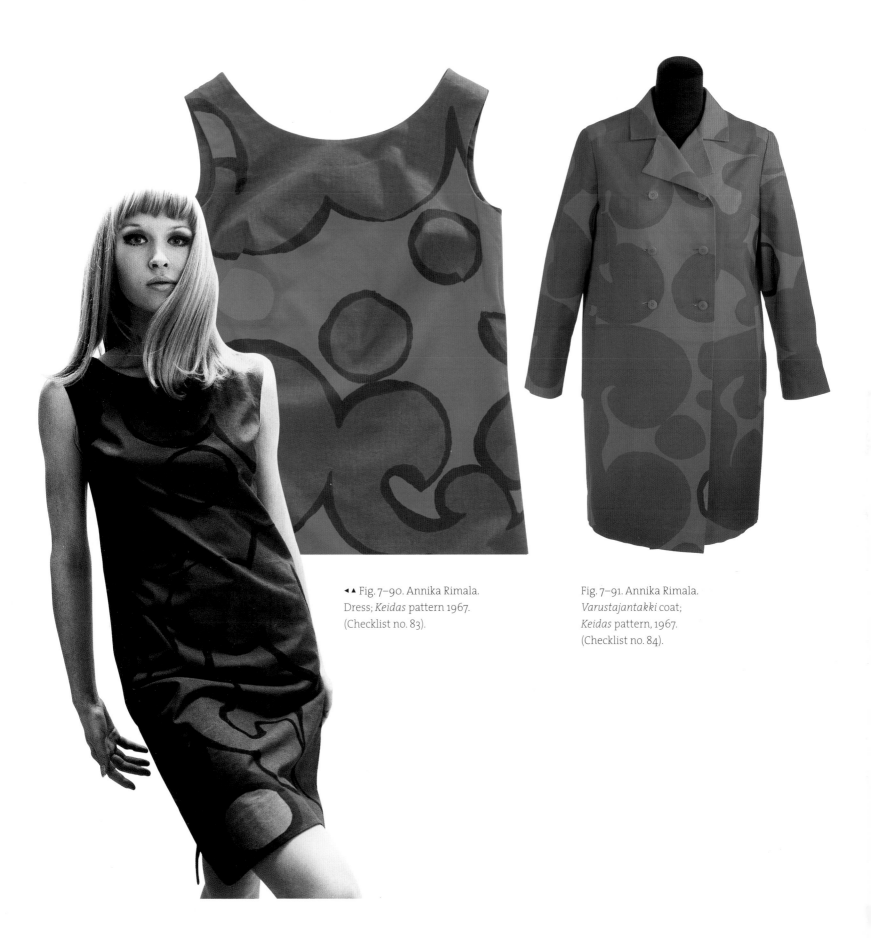

◄▲ Fig. 7–90. Annika Rimala.
Dress; *Keidas* pattern 1967.
(Checklist no. 83).

Fig. 7–91. Annika Rimala.
*Varustajantakki* coat;
*Keidas* pattern, 1967.
(Checklist no. 84).

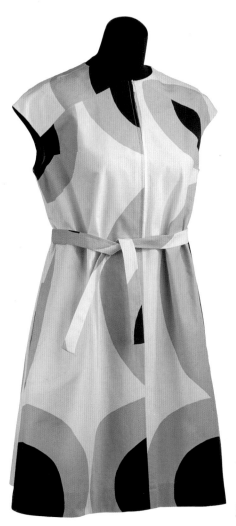

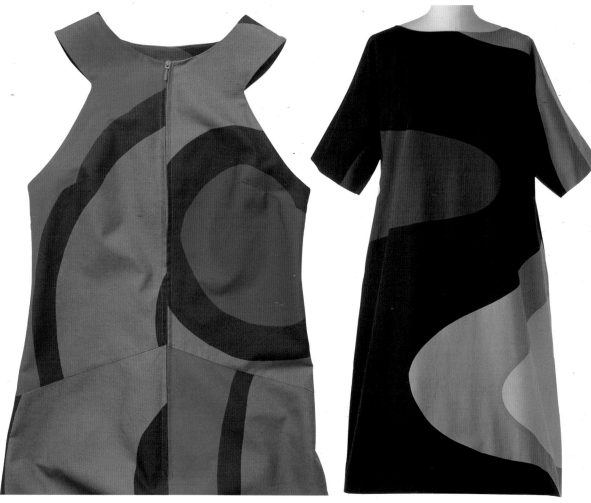

Fig. 7–92. Annika Rimala.
*Pajasso* dress;
*Klaava* pattern, 1968.
(Checklist no. 88).

Fig. 7–93. Annika Rimala.
*Myrskylyhty* dress;
*Klaava* pattern, 1968.
(Checklist no. 86).

Fig. 7–94. Annika Rimala.
Dress; *Kruuna* pattern, 1968.
Finlandia University, Hancock,
Michigan, Susan Peterson
Collection. (Checklist no. 87).

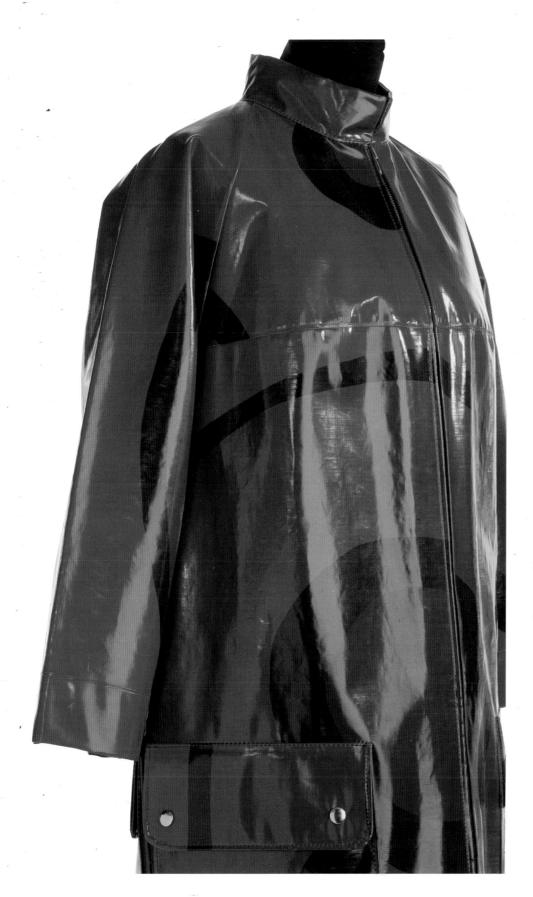

Fig. 7–95. Annika Rimala.
*Vesihiisi* raincoat; *Kruuna*
pattern, 1968. Wax-treated
cotton. (Checklist no. 85).

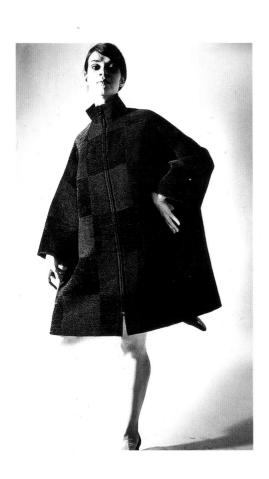

Fig. 7–96. Liisa Suvanto.
*Pohatta* coat, 1968.
Handwoven velvet.
(Checklist no. 89).

Fig. 7–97. Maija Isola.
*Ovia* pattern, 1969.
(Checklist no. 91).

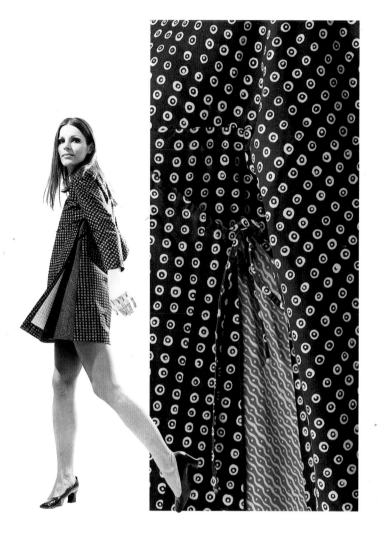

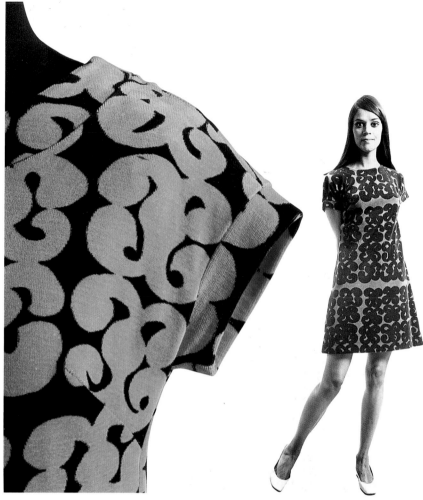

Fig. 7–98. Annika Rimala.
*Tortilla* dress; *Karakola*
and *Raspa* patterns, 1969.
(Checklist no. 92).

Fig. 7–99. Annika Rimala.
*Tutka* dress ca. 1969; *Tarha*
pattern, 1963. Cotton velvet.
(Checklist no. 93).

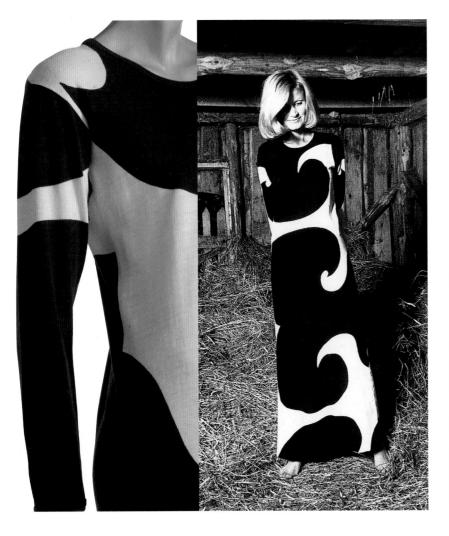

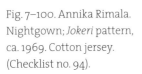

Fig. 7–100. Annika Rimala.
Nightgown; *Jokeri* pattern,
ca. 1969. Cotton jersey.
(Checklist no. 94).

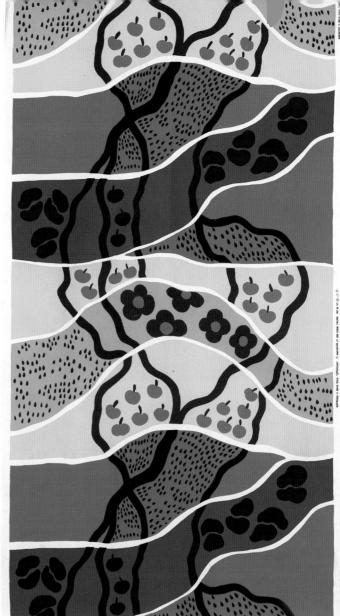

Fig. 7–101. Maija Isola.
*Lovelovelove* pattern,
1969. (Checklist no. 95).

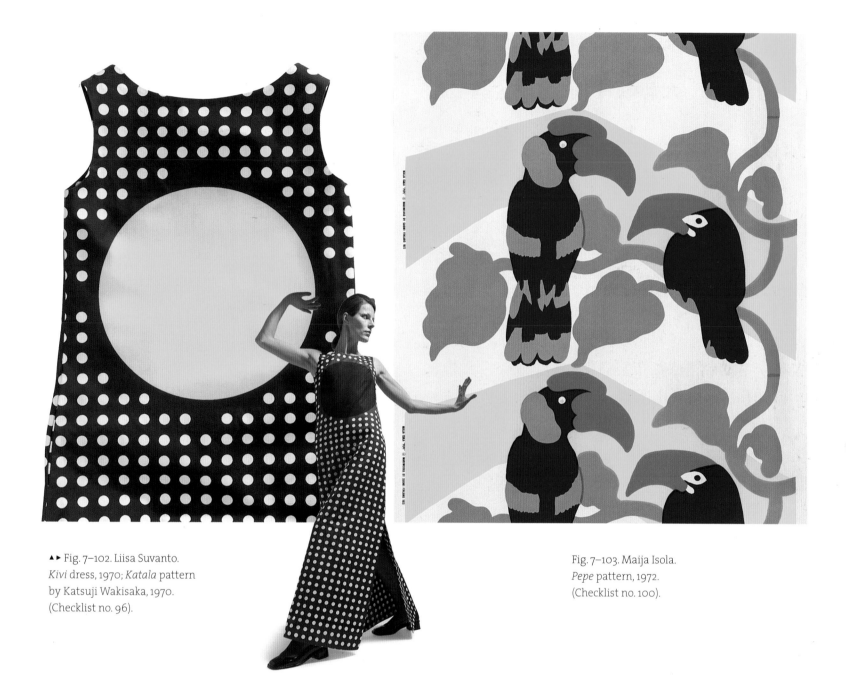

▲ ▶ Fig. 7–102. Liisa Suvanto.
*Kivi* dress, 1970; *Katala* pattern
by Katsuji Wakisaka, 1970.
(Checklist no. 96).

Fig. 7–103. Maija Isola.
*Pepe* pattern, 1972.
(Checklist no. 100).

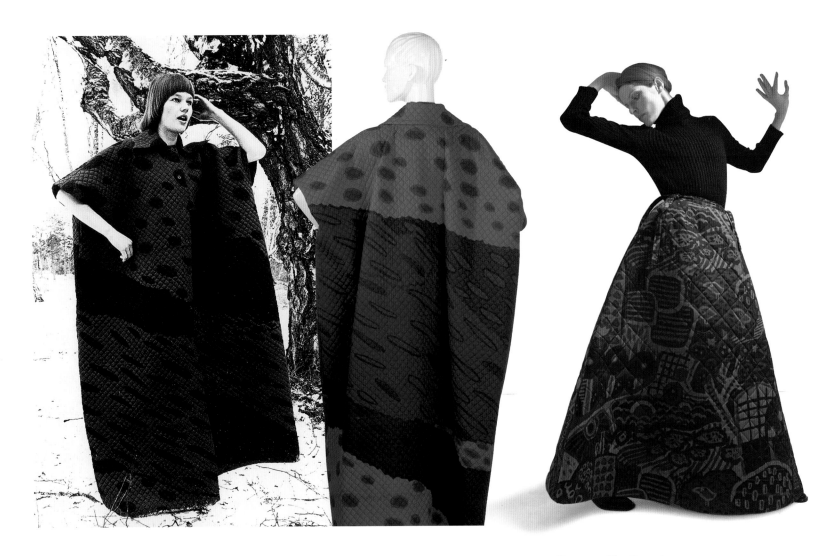

Fig. 7–104. Liisa Suvanto.
*Fregatti* coat, 1971; *Kottarainen*
pattern by Katsuji Wakisaka, 1971.
(Checklist no. 97).

Fig. 7–105. Liisa Suvanto.
*Vaski* skirt, 1971; *Eve* pattern
by Katsuji Wakisaka, 1971.
(Checklist no. 98).

Quilted clothing was introduced after
Liisa Suvanto became interested in Katsuji
Wakisaka's fabrics. The designers collabo-
rated on collections that combined their
vivid imaginations. The clothes are reminis-
cent of the fascination fashion houses had
for exoticism in the 1960s and 70s; they
combine a hint of imperial China, the
ornamentalism of Slavic folk tales, and
the Japanese kimono tradition. Quilting
the cotton made it possible to create
sculptural forms.

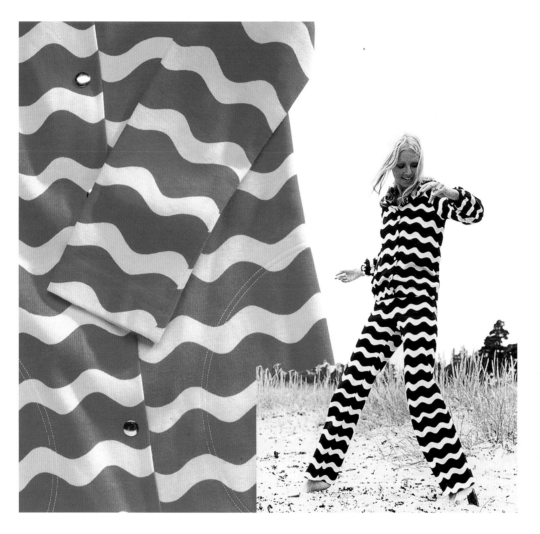

Fig. 7–106. Pentti Rinta.
*Pikomi* coat and *Peli* trousers;
*Lorina* pattern, 1972.
Cotton jersey. (Checklist no. 101).

Fig. 7–107. Pentti Rinta.
*Kuski* jacket and trousers, 1973.
Canvas. (Checklist no. 102).

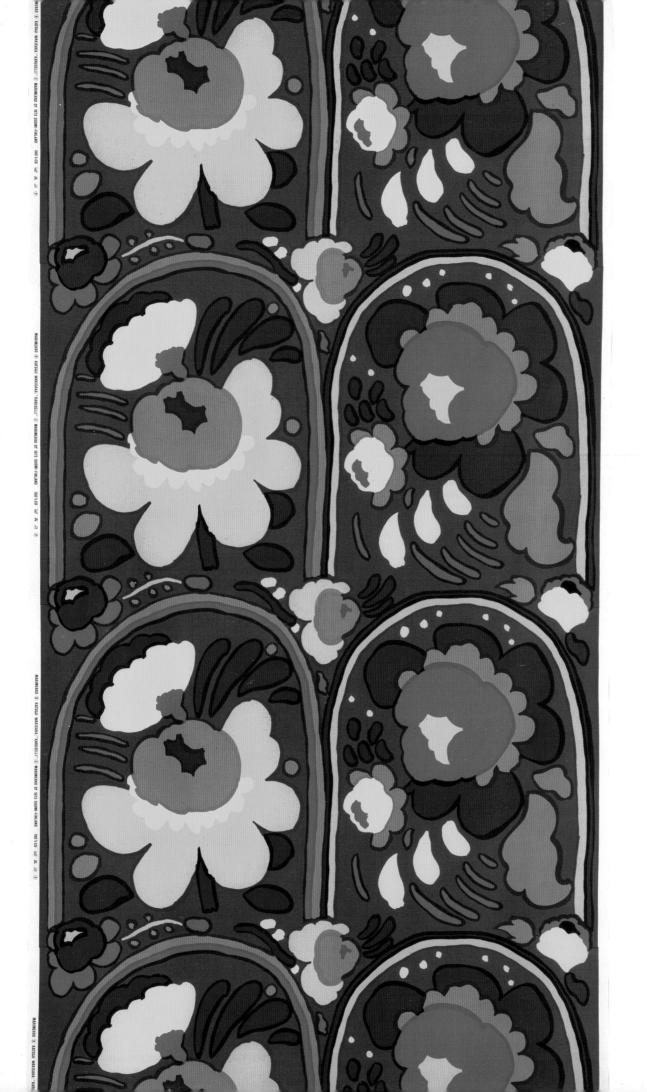

Fig. 7–108. Katsuji Wakisaka.
*Karuselli* pattern, 1973.
(Checklist no. 103).

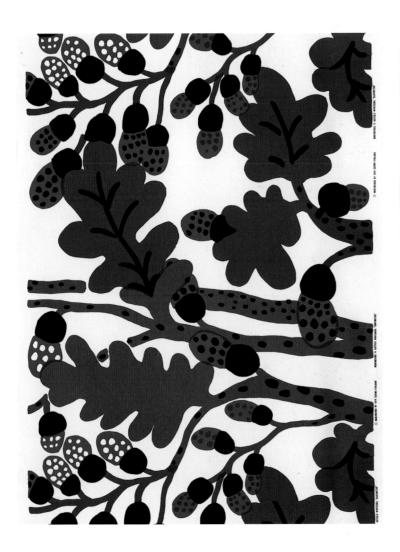

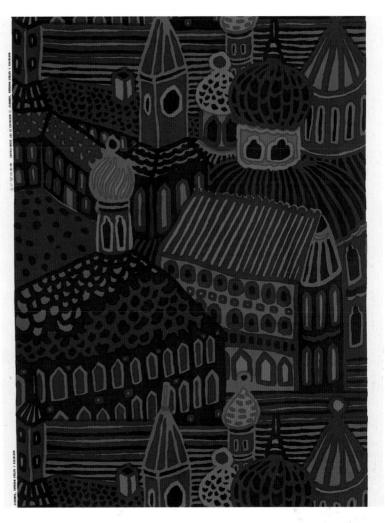

Fig. 7–109. Katsuji Wakisaka.
*Sademetsä* pattern, 1974.
(Checklist no. 107).

Fig. 7–110. Katsuji Wakisaka.
*Kumiseva* pattern, 1971.
(Checklist no. 99).

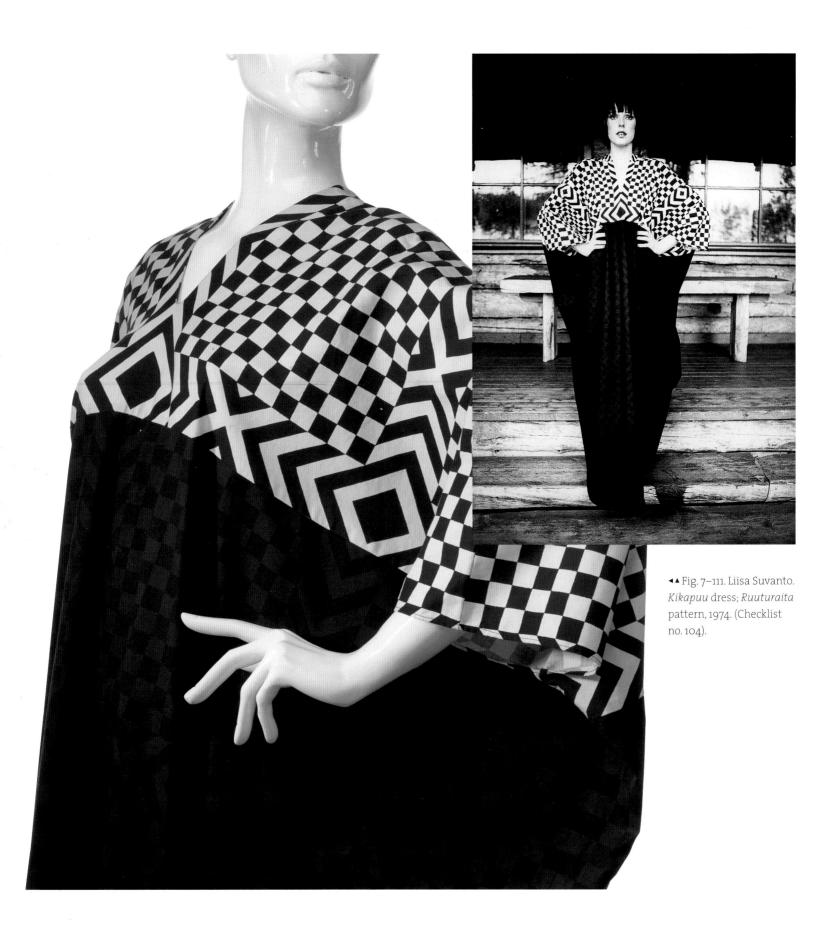

◄▲ Fig. 7–111. Liisa Suvanto. *Kikapuu* dress; *Ruuturaita* pattern, 1974. (Checklist no. 104).

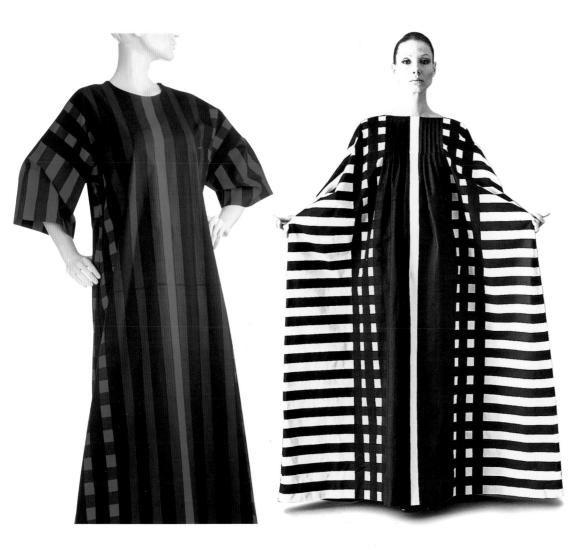

▲ Fig. 7–112. Liisa Suvanto.
*Koppelo* dress; *Tiet* pattern,
1974. (Checklist no. 108).

Fig. 7–113. Liisa Suvanto.
*Korppi* dress; *Tiet* pattern,
1974. (Checklist no. 109).

Marimekko's designers have often
used different cultures as a point of
departure for their ideas. Loose-fitting
kaftan fashion came to Marimekko in
the 1970s. Suvanto, who was inspired
by Asian and the Near Eastern cultures,
designed a number of kaftans (1973–75)
echoing nomadic dress. The color and
pattern of Pentti Rinta's *Liidokki* (fig.
7–114) dress relate to the handcraft
traditions of Latin America.

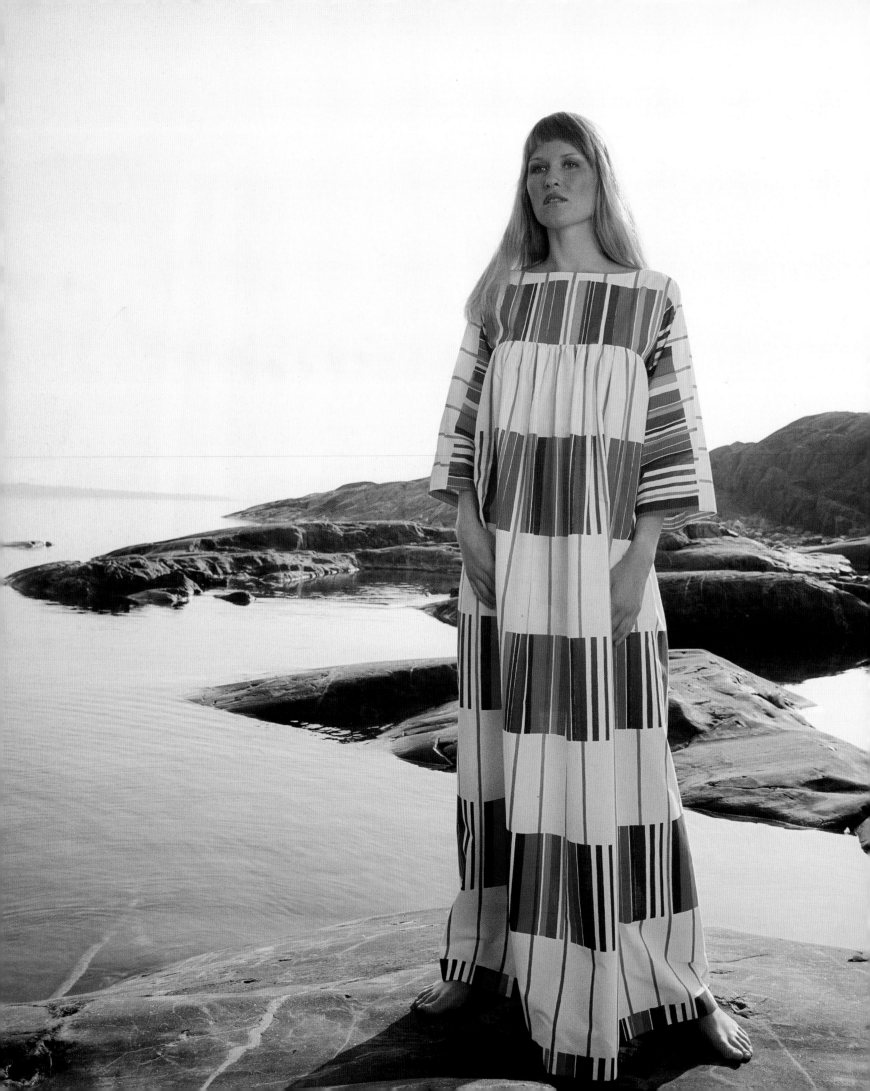

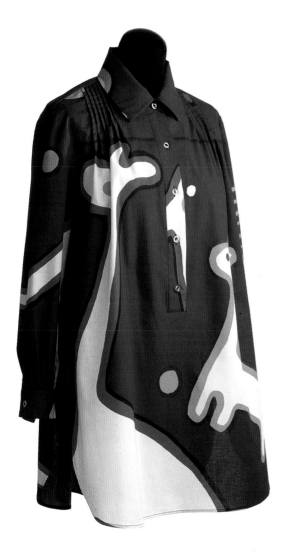

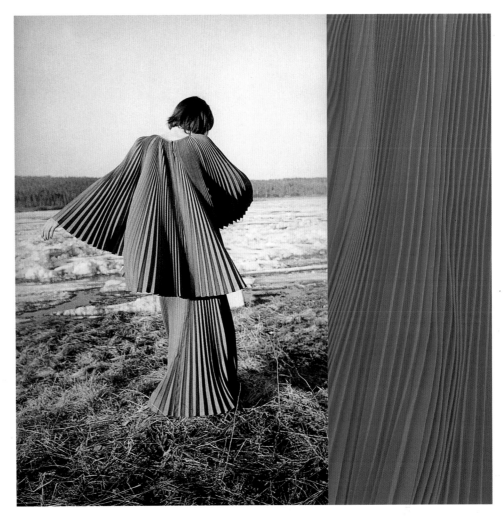

▲ Fig. 7–115. Liisa Suvanto.
Shirt, 1975; *Yume* pattern
by Katsuji Wakisaka, 1969.
(Checklist no. 110).

◄ Fig. 7–114. Pentti Rinta.
*Liidokki* dress; *Kirjo* pattern,
1974. Finlandia University,
Hancock, Michigan, Susan
Peterson Collection.
(Checklist no. 105).

Fig. 7–116. Liisa Suvanto.
*Liekki* dress, 1974. Pleated wool.
(Checklist no. 106).

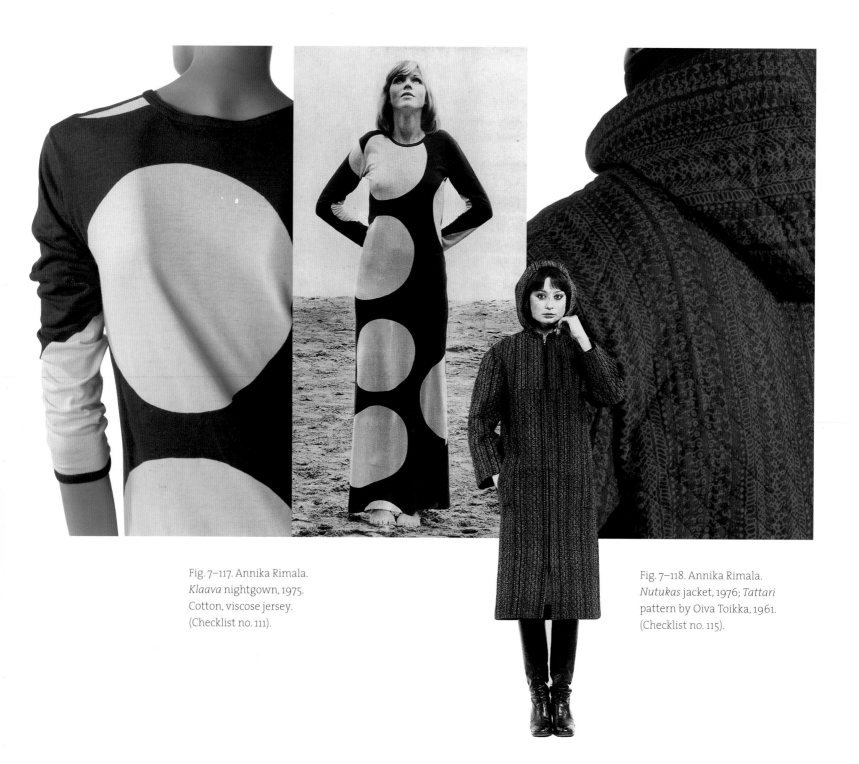

Fig. 7–117. Annika Rimala.
*Klaava* nightgown, 1975.
Cotton, viscose jersey.
(Checklist no. 111).

Fig. 7–118. Annika Rimala.
*Nutukas* jacket, 1976; *Tattari*
pattern by Oiva Toikka, 1961.
(Checklist no. 115).

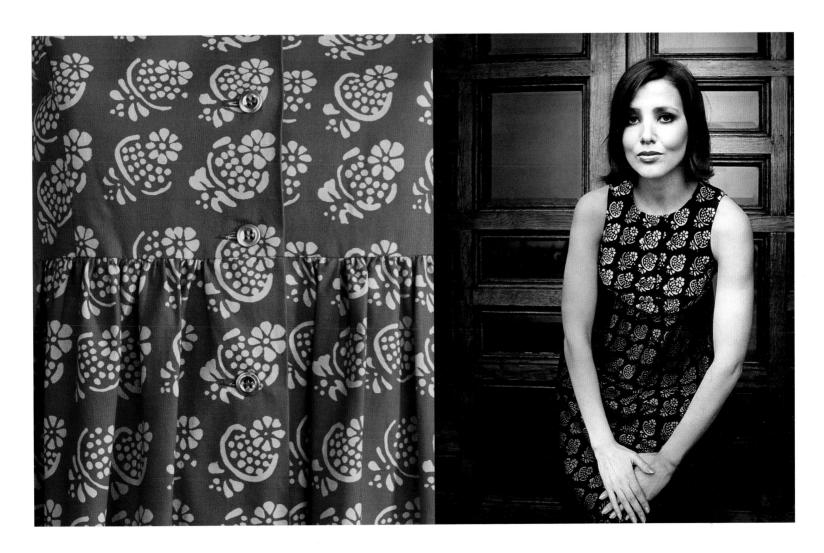

Fig. 7–119. Annika Rimala.
*Pusu* dress, 1976; *Hedelmäkori*
pattern, early 1960s.
(Checklist no. 116).

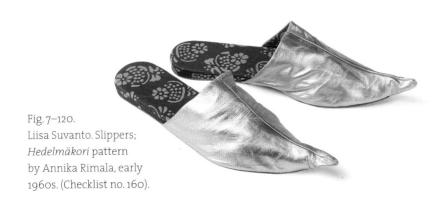

Fig. 7–120.
Liisa Suvanto. Slippers;
*Hedelmäkori* pattern
by Annika Rimala, early
1960s. (Checklist no. 160).

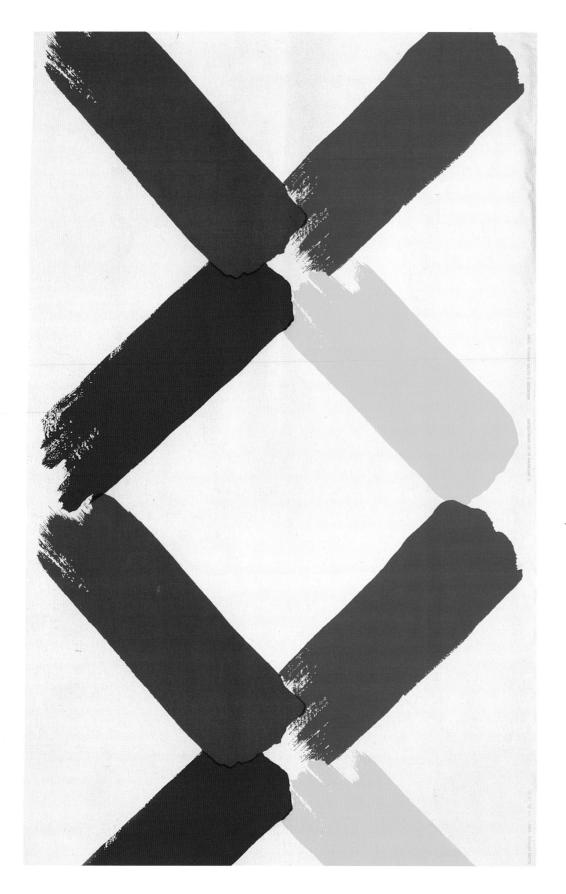

◄▲ Fig. 7–121. Fujiwo Ishimoto.
*Sumo* pattern, 1977. (Checklist
no. 117).

► Fig. 7–122. Fujiwo Ishimoto.
*Taiga* pattern, 1978. (Checklist
no. 118).

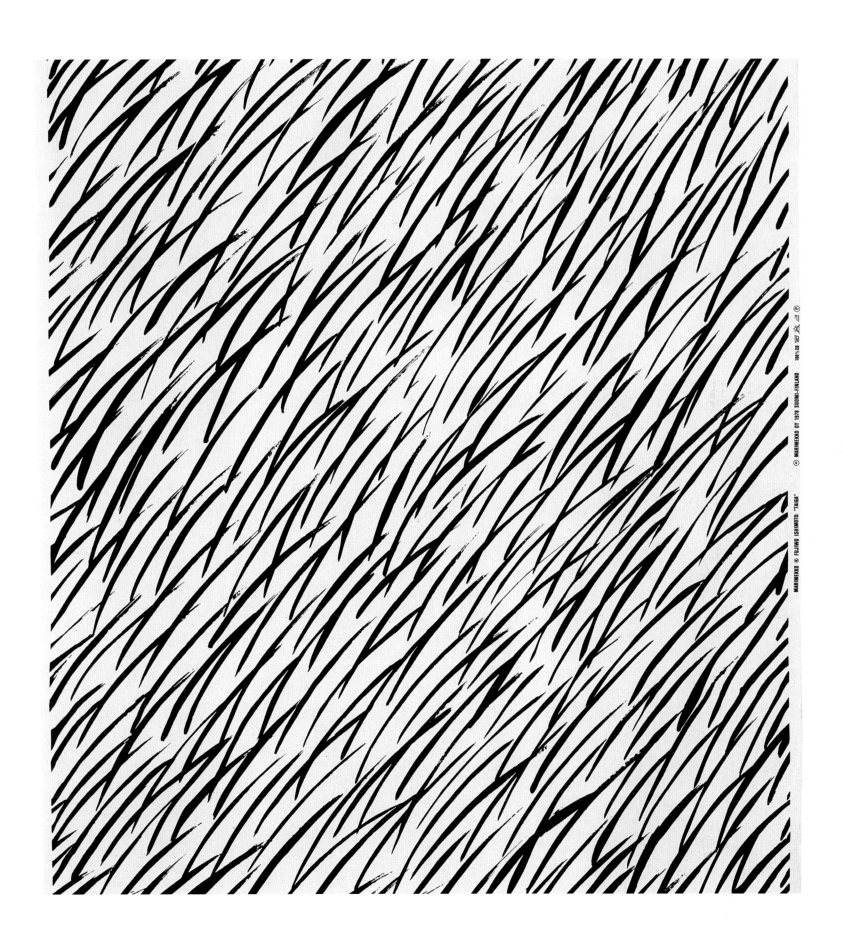

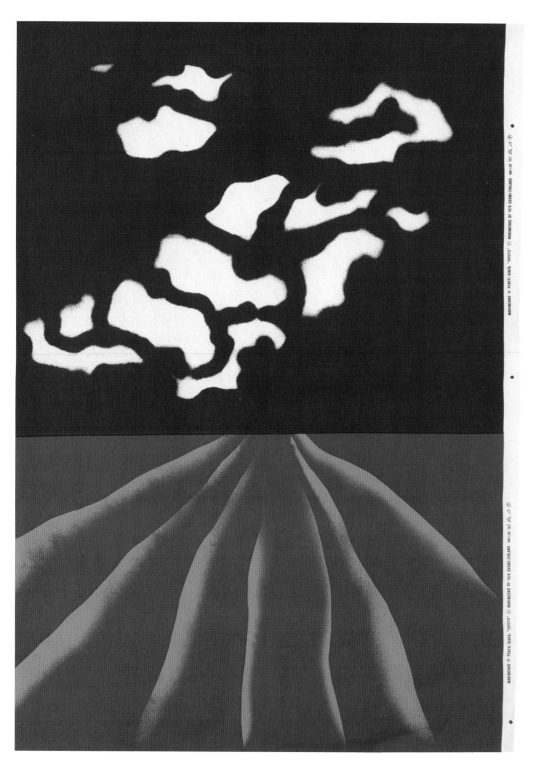

▲ Fig. 7–123. Pentti Rinta.
*Yhteys* pattern, 1978.
(Checklist no. 119).

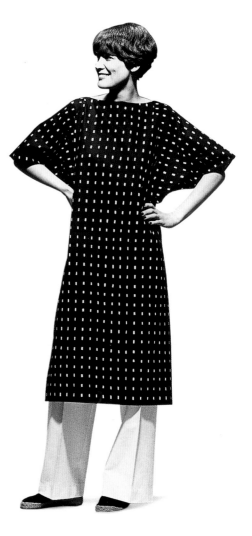

▲ Fig. 7–124. Pentti Rinta.
*Sulka* dress; *Sokkoruutu*
pattern, 1981. (Checklist
no. 120).

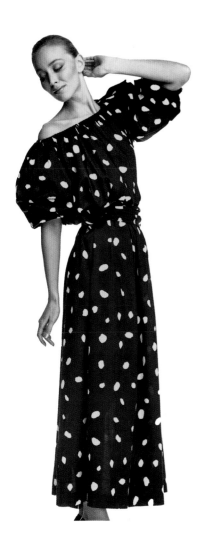

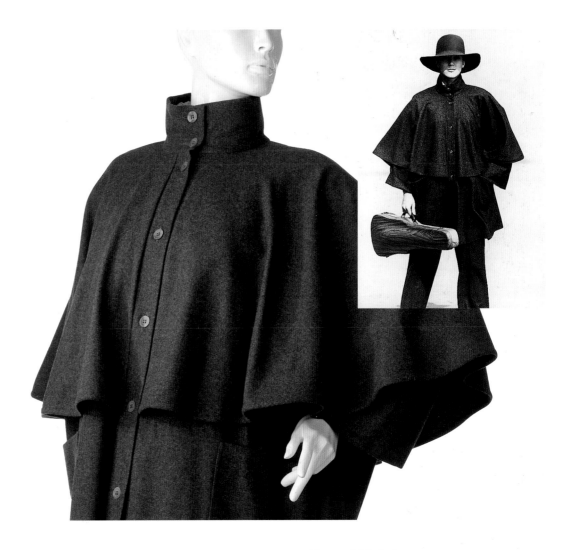

Fig. 7–125. Marja Suna.
*Kavalkadi* dress;
*Samba* pattern, 1982.
(Checklist no. 121).

Fig. 7–126. Marja Suna.
*Viipotus* coat, 1983.
Wool felt.
(Checklist no. 125).

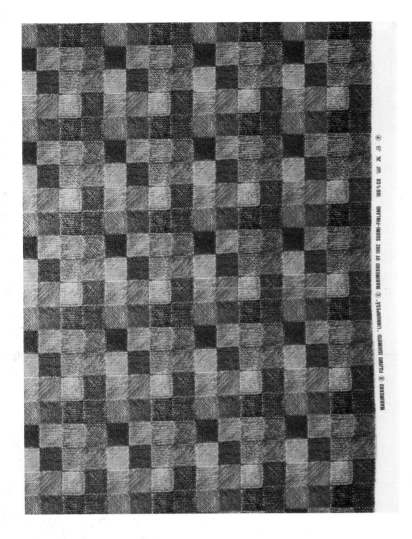

▲ Fig. 7–127. Fujiwo Ishimoto.
*Linnunpesä* pattern, 1982.
(Checklist no. 123).

◀ Fig. 7–128. Fujiwo Ishimoto.
*Maisema* pattern, 1982.
(Checklist no. 122).

This fabric brings out Ishimoto's fascination
with line and surface. The rough, scratched-
looking linework of *Maisema* was achieved
with crayons. There are numerous color
variations of the pattern, reiterating the
colors of the Finnish landscape. *Linnunpesä*
is a smaller version of the same pattern.

▶ Fig. 7–129. Fujiwo Ishimoto.
*Jäkälä* pattern, 1983.
(Checklist no. 124a).

▶▶ Fig. 7–130. Fujiwo Ishimoto.
*Ostjakki* pattern, 1983.
(Checklist no. 124b).

This pattern continues the tradition of
adopting age-old methods and patterns to
new production technology. In Ishimoto's
*Iso karhu* collection, the pattern imitates
traditional Japanese woven ikat fabrics.
Ikat patterns are painted on the warp
before weaving, and in the weaving, the
edges of the patterns are left uneven.

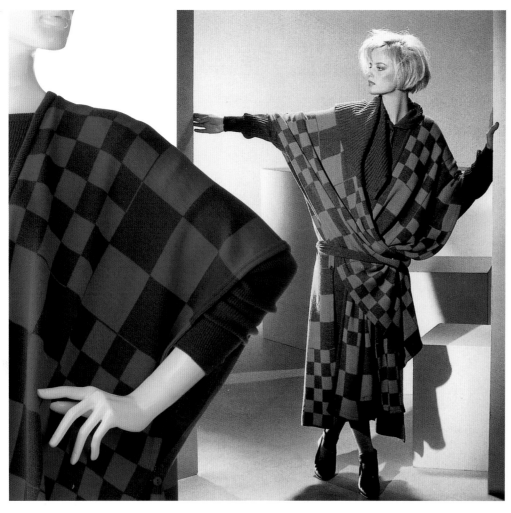

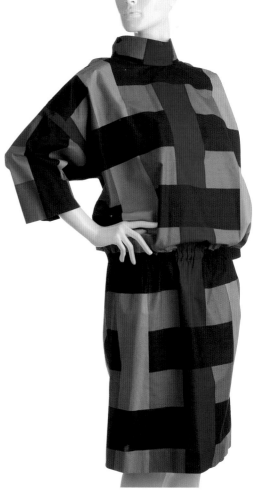

Fig. 7–131. Marja Suna.
*Kuningas* dress ensemble,
1984. Machine-knitted wool.
(Checklist no. 128).

▲ Fig. 7–132. Marja Suna.
*Tiiti* dress; *Palkki* pattern, 1984.
Cotton. Finlandia University,
Hancock, Michigan, Susan
Peterson Collection.
(Checklist no. 127).

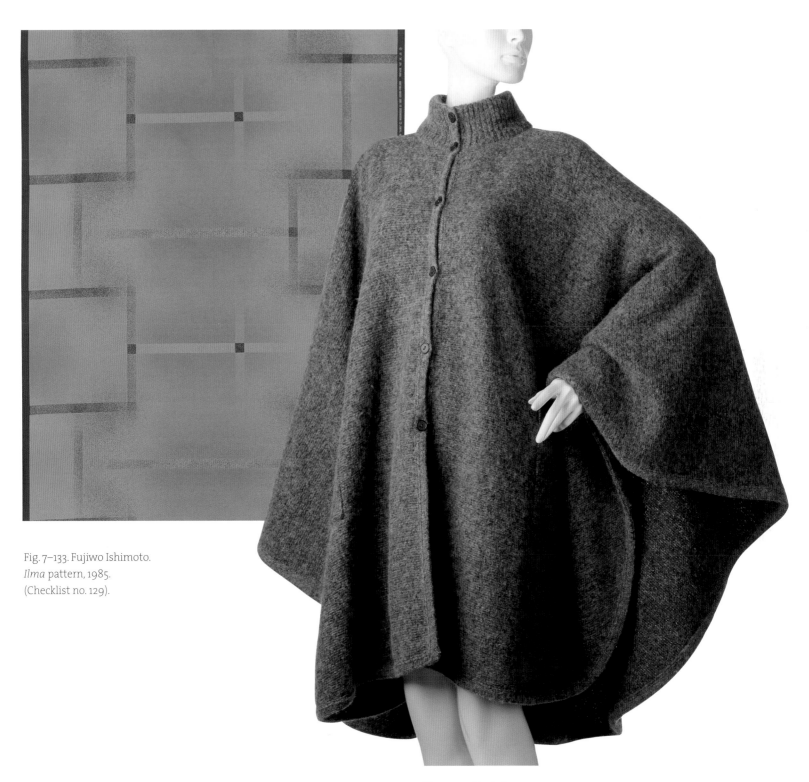

Fig. 7–133. Fujiwo Ishimoto.
*Ilma* pattern, 1985.
(Checklist no. 129).

Fig. 7–134. Marja Suna.
Cape, 1980s. Machine-knitted
wool, mohair, polyamide.
Marja Suna Collection.
(Checklist no. 126).

Fig. 7–135. Satu Montanari.
*Kapris* pattern, 1985.
(Checklist no. 130).

Fig. 7–136. Inka Kivalo.
*Mosaiikki* pattern, 1985.
(Checklist no. 131).

Many of the most important Finnish designers
and artists have worked for Marimekko.
For some Marimekko was a springboard to an
independent career, while others have stayed
with the company for a longer time. Inka Kivalo,
who worked at Marimekko from 1985 to 1990,
is a well-known tapestry-maker in Finland.

▶ Fig. 7–137. Fujiwo Ishimoto.
*Koski* pattern, 1986.
(Checklist no. 133).

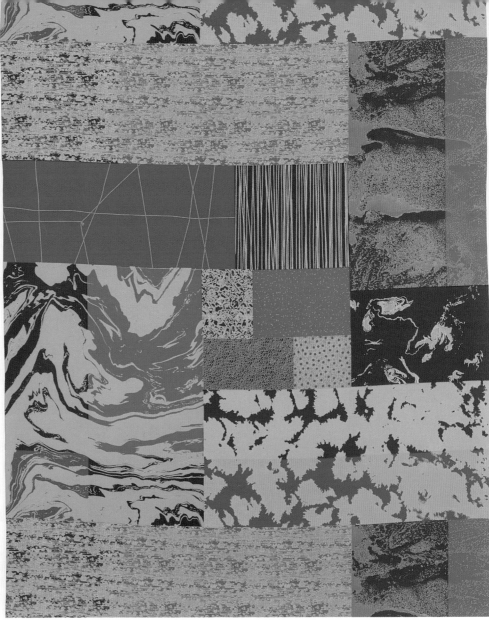

Fig. 7–138. Pekka Talvensaari.
*PT 7* man's suit, 1986. Linen.
(Checklist no. 132).

Fig. 7–139. Fujiwo Ishimoto.
*Marras* pattern, 1986.
(Checklist no. 134).

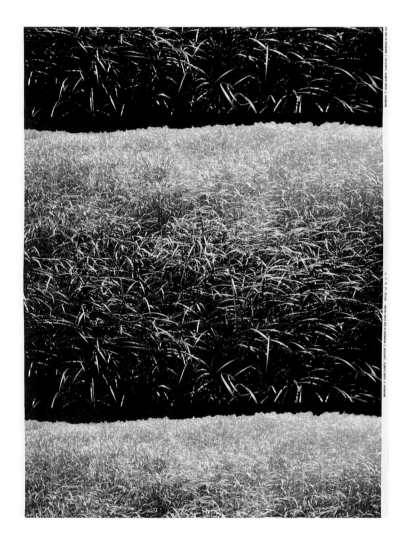

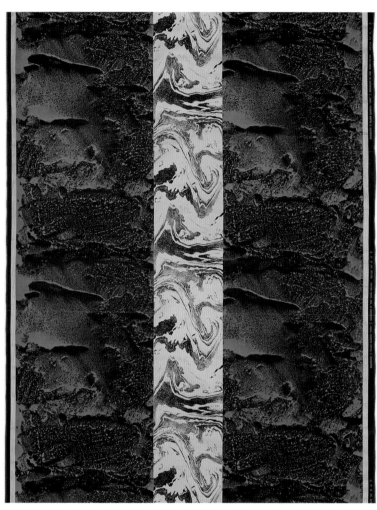

Fig. 7–140. Fujiwo Ishimoto.
*Lainehtiva* pattern, 1998.
(Checklist no. 137).

Fig. 7–141 . Fujiwo Ishimoto.
*Uoma* pattern, 1986.
(Checklist no. 135).

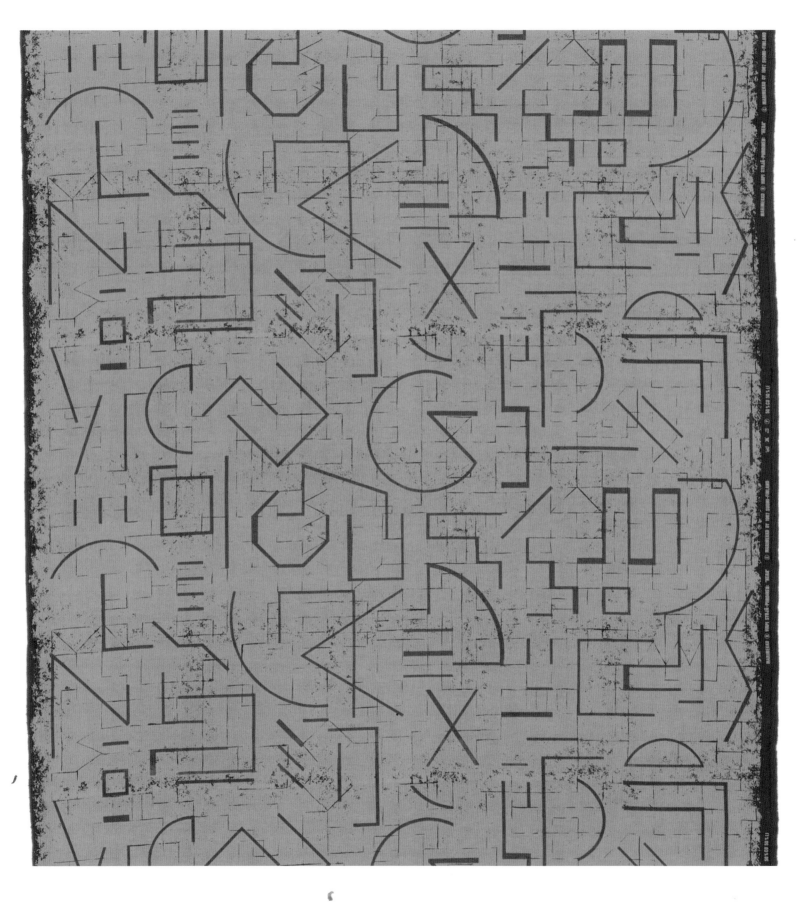

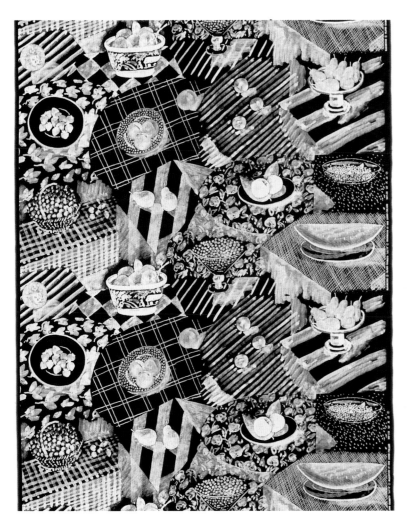

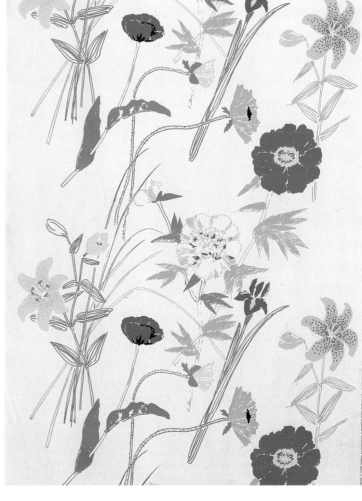

Fig. 7–143. Fujiwo Ishimoto.
*Aatto* pattern, 1988.
(Checklist no. 138).

◄ Fig. 7–142.
Virpi Syrjä-Piiroinen.
*Hera* pattern, 1987.
(Checklist no. 136).

Fig. 7–144. Fujiwo Ishimoto.
*Puutarhakutsut* pattern,
1989. (Checklist no. 139).

Fig. 7–145. Kristina Isola.
*Kohina* pattern, 1992.
(Checklist no. 142).

▶ Fig. 7–146. Fujiwo Ishimoto.
*Lepo* pattern, 1991.
(Checklist no. 140).

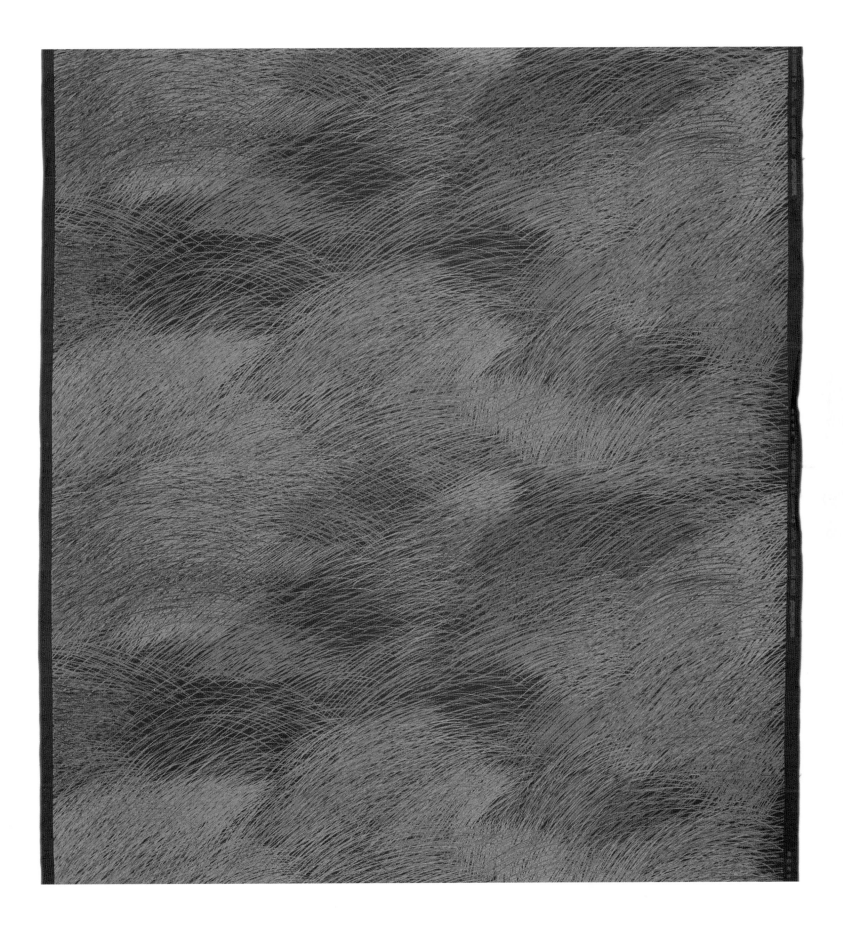

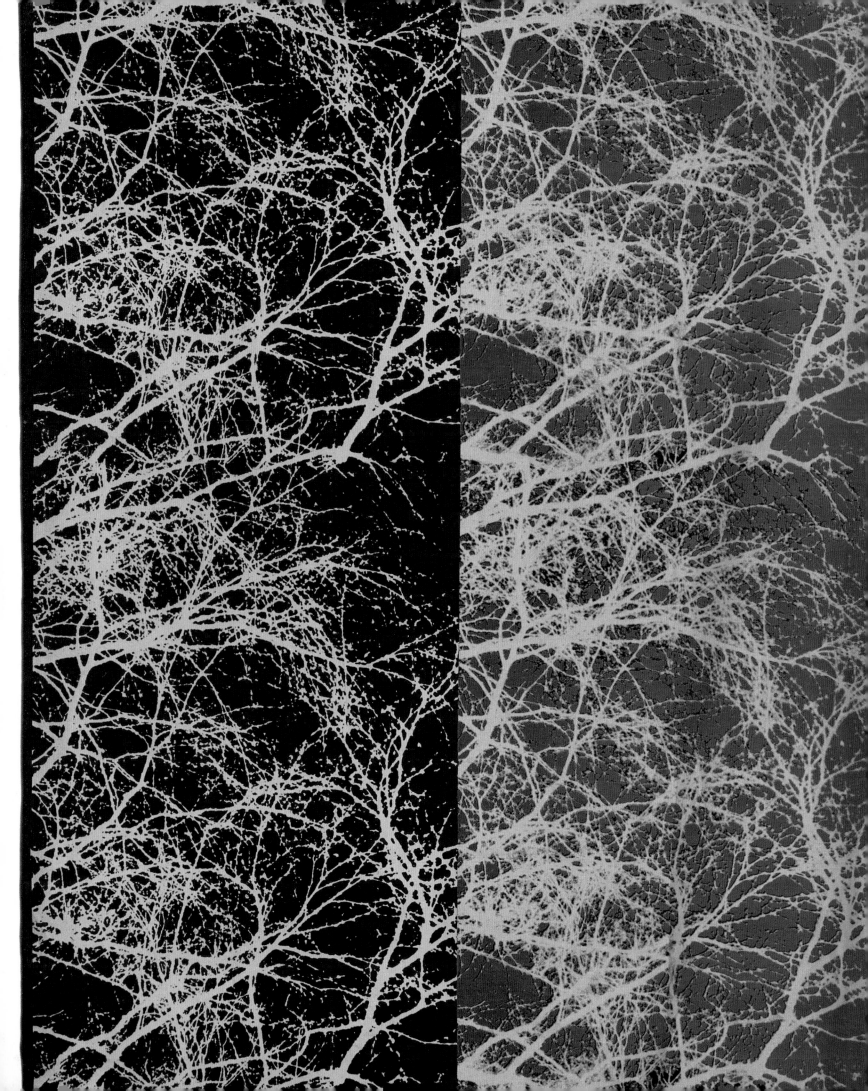

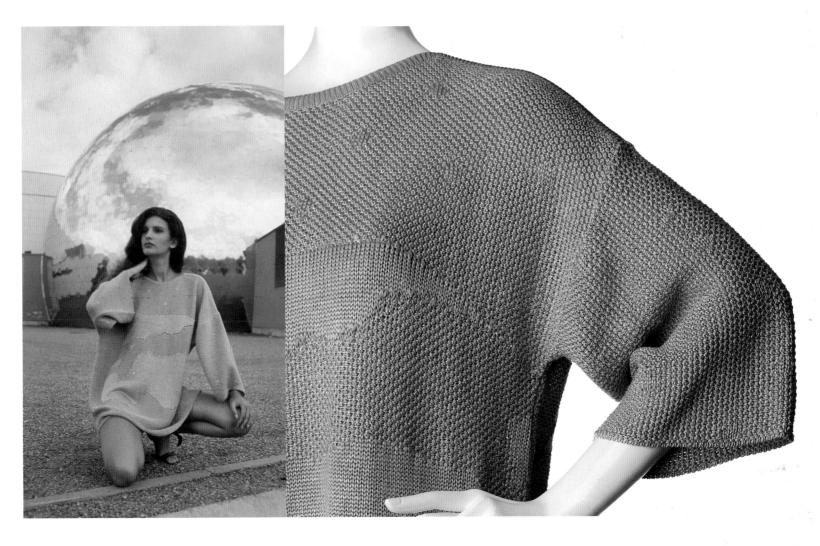

◄ Fig. 7–147. Fujiwo Ishimoto.
*Aamurusko* pattern, 1995.
(Checklist no. 146).

▲ Fig. 7–148. Marja Suna.
*Maapallo* dress, 1994.
Machine-knitted linen, viscose.
Marja Suna Collection.
(Checklist no. 143).

In addition to her multicolor, pattern knits in
the 1990s, Marja Suna designed monochrome
and luxury knits. In *Maapallo*, the pattern is
formed not with color, but with the weave.
*Maapallo* demonstrates Suna's interest in
three-dimensional surfaces.

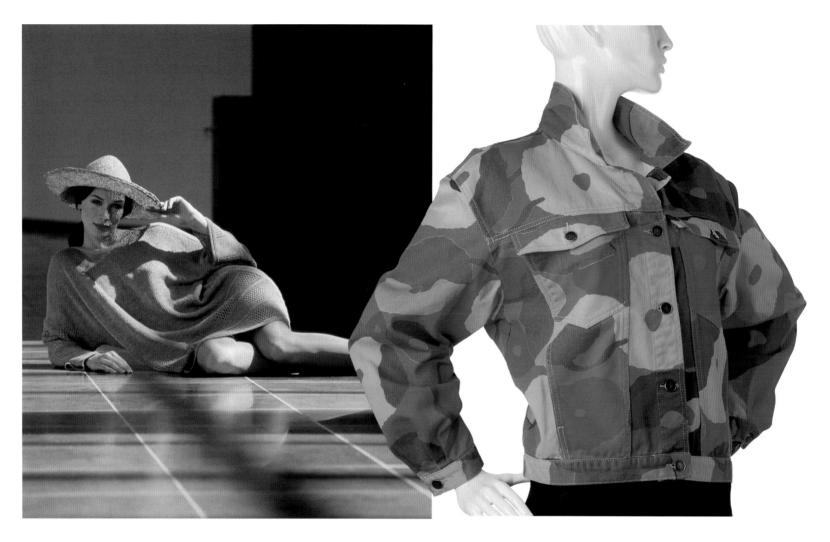

Fig. 7–149. Marja Suna.
*Paali* dress, 1994.
Machine-knitted linen.
Marja Suna Collection.
(Checklist no. 144).

Fig. 7–150. Marja Suna.
Jacket, 1990s. Cotton denim.
(Checklist no. 141).

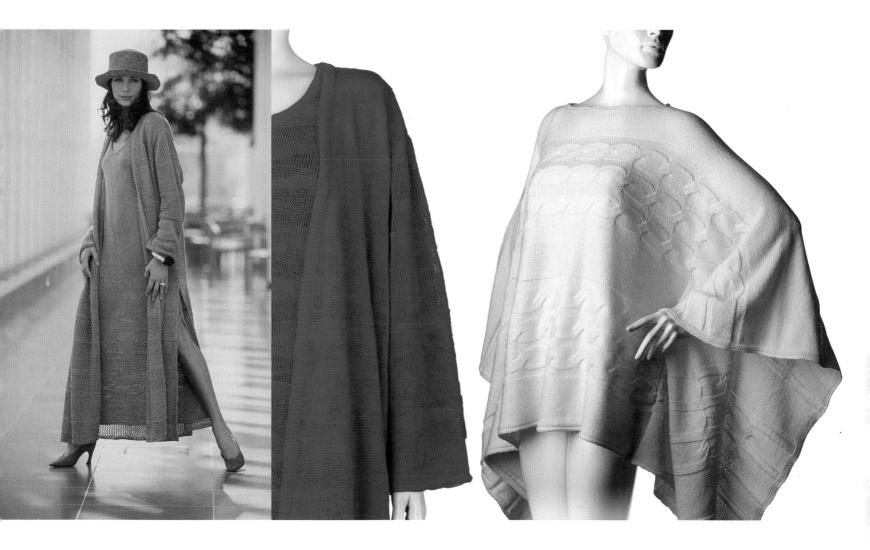

Fig. 7–151. Marja Suna. *Juuret*
dress and *Veräjä* coat, 1995.
Machine-knitted linen.
Marja Suna Collection.
(Checklist no. 145).

Fig. 7–152. Marja Suna.
Sweater, 2000.
Machine-knitted wool.
Marimekko. (Checklist no. 148).

Marja Suna has designed knitwear for
Marimekko since the 1980s. Her designs are
both simple — rectangular as in this case —
and inventive. The material is of high quality
and drapes beautifully on the wearer.

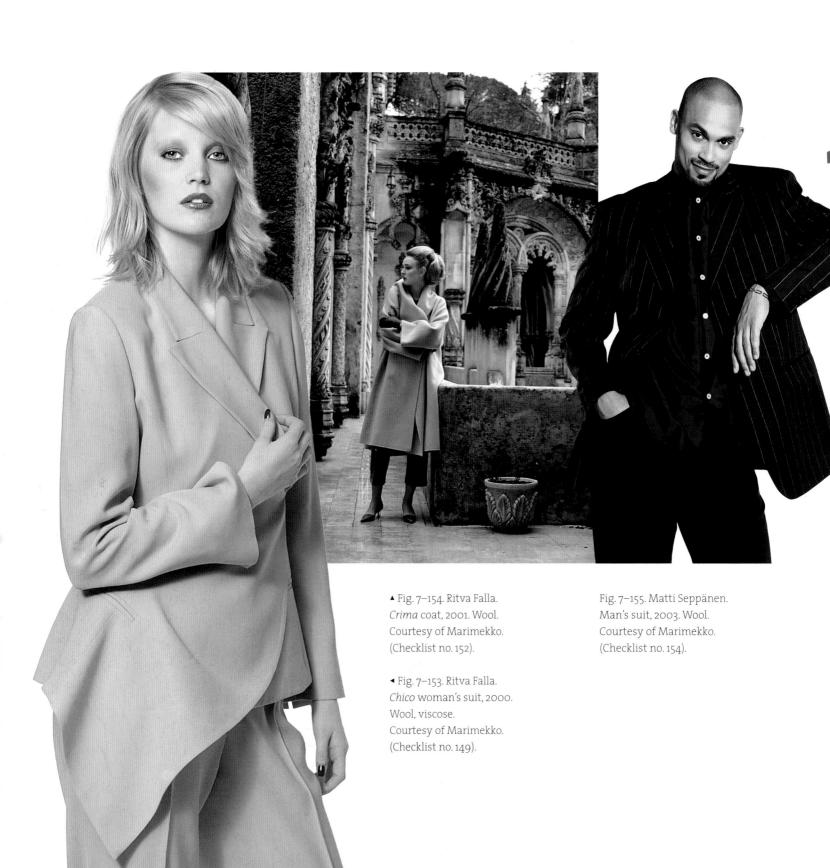

▲ Fig. 7–154. Ritva Falla.
*Crima* coat, 2001. Wool.
Courtesy of Marimekko.
(Checklist no. 152).

◄ Fig. 7–153. Ritva Falla.
*Chico* woman's suit, 2000.
Wool, viscose.
Courtesy of Marimekko.
(Checklist no. 149).

Fig. 7–155. Matti Seppänen.
Man's suit, 2003. Wool.
Courtesy of Marimekko.
(Checklist no. 154).

Fig. 7–156. Ritva Falla.
*Caisa* coat, 2001. Machine-woven
synthetic blend. *Zarah* blouse,
2001. Hand-knitted synthetic
blend. Courtesy of Marimekko.
(Checklist no. 151 a, b).

Fig. 7–157. Ritva Falla.
*Catel* coat and *Della* wraparound
skirt, 2000. Machine-woven wool,
alpaca, mohair, polyamide.
Courtesy of Marimekko.
(Checklist no. 150).

Marimekko's clothes have changed over
the decades. The core idea of Marimekko,
however, has stayed the same: to make
clothing for the independent, career
woman. Ritva Falla, Marja Suna, and Jukka
Rintala have taken this core philosophy
forward and given it a contemporary look.
High-quality materials and high produc-
tion standards are essential to the success
of the working woman's attire.

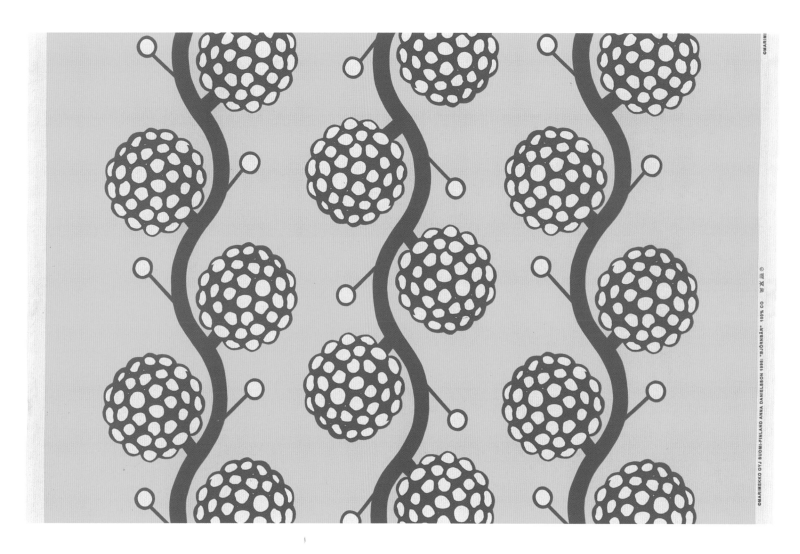

Fig. 7–158. Anna Danielsson.
*Björnbär* pattern, 1998.
(Checklist no. 147).

▸ Fig. 7–159. Anna Danielsson.
*Bottna* pattern, 2002.
(Checklist no. 153).

Anna Danielsson is a young Swedish textile
designer who has worked for Marimekko since
2001. *Björnbär* is representative of her vigorous
patterns. Its large, stylized plant theme in
bright colors is reminiscent of the patterns of
the 1960s, making it compatible with Mari-
mekko's retro production of today.

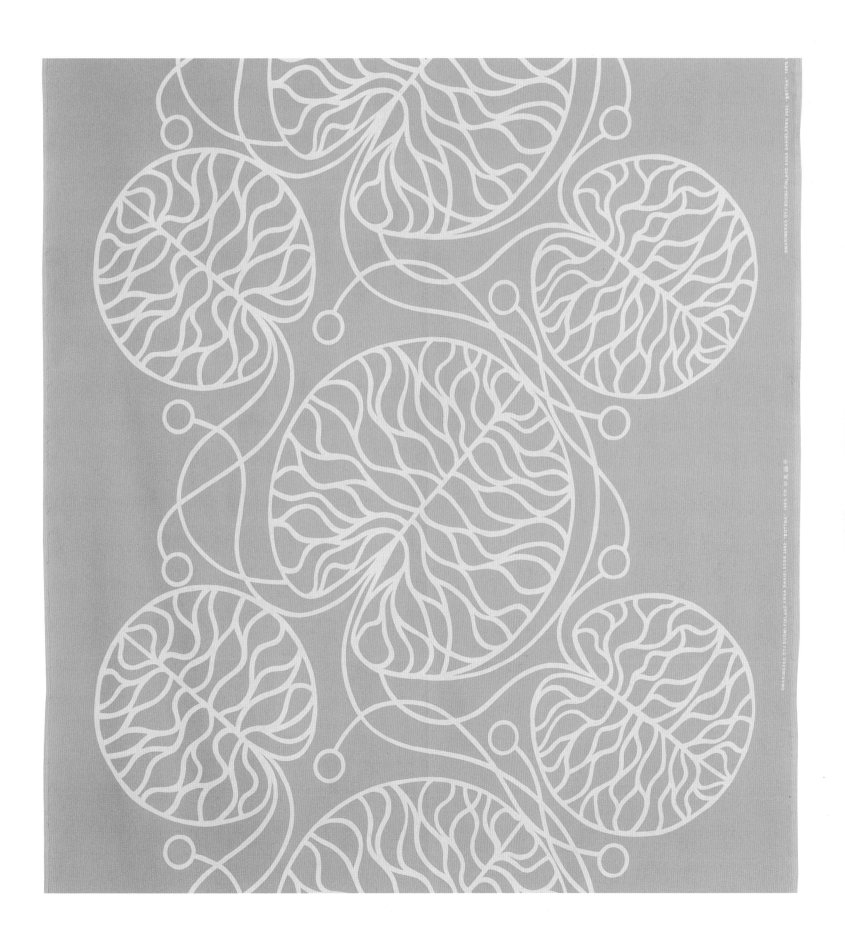

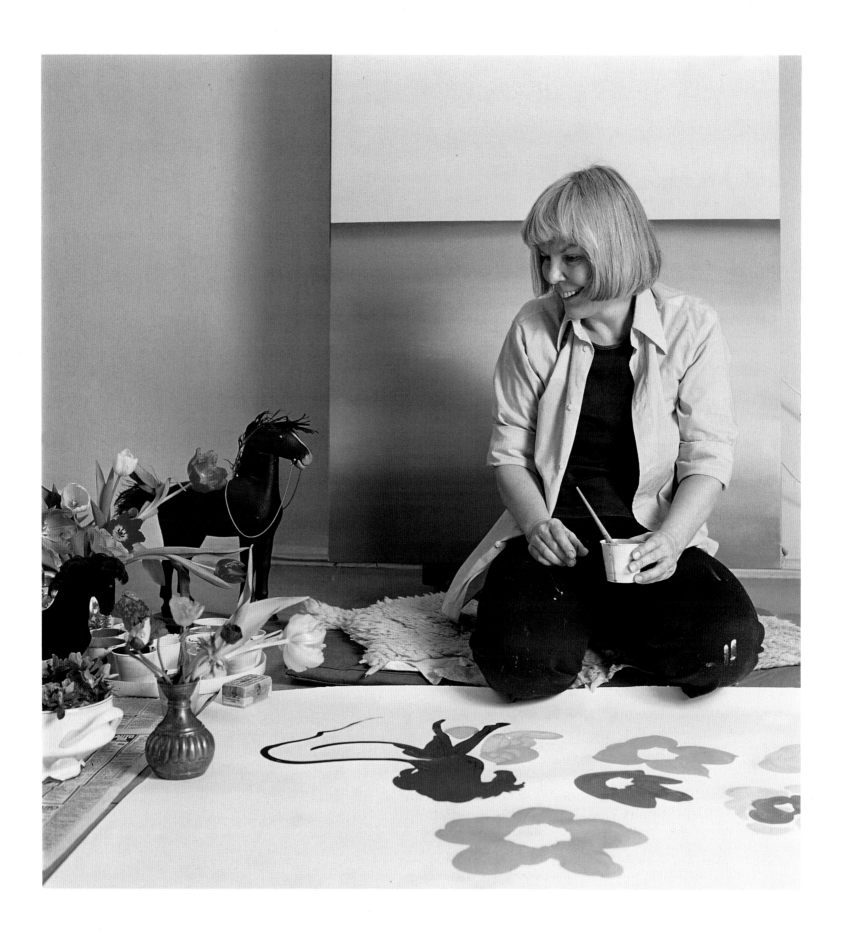

# Maija Isola (1927–2001)

In 1949 Maija Isola became the first full-time designer hired by Printex, the printed-fabric company that spawned Marimekko two years later. Isola had studied in the textile department of the Institute of Industrial Arts (Taideteollinen Oppilaitos) from 1946 to 1949, at a time when students concentrated on handweaving. In her final year she took part in a printed-fabric design competition, and it was through this event that Armi Ratia discovered her. Isola worked for Printex, and later Marimekko, until 1987.

The first complete series designed by Isola was known as the *Luonto* (nature) series, the first patterns of which appeared in 1957 and the last in 1959. The individual patterns were created through a photographic process whereby actual plants were projected onto a screen. From 1958 to 1960 Isola also designed some thirty patterns inspired by Eastern European textile art. These formed the *Ornamentti* (ornament) series. Isola next designed the *Joonas* (Jonah) series, 1961–62, which included various large-patterned fabrics with paintbrush-drawn landscapes, such as *Joonas* (Jonah), *Kiiltomato* (glowworm), *Kissapöllö* (tawny owl), *Västäräkki* (wagtail), *Koppelo* (capercaillie hen), *Käki* (cuckoo), *Nooa* (Noah), and *Silkkikuikka* (great crested grebe). Isola usually worked out her patterns at home, though the *Joonas* series originated at the Marimekko factory where Isola worked at a long printing table making sketches some 98 feet (30 m) in length, from which she cut the part she wanted to work up into a fabric.

In 1962 Isola created the *Barokki* (Baroque) series, which included *Fandango*, *Ananas* (pineapple), *Batseba*, *Reseda*, and *Rosmariini* (rosemary). From the mid-1960s onward, she began to simplify her patterns. *Kaivo* (well), *Melooni* (melon), *Pulloposti* (message-in-a-bottle), and *Pergola* represent Isola's more graphic patterns, which were based on large areas of flat color.

In addition to working as a textile designer, Isola was a painter in oils and tempera. Starting in the 1950s onwards she participated in numerous art exhibitions and had solo shows of her paintings in Helsinki (1956, 1959, 1967, 1979), and Boone (1978) and Charlotte, North Carolina (1977). Painting, in which she could realize her ideas freely, helped to balance and perhaps enhance the design work. In the 1950s her paintings were often abstract studies, while in her later work she mainly depicted nature.

Isola's many travels influenced both her textiles and paintings. In the early 1960s she visited Yugoslavia, Italy, and Greece, which inspired in 1965 a series of Cretan paintings, in which she studied nature and light. Isola was in Paris on a stipend in 1968 during the student demonstrations, an event that surfaced in her painting, *Révolution de Mai*. In the late 1960s she created large-scale flower, strawberry, and horse motifs.

Isola spent most of the 1970s abroad. From 1970 to 1974 she lived in Algeria, in a dilapidated villa near Oran. She also spent time in the United States, in Boone, North Carolina, and Madison, Wisconsin, and lectured in figurative art and fabric printing at Appalachian State University.

In the 1980s Isola let painting take second place while she concentrated on designing textiles with her daughter, Kristina, who had studied at the Free Art School (Vapaa taidekoulu) in Helsinki in 1966 and at the department of photography of the Institute of Industrial Arts from 1967 to 1971. Kristina has designed interior fabrics and other interior furnishing products for Marimekko since 1964. In the 1980s the collaboration between mother and daughter produced fresh floral fabrics, small-patterned ornaments, and abstract patterns, such as *Delta* and *Tutka* (radar).

After leaving Marimekko in 1987, Maija Isola returned to painting which she pursued until her death in 2001. A year earlier, Marimekko had reintroduced Isola's classic designs, and her patterns became a prominent feature of the Finnish street scene in 2000, especially her *Unikko* (poppy) fabric, which was used for Mika Piirainen's summer dresses.

Between 1949 and 1985 Isola took part in various exhibitions of industrial art both in Finland and abroad. She received honorable mention at the São Paulo Biennial in 1959 and was given the honorary award of the Finnish Cultural Fund in 1974 and the International Design Award in 1965 and again in 1968. Her last award was a gold medal for a collection of classically designed fabrics at the 2000 Ljubljana Fashion Biennial in Slovenia.

# Vuokko Nurmesniemi (b. 1930)

From 1948 to 1952 Vuokko Nurmesniemi (Eskolin-Nurmesniemi) studied ceramics at the Institute of Industrial Arts, Helsinki, and pattern drafting and sewing at the Helsinki Dressmaking Institute (Helsingin leikkuuopisto). She was also a student trainee at the Arabia Porcelain Factory from 1950 to 1953.

In 1953 Nurmesniemi was hired by Marimekko as a textile designer. Her first design was *Tiibet* (1953), a printed fabric for Printex. Because of the difficulties at the time in printing a pattern with such wide areas of color, Nurmesniemi's first initiative was to spur the development of new printing techniques to accommodate her work. *Tiibet* was followed by variations on the stripe motif, including *Indus* (1953), *Rötti* (1954), *Galleria* (1954), and *Ristipiccolo* (1953), in which she exploited superimposed colors through the printing process, a technique that became an essential element of Marimekko's signature fabric design. The special quality of Nurmesniemi's fabrics also derived from her powerful color combinations, free style, and simplified patterns.

In 1953 Nurmesniemi also began to design clothes for Marimekko, ultimately creating what came to be considered the Marimekko look. It was a long way from the tight-fitting fashions of the 1950s. Nurmesniemi's idea was to design clothes that were simple in line, could be worn by almost anyone, and would be suitable for industrial mass production. Because the garments had few darts and seams, Marimekko's extraordinary fabrics were emphasized. Her first designs were dresses — *Yleistakki* ( a smock for everyday) and *Kivijalkamekko* (foundation dress, both in 1957). In 1956 she designed the *Jokapoika* (everyboy) shirt using *Piccolo* fabric. Originally intended for men, it became not only a unisex fashion, but also a Marimekko classic. Nurmesniemi created other innovative items of clothing for Marimekko, such as women's dungarees and wraparound jackets.

In the late 1950s Nurmesniemi made her international breakthrough with a 1958 exhibition of Marimekko in the Stockholm Artek Gallery, for which she designed the installation. The following year, she contributed to the installation design for an exhibition of Finnish art and design at the Design Research shop in Cambridge, Massachusetts. The show, which included *ryijy* rugs and clothes by Nurmesniemi, was enthusiastically reviewed by the American press. Even more publicity was generated for Marimekko when Jacqueline Kennedy bought eight dresses by Nurmesniemi at Design Research.

Nurmesniemi designed her last collection for Marimekko in 1960. She left the firm to develop her own line and to lecture on industrial art both in Finland and abroad. Beginning in the early 1960s she also designed woolen fabrics and clothes for Villayhtymä. In 1964 she founded Vuokko Oy, where she continued to innovate. Nurmesniemi simplified the line she had started at Marimekko, beginning with the cut of the cloth. Her designs were meant to liberate, to allow the wearer to move freely. She removed any extraneous chest folds and intakes of the shoulder seams, with the result that hers were the first seamless clothes of the 1960s.

Her first collection at Vuokko Oy began with the *Pyörre* (whirl) pattern and was based on the idea of creating as many variations as possible from a single pattern. The designs incorporated such innovations as using velcro, zippers, or snaps instead of buttons. Nurmesniemi also used the fabric itself as economically as possible. After cutting the clothes, she used the remainder for such peripheral designs as pot holders and tea cozies.

Vuokko Oy also experimented with new forms and materials, such as thermal garments and paper clothes. Ecological issues became a factor after a 1968 oil tanker accident in the Gulf of Finland. Nurmesniemi rejected the use of acrylic and artificial fibers and encouraged environmentally friendly projects throughout the firm.

In the 1980s Nurmesniemi designed printed fabrics made from graphic photo-enlargements and the *Kirjeitä Chopinille* (letters to Chopin, 1984) series. She also designed her first one-of-a-kind garments, known as *Veistospuku* (sculpture-dress) series, 1984. Although Nurmesniemi had previously considered mass-produced clothing of prime importance, in the 1970s she began to view the design possibilities of unique garments and came to realize that such work preserved the important tradition of handcraft, which was then in danger of extinction.

Although in the 1970s and 1980s Vuokko Oy enjoyed considerable success, with products in hundreds of stores and more than twenty countries, in the late 1980s the firm went bankrupt. Vuokko Nurmesniemi bought back her name in the mid-1990s and has reopened her business on Esplanadi in the center of Helsinki.

In addition to her work in the fashion and textile industries, Nurmesniemi has designed: church textiles, *ryijy* rugs for the Friends of Finnish Handicraft, glassware for Nuutajärvi Glassworks (1956–57), textiles for Borås Weavers (from 1956 onward), and wallpaper for Sandudd Wallpaper Factory (beginning in 1957). Working in collaboration with her husband, interior designer Antti Nurmesniemi, she has exhibited, designed exhibition installations, and entered design competitions since the 1950s, winning many awards, including a Gold Medal in the Milan Triennial of 1957, Grand Prix at the Milan Triennial of 1964, and the Lunning Prize, 1964.

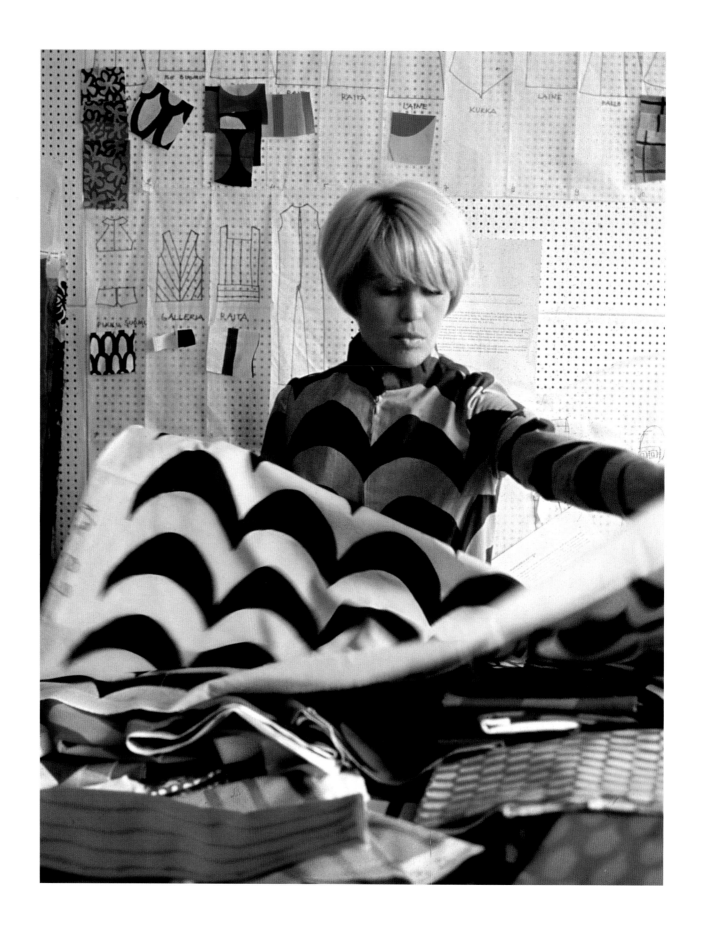

# Annika Rimala (b. 1936)

Annika Rimala (born Tegengren, married Reunanen, Piha, Rimala) studied graphic design at the Institute of Industrial Arts, Helsinki, from 1954 to 1956. Rimala's neighbor Eeva Kaarakka worked at Marimekko and encouraged Rimala to seek employment with the company, which she did in 1959. Her first job was at Muksula, Marimekko's children's clothing store on Eerinkatu, Helsinki. Just a year later, she became a designer in the factory, serving as Marimekko's chief fashion designer from 1960 to 1982.

According to Rimala herself, it was difficult at first to find her own direction, because Vuokko Nurmesniemi's influence was so strong, even after her departure in 1960. Rimala's first collection was presented in 1961, with fabrics designed by Oiva Toikka, who is known internationally as one of Finland's most accomplished glass artists. The clothes were a success, and in 1962 they gained international recognition when they appeared in *Look* and *Life* magazines. Rimala's first fabrics were small-patterned and "quiet," but as she grew more confident she increased the scale and chose stronger colors. The first collection was followed by a series of lively designs, whose colors and forms were inspired by the era's youth culture. Especially notable were the *Sirkus* (circus, 1963) apparel, made with *Petrooli* (petroleum, 1963) fabric, and *Monrepos* dress (1967), made with *Keidas* (oasis, 1967) fabric, as well as the humorous *Ryppypeppu* (smocked bottom, 1965) jumpsuit. The series also included more subdued designs, such as the *Titiko* dress (1968) and the *Kiiltokuva* (sticker) dress, made with *Puketti* (bouquet, 1964) fabric. Whether the patterns were free-form, checked, or striped, an essential feature of Rimala's clothes was variation in scale. For example, in *Keidas* she greatly enlarged her *Tarha* (garden, 1963) pattern. Her working method began by testing the practicality of a pattern in black and white. Color was added only when she was certain that the pattern and dress form were compatible. It was important that they form a structural whole.

In 1963 Rimala's designs were again the focus of media attention in the United States, when Design Research opened a store at 53 East 57th Street in New York. Rimala's cheerful, no-nonsense clothes also drew the attention of foreign magazines, and in the 1960s they could be found in the pages of *Vogue, Harper's Bazaar,* and *Elle.*

In the late 1960s Rimala began to take an increased interest in design for everyday life. The denim streetwear that had become common led her to conceive a product that would suit anyone, regardless of age, sex, or size, that would be timeless, and that could be worn anywhere and at any time. In addition, its price would be modest. The result, Rimala's *Tasaraita* (even stripe) cotton jersey, became one of Marimekko's most widely sold products. The collection was shown in 1969. It comprised T-shirts, nightshirts, and underwear. Variations of *Tasaraita* included the wide-striped *Silta* (bridge) and the narrow-striped *Viiriäinen* (quail). Rimala also designed printed cotton jersey clothes, such as the *Pallo* (ball) jersey and *Hedelmäkori* (fruit basket) shirt. After *Tasaraita,* Rimala next developed a series of unisex work clothes, with patterns that were more subdued than earlier.

Rimala retired from Marimekko in 1982. A year earlier she had founded the Santtu clothing company with her husband, Ilkka Rimala, and with graphic artist Teemu Lipasti. Santtu made clothes of printed fabric and wool and cotton knit. Rimala, who had suffered from multiple sclerosis for many years, could no longer draw, and instead her husband drew her patterns following her instructions. At Santtu, she continued to develop the design of simple, practical clothing that she had begun at Marimekko. Gray became Santtu's trademark color. Despite a promising beginning with a positive reception, Santtu went bankrupt in 1986, the victim of a Finnish recession. The brandname survived, however, when Nanso bought Santtu's licensing rights.

From 1969 to 1988 Rimala also designed jewelry for Kaunis Koru, and she and her husband collaborted on stage sets and costumes for Lilla Teatern in Helsinki. Examples of Rimala's fashion designs are in museum collections in Europe and the United States. She has received many awards for her work at Marimekko, including the State Industrial Art Award and the Pro Finlandia Prize in 1997.

In 2001 an exhibition was organized at the Design Museum, Finland, to celebrate the fortieth anniversary of Rimala's artistic career. That same year Marimekko returned *Tasaraita* to production, alongside other creations by Rimala, including the *Pallo* knits, and *Sirkus, Oktavia,* and *Monrepos* dresses.

# Liisa Suvanto (1910–1983)

Around 1960 Armi Ratia invited textile artist Liisa Suvanto to design the company's "woolen line." Suvanto came to Marimekko as an established textile designer with her own firm and more than twenty years of experience. She had graduated from the department of textile design at the Institute of Industrial Arts, Helsinki, in 1937, had founded a clothes-fabric design agency with Alli Koroma in 1937, and had worked as a designer for the textile designer Greta Skogster-Lehtinen after World War II. The Skogster-Lehtinen agency's clients included the paper company Enso Gutzeit Oy and Finnlines Oy, a shipping and sea transport firm with ferry boats, container ships, and liners.

In 1949 Suvanto had acquired her own textile workshop and design agency, in which she continued to design textiles for public spaces, from restaurants and commercial offices to ocean vessels. She also designed textiles for the Finnish president's official residence in Tamminiemi in 1956, for the presidential palace and summer residence in 1960, and for the Finnish Parliament in 1962. In her workshop she made textile wall-coverings and experimented with different materials, such as plant fibers (bast), nylon, sisal, and metal. She used some of these in design projects, such as the textiles for the president's residence which were made with metal thread — an innovation in Finland at the time. Art textiles were also designed in her studio, which she kept open until 1963 when she began to work full time at Marimekko.

Suvanto's first Marimekko collection was presented in 1960. It was a collaboration between Suvanto, Maggi Kaipiainen, and Inkeri Pylkkänen. The collection, which comprised woolens and garments made of flannel and natural silk, was well-received by the press, where it was seen as a continuation of Marimekko's simple and distinctive cotton line. The *Tanhun-punainen truutti* (red folk dance twist) dress was singled out for its distinctive cut and bold color. The core of the collection consisted of straight, knee-length dresses with three-quarter-length sleeves and round necklines. The fabrics had lively, textured surfaces and a controlled color palette. They were mainly in shades of gray, black, or brown, and occasionally in red and blue.

Suvanto's designs often began with the weave, which she built first into a fabric and then into clothes. The fabrics are relief-oriented in their surface structure, with colors ranging from light brown to combinations of neon-red and green. At Marimekko Suvanto developed an elegantly sculptural line, which was based on plain and simple cuts inspired by Balenciaga, the virtuoso minimalist of the fashion world. Suvanto's philosophy was that fashion should bring out the personality of the wearer. Indeed, she created an individual character for her clothes in various weaves, colorways, and details, such as distinctive collars or added trimmings on the hems. Her feeling for the materials and her experience as a textile designer is evident in

the multifaceted nature of her work. Although her assignment at Marimekko was the design of woven fabrics and garments, during her tenure she also created knitted, printed, pleated, and quilted fabrics from various materials, as well as rag rugs and blankets and printed cotton textiles, both for interiors and fashion. Suvanto worked at Marimekko until illness forced her to retire in 1975.

Suvanto was the recipient of several awards in competitions both in Finland and abroad. She contributed to numerous exhibitions of industrial art in Finland and elsewhere, including expositions in Brussels, Rio de Janeiro, and São Paulo. In 1978 she was awarded the Order of the Finnish Lion by the president of the Finnish republic.

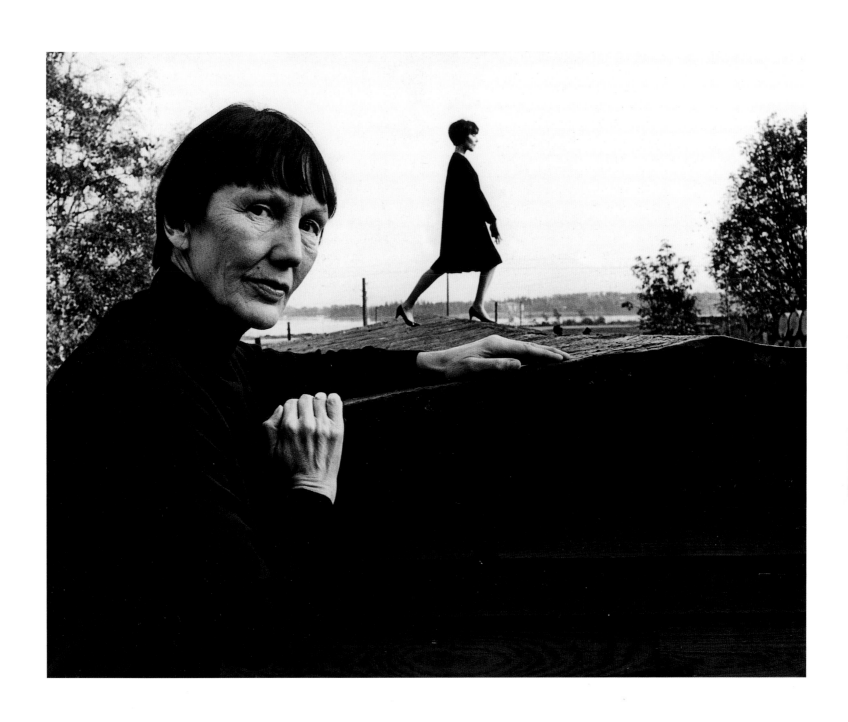

# Katsuji Wakisaka (b. 1944)

In 1968 Katsuji Wakisaka came to Marimekko from Japan, where he had trained at the Kyoto School of Art and Design. His portfolio included a distinctive animal-theme pattern that became the *Yume* fabric of his first Marimekko collection. These initial designs demonstrated the liberated, childlike design language for which he became known. It was especially appropriate for his later children's fabrics, such as *Oka* (1970), *Kalikka*, and *Bo-Boo* (1975). *Bo-Boo* became a favorite pattern for licensed production and was printed on sheets, quilted jackets, and bath towels.

Flower motifs are prominent in Wakisaka's work. The first of his flower fabrics was *Hana* (1968), and was followed by others including *Karuselli* (carousel, 1972), *Nekku* (candy, 1973), and *Kolibri* (1975) and its variant *Kiinanruusu* (rose of China, 1976). The subjects of Wakisaka's fabrics are often representational, as in *Kumiseva* (booming, 1971), which shows a typical Russian townscape with onion domes. In the early 1970s, however, he introduced a series of abstract patterns either based on variants of squares and circles or used to create three-dimensional effects.

In 1972–73 Wakisaka made quilted jackets, robes, and long dresses in collaboration with Liisa Suvanto. Wakisaka's fabrics, which combined variegated brown, sulphur-yellow, orange and purple, contrast with Suvanto's fashions, which are based on arcs and triangles. In addition to designing fabrics for Suvanto's clothes, he also created his own collection of clothes, in which there is sometimes a strong influence of Japanese culture, as in his kimono-like garments *Me-Te-Se* (we-you-it) and *Suma* of 1976. Their small, minimalist patterns and restrained colors distinguish them from his other work.

The originality of Wakisaka's fabrics lies in the exotic colors and unusual layout of the patterns. Wakisaka often designed his patterns vertically, placing patterned stripes at the edges of the fabric, like a border. His deep, brilliant colorways stand out from the color world of other 1970s Marimekko designers but suit Marimekko's Pop Art line. In their intensity, the pink, red, and green combinations of *Karuselli* fabric recall the colorways used by Vuokko Nurmesniemi in the 1950s. In his design work, Wakisaka always began by choosing a fabric, and only then designing the pattern that would be appropriate for that material. The final stage was the addition of the colors, which would ultimately define the nature of the design as a whole.

During his employment at Marimekko, Wakisaka also designed interior fabrics and designs for licensed manufacture in the United States. He left the company in 1976 to work for a design agency in New York.

# Pentti Rinta (b. 1946)

Pentti Rinta was the first of Marimekko's designers to have been trained as a fashion designer. He studied at the Institute of Industrial Arts in Helsinki from 1964 to 1969 and had been a student intern for a time at Marimekko before joining the firm after graduation.

Rinta was adept at designing for the new, casual, "everyday" style; his philosophy was that clothes should be comfortable to wear — being fashionable was secondary. Rinta was initially responsible for designing the summer collections, as well as some winter clothes. His practical style was mostly characterized by restrained colors and small patterns. He was especially interested in the possibilities offered by fabric printing and he experimented with color and printing in the factory's printing hall. He produced numerous stripe variations and stripe patterns.

In 1972 Rinta designed the *Kuskipuku* (coachman suit) for men, which became a Marimekko classic and was soon adopted by architects and fashionable professionals as their uniform. In the 1970s Rinta designed unisex dungaree-like trousers and windbreakers. Into the 1980s he also designed women's full-length evening dresses, which were bold and daring. In these "atmosphere" dresses, such as the *Liidokki* (glider, 1974) and the *Resonanssi* (resonance, 1981), he used large-scale, brightly colored printed patterns. The various folds and gathers at the cuffs and necklines lent variety to an otherwise rather simple dress design. Rinta also designed some interior fabrics.

The *Kivi näkee unta* fabric (stone-has-a-dream, 1977) and *Kohtaaminen* (meeting, 1980) patterns typify his method of reducing the theme to the limit of what is recognizable.

Rinta was awarded the State Industrial Art Award in 1983 for his work at Marimekko. He retired from the firm in the mid-1980s to concentrate on his own art work rather than designing fashion and fabrics.

# Ristomatti Ratia (b. 1941)

As the son of Armi and Viljo Ratia, Ristomatti was raised with Marimekko. He knew the designers, their products, and the business. After graduating from the Finnish Businessmen's Commercial College he pursued design studies in England, at Leicester Polytechnic, earning a degree as an interior designer in 1966. He has designed, among other products, textiles, furniture, glass, tableware, jewelry, bags, and sauna stoves. Until 1984 he was also responsible for arranging licensing agreements and production with companies in the United States.

In the late 1960s, in the aftermath of a corporate restructuring at Marimekko, small peripheral products — purses, potholders, and dishes — were dropped from the line so that the company could focus on fabrics and fashion. A spin-off company, Décembre Oy, was founded in 1970 by Armi Ratia, Ristomatti, and Eriika Ratia with the express purpose of continuing the design and marketing of these small products. They focused on designs that would enhance the human environment, be it home or office, for work or leisure activity. The company made a name for itself through its plastic products, with a spare design vocabulary and bright colors. Such items as plastic hand-held mirrors and trays designed by Ristomatti Ratia and Hilkka Rahikainen sold well in the United States and Britain, while Ratia's plastic coat hangers were the first of their kind in Finland. Most of the products — light fittings, tableware, toys, furniture, bags, and various small objects — were sold through Marimekko's retail outlets.

The canvas bags that Ristomatti Ratia designed became the cornerstone of Décembre's success and was later a Marimekko classic. The basic design was introduced in 1970, followed by *Matkuri* (traveler), a zippered version; *303*, a shoulderbag; *Arkkitehti* (architect); and *Maxi*, a satchel.

During his time with Décembre (1970–74), Ristomatti Ratia made his breakthrough as a designer with *Palaset* (set of pieces), a series of plastic interior design elements. They evolved from furnishings he had designed in 1969 for American architect Charles William Turnbull, as part of his Kresge College dormitory commission in Santa Cruz, California. *Palaset* reflects Ratia's underlying philosophy, that design should be used to create order in furnishings. The cubic elements could be assembled as needed, such as to create storage for books and phonograph records. Made by the Finnish furniture factory, Treston, *Palaset* quickly became popular with fashionable young consumers. Ristomatti received the Scandinavian Furniture of the Year award in 1973. After the oil crisis of the early 1980s, the elements were made of a less expensive material.

Ratia left Décembre in 1974 to become Marimekko's creative director. He began to develop product designs based on the lifestyle concept. Together with Annika Rimala, Gunilla Axén, Raymond Waites, and other designers, the *Peltomies* (tiller) collection, based on Rimala's *Riihipaita*, was introduced. *Peltomies* was Marimekko's widest product range to date. It included women's, men's and children's clothing, bags, and hats. Ratia and his colleagues developed a unified look for the packaging and advertising of *Peltomies* and also created an award-winning TV commercial for it.

Ristomatti Ratia bought the exclusive rights to Marimekko from Design Research, and in 1976 he established Marimekko Inc. in New York. The ready-made products came from Finland, but the New York design office, opened in 1978, specialized in production under license, with the idea of creating a Marimekko environment — unified, functional, timeless, colorful, and versatile — for the American market. The small team of designers produced about thirty collections a year. Among their first products were duvet covers, then practically unknown in the United States. They later included items such as towels, wallpaper, ceramic objects, and paper articles for the home.

Ristomatti Ratia, Raymond Waites, and Fujiwo Ishimoto collaborated on ideas for the *Mix-and-Match* sheet collection produced by Dan River. Later Ratia successfully developed a children's duvet cover based on Wakisaka's *Bo-Boo* pattern (1975). *Bo-Boo* expanded into an entire product family known as *Little People*, encompassing clothing, tableware, and paper products. Ratia and Waites supervised the advertising campaign. In the early 1980s he also designed the interiors of the Finnish ambassador's residence in Washington, D.C.

In 1985 Ratia and his siblings sold Marimekko to Amer Group, and Ristomatti became involved in various other projects, such as Ergonomia Design, the largest design firm in Scandinavia. In 1991 he opened a studio in Chicago for the design of furniture, glassware, ceramics, wooden household items, wallpapers, sheets, and bags, for such clients as Crate and Barrel.

After returning to Finland in the mid-1990s, Ratia founded Ratia Brand Company in Finland and Ratia Stuudio in Estonia. Since 1994 he has designed under his own brand for several companies, including Asko Huonekalu Oy, Kultakeskus, Saunatec, and Opa Oy, and he continues to create collections of bags and glassware for Marimekko.

# Fujiwo Ishimoto (b. 1941)

Fujiwo Ishimoto was born on the island of Shikoku in southern Japan and studied graphic design at Tokyo National University of Art from 1960 to 1964, focusing on textile design after the first year. After graduation he worked for six years as an advertising graphic artist at Ichida, a well-known Japanese kimono manufacturer. In 1970 he decided to change direction and to travel before settling down.

His interest in Finland, specifically in Marimekko, began when he was a student reading accounts of Finnish exhibitions at the Milan Triennials. He also saw Maija Isola's *Unikko* (poppy) and *Lokki* (seagull) patterns in Asko, a Finnish furniture store in Tokyo. He next encountered Marimekko fabrics in his travels, finding them displayed in Montreal, New York, and Copenhagen, and he decided to visit Finland. He met Katsuji Wakisaka, who was then working at Marimekko, and through him found a position at Décembre, Marimekko's newly founded spin-off firm that contentrated on the design of accessories and bags. There he worked on displays and design, transferring to Marimekko itself in 1974 as a designer of interior fabrics, where he continues today.

Ishimoto designs some fifteen patterns a year for Marimekko. More than three hundred of his patterns, in various colorways, have been put into production. Although he personally prefers black and white, he uses a wide range of colors. He usually begins the creative process with bright primary colors: red, blue, yellow. Movement is most important in his patterns. The "symbiosis of Japanese-ness

and Finnish-ness" is evident in his work, a connection he does not deny. He recognized the similarities between the Finnish and Japanese aesthetic, which share principles of clarity, purity, and simplicity.

The ideas behind Ishimoto's patterns or fabrics come from nature and the change of seasons. His first Marimekko patterns were the Japanese-inspired *Sumo* and *Jama*, both dating from 1977. The starting point for his *Mättäillä* (hummock) collection of 1979 was the Finnish marsh landscape, but subsequent collections are in complete contrast to the earthiness of *Mättäillä*. *Tuulentupa* (castle-in-the-air, 1981) and *Arkkitehti* (architect,1982) are strictly geometrical. The large *Karhu* (bear) collection of 1984 was especially challenging to print, with patterns suggesting woven batik fabrics. In *Maisema* (landscape, 1983) Ishimoto again drew from nature, studying changes in the quality of light in the Finnish landscape at different times of the year. His collection *Välähdys* (flash, 2001) conveys a twilight atmosphere and misty pattern that are reminiscent of Indonesian "tie-and-dye" design.

Another branch of the decorative arts with which Ishimoto feels an affinity is ceramics. His parents are farmers, but ceramics were a familiar part of his childhood. He grew up in a village with a strong ceramics tradition and thriving pottery studios. In 1989 when he received a grant from the Arabia Cultural Foundation, he spent a year as a visiting artist at the Arabia Porcelain Factory, making one-of-a-kind works and designing the

small-scale production of Arabia's Pro Arte series. Nature is again strongly present in the formal language of his ceramics as it is in his fabrics. In 1998, with Heikki Orvola, he designed the *Illusia* service, which expanded the field of his ceramics into large-scale industrial production. In 1980 he also designed stage sets and costumes for the Finnish National Opera's production of *Madame Butterfly*. Fujiwo Ishimoto's fabrics have been presented at important fashion shows both in Finland and abroad. Ishimoto received the Roscoe Award in 1983, the Finnish State Industrial Art Award in 1991, the Kaj Franck Design Award in 1994, as well as honorable mentions at Finnish design exhibitions in 1983 and 1993.

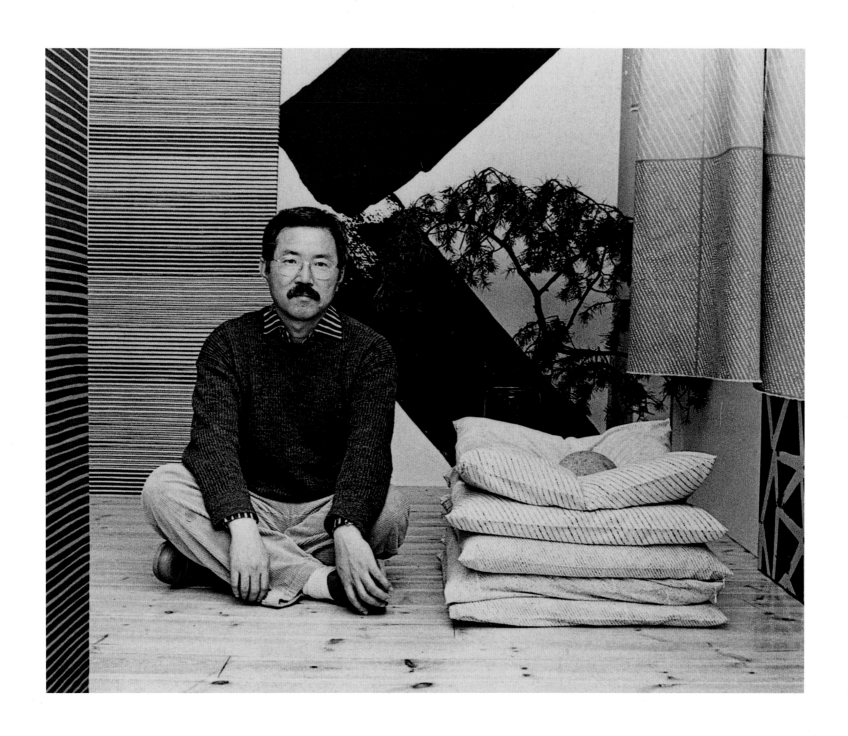

# Marja Suna (b. 1934)

Marja Suna came to Marimekko in 1979, shortly before Armi Ratia's death. She had already had a successful career. She studied fashion design at the Institute of Industrial Arts from 1951 to 1954 and had her first experience in the fashion industry as a trainee at Riitta Immonen's fashion salon in the 1950s. After graduation she worked for a few years as a curtain designer at TeMa Oy, an interior design store in Helsinki.

Suna was among the first trained fashion designers in the Finnish clothing industry. In 1958 she was hired by Herrala Oy to design synthetic-fiber, cotton, and woolen clothing. At the same time, she

created ensembles and jackets for Kestilä (1955–60) and in the 1960s, women's clothes for Muoti-Herrala. She also began to design shoes, such as quilted boots for the Roihu Shoe Factory, and she taught shoe design at the Institute of Industrial Art (1966–76). Her other work included jacket designs for Piironen Oy (1960s and 1970s) and Luhta Oy (late 1970s and 1980s).

In 1974 Suna was hired as head designer at Silo Oy, which until then had been primarily a manufacturer of underwear. The company's new owners wanted to expand their line to include women's clothes, and Suna, as the company's first designer, was given a free hand to create an integrated line for them. She became known especially for her knitwear designs.

Suna resigned from Silo to join Marimekko in 1979 and work on the firm's knitwear collection. Because Marimekko had always considered printed fabrics to be of primary importance, Suna had to make knitwear consistent with the "Marimekko" line. She solved this by selecting patterned knitting as the appropriate medium; in fact it is inherently related to printed fabric. The 1980s, during which she designed many patterned knits, became a golden age for knitwear, which became an important part of Marimekko's export market. Suna also designed cotton knits, jackets, and printed-fabric clothes.

Marimekko entered a new era when Kirsti Paakkanen assumed ownership of the company in the early 1990s. Paakkanen's charisma and her understanding of creative people made the 1990s a productive era for Marimekko designers. Suna, with Paakkanen's encouragement, worked on patterned and structured knits (the patterns of which are created through the surface structure), such as the *Maapallo* (globe) series and *Kiille* (mica) dresses.

Contemporary life and culture are important to her work, but she likes to

design classic clothes as well. The *Kiille*, a full-length dress based on rib knit, typifies her timeless design. The first versions were created in the late 1980s and subsequent designs were modified according to changing fashion, while still remaining true to the original.

In addition to multicolored, patterned knits Suna has also made monochrome knitwear, in which the pattern forms a strongly three-dimensional surface. Richly textured surface structure has always interested her. Relief or raised rib knits and cable stitches recur in her work in varying scale and are adapted to her clothes in different ways. She also combines different materials to achieve a varied surface effect, as in the *Maapallo* series, which is made with linen and viscose.

Suna's interest in surface structure is also evident in her paper artwork, which she has made since the 1980s, and in her commissioned evening dresses and custom-made jewelry of silver and glass. In these other endeavors, the wave-form, pleated paper works, and evening dresses made of silk cuttings and foldings parallel the structure of the knitwear. She has also designed jewelry on a freelance basis for Kaunis Koru since 1998.

Suna has exhibited in both solo and group exhibitions in Finland and abroad. In 1979 she received the State Industrial Art Award and in 1998 was chosen Fashion Artist of the Year by the Fashion Artists MTO, a branch of the Finnish Association of Designers, Ornamo.

# Ritva Falla (b. 1952)

Ritva Falla has had two tenures as a Marimekko designer. In 1990–91 she designed a series of printed fabrics, and in 1997 she was hired as a fashion designer, a role she continues to play. Falla's career in the fashion industry began soon after she graduated from the Institute of Industrial Arts in 1976. Within a year she had founded her own design studio, Design Ritva Falla, and was soon producing collections for Finnish clothing firms, beginning with Tiklas (1972–82), which was primarily an export firm at the time. Her other clients included Kestilä (1980–83), Finland's oldest manufacturer of ready-to-wear fashion, and Jil's Oy (1983–86), where she worked as head designer. The assignment at Jil's was challenging; she was responsible for a wide range of new items. In the early 1990s she designed fur-lined coats and leather garments for Grünstein and women's leisurewear for Luhta's export market. She also taught at the University of Art and Design.

From 1989 to 1990 Falla was head designer at Piretta PTA, Ltd., a design company that had earned a reputation for its coats in the 1960s. Initially working on the general line, Falla eventually focused on the corporation's Avenue collection of business wear, at least until Kirsti Paakkanen hired her for Marimekko in 1997. Falla has helped to make business wear an important part of Marimekko's production. She designs high-quality clothes for the career woman; some 30 percent of the production is sold in the export market. The collection, which carries her name, ranges from evening wear to sports clothes, from contemporary high fashion designs to timeless classics. She specifies the finest quality materials carefully selected to suit the cut of the clothes. As a fashion designer, she is interested in the construction of three-dimensional form and uses different combinations of materials and structural details as aesthetic elements.

Falla's work has been widely exhibited. She was awarded the Fashion Art Diploma of the Finnish Association of Decorative Artists, Ornamo, in 1987, the Pro Finnish Design Award for her work at Piretta PTA in 1990, and the Ruben Jaari Foundation Prize and Medal in 1995. In 1999 Falla received the Clothes Hanger Prize.

# Marimekko: Fabrics, Fashion, Architecture Checklist of the Exhibition

Unless otherwise noted, the objects in the exhibition are from the Design Museum, Finland. The museum's accession numbers are preceded by "DM" below.

### 1. *Amfora* pattern
Designed by Maija Isola, 1949
Screen-printed cotton
Length 114⅛ in. (290 cm),
width 58¼ in. (148 cm),
repeat 22½ in. (57 cm)
DM 27414
Fig. 7–1

### 2. *Musta lammas* (black sheep) pattern
Designed by Maija Isola, 1950
Screen-printed cotton
Length 47¼ in. (120 cm),
width 52 in. (132 cm),
repeat 15¾ in. (40 cm)
DM 27408
Fig. 7–4

### 3. Skirt; *Musta lammas* (black sheep) pattern
Designed by Maija Isola, 1950
Screen-printed cotton, plastic buttons
Length 24¾ in. (63 cm),
waist 27½ in. (70 cm)
DM 30007
Fig. 7–2

### 4. Skirt; *City* pattern
Designed by Maija Isola, 1950
Screen-printed cotton, plastic button
Length 26¾ in. (68 cm),
waist 23⅝ in. (60 cm)
DM 30005
Fig. 7–3

### 5. Blouse and skirt; *Caramba* pattern
Blouse and skirt designed by
Riitta Immonen, 1950;
pattern designed by Elis Muona, 1950
Screen-printed cotton

Blouse: length 21⅝ in. (55 cm),
bust 40⅛ in. (102 cm)
Skirt: length 26¾ in. (68 cm),
waist 25¼ in. (64 cm)
DM 30020
Fig. 3–3

### 6. *Tiiliskivi* (brick) pattern
Designed by Armi Ratia, 1952
Screen-printed cotton
Length 37 in. (94 cm),
width 53⅘ in. (136 cm),
repeat 9⅜ in. (24 cm)
DM 7033
Fig. 7–7

### 7. *Faruk* pattern
Designed by Armi Rattia, 1952
Screen-printed cotton
Length 38⅖ in. (97 cm),
width 53⅘ in. (136 cm),
repeat 5⅘ in. (14 cm)
DM 7044
Fig. 7–8

### 8. *Tiibet* (Tibet) pattern
Designed by Vuokko Nurmesniemi, 1953
Screen-printed cotton
Length 70 in. (175 cm),
width 50¼ in. (128 cm),
repeat 9⅝ in. (25 cm)
DM 7639
Fig. 7–9

### 9. Wraparound skirt; *Pohjanakka* (little old woman from the north) pattern
Designed by Vuokko Nurmesniemi, 1954
Screen-printed cotton
Length 29½ in. (75 cm),
waist 23⅝ in. (60 cm)
DM 30016
Fig. 7–10

### 10a–c. *Rötti* pattern
Designed by Vuokko Nurmesniemi, 1954
Screen-printed cotton
a) Length 452¾ in. (1150 cm),
width 56 in. (142 cm),
repeat 28½ in. (72 cm)
b) Length 39 in. (99 cm),

width 54 in. (137 cm),
repeat 27¾ in. (71 cm)
c) Length 55 in. (140 cm),
width 55⅝ in. (141 cm),
repeat 27¾ in. (71 cm)
a) DM 6640;
b, c) Susan Ward Collection, Boston
Fig. 7–11

### 11. *Alkupaita* (first shirt) dress; *Galleria* pattern
Designed by Vuokko Nurmesniemi, 1955 (dress); 1954 (pattern)
Screen-printed cotton
Length 35 in. (89 cm),
bust 38⅝ in. (98 cm)
DM 30058
Fig. 3–5

### 12. *Kivet* (stones) pattern
Designed by Maija Isola, 1956
Screen-printed cotton
Length 122 in. (310 cm),
width 54⅛ in. (138 cm),
repeat 13⅛ in. (33 cm)
DM 28879
Fig. 2–12

### 13. Blouse
Designed by Vuokko Nurmesniemi, 1956
Felted wool
Length 22⅞ in. (58 cm),
bust 48⅞ in. (124 cm)
DM 30019
Fig. 3–6

▶ Maija Isola.
*Kivet* pattern.

14. Dress; *Elämänlanka* (life's thread) pattern
Designed by Vuokko Nurmesniemi, 1956
Screen-printed cotton
Length 44⅞ in. (114 cm),
shoulders 15⅜ in. (39 cm),
bust 36¼ in. (92 cm)
DM 30072
Fig. 7–15

15. *Jokapoika* (everyboy) shirt; *Piccolo* and *Ristipiccolo* (cross-piccolo) patterns
Designed by Vuokko Nurmesniemi,
1956 (shirt); 1953 (*Piccolo, Ristipiccolo*)
Screen-printed cotton
Length 25 in. (64 cm),
chest 45½ in. (116 cm),
sleeve length 25 in. (64 cm);
various other sizes
DM 30092, 30371, 30372, 30375, 30376, 30378, 30379, 30380, 30381, 31366, 31367, 31368
Fig. 7–12

16. *Hepskukkuu* pattern
Designed by Vuokko Nurmesniemi, 1956
Screen-printed cotton
Length 189 in. (480 cm);
width 37½ in. (95 cm),
repeat 55 in. (140 cm)
DM 7563
Fig. 7–14

17. *Humiseva* (murmuring) pattern; from the *Luonto* (nature) series, 1957–59
Designed by Maija Isola, 1957
Screen-printed cotton
Length 31½ in. (80 cm),
width 53½ in. (136 cm),
repeat 28¾ in. (73 cm)
DM 7876

18. *Korpi* (wilderness) pattern; from the *Luonto* (nature) series, 1957–1959
Designed by Maija Isola, 1957
Screen-printed cotton
Length 45 in. (114 cm),
width 56½ in. (144 cm),
repeat 17½ in. (46 cm)
DM 29142
Fig. 7–21

19. *Saunakukka* (chamomile) pattern; from the *Luonto* (nature) series, 1957–59
Designed by Maija Isola, 1957
Screen-printed cotton
Length 31½ in. (80 cm),
width 53½ in. (136 cm),
repeat 15¾ in. (40 cm)
DM 7870
Fig. 7–20

20. *Putkinotko* (dell of wild chervil) pattern; from the *Luonto* (nature) series, 1957–59
Designed by Maija Isola, 1958
Screen-printed cotton
Length 189 in. (480 cm),
width 55½ in. (141 cm),
repeat 31 in. (79 cm)
DM 29153
Fig. 7–16

21. *Tuulenpesä* (witches' broom) pattern; from the *Luonto* (nature) series, 1957–59
Designed by Maija Isola, 1959
Screen-printed cotton
Length 24 in. (61 cm),
width 56 in. (142 cm),
repeat 22½ in. (52 cm)
DM 7873
Fig. 7–17

22. *Sananjalka* (fern) pattern; from the *Luonto* (nature) series, 1957–1959
Designed by Maija Isola, 1959
Screen-printed cotton
Length 53¼ in. (135 cm),
width 31¾ in. (79 cm),
repeat 18 in. (46 cm)
DM 7897
Fig. 7–19

23. *Mänty* (pine) pattern; from the *Luonto* (nature) series, 1957–1959
Designed by Maija Isola, 1959
Screen-printed cotton
Length 27⅜ in. (70 cm),
width 31 in. (79 cm),
repeat 22 in. (56 cm)
DM 29141
Fig. 7–18

24. *Ruusupuu* (rose tree) pattern
Designed by Maija Isola, 1957
Screen-printed cotton
Length 161 in. (409 cm),
width 52½ in. (133 cm),
repeat 25½ in. (65 cm)
DM 10687
Fig. 7–30

25. *Kivijalkamekko* (foundation dress) dress; *Piccolo* pattern
Designed by Vuokko Nurmesniemi,
1957 (dress); 1953 (pattern)
Screen-printed cotton
Length 45¼ in. (115 cm),
shoulders 14½ in. (37 cm),
bust 48⅞ in. (124 cm)
DM 30085
Fig. 7–22

26. *Kaappikello* (tall case clock) pattern
Designed by Vuokko Nurmesniemi, 1958
Screen-printed cotton
Length 51⅛ in. (130 cm),
width 27½ in. (70 cm),
repeat 24½ in. (62 cm)
DM 6627
Fig. 7–5

27. Dress; *Prenikka* (decoration) pattern
Designed by Vuokko Nurmesniemi, 1958
Screen-printed cotton
Length 42½ in. (108 cm),
bust 48⅞ in. (124 cm)
DM 30035
Fig. 7–23

28. *Lintu sininen* (bird blue) dress; *Suolampi* (bog pond) pattern
Designed by Vuokko Nurmesniemi, 1959
Screen-printed cotton
Length 42⅛ in. (107 cm),
bust 42⅛ in. (107 cm)
DM 30053
Fig. 3–9

29. *Tervakukka* (tar flower) dress;
*Suolampi* (bog pond) pattern
Designed by Vuokko Nurmesniemi, 1959
Screen-printed cotton
Length 34 in. (86.4 cm),
shoulders 14½ in. (37 cm),
bust 37 in. (94 cm)
DM 30032
Fig. 3–7

30. *Kylätie* (village lane) dress;
*Kuurupiilo* (hide and seek) pattern
Designed by Vuokko Nurmesniemi,
1959 (dress); 1958 (pattern)
Screen-printed cotton, metal buttons
Length 35 in. (89 cm),
shoulders 14½ in. (37 cm),
bust 36¼ in. (92 cm)
DM 30002
Fig. 7–25

31. *Krookus* (crocus) dress; *Piccolo* pattern
Designed by Vuokko Nurmesniemi,
1959 (dress); 1953 (pattern)
Screen-printed cotton; elasticized waist
Blouse: length 42⅛ in. (107 cm),
shoulders 15 in. (38 cm),
bust 38⅝ in. (98 cm)
Skirt: length 27½ in. (70 cm),
waist 34 in. (86 cm)
DM 30087
Fig. 7–24

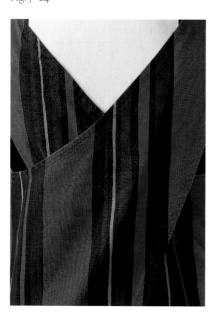

▶ Vuokko Nurmesniemi. *Ritsa* apron in *Raituli* pattern.

32. *Ritsa* (slingshot) apron;
*Raituli* (stripy) pattern
Designed by Vuokko Nurmesniemi, 1959
Screen-printed cotton, metal buttons
Length 35⅜ in. (90 cm),
bust 35⅜ in. (90 cm)
DM 30065
Fig. 7–29

33. *Leikki* (play) dress;
*Pirput parput* (tiny trifles) pattern
Designed by Vuokko Nurmesniemi,
1959 (dress); 1957 (pattern)
Screen-printed cotton
Length 30 in. (76 cm),
width at hem 27 in. (69 in.)
DM 33870
Fig. 3–15

34. Dress; *Nasti* pattern
Designed by Vuokko Nurmesniemi,
1959 (dress); 1958 (pattern)
Screen-printed cotton
Length 40 in. (102 cm),
width at hem 39¼ in. (100 cm)
DM 33871
Fig. 3–14

35. *Garçon-tytön pyjama* (tomboy's pajamas); *Varvunraita* (twig stripe) pattern
Pajamas designed by Liisa Suvanto, 1960;
pattern designed by Vuokko
Nurmesniemi, 1959
Screen-printed cotton, plastic buttons;
elasticized waist
Top: length 26⅜ in. (67 cm),
shoulders 16½ in. (42 cm),
bust 44⅞ in. (114 cm)
Pants: length 39 in. (99 cm),
waist 33 in. (84 cm)
DM 30093
Fig. 7–32

36. *Pidot* (feast) pattern
Designed by Maija Isola, 1960
Screen-printed cotton
Length 97 in. (246 cm),
width 56 in. (142 cm),
repeat 29 in. (74 cm)
DM 27426; Fig. 7–33

37. *Tamara* pattern
Designed by Maija Isola, 1960
Screen-printed cotton
Length 311 in. (790 cm),
width 54 in. (137 cm),
repeat 28 in. (71 cm)
DM 7437
Fig. 2–13

38. *Tantsu* (country dance) pattern
Designed by Maija Isola, 1960
Screen-printed cotton
Length 31 in. (79 cm),
width 55 in. (140 cm),
repeat 27½ in. (70 cm)
DM 7417
Fig. 7–34

39. *Kihlatasku* (betrothal pocket) dress;
*Pirput parput* (tiny trifles) pattern
Designed by Vuokko Nurmesniemi,
1960 (dress); 1957 (pattern)
Length 36 in. (92 cm),
shoulders 19⅞ in. (51 cm),
bust 56¾ in. (144 cm)
Screen-printed cotton, metal buttons
DM 30042
Fig. 7–26

40. *Iloinen takki* (joyous smock) dress;
*Nadja* pattern
Designed by Vuokko Nurmesniemi,
1960 (dress); 1959 (pattern)
Screen-printed cotton, metal buttons
Length 38¼ in. (97 cm),
shoulders 20⅞ in. (53 cm),
bust 52⅜ in. (133 cm)
DM 30106
Fig. 7–27

41. Cape; *Piccolo, Pirput parput*
(tiny trifles), and *Varvunraita*
(twig stripe) patterns
Designed by Vuokko Nurmesniemi,
1960 (cape), 1953 (*Piccolo*), 1957
(*Pirput parput*), 1959 (*Varvunraita*)
Screen-printed cotton
Length 61¾ in. (157 cm),
width at hem 118 in. (300 cm)
DM 30111; Fig. 7–28

**42.** *Joonas* (Jonah) pattern
Designed by Maija Isola, 1961
Screen-printed cotton
Length 295½ in. (750 cm),
width 55¾ in. (142 cm),
repeat 46 in. (117 cm)
DM 7143
Fig. 7–35

**43.** *Lokki* (seagull) pattern
Designed by Maija Isola, 1961
Screen-printed cotton
Length 393⅝ in. (1000 cm),
width 54¼ in. (138 cm),
repeat 21¼ in. (54 cm)
DM 28836
Fig. 7–36

**44.** *Kesäheila* (summertime sweetheart)
dress; *Hilla* (cloudberry) pattern
Designed by Annika Rimala, 1961
Screen-printed cotton, metal buttons,
zipper
Length 38⅝ in. (98 cm),
shoulders 15 in. (38 cm),
bust 35½ in. (90 cm)
DM 30123
Fig. 7–31

**45a.** *Silkkikuikka* (great crested grebe)
pattern
Designed by Maija Isola, 1961
Screen-printed cotton
Length 196⅞ in. (500 cm),
width 58 in. (147 cm),
repeat 100½ in. (255 cm)
DM 7370
Fig. 2–1

**45b.** Sketch for *Silkkikuikka*
(great crested grebe) pattern
Maija Isola, 1961
Ink on paper
Length. 69⅛ in. (175.5 cm),
width 53½ in. (136 cm)
DM 9000 P

**46.** *Kukko* (rooster) dress
Designed by Liisa Suvanto, 1961
Handwoven wool, fabric-covered buttons,

metal snap fastener
Length 39⅜ in. (100 cm),
shoulders 15⅜ in. (39 cm)
DM 30426
Fig. 7–39

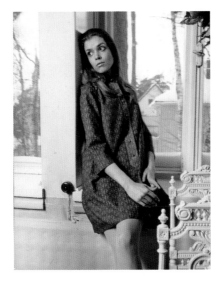

**47.** *Filippopovna* dress;
*Kuukuna* (goomba) pattern
Dress designed by Annika Rimala, 1961;
pattern designed by Oiva Toikka, 1961
Screen-printed cotton, metal buttons
Length 37 in. (94 cm),
shoulders 15 in. (38 cm),
bust 39½ in. (100 cm)
Finlandia University, Hancock, Michigan,
Susan Peterson Coll. No. 6
Fig. 3–16

**48.** *Sudensuitset* (wolf bridle) dress
Designed by Liisa Suvanto, 1962
Handwoven wool, zipper
Length 41⅜ in. (105 cm),
bust 41¾ in. (106 cm)
DM 30425
Fig. 7–38

**49.** *Fandango* pattern
Designed by Maija Isola, 1962
Screen-printed cotton
Length 94 in. (239 cm),
width 55¼ in. (140 cm),
repeat 20⅞ in. (53 cm)
DM 7476
Fig. 7–44

**50.** *Sokkeli* (basement) dress;
*Luukku* (shutter) pattern
Designed by Annika Rimala, 1963
Screen-printed cotton
Length 38⅝ in. (98 cm),
shoulders 15 in. (38 cm),
bust 38¼ in. (97 cm)
Belt: 54½ in. (138 cm) x 1 in. (2.5 cm)
DM 30869
Fig. 7–43

**51.** *Ludmila* dress; *Helmipitsi* (pearl lace)
and *Varvunraita* (twig stripe) patterns
Dress designed by Annika Rimala, 1963;
patterns designed by Vuokko Nurmesnie-
mi, 1959 (*Varvunraita*), 1959 (*Helmipitsi*)
Screen-printed cotton, metal buttons
Length 39 in. (99 cm),
shoulders 14⅝ in. (37 cm),
bust 36¼ in. (92 cm)
DM 30154
Fig. 3–18

**52a–c.** *Sirkus* (circus) dress;
*Petrooli* (petroleum) pattern
Designed by Annika Rimala, 1963
Screen-printed cotton, plastic buttons
a) Length 33½ in. (85 cm),
shoulders 19⅝ in. (50 cm),
bust 44⅛ in. (112 cm)
b) Length 35⅞ in. (91 cm),
shoulders 19¼ in. (49 cm),
bust 47¼ in. (120 cm)
c) Length 43¼ in. (110 cm),
shoulders 18⅛ in. (46 cm),
bust 44⅛ in. (112 cm)
a) DM 30175; b) DM 30177;
c) Finlandia University, Hancock, Michigan,
Susan Peterson Coll. No. 2
Fig. 7–45

**53.** *Barokkipaita* (baroque shirt) dress;
*Samettiruusu* (velvet rose) pattern
Designed by Annika Rimala, 1963 (dress);
1962 (pattern)
Screen-printed cotton
Length 37 in. (94 cm),
bust 43¼ in. (110 cm)
DM 30178
Fig. 7–42

◄ Annika Rimala.
*Filippopovna* dress;
*Kuukuna* pattern by
Oiva Toikka.

**54.** *Sepeli* (gravel) dress
Designed by Liisa Suvanto, 1963
Handwoven wool, zipper
Length 39 in. (99 cm),
shoulders 15⅜ in. (39 cm),
bust 36 in. (91 cm)
DM 30433
Fig. 7–40

◄ Maija Isola.
*Kaivo* pattern.

**55.** *Melooni II* (melon II) pattern
Designed by Maija Isola, 1963
Screen-printed cotton
Length 149⅝ in. (380 cm),
width 56¾ in. (144 cm),
repeat 38¼ in. (97 cm)
DM 6689
Fig. 7–48

**56a.** Pillowcase; *Vihkiruusu*
(wedding rose) pattern
Pattern designed by Maija Isola, 1964
Screen-printed cotton
Length 29¾ in. (76 cm),
width 14⅞ in. (38 cm),
repeat 4 in. (10 cm)
DM 7384
Fig. 7–47

**56b.** *Maalaisruusu* (country rose) pattern
Designed by Maija Isola, 1964
Screen-printed cotton
Length 95 in. (241 cm),
width 53 in. (135 cm),
repeat 15¼ in. (39 cm)
DM 7888
Fig. 7–46

**57.** *Kaarimekko* (arch dress) dress
Designed by Liisa Suvanto, 1964
Handwoven wool, fabric-covered buttons
Length 38⅝ in. (98 cm),
shoulders 16½ in. (42 cm),
bust 39⅜ in. (100 cm)
DM 30443
Fig. 7–41

**58.** *Tamma* (mare) dress;
*Hedelmäkori* (fruit basket) pattern
Designed by Annika Rimala, 1964 (dress);
early 1960s (pattern)

Screen-printed cotton, plastic button
Length 38⅝ in. (98 cm),
shoulders 20⅛ in. (51 cm),
bust 50⅜ in. (128 cm)
DM 30141
Fig. 7–49

**59.** *Lupiini* (lupin) dress;
*Tarha* (garden) pattern
Designed by Annika Rimala, 1964 (dress);
1963 (pattern)
Screen-printed cotton
Length 36⅝ in. (93 cm),
shoulders 12⅝ in. (32 cm),
bust 36¼ in. (92 cm)
DM 30148
Fig. 7–50

**60.** Dress; *Puketti* (bouquet) pattern
Designed by Annika Rimala, 1964
Screen-printed cotton
Length 34¼ in. (87 cm),
shoulders 14½ in. (37 cm)
Belt: 51¾ in. (132 cm) x 1 in. (2.5 cm)
Susan Ward Collection, Boston
Fig. 7–51

**61.** *Seireeni* (siren) pattern
Designed by Maija Isola, 1964
Screen-printed cotton
Length 96 in. (244 cm),
width 55½ in. (141 cm),
repeat 61 in. (155 cm)
Susan Ward Collection, Boston
Fig. 7–53

**62a–d.** *Kaivo* (well) pattern
Designed by Maija Isola, 1964
Screen-printed cotton
a) Length 98 in. (249 cm), width 54 in.
(137 cm), repeat 34 in. (86 cm)
b) Length 53 in. (147 cm), width 54 in.
(137 cm), repeat 34 in. (86 cm)
c) Length 84 in. (213 cm), width 54¼ in.
(138 cm), repeat 33¾ in. (86 cm)
d) Length 85¼ in. (217 cm), width 51⅜ in.
(131 cm), repeat 33½ in. (85 cm)
a) DM 8681; b) DM 28798;
c,d) Susan Ward Collection, Boston
Fig. 7–54

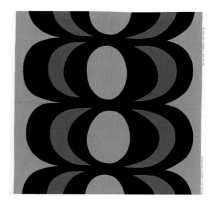

**63.** *Unikko* (poppy) pattern
Designed by Maija Isola, 1964
Screen-printed cotton
Length 157½ in. (400 cm),
width 58¼ in. (148 cm),
repeat 40½ in. (103 cm)
DM 6693
Figs. 3–40, 5–1, 7–55

**64.** *Tiira* (tern) dress; *Laine* (wave) pattern
Designed by Annika Rimala, 1965
Screen-printed cotton, zipper
Length 37⅜ in. (95 cm),
bust 33⅞ in. (86 cm)
Belt: 52 in. (132 cm) x 1¼ in. (3.2 cm)
DM 30116
Fig. 7–57

**65.** *Tiira* (tern) dress;
*Iso laine* (great wave) pattern
Designed by Annika Rimala, 1965
Screen-printed cotton,
metal snap fasteners
Length 33⅛ in. (84 cm),
bust 34⅝ in. (88 cm)
DM 30113
Fig. 7–56

**66.** *Maininki* (roller) dress;
*Laine* (wave) pattern
Designed by Annika Rimala, 1965
Screen-printed cotton;
shirred and elasticized top
Length 34⅝ in. (88 cm),
shoulders 9⅞ in. (25 cm),
variable bust 32–38 in. (81–97 cm)
DM 30117
Fig. 7–58

67. *Ryppypeppu* (smocked bottom) jumpsuit; *Iso suomu* (big scale) pattern
Designed by Annika Rimala, 1965
Screen-printed cotton, zipper; shirred and elasticized at elbow, seat, and knee
Length 55½ in. (141 cm),
shoulders 15 in. (38 cm),
bust 35 in. (89 cm)
DM 30078
Figs. 3–19, 7–89

68. *Saniainen* (fern) dress;
*Pilvi* (cloud) pattern
Designed by Annika Rimala, 1966
Screen-printed cotton,
metal snap fasteners
Length 37 in. (94 cm),
shoulders 14⅛ in. (36 cm),
bust 36¼ in. (92 cm)
DM 30122
Fig. 7–62

69. *Idän pikajuna* (Orient Express) coat and trouser ensemble
Designed by Liisa Suvanto, 1966
Thai silk, metal buttons, zipper
Coat: length 53⅛ in. (135 cm),
width at hem 50 in. (127 cm)
Trousers: length 38⅝ in. (98 cm),
waist 38 in. (96.5 cm)
DM 30408, 30435
Fig. 7–61

70. *Nunatakki* (Nuna-coat) dress
Designed by Liisa Suvanto, 1966
Wool felt, zipper
Length 33⅞ in. (86 cm),
shoulders 15 in. (38 cm),
bust 36 in. (91.4 cm)
DM 30444
Fig. 7–64

71. *Istuva härkä* (Sitting Bull) pattern
Designed by Maija Isola, 1966
Screen-printed cotton
Length 86½ in. (220 cm),
width 51½ in. (131 cm),
repeat 29 in. (74 cm)
DM 6680
Fig. 7–52

72. *Husaari* (hussar) pattern
Designed by Maija Isola, 1966
Screen-printed cotton
Length 216½ in. (550 cm),
width 54 in. (137 cm),
repeat 30¼ in. (77 cm)
DM 7453
Fig. 7–59

73. *Keisarinkruunu* (crown imperial) pattern
Designed by Maija Isola, 1966
Screen-printed cotton
Length 452¾ in. (1150 cm),
width 54¾ in. (139 cm),
repeat 57½ in. (146 cm)
DM 7123
Fig. 7–60

74. *Piilo* (hide) dress; *Linssi* (lens) pattern
Dress designed by Annika Rimala, 1966;
pattern designed by Kaarina Kellomäki, 1966
Screen-printed cotton
Length 35 in. (89 cm),
shoulders 11 in. (28 cm),
bust 33⅛ in. (84 cm)
DM 30191
Fig. 7–65

75. T-shirts and underwear; *Tasaraita* (even stripe) collection
Designed by Annika Rimala, 1967–68
Cotton, polyester jersey
Produced by Suomen Trikoo
(Tampere, Finland)
Tops: length 50¼ in. (127.5 cm),
shoulders 15 in. (38 cm);
length 32¼ in. (82 cm),
shoulders 16½ in. (42 cm);
length 29⅛ in. (74 cm),
shoulders 9⅞ in. (25 cm);
length 26 in. (66 cm),
shoulders 14⅝ in. (37 cm);
length 24¾ in. (63 cm),
shoulders 14¾ in. (37.7 cm);
length 26⅝ in. (67.5 cm),
shoulders 13 in. (33 cm)
Bottoms: length 14⅜ in. (36.5 cm),
waist 29⅞ in. (76 cm);
length 43¼ in. (110 cm),
waist 22 in. (56 cm);

length 8¼ in. (21 cm),
waist 22 in. (56 cm)
DM 1233, 1260, 3366, 3369, 13370, 30280,
1311, 1312, 1317
Figs. 3–23, 3–37, 6–7, 7–66

76. *Passi* (passport) dress;
*Klaava* (toss) pattern
Designed by Annika Rimala, 1967
Screen-printed cotton velour
Length 33⅛ in. (84 cm),
bust 33⅛ in. (84 cm)
DM 30210
Fig. 7–83

77. *Tarkiainen* dress
Designed by Liisa Suvanto, 1967
Wool doubleknit
Length 32½ in. (83 cm),
bust 37¾ in. (96 cm)
DM 30605
Figs. 3–1, 7–84

78. *Linjaviitta* (beacon) dress;
*Galleria* pattern
Dress designed by Annika Rimala, 1967;
pattern designed by Vuokko Nurmesniemi,
1954
Screen-printed cotton
Length 53½ in. (136 cm),
bust 37¾ in. (96 cm)
DM 30226
Fig. 7–87

79. *Kytkin* (gear) woman's trousers;
*Kisko* (rail) pattern
Designed by Annika Rimala, 1967
Length 42½ in. (108 cm),
waist 27½ in. (70 cm)
Screen-printed cotton
DM 30201
Fig. 7–86

80. *Kytkin* (gear) woman's jacket;
*Kisko* (rail) pattern
Designed by Annika Rimala, 1967
Screen-printed cotton, metal buttons
Length 28¾ in. (73 cm),
bust 44⅞ in. (114 cm)
DM 30202; Fig. 7–86

81. *Takila* (rigging) dress; *Galleria* pattern
Dress designed by Annika Rimala, 1967;
pattern designed by Vuokko Nurmesniemi,
1954
Screen-printed cotton
Length 35 in. (89 cm),
bust 41¾ in. (106 cm)
DM 30073
Fig. 7–88

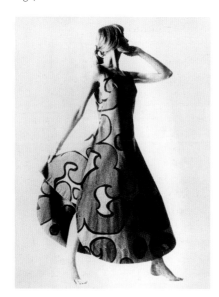

▶ Annika Rimala.
*Monrepos* dress in
*Keidas* pattern.

82. *Monrepos* dress; *Keidas* (oasis) pattern
Designed by Annika Rimala, 1967
Screen-printed cotton, zipper
Length 50¾ in. (129 cm),
shoulders 13¾ in. (35 cm),
bust 33⅞ in. (86 cm)
DM 30075
Fig. 3–20

83. Dress; *Keidas* (oasis) pattern
Designed by Annika Rimala, 1967
Screen-printed cotton
Length 35⅞ in. (91 cm),
shoulders 15⅜ in. (39 cm),
bust 33½ in. (85 cm)
Belt: 51 in. (129.5 cm) x 1 in. (2.5 cm)
DM 30194
Fig. 7–90

84. *Varustajantakki* (shipowner's coat)
double-breasted coat; *Keidas* (oasis)
pattern
Designed by Annika Rimala, 1967

Screen-printed cotton, plastic buttons,
synthetic lining
Length 33⅛ in. (84 cm),
shoulders 15⅜ in. (39 cm),
bust 44 in. (112 cm)
DM 30166
Fig. 7–91

85. *Vesihiisi* (water devil) raincoat;
*Kruuna* (pitch) pattern
Designed by Annika Rimala, 1968
Screen-printed and wax-treated cotton,
zipper
Length 36¼ in. (92 cm),
bust 47¼ in. (120 cm)
DM 30188
Fig. 7–95

86. *Myrskylyhty* (storm lantern) dress;
*Klaava* (toss) pattern
Designed by Annika Rimala, 1968
Screen-printed cotton, zipper
Length 57⅛ in. (145 cm),
bust 33 in. (84 cm)
DM 30187
Fig. 7–93

87. Dress; *Kruuna* (pitch) pattern
Designed by Annika Rimala, 1968
Screen-printed cotton
Length 41 in. (104 cm),
bust 46½ in. (118 cm)
Finlandia University, Hancock, Michigan,
Susan Peterson Coll. No. 7
Fig. 7–94

88. *Pajasso* dress; *Klaava* (toss) pattern
Designed by Annika Rimala, 1968
Screen-printed cotton, zipper
Length 36¼ in. (92 cm),
bust 42⅞ in. (109 cm);
belt: 52½ in. (133 cm) x 1 in. (2.5 cm)
DM 30184
Fig. 7–92

89. *Pohatta* (tycoon) coat
Designed by Liisa Suvanto, 1968
Handwoven velvet, zipper
Length 36¼ in. (92 cm),
shoulders 23¼ in. (59 cm),

bust 54 in. (137 cm)
DM 30424
Fig. 7–96

90. *Mansikkavuoret* (strawberry hills)
pattern
Designed by Maija Isola, 1969
Screen-printed cotton
Length 124 in. (315 cm),
width 55½ in. (141 cm),
repeat 41¾ in. (106 cm)
Susan Ward Collection, Boston
Fig. 7–63

91. *Ovia* (doors) pattern
Designed by Maija Isola, 1969
Screen-printed cotton
Length 74 in. (188 cm),
width 55½ in. (141 cm),
repeat 51 in. (130 cm)
DM 28799
Fig. 7–97

92. *Tortilla* dress; *Karakola* and *Raspa*
patterns
Designed by Annika Rimala, 1969
Screen-printed cotton
Length 36⅝ in. (93 cm),
bust 33⅞ in. (86 cm)
DM 30264
Fig. 7–98

93. *Tutka* (radar) dress; *Tarha* (orchard)
pattern
Designed by Annika Rimala,
ca. 1969 (dress); 1963 (pattern)
Cotton velvet
Length 32¼ in. (82 cm),
bust 34⅝ in. (88 cm)
DM 30221
Fig. 7–99

94. Nightgown; *Jokeri* (joker) pattern
Designed by Annika Rimala, ca. 1969
Cotton jersey
Length 55½ in. (141 cm),
shoulders 16½ in. (42 cm),
bust 33½ in. (85 cm)
DM 30170
Fig. 7–100

95. *Lovelovelove* pattern
Designed by Maija Isola, 1969
Screen-printed cotton
Length 196⅞ in. (500 cm),
width 54 in. (137 cm),
repeat 56½ in. (144 cm)
DM 6702
Fig. 7–101

96. *Kivi* (stone) dress; *Katala* (despicable)
pattern
Dress designed by Liisa Suvanto, 1970;
pattern designed by Katsuji Wakisaka, 1970
Screen-printed cotton
Length 57½ in. (146 cm),
bust 31½ in. (80 cm)
DM 30485
Fig. 7–102

97. *Fregatti* (frigate) coat;
*Kottarainen* (starling) pattern
Coat designed by Liisa Suvanto, 1971;
pattern designed by Katsuji Wakisaka, 1971
Screen-printed quilted cotton,
plastic buttons
Length 60¼ in. (153 cm),
width at hem 85 in. (216 cm)
DM 30493
Fig. 7–104

98. *Vaski* (brass) coat and wraparound
skirt ensemble; *Eve* pattern
Coat and skirt designed by Liisa Suvanto,
1971; pattern designed by
Katsuji Wakisaka, 1971
Screen-printed quilted cotton
Coat: length 58 in. (147 cm),
width at hem 62 in. (158 cm)
Skirt: length 41⅜ in. (105 cm),
waist 27½ in. (70 cm)
DM 30611
Fig. 7–105

99. *Kumiseva* (booming) pattern
Designed by Katsuji Wakisaka, 1971
Length 54¼ in. (138 cm),
width 54½ in. (138 cm),
repeat 53½ in. (136 cm)
DM 28735
Fig. 7–110

100. *Pepe* pattern
Designed by Maija Isola, 1972
Screen-printed cotton
Length 374 in. (950 cm),
width 54 in. (137 cm),
repeat 32 in. (81 cm)
DM 28854
Fig. 7–103

101. *Pikomi* coat and *Peli* (game) trousers;
*Lorina* (burbling) pattern
Designed by Pentti Rinta, 1972
Screen-printed cotton jersey, metal snap
fasteners
Coat: length 45¼ in. (115 cm),
shoulders 13⅜ in. (34 cm),
bust 33⅛ in. (84 cm)
Trousers: length 42⅞ in. (109 cm),
waist 30 in. (76 cm)
DM 30686, 30687
Fig. 7–106

102. *Kuski* (coachman) unisex suit
Designed by Pentti Rinta, 1973
Wool flannel (or canvas),
metal snap fasteners
Jacket: length 29⅞ in. (76 cm),
shoulders 15 in. (38 cm),
bust 36 in. (91 cm)
Trousers: length 43¾ in. (111 cm),
waist 30 in. (76 cm)
DM 30691, 30692
Figs. 3–33, 7–107

103. *Karuselli* (carousel) pattern
Designed by Katsuji Wakisaka, 1973
Screen-printed cotton
Length 173½ in. (440 cm),
width 54 in. (137 cm),
repeat 30¼ in. (77 cm)
DM 28706
Fig. 7–108

104. *Kikapuu* (kikapoo dance) dress;
*Ruuturaita* (square stripe) pattern
Designed by Liisa Suvanto, 1974
Screen-printed cotton
Length 59 in. (150 cm),
width at hem 48 in. (122 cm)
DM 29238; Fig. 7–111

105. *Liidokki* (glider) dress;
*Kirjo* (spectrum) pattern
Designed by Pentti Rinta, 1974
Screen-printed cotton
Length 53⅛ in. (135 cm),
bust 39⅜ in. (100 cm)
Finlandia University, Hancock, Michigan,
Susan Peterson Coll. No. 4
Fig. 7–114

106. *Liekki* (flame) dress
Designed by Liisa Suvanto, 1974
Pleated wool
Blouse: length 33½ in. (85 cm),
width at hem 123 in. (312 cm)
Skirt: length 40½ in. (103 cm),
waist 27½ in. (70 cm)
DM 30479, 30480
Fig. 7–116

107. *Sademetsä* (rainforest) pattern
Designed by Katsuji Wakisaka, 1974
Screen-printed cotton
Length 248 in. (630 cm),
width 54½ in. (138 cm),
repeat 57½ in. (146 cm)
DM 28718
Fig. 7–109

108. *Koppelo* (capercaillie hen) dress;
*Tiet* (roads) pattern
Designed by Liisa Suvanto, 1974
Screen-printed cotton
Length 55⅛ in. (140 cm),
bust 47 in. (119 cm)
DM 30498
Fig. 7–112

109. *Korppi* (raven) dress;
*Tiet* (roads) pattern
Designed by Liisa Suvanto, 1974
Length 59⅞ in. (152 cm),
width at hem 50 in. (127 cm)
DM 30601
Fig. 7–113

**110. Shirt; *Yume* pattern**
Shirt designed by Liisa Suvanto, 1975;
pattern designed by Katsuji Wakisaka,
1969
Screen-printed cotton, metal buttons
Length 33½ in. (85 cm),
bust 42 in. (107 cm)
DM 30477
Fig. 7–115

**111. *Klaava* (toss) nightgown**
Annika Rimala, 1975
Cotton, viscose jersey
Length 59 in. (150 cm),
shoulders 15¾ in. (40 cm),
bust 33⅞ in. (86 cm)
DM 30348
Fig. 7–117

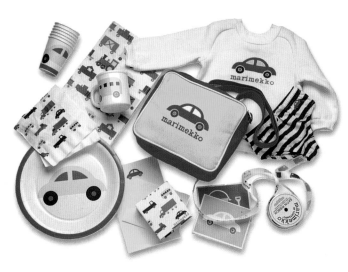

▲ Katsuji Wakisaka.
Selection of products
from the *Bo-Boo* line.

**112a–k. Selection of products from the
*Bo-Boo* line; from the *Little People*
collection**
Designed by Katsuji Wakisaka, 1975–85

**a) *Bo-Boo* pattern**
Screen-printed cotton
Length 177⅛ in. (450 cm),
width 54 in. (137 cm),
repeat 28⅜ in. (72 cm)
DM 28729
Fig. 2–30

**b) Child's bag**
Canvas
Produced by Décembre (Sulkava, Finland)
Height 8¼ in. (21 cm),
width 9⅞ in. (25 cm),
depth 4⅛ in. (10.5 cm); adjustable strap
DM 333

**c) Child's sweatshirt**
Cotton, polyester
Manufacturer unknown
Length 15 in. (38 cm),
chest 24¾ in. (63 cm)
DM 331

**d) Sweatshirt**
Cotton
Manufacturer unknown
Length 29⅛ in. (74 cm),
chest 48 in. (122 cm)
Finlandia University, Hancock, Michigan,
Susan Peterson Coll. No. 1

**e) Bathmat**
Vat-dyed cotton pile
Produced by Regal Rugs
(North Vernon, Indiana)
Length 23⅝ in. (60 cm),
width 27⅞ in. (70 cm)
DM 6433

**f) Stationery and supplies**
Printed paper
Produced by Contempo
(Kalamazoo, Michigan)
Boxed set of writing paper and envelopes:
length 9⅛ in. (23.3 cm),
width 6¼ in. (16 cm)
Set of 7 postcards, each:
length 4¼ in. (11 cm),
width 5½ in. (14 cm)
Two rolls of gift ribbon,
each: diameter 3½ in. (9 cm)
DM 6427, 6428

**g) Notebook**
Printed paper
Produced by Walki (Valkeakoski, Finland)
Length 4⅜ in. (11 cm),
width 4⅜ in. (11 cm),

depth 1 in. (2.5 cm)
DM 6426

**h) Party/picnic supplies**
Paper
Produced by Contempo
(Kalamazoo, Michigan)
Plate: diameter 11¾ in. (30 cm)
Cups: height 3¾ in. (9.5 cm),
diameter 3 in. (7.5 cm)
Tablecloth: length 41 in. (104 cm),
width 21¼ in. (54 cm)
Napkins: length 6¾ in. (17 cm),
width 6¾ in. (17 cm)
DM 6429, 6432, 6431

**i) Mug**
Glazed ceramic
Produced by Pfaltzgraff
(York, Pennsylvania)
Height 3¾ in. (9.5 cm),
diameter 3⅜ in. (8.5 cm)
DM 6430

**j) Child's swimming shorts**
Lycra, cotton
Manufacturer unknown
Length 6⅞ in. (17.5 cm),
waist 16½ in. (42 cm)
DM 330

**k) Blanket/sleeping bag**
Resin-treated polyester
Manufacturer unknown, USA
Length 41⅜ in. (105 cm),
width 35½ in. (90 cm)
DM 6436

**113. *Resla* (sled) waistcoat;
*Viiriäinen* (quail) pattern**
Designed by Annika Rimala,
1976 (waistcoat); 1969 (pattern)
Screen-printed cotton,
metal snap fasteners
Length 17⅞ in. (45.5 cm),
shoulders 11¾ in. (30 cm),
bust 32¼ in. (82 cm)
DM 30257

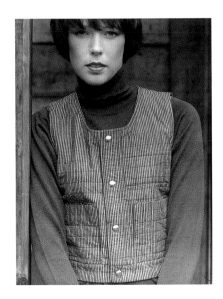

**114.** *Nopsa* (nimble) shorts;
*Viiriäinen* (quail) pattern
Designed by Annika Rimala,
1976 (shorts); 1969 (pattern)
Screen-printed cotton, plastic button,
zipper
Length 14½ in. (37 cm),
waist 26 in. (66 cm)
DM 30252
Fig. 3–24

**115.** *Nutukas* (reindeer fur shoe) jacket;
*Tattari* (buckwheat) pattern
Jacket designed by Annika Rimala, 1976;
pattern designed by Oiva Toikka, 1961
Screen-printed cotton, zipper
Length 43¾ in. (111 cm),
shoulders 18⅛ in. (46 cm),
bust 41 in. (104 cm)
DM 30235
Fig. 7–118

**116.** *Pusu* (kiss) dress;
*Hedelmäkori* (fruit basket) pattern
Designed by Annika Rimala, 1976 (dress);
early 1960s (pattern)
Screen-printed cotton, metal buttons
Length 57½ in. (146 cm),
shoulders 13 in. (33 cm),
bust 31½ in. (80 cm)
DM 30144
Fig. 7–119

**117.** *Sumo* pattern
Designed by Fujiwo Ishimoto, 1977
Screen-printed cotton
Length 98⅜ in. (250 cm),
width 54¾ in. (137 cm),
repeat 49 in. (125 cm)
DM 6518
Fig. 7–121

**118.** *Taiga* pattern
Designed by Fujiwo Ishimoto, 1978
Screen-printed cotton
Length 98 in. (249 cm),
width 54 in. (137 cm),
repeat 69 in. (175 cm)
DM 6526
Fig. 7–122

**119.** *Yhteys* (connection) pattern
Designed by Pentti Rinta, 1978
Screen-printed cotton
Length 70⅞ in. (180 cm),
width 50⅜ in. (128 cm),
repeat 70½ in. (179 cm)
DM 7543
Fig. 7–123

**120.** *Sulka* (feather) dress;
*Sokkoruutu* (blind square) pattern
Designed by Pentti Rinta, 1981
Screen-printed cotton
Length 45¼ in. (115 cm),
bust 45¼ in. (115 cm)
DM 30767
Fig. 7–124

**121.** *Kavalkadi* (cavalcade) dress;
*Samba* pattern
Designed by Marja Suna, 1982
Screen-printed cotton; elasticized neckline
Length 61 in. (155 cm),
bust 100¾ in. (256 cm)
DM 29167
Fig. 7–125

**122.** *Maisema* (landscape) pattern
Designed by Fujiwo Ishimoto, 1982
Screen-printed cotton
Length 196 in. (498 cm),
width 57½ in. (146 cm),

repeat 41½ in. (105 cm)
DM 7824
Fig. 7–128

**123.** *Linnunpesä* (bird's nest) pattern
Designed by Fujiwo Ishimoto, 1982
Screen-printed cotton
Length 57½ in. (146 cm),
width 41 in. (104 cm),
repeat 6¼ in. (16 cm)
DM 7271
Fig. 7–127

**124a.** *Jäkälä* (lichen) pattern;
from the *Iso karhu* (big bear) collection
Designed by Fujiwo Ishimoto, 1983
Screen-printed cotton
Length 315 in. (800 cm),
width 57¾ in. (147 cm),
repeat 16¾ in. (43 cm)
DM 28958
Fig. 7–129

**124b.** *Ostjakki* (Ostyak) pattern;
from the *Iso karhu* (big bear) collection
Designed by Fujiwo Ishimoto, 1983
Screen-printed cotton
Length 283½ in. (720 cm),
width 58½ in. (149 cm),
repeat 59 in. (150 cm)
DM 28159
Fig. 7–130

**125.** *Viipotus* (hither and thither) coat
Designed by Marja Suna, 1983
Wool felt, plastic buttons
Length 35⅝ in. (93 cm),
bust 70⅞ in. (180 cm)
DM 29200
Fig. 7–126

**126.** Cape
Designed by Marja Suna, 1980s
Machine-knitted wool, mohair, polyamide
Length 39⅜ in. (100 cm),
width 70⅞ in. (180 cm)
Marja Suna Collection
Fig. 7–134

◄ Annika Rimala.
*Resla* waistcoat.

**127.** *Tiiti* dress; *Palkki* (beam) pattern
Designed by Marja Suna, 1984
Screen-printed cotton, plastic buttons;
elasticized hip
Length 44⅞ in. (114 cm),
shoulders 27½ in. (70 cm),
bust 53½ in. (136 cm)
Finlandia University, Hancock, Michigan,
Susan Peterson Coll. No. 3
Fig. 7–132

**128.** *Kuningas* (king) dress ensemble
Designed by Marja Suna, 1984
Machine-knitted wool, plastic buttons
Overdress: length 47¼ in. (120 cm),
width at hem 36 in. (91.4 cm)
Dress: length 50¾ in. (129 cm),
bust 46 in. (116.8 cm)
Belt: length 67 in. (170 cm),
width 3½ in. (9 cm)
DM 18758, 18759, 18760
Fig. 7–131

**129.** *Ilma* (air) pattern
Designed by Fujiwo Ishimoto, 1985
Screen-printed cotton
Length 287⅜ in. (730 cm),
width 58 in. (147 cm),
repeat 32½ in. (83 cm)
DM 6472
Fig. 7–133

**130.** *Kapris* pattern
Designed by Satu Montanari, 1985
Screen-printed cotton
Length 157½ in. (400 cm),
width 57⅞ in. (147 cm),
repeat 39 in. (99 cm)
DM 7545
Fig. 7–135

**131.** *Mosaiikki* (mosaic) pattern
Designed by Inka Kivalo, 1985
Screen-printed cotton
Length 98⅜ in. (250 cm),
width 55⅛ in. (140 cm),
repeat 25¼ in. (64 cm)
DM 6524
Fig. 7–136

**132.** *PT 7* man's suit
Designed by Pekka Talvensaari, 1986
Linen, plastic buttons
Jacket: length 30¼ in. (77 cm),
shoulders 19¼ in. (49 cm),
chest 44 in. (112 cm)
Trousers: length 44⅛ in. (112 cm),
waist 27½ in. (70 cm)
DM 352, 353
Fig. 7–138

**133.** *Koski* (waterfall) pattern
Designed by Fujiwo Ishimoto, 1986
Screen-printed cotton
Length 165⅜ in. (420 cm),
width 56½ in. (143.5 cm),
repeat 113⅜ in. (288 cm)
DM 27398
Fig. 7–137

**134.** *Marras* (dead) pattern
Designed by Fujiwo Ishimoto, 1986
Screen-printed cotton
Length 138 in. (351 cm),
width 57 in. (145 cm),
repeat 54½ in. (138 cm)
DM 27400
Fig. 7–139

**135.** *Uoma* (river bed) pattern
Designed by Fujiwo Ishimoto, 1986
Screen-printed cotton
Length 318⅞ in. (810 cm),
width 57⅞ in. (147 cm),
repeat 33⅞ in. (86 cm)
DM 27401
Fig. 7–141

**136.** *Hera* pattern
Designed by Virpi Syrjä-Piiroinen, 1987
Screen-printed cotton/linen
Length 212⅝ in. (540 cm),
width 58¼ in. (148 cm),
repeat 39⅜ in. (100 cm)
DM 8690
Fig. 7–142

**137.** *Lainehtiva* (waving) pattern
Designed by Fujiwo Ishimoto, 1988
Screen-printed cotton

Length 216½ in. (550 cm),
width 57 in. (145 cm),
repeat 43 in. (109 cm)
DM 27397
Fig. 7–140

**138.** *Aatto* (eve) pattern
Designed by Fujiwo Ishimoto, 1988
Screen-printed cotton
Length 283½ in. (720 cm),
width 56⅞ in. (144.5 cm),
repeat 35 in. (89 cm)
DM 27399
Fig. 7–143

**139.** *Puutarhakutsut* (garden party) pattern
Designed by Fujiwo Ishimoto, 1989
Screen-printed cotton
Length 196⅞ in. (500 cm),
width 57⅝ in. (146.5 cm),
repeat 46⅛ in. (117 cm)
DM 27403
Fig. 7–144

**140.** *Lepo* (rest) pattern
Designed by Fujiwo Ishimoto, 1991
Screen-printed cotton
Length 151 in. (384 cm),
width 57 in. (145 cm),
repeat 32 in. (81 cm)
DM 27395
Fig. 7–146

**141.** Jacket
Designed by Marja Suna, 1990s
Screen-printed cotton denim
Length 23⅝ in. (60 cm),
shoulders 19⅝ in. (50 cm),
bust 48 in. (122 cm)
DM 33849
Fig. 7–150

**142.** *Kohina* (rush) pattern
Designed by Kristina Isola, 1992
Screen-printed cotton
Length 102⅜ in. (260 cm),
width 57⅝ in. (146.5 cm),
repeat 33⅞ in. (86 cm)
DM 27402
Fig. 7–145

**143.** Dress from the *Maapallo* (globe) collection
Designed by Marja Suna, 1994
Machine-knitted linen, viscose
Produced by Tuoriniemi Ky
(Lapinlahti, Finland)
Blouse: length 31½ in. (80 cm),
shoulders 26¾ in. (68 cm),
bust 50 in. (127 cm)
Skirt: length 33⅛ in. (84 cm),
waist 27 in. (69 cm)
Marja Suna Collection
Fig. 7–148

**144.** *Paali* (bale) dress
Designed by Marja Suna, 1994
Machine-knitted linen; elasticized waist
Produced by Terene Oy (Oitti, Finland)
Blouse: length 29⅞ in. (76 cm),
width at hem 48 in. (122 cm)
Skirt: length 32⅝ in. (83 cm),
waist 39 in. (99 cm)
Marja Suna Collection
Fig. 7–149

**145.** *Veräjä* (gate) coat and
*Juuret* (roots) dress
Designed by Marja Suna, 1995
Machine-knitted linen; elasticized waist
Produced by Terene Oy (Oitti, Finland)
Coat: length 46½ in. (118 cm),
shoulders 20⅛ in. (51 cm),
width at hem 30 in. (76 cm)
Dress: length 49¼ in. (125 cm),
shoulders 16½ in. (42 cm),
bust 42 in. (107 cm)
Marja Suna Collection
Fig. 7–151

**146.** *Aamurusko* (aurora) pattern
Designed by Fujiwo Ishimoto, 1995
Screen-printed cotton
Length 258⅞ in. (660 cm),
width 57⅛ in. (145 cm),
repeat 39 in. (99 cm)
DM 27396
Fig. 7–147

**147.** *Björnbär* (blackberry) pattern
Designed by Anna Danielsson, 1998
Screen-printed cotton
Length 117 in. (297 cm),
width 58 in. (147 cm),
repeat 16⅞ in. (43 cm)
DM 27414
Fig. 7–158

**148.** Sweater and cap
Designed by Marja Suna, 2000
Machine-knitted wool
Produced by Kutomo Holopainen
(Tuusula, Finland)
Sweater: length 26⅜ in. (67 cm),
width 57⅛ in. (145 cm)
Cap: height 9⅞ in. (25 cm),
width at brim 9 in. (22.9 cm)
Marimekko
Fig. 7–152

**149.** *Chico* woman's suit
Designed by Ritva Falla, 2000
Wool, viscose, plastic buttons, zipper
Jacket: length 32½ in. (83 cm),
shoulders 15 in. (38 cm),
bust 38 in. (97 cm)
Trousers: length 42½ in. (108 cm),
waist 28⅜ in. (72 cm)
Marimekko
Fig. 7–153

**150.** *Catel* coat, knitted top,
and *Della* wraparound skirt
Designed by Ritva Falla, 2000
Machine-woven wool, alpaca, mohair,
polyamide, machine-knitted cotton,
metal buckle, plastic buttons
Coat: length 55⅛ in. (140 cm),
shoulders 15¾ in. (40 cm),
width at hem 31 in. (78 cm)
Top: length 22 in. (56 cm),
bust 31½ in. (80 cm)
Skirt: length 19⅛ in. (48.5 cm),
waist 26 in. (66 cm)
Marimekko
Fig. 7–155

**151a.** *Caisa* coat
Designed by Ritva Falla, 2001
Machine-woven synthetic blend,
plastic buttons
Length 49¼ in. (125 cm),
shoulders 24¾ in. (63 cm)
Marimekko
Fig. 7–156

**151b.** *Zarah* blouse and pair of mittens
Designed by Ritva Falla, 2001
Hand-knitted synthetic blend
Blouse: length 28⅜ in. (72 cm),
width at hem 24 in. (61 cm)
Mittens, each: length 10½ in. (27 cm),
width 3¾ in. (10 cm)
Marimekko
Fig. 7–156

**152.** *Crima* coat
Designed by Ritva Falla, 2001
Wool, plastic buttons
Length 49⅝ in. (126 cm),
shoulders 20½ in. (52 cm),
width at hem 32 in. (81 cm)
Marimekko
Fig. 7–154

**153.** *Bottna* (down to the bottom) pattern
Designed by Anna Danielsson, 2002
Screen-printed cotton
Length 118 in. (300 cm),
width 59¼ in. (148 cm),
repeat 31⅞ in. (81 cm)
DM 27413
Fig. 7–159

**154.** Man's suit
Designed by Matti Seppänen, 2003
Wool, plastic buttons
Jacket: length 33½ in. (85 cm),
shoulders 18½ in. (47 cm),
chest 42 in. (107 cm)
Waistcoat: length 23¼ in. (59 cm),
chest 43¼ in. (110 cm)
Trousers: length 44⅛ in. (112 cm),
waist 34⅝ in. (88 cm)
Marimekko
Fig. 7–155

Various products

**155a.** *Neiti Hiirulainen*
**(Miss Tiny Mouse) toy;** *Nasti* **pattern**
Toy designed by Mysi Lahtinen,
early 1960s; pattern designed by
Vuokko Nurmesniemi, 1958
Screen-printed cotton,
synthetic foam stuffing
Height 3⅛ in. (8 cm),
overall length 10 in. (25.4 cm)
DM 649

**155b. Toy ball;** *Suolampi*
**(bog pond) pattern**
Toy designed by Annika Rimala,
early 1960s; pattern designed by
Vuokko Nurmesniemi, 1959
Screen-printed cotton, cotton stuffing
Height 7 in. (18 cm),
diameter 7⅞ in. (20 cm)
DM 1477

**156.** *Möhköfantti* **(chunky-phant) toy;**
*Linjaarirattaat* **(spring wagon) pattern**
Toy designed by Annika Rimala, 1959;
pattern designed by Vuokko
Nurmesniemi, 1959
Screen-printed cotton, synthetic foam
stuffing, wooden spool wheels
Height 10⅝ in. (27 cm),
width 13¼ in. (34 cm)
DM 1474
Fig. 7–67

**157.** *Porsas Urhea* **(piggy brave) toy;**
*Pirput parput* **pattern**
Toy designed by Annika Rimala, early
1960s; pattern designed by Vuokko
Nurmesniemi, 1959
Screen-printed cotton, synthetic foam
stuffing
Height 15¾ in. (40 cm),
width 11¾ in. (30 cm)
DM 1475

**158. Shoes;** *Kuurupiilo*
**(hide and seek) pattern**
Pattern designed by
Vuokko Nurmesniemi, 1959
Screen-printed cotton, leather lining
Manufacturer unknown
Length 10⅜ in. (26.5 cm),
width 3 in. (7.5 cm),
heel height 1¾ in. (4.5 cm)
DM 27410
Fig. 3–13

**159. Hat;** *Suolampi* **(bog pond) pattern**
Designed by Vuokko Nurmesniemi, 1959
Screen-printed cotton
Height 6¾ in. (17 cm),
brim diameter 4¾ in. (12 cm)
DM 390

**160. Slippers;** *Hedelmäkori*
**(fruit basket) pattern**
Slippers designed by Liisa Suvanto,
early 1960s; pattern designed by
Annika Rimala, early 1960s
Leather, cotton lining
Manufacturer unknown
Length 11⅜ in. (29 cm),
width 3⅛ in. (8 cm)
DM 27411
Fig. 7–120

**161. Scarf;** *Pilvi* **(cloud) pattern**
Designed by Annika Rimala, 1963
Screen-printed cotton
Length 22⅞ in. (58 cm),
width 23⅝ in. (60 cm)
DM 30818

**162. Scarves;** *Hedelmäkori*
**(fruit basket) pattern**
Designed by Annika Rimala, 1964 (scarves);
early 1960s (pattern)
Screen-printed cotton
Length 32⅞ in. (83.5 cm),
width 33½ in. (85 cm);
length 32¼ in. (82 cm),
width 32¼ in. (82 cm)
DM 30406-1, 3

**163. Hat;** *Suomu* **(scale);** *Isoruutu* **(large
square) and** *Kukka* **(flower) patterns**
Designed by Annika Rimala, ca. 1966
Screen-printed cotton
Height 6¾ in. (17 cm),
brim diameter 41⅜ in. (105 cm)
DM 795

**164. Boots;** *Galleria* **pattern**
Boots designed by Annika Rimala, 1960s
Pattern designed by Vuokko Nurmesniemi,
1954
Screen-printed
cotton;
machine-stitched
Manufacturer
unknown
Height 15 in. (38 cm),
foot length
11¾ in. (30 cm)
DM 27409

**165.** *Hiljaset* **(quietly) boots**
Designed by Liisa Suvanto, 1967
Wool felt
Manufacturer unknown
Height 15 in. (38 cm),
foot length 10¼ in. (26 cm)
DM 8021
Fig. 7–85

**166. Socks;** *Tasaraita* **(even stripe)
collection**
Annika Rimala, 1968
Cotton
Length 23¼ in. (59 cm),
width 3½ in. (9 cm);
length 20⅝ in. (52.5 cm),
width 3½ in. (9 cm);
length 21⅛ in. (53.5 cm),
width 3⅛ in. (8 cm);
length 21¼ in. (54 cm),
width 3½ in. (9 cm);
length 17⅜ in. (44 cm),
width 3 in. (7.5 cm)
DM 13372, 30285, 30288, 30290, 30300
Fig. 7–71

**167. Drinking glasses**
Designed by Hilkka Rahikainen, 1960s
Screen-printed pressed glass
Produced by Riihimäki Glassworks
(Riihimäki, Finland)
Set of four, each: height 4¼ in. (10.8 cm),
diameter 2¾ in. (6.9 cm)
DM 19024, 19031, 19038-1, 2
Fig. 7–68

**168. Hand mirror**
Designed by Hilkka Rahikainen and
Ristomatti Ratia, 1968–69
Styrene acrilonitrile plastic
Produced by Karhumuovi (Pori, Finland)
Length 11⅜ in. (28.8 cm),
width 5¾ in. (14.5 cm)
DM 8252

**169. Vase**
Designed by Heidi Blomstedt, 1970
Mold-blown glass
Produced by Riihimäki Glassworks
(Riihimäki, Finland)
Height 6¼ in. (16 cm),
width 6¼ in. (16 cm),
depth 6¼ in. (16 cm)
DM 10974

**170.** *Peruskassi* **(basic bag) tote bag**
Designed by Ristomatti Ratia, 1971
Vat-dyed canvas
Produced by Décembre (Sulkava, Finland)
Height 14¾ in. (37.5 cm),
width 21¼ in. (54 cm)
DM 14745
Fig. 7–72

**171.** *303* **shoulder bag**
Designed by Ristomatti Ratia, 1971
Vat-dyed canvas
Produced by Décembre (Sulkava, Finland)
Height 11¾ in. (30 cm),
width 11¾ in. (30 cm),
adjustable strap 34 in. (87 cm)
DM 14744
Fig. 6–9

**172. Lidded containers and tray**
Designed by Hilkka Rahikainen and
Ristomatti Ratia, 1972
Styrene acrilonitrile plastic
Produced by Karhumuovi (Pori, Finland)
Containers: height 3½ in. (8.8 cm),
diameter 3¾ in. (9.5 cm);
height 3 in. (7.5 cm),
diameter 2⅜ in. (5.9 cm)
Tray: length 13 in. (33 cm),
width 13 in. (33 cm)
DM 8243, 32125, 11496
Fig. 7–69

**173. Salad bowl, ash trays, and container**
Designed by Ristomatti Ratia, 1972
Melamine plastic
Produced by Karhumuovi (Pori, Finland)
Salad bowl: height 3½ in. (9 cm),
diameter 8 in. (20.2 cm)
Ashtrays: height 1¼ in. (3.2 cm),
width 2⅜ in. (6 cm),
depth 2⅜ in. (6 cm);
height 1¼ in. (3.2 cm),
width 4¾ in. (12 cm),
depth 4¾ in. (12 cm)
Container: height 4 in. (10 cm),
width 2½ in. (6.4 cm),
depth 2½ in. (6.4 cm)
DM 8255:1, 8259, 8255-2, 8257-1, 8257-3,
32126-3
Fig. 7–69

**174. Salad tongs**
Designed by Ismo Kajander, 1972
Styrene acrilonitrile plastic
Produced by Treston (Turku, Finland)
Length 8⅞ in. (22.5 cm),
width 1½ in. (4 cm)
DM 8249
Fig. 7–69

**175.** *Maxi-salkku* **suitcase**
Designed by Ristomatti Ratia, 1973
Vat-dyed canvas
Produced by Décembre (Sulkava, Finland)
Height 11¾ in. (30 cm),
width 17⅜ in. (44 cm),
depth 2⅛ in. (5.5 cm)
DM 14746

**176.** *Section* **vases**
Designed by Ristomatti Ratia, 1979
Mold-blown glass
Produced by Iittala Glassworks
(Iittala, Finland)
Set of four, each: height 7 in. (17.7 cm),
width 4¼ in. (11 cm),
assembled diameter 8½ in. (22 cm)
DM 32045

**177. Pouches;** *Piccolo*, *Nadja*,
**and** *Puketti* **(bouquet) patterns**
Purses designed 1980s;
patterns designed by Vuokko Nurmes-
niemi, 1953 (*Piccolo*), 1959 (*Nadja*), and
Annika Rimala, 1964 (*Puketti*)
Screen-printed cotton, metal clasp
Length 4 in. (10 cm),
width 7⅞ in. (20 cm);
length 7¼ in. (18.5 cm),
width 6¾ in. (17 cm);
length 4 in. (10 cm),
width 7⅞ in. (20 cm)
DM 27412-2, 3, 1
Fig. 7–70

### Architecture

**178. Scale model of experimental
Marihouse, Bökars, Porvoo**
Designed by Aarno Ruusuvuori, 1966
Wood, cardboard
Height 5⅞ in. (15 cm),
width 29½ in. (75 cm),
depth 17¾ in. (45 cm)
Museum of Finnish Architecture, Helsinki
Fig. 7–74

**179. Scale model of the Marimekko
factory, Herttoniemi, Helsinki**
Designed by Erkki Kairamo and Reijo
Lahtinen, 1973
Wood, metal, cardboard
Height 14¾ in. (37.5 cm),
width 70⅞ in. (180 cm),
depth 47⅜ in. (120.5 cm)
Museum of Finnish Architecture, Helsinki
Fig. 7–81

# Corporate Chronology

**1949** Viljo Ratia acquires Printex. Originally an oil-cloth factory, the company's primary production consists of fabrics for the interior.

**1949–87** Maija Isola designs, first for Printex, then for Marimekko; from 1979 to 1987 she works in collaboration with her daughter Kristina Isola.

▶ Shelving in the Vintti shop.

**1951** "Marimekko" is initiated by Armi Ratia and her circle of friends to develop, design, and market textiles manufactured by Printex. The first Marimekko collection is presented (May 20) at the Kalastajatorppa Hotel, Helsinki; it is one of Finland's first fashions shows. The fashions and stage set were designed by Riitta Immonen. Marimekko Oy is established and formally entered in the Trade Register (May 25), with Armi Ratia and Riitta Immonen as majority owners and Viljo Ratia and Viljo Immonen as minority owners with one share each. The Immonen shares are later transferred to Armi Ratia.

**1951–79** Armi Ratia acts as Marimekko's managing director, art director, and chief publicist.

**1952** Office space is rented in the Palace Hotel, Etelä-Ranta 10, Helsinki, a new

▶ Display window in the Marin Piironki shop.

building designed by Viljo Revell and Keijo Petäjä.

**1953** Printex files for bankruptcy; it reorganizes under the same name and with Armi Ratia as a principal shareholder. The first Marimekko retail shop opens at Tunturikatu 1, Helsinki.

**1953–60** Vuokko Nurmesniemi designs furnishing fabric patterns for Printex and fashions for Marimekko.

**1954** The Marimekko logo is designed by graphic artist Helge Mether-Borgström with all lowercase letters in Courier font, a standard typewriter typeface.

**1956** Company earnings reach 209,000 Fmk (approx. $ 38,000).

**1957–59** Maija Isola produces her groundbreaking *Luonto* (nature) series of life-size, naturalistic images of plants in silhouette.

**1958** Printex and Marimekko products are exhibited at the Brussels World's Fair (opens April 17). There Armi and Viljo Ratia meet Ben Thompson, architect and owner of Design Research, a pioneering design firm and retail store located in Cambridge, Massachusetts. Marimekko sale and exhibition is held at Artek, Stockholm (August). Two new shops are opened in Helsinki: Boutique at Kasarmikatu 42, and Muksula at Eerikinkatu 8.

**1959** "Finnish Industrial Design," an exhibition at Design Research, Cambridge, Massachusetts, features Marimekko fabrics and fashions. Design Research becomes the exclusive representative for Marimekko in the United States. Printex begins to export fabrics.

**1959–82** Annika Rimala designs fashions and fabric patterns for Marimekko.

**1960** New shops are opened: Piironki, at Fabianinkatu 31, Helsinki, and two others

in Turku and Stockholm. Urpo Ratia, Viljo Ratia's brother, is hired to assist in running Printex and Marimekko. Jacqueline Kennedy buys Marimekko dresses surrounded with media publicity.

**1960–75** Liisa Suvanto designs fashions, starting with wool dresses, for Marimekko.

**1961** Company earnings reach 2.18 million Fmk (approx. $ 400,000).

**1961–62** Printex and Marimekko exhibitions are held in Boston, New York, Paris, Stuttgart, and Stockholm.

**1963** Armi and Viljo Ratia purchase Bökars, a manorhouse near Porvoo, and lease it to Marimekko; it becomes an important venue for Marimekko gatherings. Aarno Ruusuvuori plans Marikylä, a visionary design project consisting of a village and factory to be built in the rural setting.

**1963–64** Aarno Ruusuvuori, assisted by Reijo Lahtinen, designs the new Marimekko factory, Vanha Talvitie 3, Helsinki.

**1965** The Vintti shop is opened in the Rautatalo, Keskuskatu 3, Helsinki.

**1966** Printex merges with Marimekko, January 4; Viljo Ratia becomes a minority shareholder. An area in Porvoo is leased for the future Marikylä and Marimekko

factory; the Marihouse, a prototype for the houses to be built in Marikylä, is designed by Ruusuvuori and erected at Bökars (ultimately it is the only one to be built). The Marihouse and a sauna (the Marisauna) appear in *Arkkitehti*.

**1966–70** Armi Ratia hires her son, Ristomatti Ratia, as the first full-time male designer at Marimekko.

**1967** New Marimekko shop opens in Copenhagen (September 5); Marimekko shops now number eighteen in all: fourteen in Finland, three in Sweden, and one in Denmark. Marimekko products are also sold in 90 retail shops in Finland, and about 140 abroad. A new printworks, designed by Aarno Ruusuvuori and Reijo Lahtinen, is built in Helsinki, at Vanha Talvitie 6, next door to the old one. Earnings reach 12.8 million Fmk (approx. $ 2 million).

**1968** Printing at the new factory begins (January); sales increase, especially in the United States. Marimekko begins to collaborate with other Finnish factories on products including cotton jersey knitwear. The exhibition "To Finland with Love" is held in New York where Armi organized the Marimekko display for the opening of the Design Research store. Armi Ratia receives the Neiman-Marcus Award. Viljo and Urpo Ratia leave the company and are replaced by professional managers. Marimekko shops number fifteen: twelve in Finland, two in Sweden, and one in

Denmark; 80 retailers sell Marimekko in Finland, and 200 abroad. Earnings are 16.2 million Fmk (approx. $ 3 million); production totals approximately 1.09 million yards (994,000 meters) of printed fabrics, of which 29.5 percent is used for Marimekko clothes. The ready-to-wear factory manufactures 95,000 cotton dresses, 8,000 wool dresses, and 65,000 accessories (toys, bags, purses, aprons, placemats, teacosies, mittens). Of the overall production 45 percent is exported to some twenty foreign markets, including most European countries, the United States, Canada, and Australia.

**1968–70** The corporate structure of Marimekko is reorganized by new administrators after the departure of Viljo and Urpo Ratia.

**1968–76** Katsuji Wakisaka designs fabric patterns for Marimekko.

**1969** The staff numbers 410 in all.

**1970** Décembre Oy, a spin-off company, is founded by Ristomatti Ratia and his sister Eriika Ratia, with Ristomatti as director (1970–74). Fujiwo Ishimoto is hired to work for Décembre.

**1971** Marimekko's main shop, at Pohjois-Esplanadi 31 in Helsinki, opens. Company earnings are 17.7 million Fmk (approx. $ 3 million).

**1972** Licensing agreements are reached in the United States with, among others, Dan River, Pfalzgraff, Contempo, Motif, Samuel Ward, and in Japan with the Nishigawa-Sangyo corporation.

**1972–74** Marimekko's new factory in Herttoniemi (about 3 miles [5 km] from the center of Helsinki), is designed by Erkki Kairamo and Reijo Lahtinen (former colleagues from Ruusuvuori's office); it opens in stages.

**1973** Printing operations are transferred into the new factory in Herttoniemi.

**1974** Fujiwo Ishimoto transfers from Décembre to Marimekko as designer of furnishing fabrics. Marimekko is listed on the Helsinki Stock Exchange.

**1975** Marimekko Inc. and Ristomatti Ratia's Design studio, are established in New York. A Marimekko shop in Malmö, Sweden, opens. Company earnings are 45.54 million Fmk (approx. $ 8.5 million).

**1977** Second phase of the Herttoniemi factory project begins. Marimekko shops open in New York and Paris.

**1978** Kari Mattsson, marketing manager is hired.

**1979** Marja Suna is the last designer personally hired by Armi Ratia. Ratia dies on October 3. Financial manager Risto Takala is named the new CEO; Armi Ratia's children, Antti, Eriika, and Ristomatti, inherit her share of the voting rights (amounting to 73 percent).

**1981** Chairman of the board Jaakko Lassila resigns and is replaced by Aarno Esilä, who stays until 1983. An extension to the Herttoniemi factory is designed by architect Ilkka Salo. Décembre Oy and Marimekko merge. Company earnings are 73.36 million Fmk (approx. $ 13 million).

▲ Marisauna in Karhusaari. Museum of Finnish Architecture.

▼ The Marimekko factory in Herttoniemi. Museum of Finnish Architecture.

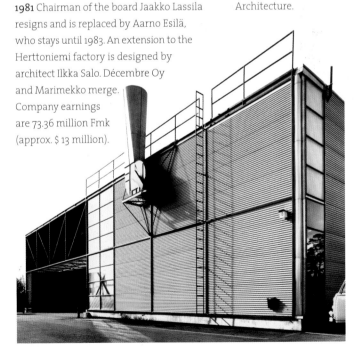

**1982** Risto Takala leaves the firm and Kari Mattson is the new CEO. Marimekko buys the Bökars property outright after almost twenty years of renting it from the Ratias. The third phase of the Herttoniemi factory project begins. Company earnings are 81.7 million Fmk (approx. $ 15 million). Marimekko personnel total 370; fabric production is 1.2 million yards (1.1 million meters) of fabric; 258,000 dresses and shirts. Of this 41 percent is exported to some thirty foreign markets, the most important being West Germany, The Netherlands, Sweden, and Switzerland. Licensed manufacturing includes: jersey knitwear, paper goods, canvas bags, wallpaper; bedsheets in Sweden (production by license agreement with Borås Wäfveri); home textiles in Japan and the United States; and paper goods, wallpaper, and children's wear in the United States. There are Marimekko agents or importers in sixteen countries.

**1983** Heikki O. Salonen, the president and CEO of Amer Group Ltd., becomes chairman of the board for Marimekko.

**1985** The Ratia heirs (Antti Ratia, Ristomatti Ratia, and Eriika Ratia [Gummerus]) sell Marimekko to Amer Group Ltd., a large conglomerate that represents, among other companies, the Phillip Morris tobacco company.

**1986** Kari Mattson resigns; Jan-Erik Grönlund is named the new CEO. Company earnings are 94.43 million Fmk (approx. $ 17 million). Financial situation deteriorates.

**1987** Amer Group subsidizes Marimekko with 28 million Fmk (approx. $ 5 million).

**1988** Magnus Hästö becomes the new CEO.

**1990** Ritva Falla is hired.

**1991** Workidea Oy owned by Kirsti Paakkanen assumes ownership of Marimekko. Hästö leaves. Kirsti Paakkanen removes Marimekko from the Helsinki Stock Exchange.

**1999** As promised, Kirsti Paakkanen again lists Marimekko Oyj on the Helsinki Stock Exchange. Company earnings are 26.41 million Eur (approx. $ 29 million). Marimekko personnel total 254. Of the overall production, clothing accounts for 60.1 percent; interior textiles, 27.5 percent; and accessories, 12.4 percent. There are 25 shops in Finland, 1 in Sweden, 1 in Germany. Products are exported to more than 20 countries; retailers total 700 worldwide.

**2001** Kirsti Paakkanen is given an honorary doctorate by the University of Art and Design.

**2002** Company earnings are 49.31 million Eur (approx. $ 54 million); Marimekko personnel total 344. Clothing accounts for 53.6 of production; interior textiles for 35.5 percent; accessories for 10.9 percent. There are 25 Marimekko shops in Finland and 1 in Sweden.

Elsewhere, department store chains and design stores represent Marimekko in the United States (New York), United Kingdom (London), and Norway (Oslo, Trondheim, and Stavanger). There are more than eight-hundred retailers, primarily in Central Europe, the United States, and Japan. Marimekko operates three factories in Finland — a printworks in Helsinki, clothing factory in Kitee, and bag factory in Sulkava — as well as having some of its products manufactured outside Finland.

▸ Dress in *Unikko* pattern. Courtesy of Marimekko Oyj.

# Selected List of Marimekko Designers, 1950–2003

This list includes individuals whose designs went into production at Marimekko. It is organized alphabetically, with letters (in parentheses) designating the type of product that was made. The dates indicate life dates followed by the years the designer worked at Marimekko.

Key:  a = accessories    d = dresses and other clothing
      f = fabric, patterns    g = graphics

| | |
|---|---|
| Aarikka, Kaija (f) | b. 1929 / 1952–53 |
| Anttila, Lea (a, d, f) | b. 1962 / 1989–93 |
| Backlund, Agneta (f) | b. 1948 / 1978–80 |
| Danielsson, Anna (a, f) | b. 1972 (Swedish) / 2001– |
| Enbom, Kerstin (a, d, f) | b. 1945 / 1966–79 |
| Eklund, Antti (a, d, f, g) | b. 1960 / 1994–99 |
| Fagerholm, Karin (d) | b. 1968 / 1992–93 |
| Falla, Ritva (a, d, f) | b. 1952 / 1990–91, 1997– |
| Favén, Aino (f) | b. 1957 / 1988 |
| Flander, Brita (a) | b. 1957 / 1992–98 |
| Haglund, Bo (a, f, g) | b. 1963 / 1997–2001 |
| Harni, Pekka (a, f) | b. 1956 / 1999 |
| HEL Communications (f) | 2001 |
| Helenius, Elina (a, d, f) | b. 1963 / 1989–95 |
| Hirvi, Erja (a, d, f) | b. 1968 / 1995– |
| Hobin, Agneta (f) | b. 1945 / 1975–76 |
| Hopea, Saara (a) | 1925–84 / 1959, 1983 |
| Häyrinen, Susanna (d) | b. 1964 / 1989–93 |
| Immonen, Riitta (d) | b. 1918 / 1950–51 |
| Ishimoto, Fujiwo (a, d, f) | b. 1941 (Japanese) / 1974– |
| Isola, Kristina (a, d, f) | b. 1946 / 1964– |
| Isola, Maija (f) | 1927–2001 / 1949–87 |
| Isoniemi, Laura (f) | b. 1962 / 1989–90 |
| Järnefelt, Heljä (f) | b. 1950 / 1984–85 |
| Kaarakka, Eeva (d) | b. 1934 / 1957–1986 |
| Karlsson, Kalervo (d) | b. 1967 / 2002 |
| Karlsson, Niina (d) | b. 1969 / 2002 |
| Kellomäki, Kaarina (f) | b. 1943 / 1965–66 |
| Kivalo, Inka (a, f) | b. 1956 / 1985–90 |
| Konttinen, Juhani (f) | 1934–2003 / 1984 |
| Konttinen, Raili (f) | b. 1932 / 1983–84 |
| Korhonen, Tarja (f) | b. 1951 / 1985 |
| Kotilainen, Liisa (f) | b. 1955 / 1980 |
| Kranz, Gunhild (d) | b. 1973 (German) / 2001 |
| Kukkapuro, Yrjö (a) | b. 1933 / 1962–63 |
| Kukkasjärvi, Irma (f) | b. 1941 / 1984 |
| Kylmänen, Miia (a, d) | b. 1973 / 1993–94 |
| Lahtinen, Mysi (a, f) | b. 1938 / 1958–66 |
| Larna-Helkiö, Anita (f) | b. 1953 / 1981 |
| Launonen, Tuula (d, f) | b. 1950 / 1986 |
| Laurikainen, Juha (f) | b. 1955 / 1989–90 |
| Lavonen, Kuutti (f) | b. 1960 / 1975, 1987 |
| Lavonen, Maija (f) | b. 1931 / 1974–75 |
| Lind, Leena (d, f) | b. 1958 / 1986–90 |
| Lindfors, Stefan (a, d, f, g) | b. 1962 / 1992–2000 |
| Marttila, Juha (d) | b. 1977 / 1999– |
| Mikkola, Ulla (f) | b. 1948 / 1979–83 |
| Montanari, Satu (f) | b. 1956 / 1983–85 |
| Nissinen, Marjatta (d, f) | b. 1954 / 1987–91 |
| Nurmesniemi, Vuokko (d, f) | b. 1930 / 1953–60 |
| Nyström, Per-Olof (f, g) | b. 1925 / 1950–51 |
| Orvola, Heikki (f) | b. 1943 / 1984, 1986, 1987, 1999 |
| Palojoki-Joustela, Hilkka (f) | b. 1913 / 1952–53 |
| Parkkila, Jaana (a, d, f) | b. 1958 / 1993– |
| Pelli, Ilona (d) | b. 1951 / 1992–93 |
| Piirainen, Mika (a, d, f) | b. 1969 / 1994– |
| Piri, Markku (f) | b. 1955 / 1979–81 |
| Qveflander, Anneli (f) | b. 1930 / 1968–69 |
| Raekallio, Kirsti (a, d, f) | b. 1948 / 1985–86 |
| Rahikainen, Hilkka (a, f, g) | b. 1935 / 1961–2000 |
| Ratia, Armi (f) | 1912–79 / 1951–79 |
| Ratia, Ristomatti (a, f) | b. 1941 / 1967–83, 1994– |
| Rautiainen, Pirjo (d, f) | b. 1950 / 1986–87 |
| Rimala, Annika (d, f) | b. 1936 / 1960–81 |
| Rinta, Pentti (d, f) | b. 1946 / 1969–87 |
| Rintala, Jukka (a, d, f) | b. 1952 / 1986–88, 1991– |
| Rosauer, Alicia (a, d, f) | b. 1977 (American) / 1999– |
| Salonen, Jatta (f) | b. 1945 / 1983–91 |
| Segal, Robert (a, d, f) | b. 1974 (American) / 1999– |
| Seppä, Jaana (a, d, f) | b. 1966 / 1995–97 |
| Seppänen, Matti (a, d) | b. 1944 / 1999– |
| Sewón, Kristina (d) | b. 1975 / 2002– |
| Silfvenius, Outi (f) | b. 1940 / 1982 |
| Suna, Marja (a, d, f) | b. 1934 / 1979– |
| Suvanto, Liisa (d, f) | 1910–83 / 1960–75 |
| Syrjä, Virpi (a, f) | b. 1959 / 1986–91 |
| Talvensaari, Pekka (d, f) | b. 1955 / 1984–86 |
| Tilhe, Eeva Inkeri (f) | b. 1919 / 1950 |
| Toikka, Oiva (f) | b. 1931 / 1960–61 |
| Torkkola, Terttu (d, f) | b. 1954 / 1986 |
| Tuominen, Susanna (a, d) | b. 1970 / 2000–02 |
| Tuominen-Mäkinen, Outi (f) | b. 1955 / 1981–85 |
| Turick, Albert (a, f) | b. 1953 (American) / 1979–87 |
| Wakisaka, Katsuji (d, f) | b. 1944 (Japanese) / 1968–76, 2001 |
| Vikman, Ulla-Maija (f) | b. 1943 / 1979 |
| Villanen, Mari (d) | b. 1936 / 1958–69, 1972–2001 |
| Virta, Marjaana (a, d, f, g) | b. 1958 / 1993– |
| Vuorisalo, Pauli (f) | b. 1944 / 1989 |

# Bibliography

- Aav, Marianne, ed. *Arttu Brummer: Taide-teollisuuden tulisielu* (Arttu Brummer: Trailblazer of industrial art). University of Art and Design publications B 20. Helsinki: VAPK-kustannus, 1991.

- ———, ed. *Tapio Wirkkala: Eye, Hand and Thought.* Porvoo: Museum of Art and Design and Werner Söderström Corporation, 2000.

- Aav, Marianne, and Nina Stritzler-Levine, eds. *Finnish Modern Design: Utopian Ideals and Everyday Realities, 1930–97.* New Haven and London: Yale University Press with The Bard Graduate Center for Studies in the Decorative Arts, 1998.

- Ahmavaara, Anna-Liisa. *Finnish Textiles.* Helsinki: Otava, 1970.

- Ahtiluoto, Anna-Liisa. "Naisemme New Yorkissa" (Our lady in New York). *Hopea-peili* 1 (1964): 14.

- Ainamo, Antti. *Industrial Design and Business Performance: A Case Study of Design Management in a Finnish Fashion Firm.* Acta Universitatis Oeconomicae Helsingiensis A-112. Helsinki: School of Economics and Business Administration, 1996.

- Alexander, Christopher. "A City is Not a Tree." 2 Parts. *Architectural Forum* 122 (April 1965): 58–87. Translated into Finnish by Leena Maunula. *Arkkitehti* (July–August 1966).

- *Annika Rimala, 1960–2000: Väriä arkeen — Färg på vardagen — Color on our life.* Exhib. cat. Helsinki: Taideteollisuusmuseo and Libris, 2000.

- *Annika Rimala — Tarinoita* (Stories). Exh. pamphlet. Helsinki: Design Forum Finland, 1996.

- *Artek.* Exh. cat. 16. Helsinki: Taideteolli-suusmuseo, 1985.

- Blomstedt, Aulis. "Taiteilijoittemme lausuntoja sarjatuotannosta" (Statements by our artists about mass production). *Arkkitehti* 1–2 (1949).

- Boydell, Christine. *The Architect of Floors: Modernism, Art and Marion Dorn Designs.* Exh. cat. Coggleshall, England: Schoeser in association with the British Architectural Library, Royal Institute of British Architects, London, 1996.

- ———. *Our Best Dresses: The Story of Horrockses Fashions Limited.* Exh. leaflet. Preston, England: Harris Museum and Art Gallery, 2001.

- *Boxes, Boxes, More Boxes: Ristomatti Ratia.* Exhib. pamphlet. Helsinki: Finnish Museum of Art and Design, 1996.

- "The Bright Spirit of Marimekko: The U.S. Goes for Colorful, Simple, Finnish Style." *Life* (24 June 1966): 60–71.

- Brummer, Arttu. "Mieskohtainen kiitos edesmenneelle mestarille" (Personal thanks to a deceased master). Helsinki: *Domus* 2 (1931).

- Brännback, Ebba. *Margareta Ahlstedt-Willandt: Tekstiilitaiteilija-Textilkonstnär, 1888–1967* (Margareta Ahlstedt-Willandt: textile artist, 1888–1967). Exh. cat. 24. Helsinki: Taideteollisuusmuseo, 1988.

- "By Any Name — Still a Sack." *Life* (15 June 1962): 47–53, photography by Milton H. Greene.

- C. L. "Marimekko: Fashion's Status Symbol for the Intellectual." *American Fabrics Magazine* (Fall–Winter 1963).

- Dahlbäck Lutteman, Helena, ed. *Stig Lindberg: Formgivare.* Stockholm: Nationalmuseum, 1982.

- ———, ed. *Astrid Sampe: Swedish Industrial Textiles.* Stockholm: National-museum, 1984.

- Damase, Jacques. *Sonia Delaunay: Fashion and Fabrics.* London: Thames and Hudson, 1991.

- *Design textile Scandinave 1950 / 1985.* Mulhouse: Musée de l'impression sur étoffes, 1986.

- Deslandres, Jacques, and Dorothée Lalanne. *Poiret: Paul Poiret, 1879–1944.* London: Thames and Hudson, 1987.

- Donner, Jörn. *Uusi maammekirja* (A new book about our land). Helsinki: Otava, 1967.

- Enbom, Carla. *Fujiwo Ishimoto: Matkalla — Resan — On The Road.* Amos Anderson Art Museum publications, new series 38. Helsinki: Marimekko Oyj, 2001.

- *Erkki Kairamo: Luonnoksia Sketches.* Helsinki: Museum of Finnish Architecture, 1997.

- "The Finnish Look." *Look* (4 December 1962): 68–75.

- Flory, Elisabeth. ed. *Homage à Christian Dior, 1947–1957.* Exh. cat. Paris: Union des Arts décoratifs, 1986.

- Frampton, Kenneth. *Modern Architecture: A Critical History.* London: Thames and Hudson, 1992.

- Goodden, Susanna. *A History of Heal's.* London: Heal and Son, 1984.

- Hansen, Henry Harald. *Muotipuku kautta aikojen: Pukuhistoriallinen värikuvasto.* Porvoo-Helsinki: Werner Söderström Corporation, 1957.

- Hayes Marshall, H. G. *British Textile Designers Today.* Leigh-on-Sea, Brighton: Frank Lewis, 1939.

· Hunt, Antony. *Textile Design*. London: Studio, 1937.

· Ikoku, Ngozi, ed. *Post-War British Textiles*. London: Francesca Galloway, 2002.

· Ind, Nicholas. *Terence Conran: The Authorised Biography*. London: Sidgwick and Jackson, 1995.

· Jackson, Lesley. *Sixties: Decade of Design Revolution*. London: Phaidon, 1998.

· ———. *Robin and Lucienne Day: Pioneers of Contemporary Design*. London: Mitchell Beazley, 2001. Published in the United States as *Robin and Lucienne Day: Pioneers of Modern Design*. New York: Princeton Architectural Press, 2001.

· ———. *20th Century Pattern Design: Textile and Wallpaper Pioneers*. London: Mitchell Beazley; New York: Princeton Architectural Press, 2002.

· Juuti, Sirpa, Kaisa Koivisto, and Tauno Tarna, eds. *Kaj Franck: teema ja muunnelmia*. Lahti: Lahden Tuotepaino Oy, 1997. In English as *Kaj Franck: Theme and Variations*. Publication 6. Lahti: Heinola Town Museum Publications, 1997

· *Kaj Franck: Muotoilija, Formgivare, Designer*. Helsinki: Taideteollisuusmuseo and Werner Söderström Corporation, 1992.

· Kalin, Kaj. *Sarpaneva*. Helsinki: Otava, 1985.

· Karling, Ritva. "Finnish Design Houses: Marimekko and Hackman." In *Financial Analysis Report*. Helsinki: Conventum, 2000.

· Kaufmann Jr., Edgar J. "Letter for Art and Industry of Finland." *Ornamo* (1949): 17.

· Kopisto, Sirkka. *Moderni Chic Nainen: Muodin vuosikymmenet 1920–1960* (The modern chic woman; the fashion decades 1920–1960). Helsinki: Museovirasto, 1997.

· Koskennurmi-Sivonen, Ritva. "Creating a Unique Dress: A Study of Riitta Immonen's Creations in the Finnish Fashion House Tradition," Ph. D. dissertation, University of Helsinki, Akatiimi, 1998.

· Koski, Katri. "Marimekon tehdasrakennus: Arkkitehtuuritutkielma" (The Marimekko factory building: a study in architecture). Interview with Reijo Lahtinen, the architect. University of Art and Design, Helsinki, 1997.

· Kruft, Hanno-Walter. *Städte in Utopia: Die Idealstadt vom 15. bis zum 18. Jahrhundert*. Munich: C. H. Beck, 1989.

· Kruskopf, Erik. *Suomen taideteollisuus: suomalaisen muotoilun vaiheita* (Finnish industrial art: phases of Finnish design). Porvoo: Werner Söderström Corporation, 1989.

· Lappalainen, Piippa, and Almay, Mirja. *Kansakunnan vaatettajat* (The nation's clothiers). Porvoo: Werner Söderström Corporation, 1996.

· L. I. "Joulutunnelmaa Carl Larssonin perhepiirissä 60 vuotta sitten — Joulutunnelmaa Armi ja V. Ratian perhepiirissä meidän aikanamme" (The Christmas mood in Carl Larsson's family circle 60 years ago – The Christmas mood in Armi and V. Ratia's family circle in our own time). *Hopeapeili* (December 1964).

· Larsen, Jack Lenor. *Jack Lenor Larsen: 30 Years of Creative Textiles*. Paris: Musée des Arts décoratifs; New York: Jack Lenor Larsen, 1981.

· Lehnert, Gertrud. *1900-luvun muodin historia* (History of 20th century fashion). Translation into Finnish by Kirsi Niemi. Cologne: Könemann, 2001.

· Lindegren, Riitta. "Marimekon maallikkosaarnaaja" (Marimekko's lay preacher). *Anna* 28 (1964): 18.

· MacKeith, Peter B., and Kerstin Smeds. *Finland at the Universal Expositions, 1900–1992: The Finland Pavilions*. Tampere: Kustannus Oy City, 1993.

· *Maija Isola: maalauksia vuosilta 1955–1988* (Maija Isola: paintings from the years 1955–1988). Publication 4. Hämeenlinna Art Museum, 1992.

· Maunula, Leena. *"Idealähteenä tennistossut ja kaljakori"* (Ideas from tennis shoes and a beer crate,) *Helsingin Sanomat* (20 April 1996).

· Mendes, Valerie, and Frances Hinchcliffe. *Ascher: Fabric, Art, Fashion*. London: Victoria and Albert Museum, 1987.

· Mendes, Valerie. *British Textiles from 1900 to 1937*. London: Victoria and Albert Museum, 1992.

· *Muoto ja rakenne, konstruktivismi Suomen modernissa arkkitehtuurissa, kuvataiteessa ja taideteollisuudessa* (Form and structure, constructivism in modern Finnish architecture, pictorial and industrial art). Exh. cat. Helsinki: Ateneumin taidemuseo, 1981.

· Naylor, Colin. ed. *Contemporary Designers*. Chicago and London: St James Press, 1990.

· "New Verve from Finland: The Marimekko Idea — Boots, Shoes, the Works." *Vogue* (15 November 1965): 140–45, photography by Gordon Parks.

· Niilonen, Kerttu. "Mari-nainen pukeutuu marivillaan" (The Mari-woman dressed in Mari wool). *Omin käsin* (1961):1.

· "Niin, haluan perustaa sateliitin, eräänlaisen lentävän johtoryhmän" (Yes, I want to found a satellite, a kind of flying board of directors). Interview with Armi Ratia. *Liikemaailma* 7 (1964).

- Nikula, Riitta. *Architecture and Landscape: The Building of Finland*. Translated by Timothy Binham. Helsinki: Otava, 1993.

- Norri, Marja-Riitta, and Maija Kärkkäinen, eds. *Aarno Ruusuvuori: Structure is the Key to Beauty / Järjestys on kauneuden avain*. Exh. cat. Helsinki: Museum of Finnish Architecture, 1992.

- Norri, Marja-Riitta, Elina Standertskjöld, and Wilfried Wang, eds. *Twentieth-Century Architecture: Finland*. Munich: Prestel, 2000.

- "Nouvelles robes — Soir d'eté." *Elle* (22 July 1965).

- O'Hara, Georgina. *The Encyclopaedia of Fashion*. London: Thames and Hudson, 1986.

- Piña, Leslie. *Alexander Girard: Designs for Herman Miller*. Atglen, Penn.: Schiffer, 1998.

- *Puoli vuosisataa MMM* (Half a century of MMM). Keuruu: Otava, 1999.

- Ratia, Armi. "Mihin ryijy joutui?" (Where did the *ryijy* rug go?). *Kaunis Koti* 4 (1949).

- Ratia, Ristomatti. *Paha poika (Bad boy)*. Keuruu: Otava, 2002.

- Richards, Michaela. *The Best Style: Marion Hall Best and Australian Interior Design, 1935–1975*. New York: Art and Australia books G+B Arts International Ltd., 1993.

- Robertson, Bryan, and Sarah Wilson, eds. *Raoul Dufy*. London: Hayward Gallery, 1983.

- "The Roots of Contemporary." *Ambassador* (January 1963): 61.

- Rosenau, Helen. *The Ideal City: Its Architectural Evolution*. 2nd ed. London: Studio Vista, 1974.

- Sarvisto, Soile. "Tekstiilitaiteilija Maija Isola: Printex-Marimekko Oy:n painetut kankaat, 1949–1969" (Maija Isola, textile artist: fabrics printed by Printex-Marimekko Oy, 1949–1969). MA thesis, University of Helsinki, 1970.

- S. T. "Karjalainen kosmopoliitti" (A Karelian cosmopolitan). *Karjala* (9 January 1964).

- Saarikoski, Tuula. *Armi Ratia: Legenda jo eläessään* (Armi Ratia: a legend in her lifetime). Porvoo: Werner Söderström Corporation, 1977.

- Saint Laurent, Yves, et al. *Yves Saint Laurent*. Exh. cat. New York: The Metropolitan Museum of Art and Thames and Hudson, 1984.

- Salonen, Marjatta, ed. *Suomen tekstiiliteollisuus 250 vuotta, 1738–1988* (250 years of the Finnish textile industry, 1738–1988). Helsinki: Tekstiiliteollisuusliitto, 1988.

- Sassi, Mirja. "Lähellä luontoa" (Close to nature). *Hopeapeili* 8 (1957).

- Seeling, Charlotte. *Fashion: The Century of the Designer, 1900–1999*. Translated by Neil and Ting Morris and Karen Waloschek. Cologne: Könemann, 1999.

- Sotamaa, Yrjö, and Pia Strandman, eds. *Ateneum Maskerad: Taideteollisuuden muotoja ja murroksia — Taideteollinen korkeakoulu 130 vuotta* (Ateneum Masquerade: Forms and crises in industrial art — 130th anniversary of the University of Art and Design). Helsinki: Taideteollinen korkeakoulu, 1999.

- Sparke, Penny. "Bold Strokes on a Broad Canvas." *Design* (June 1982): 32.

- Suhonen, Pekka. *Artek: Alku, tausta, kehitys*. Espoo: Artek, 1985.

- Suhonen, Pekka, and Juhani Pallasmaa, eds. *Marimekkoilmiö* (Phenomenon Marimekko). Espoo: Amer Group Ltd. / Weilin & Göös, 1986.

- ———, eds. *Phenomenon Marimekko*, translated by Michael Wynne-Ellis. Espoo: Amer Group Ltd. / Weilin & Göös, 1986.

- *Suomi rakentaa* (Finland builds) 4. Exh. cat. Helsinki: Museum of Finnish Architecture, 1970.

- *Suomi rakentaa* (Finland builds) 5. Exh. cat. Helsinki: Museum of Finnish Architecture, 1976.

- Supinen, Marja. *AB. Iris: Suuri yritys* (AB. Iris: a great enterprise). Helsinki: Kustannusosakeyhtiö Taide, 1993.

- Svensson, Inez. *Tryckta tyger från 30-tal till 80-tal*. Stockholm: Liber Förlag, 1984.

- Tabermann, Tommy, and Tuija Wuori-Tabermann. *Spirit and Life*. Porvoo: Marimekko and WS Bookwell Oy, 2001.

- Tanttu, Juha. *Tyylimies, pukeutumisen aakkosia* (The man of style, the ABC of fashion). Helsinki, Juva, and Porvoo: Werner Söderström Corporation, 1988.

- Tapiovaara, Ilmari. "Hyötytaide ja teollisuus" (Utility art and industry). *Ornamo* 12 (1945): 14–15.

- Tarschys, Rebecka. "Marimekko." *Mobilia* (January 1964).

- ———. "Design Research." *Mobilia* (May 1966).

- ———. "Marimekko." *Mobilia* (January 1968).

- Thurman, Christa C. Mayer. *Rooted in Chicago: Fifty Years of Textile Design Traditions*. Museum Studies, vol. 23, no.1. Chicago: Art Institute of Chicago, 1997.

- Vattula, Kaarina, ed. *Suomen talous-historia 3. Historiallinen tilasto.* Helsinki: Kustannusosakeyhtiö Tammi, 1983.

- Völker, Angela. *Textiles of the Wiener Werkstätte, 1910–1932.* London: Thames and Hudson, 1994.

- *Vuokko Nurmesniemi.* Exh. cat. Ikaalisten taidekeskus, 1994.

- Wängberg-Eriksson, Kristina. *Josef Frank: Textile Designs.* Lund, Sweden: Bokför-laget Signum, 1999.

- Wiberg, Marjo. *The Textile Designer and the Art of Design: On the Formation of a Profession in Finland.* Helsinki: University of Art and Design, 1996.

- Wickman, Kerstin. *Ten Swedish Designs: Printed Patterns.* Stockholm: Raster Förlag, 2001.

- Woirhaye, Helena. *Maire Gullichsen, taiteen juoksutyttö* (Maire Gullichsen, messenger of art). Helsinki: Museum of Art and Design, 2002.

- "Yrittäjäpalkinto ensi kerran naiselle" (Enterprise award goes to woman for first time). *Kymen Keskilaakso* 25 (1972).

# Biography References

**Ritva Falla**: Interviewed by Maria Härkä-pää, 9 June 2003. Papers in the Designmu-seo Archive; Piippa Lappalainen and Mirja Almay, *Kansakunnan vaatettajat* (The nation's clothiers) (Porvoo: WSOY, 1996).

**Fujiwo Ishimoto**: Papers in the Marimekko Archive, Designmuseo, Helsinki; *Matkalla – Resan — On the Road: Fujiwo Ishimoto* (Marimekko Oyj, Amos Anderson Art Museum publication, no. 38 (2001).

**Maija Isola**: *Maija Isola, maalauksia vuodelta, 1955–1988* (Maija Isola, paintings, 1955–1988), exhib. cat. (Riihimäki: Galleria Allina, 1992); Soile Sarvisto, "Tekstiilitaiteilija Maija Isola: Printex-Marimekko Oy:n painetut kankaat, 1949–1969" (Maija Isola, textile artist: fabrics printed by Printex-Marimekko Oy, 1949–1969), master's thesis, Helsinki University, 1970.

**Vuokko Nurmesniemi**: Interviewed by Leena Svinhufvud, 10 July 1990, copy in Designmuseo Archive; Vuokko Nurmes-niemi, lecture in the series of "Finnish Fashion Designers" at the University of Art and Design, 17 September 2001 (from notes made by Maria Härkäpää); Nurmesniemi, interviewed by Maria Härkäpää, 5 Febru-ary 2003; *Vuokko Nurmesniemi*, exhib. cat. (Helsinki: Ikaalisten taidekeskus, 1994).

**Ristomatti Ratia**: *Boxes, Boxes, More Boxes: Ristomatti Ratia*, exhib. leaf-let, (Helsinki: Finnish Museum of Art and Design, 1996); Leena Maunula, *"Idealähteenä tennistossut ja kaljakori"* (Ideas from tennis shoes and a beer crate,) *Helsingin Sanomat* (20 April 1996); Ristomatti Ratia, *Paha poika* (Bad boy) (Keuruu: Otava, 2002) .

**Annika Rimala**: *Annika Rimala — Tarinoita* (Stories), exh. leaflet (Helsinki: Design Forum Finland, 1996); Eeva-Kaarina Aro-nen, "Raidan kurinalaisuus kiehtoo Annika Rimalaa. Niukkuus on suomalaista iden-titeettiä" (The discipline of the stripe fasci-nates Annika Rimala. Economy is Finnish identity), *Helsingin Sanomat* (supplement, 2 October 1988); Erja Hyytiäinen,"Rouva Tasaraita" (Mrs. Tasaraita), *Turun Sanomat* (Extra, 21 July 2001); Leena Maunula, "An-nika Rimala 40 years textile design", in *Annika Rimala 1960–2000. Väriä arkeen — Färg på vardagen — Color on our life,* exhib. cat. (Helsinki: Taideteollisuusmuseo, 2000); Arja Myllyneva, "Vaatesuunnittelijat hu-kanneet itsetuntonsa, muotoilu kriisissä, Annika Rimala 50-vuotias" (Clothing de-signers have lost their self-esteem, design in crisis, Annika Rimala's 50th birthday), *Helsingin Sanomat* (27 August 1986); Rebecka Tarschys, "Color on our life", in *Annika Rimala, 1960–2000*; Anna-Liisa Wiikeri, "Ajattomuus auttaa Santtua" (Timelessness helps Santtu), *Helsingin Sanomat* (13 March 1983); idem, "Yksilöllistä pukeutumista" (Individual dressing), ibid.

**Pentti Rinta**: Interviewed by Maria Härkä-pää, 9 May 2003; Papers in the Marimekko Archive, Designmuseo; Anna-Liisa Wiikeri, "Aina aikaansa edellä" (Always before his time), *Helsingin Sanomat* (20 February 1970); idem, "Uusi marimekko on Pentti Rinnan" (The new Marimekko is Pentti Rinta's breakthrough) *Helsingin Sanomat* (13 October 1974).

**Marja Suna**: Interviewed by Maria Härkä-pää, 8 March 2003; Picture Archive, Designmuseo.

**Liisa Suvanto**: Sources: "Liisa Suvanto" (obituary), *Helsingin Sanomat* (12 August 1983); A.P., "Marimekko's Woolen Line," *Kaunis koti* (June 1960), papers in the Marimekko Archive, Designmuseo.

**Katsuji Wakisaka**: papers in the Marimekko Archive, Designmuseo.

# Index

Principal references in bold type, references to captions in italics.

# Contributors' page

**Marianne Aav** — director, Design Museum, Finland; curator of exhibitions on decorative arts and design; author of articles and editor of books on Finnish design. Publications include "Simplicity and Materialism in the Design of Finnish Jewelry and Metalwork," in *Modern Finnish Design* (co-editor with Nina Stritzler-Levine, 1998); "A Feeling for Precious Metals," in *Tapio Wirkkala — Eye, Hand, and Thought* (editor, 2000); and "Ruukuntekijä vai taiteilija — kansainvälisiä heijastuksia" (Potter or artist — international reflections) in *Ruukun runoutta ja materiaalin mystiikkaa* (Poetics of pottery and mysticism of material, 2003).

**Antti Ainamo** — adjunct professor, Helsinki School of Economics; adjunct professor, University of Art and Design, Helsinki; associate principal, Jaakko Pöyry Consulting. Has written extensively on Finnish business and economics, including the dissertation "Industrial Design and Business Performance: a Case Study of Design Management in a Finnish Fashion Firm" (1996); *The Coevolution of New Organizational Forms in the Fashion Industry: A Historical and Comparative Study of France, Italy, and the United States* (co-author with Marie-Laure Djelic, 1999); and "The Marikylä Utopia," in *The Charm of the Everyday* (forthcoming 2003).

**Riitta Anttikoski** — journalist and former staff writer for the Finnish daily newspaper *Helsingin Sanomat*. Author of numerous articles on Finnish culture, including "*Anna-Liisa Wiikeri — muodin kriitikko*" (Anna-Liisa Wiikeri — fashion critic), *in Kansakunnan vaatettajat* (They dressed the nation; 1996); and *Materiaalien mestari: Jukka Rintala* (Master of materials: Jukka Rintala; 1999).

**Lesley Jackson** — independent design historian, writer, and curator. Publications include *The New Look: Design in the Fifties* (1991); *The Sixties: Decade of Design Revolution* (1994); *Robin and Lucienne Day: Pioneers of Modern Design* (2001); *and Twentieth-Century Pattern Design: Textile and Wallpaper Pioneers* (2002).

**Hedvig Hedqvist** — interior architect and journalist specializing in architecture and design; former staff writer (25 years) for the Swedish daily national newspaper *Svenska Dagbladet*; freelance writer for the leading Swedish design magazines *Form* and *Sköna Hem* (Beautiful home). Publications include *1900–2002 Svensk Form — Internationell Design* (Swedish form — international design; 2002).

**Riitta Nikula** — professor of art history; Ph.D., University of Helsinki; author, contributor, and editor of books and articles specializing in twentieth-century Finnish architecture and urbanism. Publications include *Yhtenäinen kaupunkikuva, 1900–1930* (Urban unity; 1975); *Armas Lindgren, 1874–1929* (1989);

*Erik Bryggman, 1891–1955* (1991); *Architecture and Landscape: The Building of Finland* (1993); and *Sankaruus ja arki: Suomen 50-luvun miljöö* (Heroism and the everyday: building Finland in the 1950s; editor, 1994).

**Rebecka Tarschys** — freelance journalist and writer specializing in design and architecture; former staff writer (20 years) for Swedish daily national newspaper *Dagens Nyheter*. Publications include "From Cleaning Smock to Party Frock," in *Phenomenon Marimekko* (1986); and "Colour on Our Life," in *Annika Rimala, 1960–2000* (2000).

## Photographic credits

Museum photo studios and photographs commissioned by private collectors are assumed as part of the caption credits. Photographs neither credited in the captions nor found in the list below represent images from the Marimekko Archive in the Design Museum, Finland. For these, while many of the actual photographers are known, it is not always possible to match the photographer with the work. Those known to have worked for Marimekko during this period include: **Jussi Aalto, Claire Aho, Ken Arnold, Martti Brandt, Ulla Finnilä, Roger Gain, Kari Haavisto, C. G. Hagström, Arto Hallakorpi, Serge Hambourg, Pekka Haraste, Kaius Hedenström, Helge Heinonen, Ismo Kajander, Timo Kirves, Kimmo Koskela, Olavi Koskinen, Ilmari Kostiainen, Lehtikuva Oy, Markus Leppo, Kaj G. Lindholm, Joel Nokelainen, Sebastian Nurmi, Aulis Nyqvist, Mikko Oksanen, Max Petrelius, Matti A. Pitkänen, Vladimir Pohtokari, Kai Pulkkinen, Istvan Rácz, K. G. Roos, Kristian Runeberg, Karl-Johan Rönn, Seppo Saves, Henrik Schütt, Douglas Sivén, Manne Stenroos, Arthur Travis, Jukka Vatanen,** and **Lasse Wuori.** Jan Berg: Fig. 2–44. Sheldan C. Collins/Spontaneous Accomplishments: Figs. 3–14, 3–15, 7–51, 7–63. **Fritz Dressler:** Figs. 1–14, 1–16, 1–17. **Ä. Fethulla:** Fig. 4–8. **Sven Gillsäter:** Fig. 5–6. **H. Havas:** Fig. 4–3. Lehtikuva Oy: Fig. 3–35. Risto Lounema: Fig. 3–1. **Ari Lyijynen:** Fig. 3–34. **Atte Matilainen:** Fig. 4–2. Tuovi Nousiainen: Fig. 1–13. **Aulis Nyqvist:** Fig. 1–20. Ateljee Max Petrelius: Fig. 3–31. Photo Pietinen: Fig. 4–14. Jussi Pohjakallio: Fig. 1–25. Ana Pullinen: Fig. 6–13. **Simo Rista:** page 14 and figs. 4–1, 4–6, 4–9, 4–21, 4–24, 4–26, 4–27. **Matti Saanio:** Fig. 4–11. **Rauno Träskelin:** Figs. 2–1, 2–7 to 2–40, 3–3a, 3–5, 3–6, 3–7b, 3–9, 3–13, 3–16, 3–20a, 7–1 to 7–5, 7–7 to 7–9, 7–10 (B), 7–11, 7–12, 7–14 to 7–21, 7–22 (D), 7–23, 7–24, 7–25 (F), 7–27 to 7–30, 7–31 (B), 7–32 (B), 7–33 to 7–36, 7–38 (D), 7–39 (D), 7–40 (D), 7–42 (B), 7–43 to 7–49, 7–50 (Dl), 7–52 to 7–60, 7–61 (D), 7–62 (D), 7–66 (B), 7–67 to 7–72, 7–83 to 7–86, 7–88, 7–89 (D), 7–90 to 7–95, 7–97, 7–98 (D), 7–99 (D), 7–100 (D), 7–101, 7–102 (D), 7–103, 7–104 (D), 7–106 (D), 7–108 to 7–110, 7–111 (D), 7–115, 7–116 (D), 7–117 (D), 7–119 (D), 7–120 to 7–123, 7–125, 7–126 (D), 7–127 to 7–130, 7–131 (D), 7–132 to 7–137, 7–139 to 7–147, 7–148 (D), 7–150, 7–151 (D), 7–152, 7–158, 7–159. **Tony Vaccaro:** pages 8 and 298 and figs. 1–5, 1–10, 1–15, 1–21, 1–22, 3–26, 3–27, 5–1, 5–12, 5–15, 5–19 a, b, c, 6–1, 7–82. **Key:** (B): Background (D): Detail (F): Foreground